O9-BSA-928

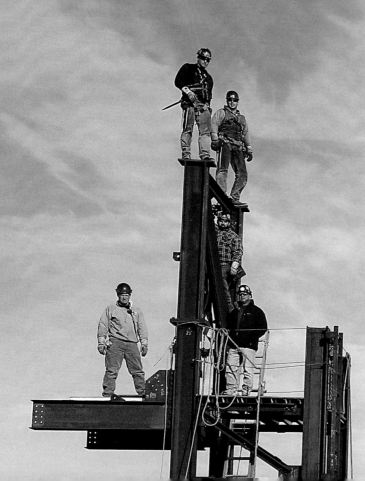

ONCE MORE TO THE SKY

THE REBUILDING *of the* WORLD TRADE CENTER

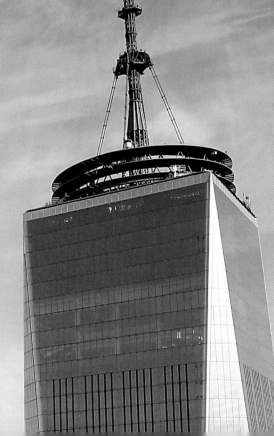

Scott Raab and
Joe Woolhead

FOREWORD BY
COLUM McCANN

SIMON & SCHUSTER
NEW YORK LONDON
TORONTO SYDNEY
NEW DELHI

Previous spread: Ironworkers Mike O'Reilly, Sean Daly, Tim Conboy, Gary Holder, and operating engineer John Shaffner stand on the steel frame for the derrick crane at the top of 3 WTC, with One World Trade Center in the background. July 2015.

Simon & Schuster
1230 Avenue of the Americas
New York, NY 10020

Foreword copyright © 2021 by Colum McCann
Prologue copyright © 2021 by Joe Woolhead
Epilogue copyright © 2021 by Scott Raab

Copyright © 2021 by Hearst Magazine Media, Inc.

All rights reserved, including the right to reproduce this book or portions thereof in any form whatsoever. For information, address Simon & Schuster Subsidiary Rights Department, 1230 Avenue of the Americas, New York, NY 10020.

First Simon & Schuster hardcover edition August 2021

SIMON & SCHUSTER and colophon are registered trademarks of Simon & Schuster, Inc.

For information about special discounts for bulk purchases, please contact Simon & Schuster Special Sales at 1-866-506-1949 or business@simonandschuster.com.

The Simon & Schuster Speakers Bureau can bring authors to your live event. For more information or to book an event, contact the Simon & Schuster Speakers Bureau at 1-866-248-3049 or visit our website at www.simonspeakers.com.

Interior design by Ruth Lee-Mui

Manufactured in the United States of America

1 3 5 7 9 10 8 6 4 2

Library of Congress Cataloging-in-Publication Data
Names: Raab, Scott, 1952- author. | Woolhead, Joe, author.
Title: Once more to the sky : the rebuilding of the World Trade Center /Scott Raab, Joe Woolhead.
Other titles: Rebuilding of the World Trade Center
Description: First Simon & Schuster hardcover edition. | New York : Simon & Schuster, 2021.
Identifiers: LCCN 2021020415 (print) | LCCN 2021020416 (ebook) | ISBN 9781982176143 (hardcover) | ISBN 9781982176204 (ebook)
Subjects: LCSH: One World Trade Center (World Trade Center, New York, N.Y.: 2014-)—History. | One World Trade Center (World Trade Center, New York, N.Y. : 2014-)—Pictorial works. | Skyscrapers—New York (State)—New York—Design and construction—History—21st century. | Skyscrapers—New York (State)—New York—Design and construction—Pictorial works. | Manhattan (New York, N.Y.)—Buildings, structures, etc.—History—21st century. | New York (N.Y.)—Buildings, structures, etc.—History—21st century. | World Trade Center Site (New York, N.Y.)—History—21st century. | World Trade Center Site (New York, N.Y.)—Pictorial works. | New York (N.Y.)—Politics and government—21st century.
Classification: LCC F128.8.W85 R33 2021 (print) | LCC F128.8.W85 (ebook) | DDC 974.7/1—dc23
LC record available at https://lccn.loc.gov/2021020415
LC ebook record available at https://lccn.loc.gov/2021020416

ISBN 978-1-9821-7614-3
ISBN 978-1-9821-7620-4 (ebook)

CONTENTS

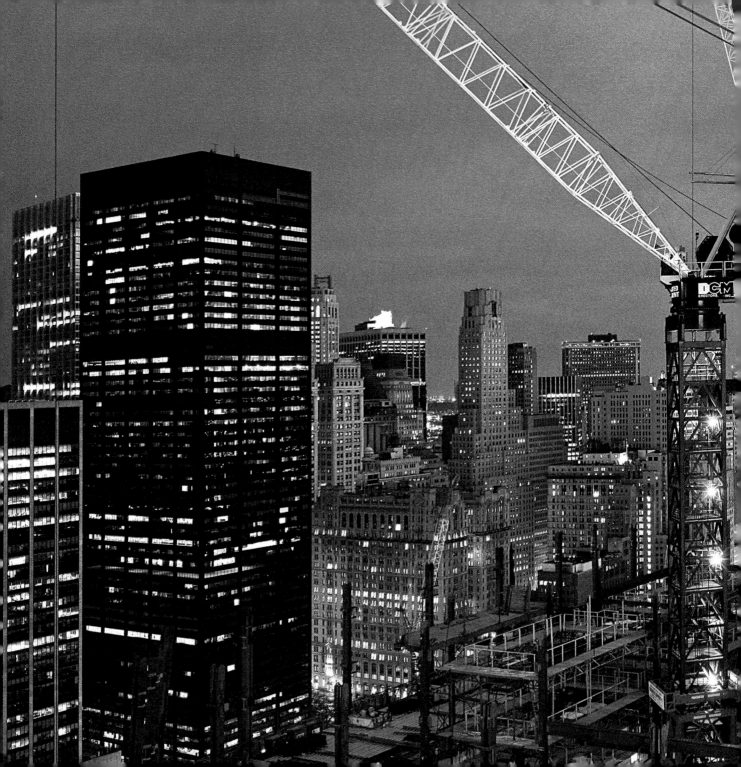

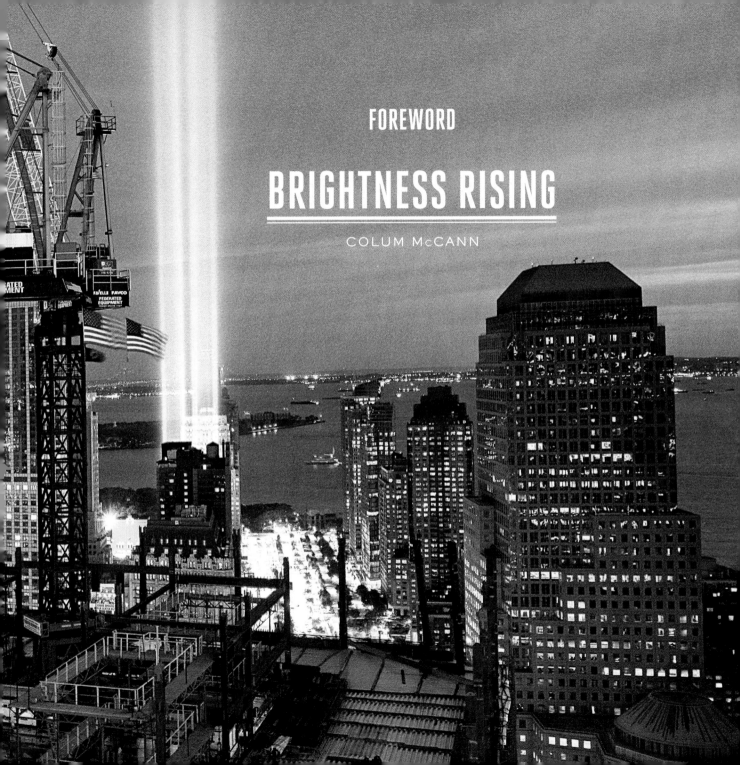

FOREWORD

BRIGHTNESS RISING

COLUM McCANN

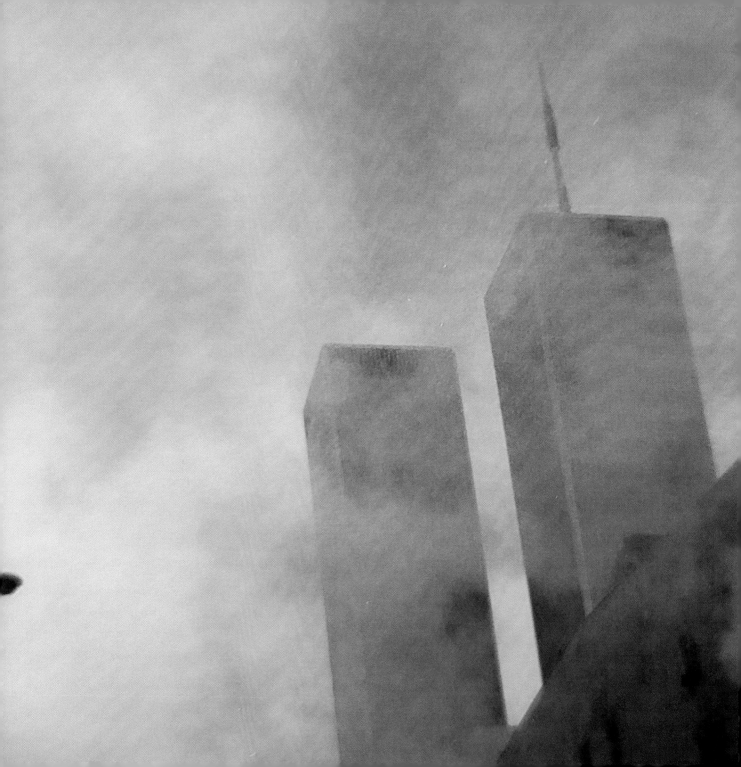

He is still up there, a quarter of a mile in the sky. He holds, in his hands, an aluminum balancing pole. He walks, he kneels, he salutes, he runs. He carries his life over the city. He makes eight passes along the three-quarter-inch wire, all the time refusing the idea of failure. Back and forth he goes, a slice of daring between the two towers, though the towers themselves are gone.

It all happens in the backspin of memory, of course, or in the smithy of the imagination, but Philippe Petit's tightrope walk across the World Trade Center towers in 1974 still happens today precisely because it was—or rather, *is*—a work of art. Petit's walk speaks to the human need for both beauty and shock, for presence over absence, for the act of creation in the face of destruction.

The walk also speaks to the art of the narrative. Stories are the fundamental building blocks of our universe: They are as old as time itself. *Once upon a time . . .* Stories outlast death. And when we tell them—especially if we tell them well, and honestly, and candidly, and proudly, and tinged with the music of the human—we bring the world alive again.

So if we go to tell the story of a place that insists on being called the Freedom Tower—even though officially it's One World Trade—we might just say that it's a 1,776-foot building in downtown Manhattan, and we might remark on its iconic status, and we might drill into the tragedy of two towers that stood before it, and we might talk about the political shitstorm that surrounded its making—the wait and the waste and the wastrels—or we might talk about it as a cathedral of greed, and we might even unwrap a patriotic lozenge to soothe the curious tinge of sorrow in our throat, or we might go even further—the way Scott Raab and Joe Woolhead have done—not just into the building itself, but into the steel of it, the bones of it, the liver of it, the cranium of it, and beyond that, into the full thumping heart of it, the lives of the ironworkers and the architects and the cement truck drivers and the city hall suits, and, most poignantly, beyond that again, into the souls of the 2,977 victims who are remembered there, those souls to whom we are inextricably linked, because like it or not, this is everyone's story, yours

and mine, too. And even though we seldom acknowledge it, we last, through our stories, so much longer than our buildings.

A concussion is a blunt-force injury that changes the way our brain functions. It's all there in Newton's Laws of Motion. When the skull is stopped, the brain, surrounded by cerebral-spinal fluid, continues its original motion and—boom!—the brain strikes the hard inside surface of the skull, leading to a bruising and swelling, a tearing of blood vessels, and a profound injury to the nerves, resulting then in a possible loss of consciousness, dizziness, blurred vision, memory problems, fatigue, and sometimes death.

America—and much of the world—was immediately concussed when the attacks occurred in 2001. We were sent reeling. Twenty years on, it doesn't take too much hindsight to see that the punch-drunk boxer came out in

Union Square. September 15, 2001.

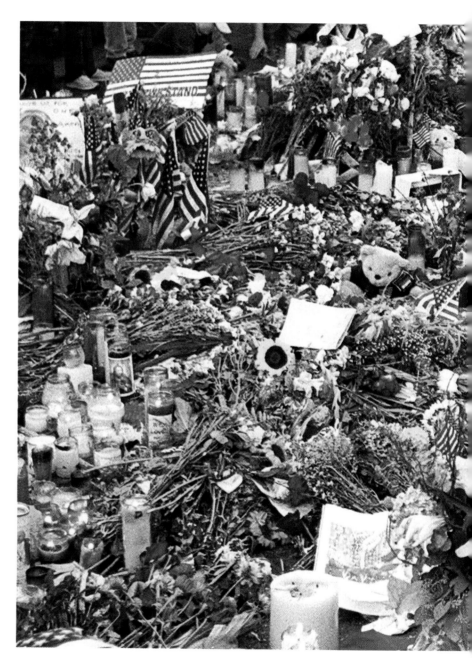

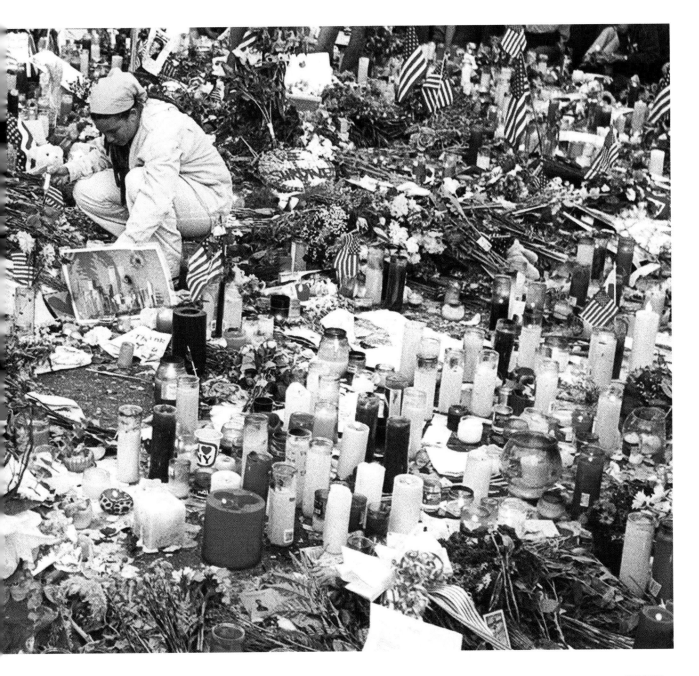

us afterward. We were still on for the fight, still on for the payday, still on for the press conference, still wrapping the white towels around our necks. *Come on pay TV, follow me jogging the dawn roads, throwing my fists at the sky. This is going to be one hell of a brawl. We're going to take on Iraq and Afghanistan and whoever the hell else comes our way.* But behind it all there was something else going on. Not many people were talking about it. America was feeling the sweats, the dizziness, the dropped forks, the dodgy moments on the stairs, the changes in mood and behavior. The promoter was in one ear, and the doctor was in the other.

Even two decades on, we're still in the middle of the fight—but one of the things about a severe concussion is that if it's managed properly, the patient can learn to recover.

We are living now in the exponential age, in a carousel of quickening, where everything is faster-smaller, faster-cheaper, faster–incomprehensibly reduced, not least our expectations for what constitutes America. Raab and Woolhead know this. One can almost feel them grasping out for a sense of meaning, a way to say that the other America—the nuanced version, the dignified version, the layered version—is still within our grasp.

This, in its elemental form, is a book about recovery. It's also about hope in the face of all available evidence. What Raab and Woolhead do, through their words and photographs, and the consequential images that sear themselves on our minds, is confront the everyday torments and the sorrows and, yes, even the well-meaning fuckups, and find a deep dignity in them—dare I say it, an American dignity. They take us beyond the traumatic encephalopathy that the country fell into, and they use storytelling and image-making as the fundamental basis of that recovery. The fact of the matter, as Raab says, is that the building now exists. It is composed as much of desire as it is of concrete. It simply had to be built. It took ten years and nearly four billion dollars, and it survived a series of traumas. If it had remained as two towers of projected light shining up in the sky—a gorgeous image, let us not forget—it would have

Ironworkers Jim Brady and Billy Gehegon linger near steel columns, soon to be lifted into place on top of 1 WTC, making it the tallest building in New York and surpassing the Empire State Building (1,270 feet in height) by one foot.

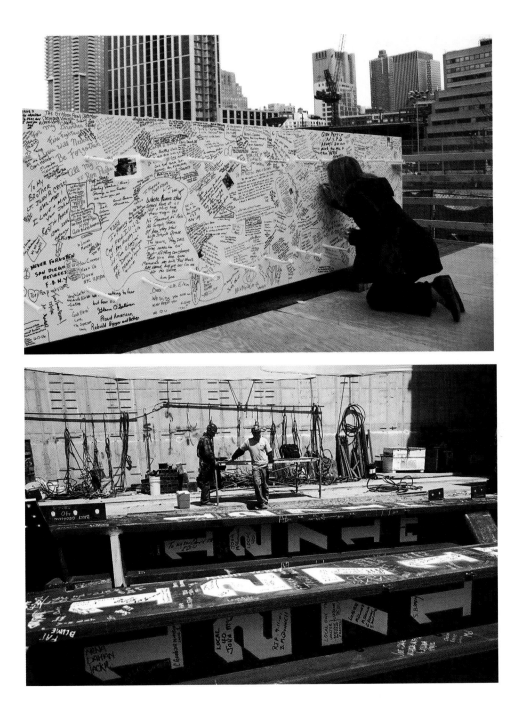

fallen short, because one of the things this country now needs is absolute practicality within the dreamed reality.

The Freedom Tower is one of the most environmentally sustainable skyscrapers in the world. Part of the eco-friendly design includes smart lighting, wind power, and steam heating. The windows are made of an ultraclear glass. The waste steam generates electricity. There is a rainwater collection system on the roof. The lights automatically dim on sunny days. The building also remembers: the inner beams are covered in graffiti, including the signatures of all the tradespeople who worked the structure, and many of the names of the dead from 2001, and also a message from Barack Obama, who visited the construction site and wrote, on a steel beam that was hoisted to the top of the tower: *We remember, we rebuild, we come back stronger.*

But—beyond the aspirational—you can go down there any day, even during the pandemic, and you can see men and women going about the everyday business of getting to work. There are magazines to publish, and real estate deals to be done, and cybersecurity to negotiate, and all manner and means of human interaction to witness. Indeed the ordinary can sometimes turn extraordinary, as happened in November 2014, just after the building opened for business.

Two window washers had to be rescued by over a hundred New York City firefighters when the pair were left dangling precariously in their rig sixty-nine stories above the ground. The firefighters had to use a diamond saw to cut through the glass and lean out over the void to pull the men to safety. They were taken briefly to the hospital and treated for hypothermia.

The story hit the front page of the *New York Times*, precisely because it made us think of other stories, reminding us that good things can sometimes occur and help us fill up the emptiness in the national soul.

When the towers came down I thought a lot about eyelashes. I lived, at that stage, on East Seventy-First Street, about five crow-flying miles

from the World Trade Center. For a good few days, the ash drifted up from downtown and some of it settled in an eyelash pattern on the windowsill of my home office. I began to wonder what the ash contained: the contents of a résumé, a part of an office desk, a flake of shoelaces. It was a chilling thing to think that a couple of thousand bodies might be aloft in the air—their shirts, their ties, and, yes, their eyelashes.

But just about everything was chilling in those days. Everything had meaning. The lone dog that walked across the Brooklyn Bridge. The fire hydrant wreathed in flowers. The supermarket shelves empty of eyewash. The trucks heading in the direction of Staten Island to a place called Fresh Kills, not to mention the mothers and fathers following behind, wondering if some memory of their sons or daughters might be found inside.

My father-in-law, Roger Hawke, a lawyer, was in the first building to be hit that morning, the second one to come down. He got out: He survived. When he finally came uptown, hours later, my four-year-old daughter, Isabella, ran into his arms and then immediately recoiled. He was still covered in dust from the glaucoma storm of debris—oh, the eyelashes—through which he had walked. She hid in a cupboard. When I found her, I asked her what was wrong.

"Poppy's burning," she said.

I said to her that Poppy wasn't burning, but maybe there was some smoke on his clothes from a fire downtown. She looked up at me and said: "No, he's burning from the inside out."

She might, I thought then, have been talking about a nation.

My daughter is twenty-four years old now. When I am asked about her—who she is, and what she does—I say that she is smart and brilliant and invested in politics, in particular the politics of immigration and the environment, and she carries, by the way, a copy of the U.S. Constitution in her pocket wherever she goes. Her grandfather still remembers the day when he walked down the World Trade Center staircase, and he will forever recall the faces of those young men and women, firefighters and police,

who were hurrying their way upward to try to save others.

My daughter doesn't remember that day, but she has been told the story of it.

———————

There once was a 450-pound steel cable strung across the gap between two high towers, and a man walked along it. The towers are no more, and there is no cable between them, but the man is alive, both literally and figuratively, and the walk is still being walked, simply because we have the power to fire lines of braided, quilted, imaginative thought along the neurons in our brains: stories.

It might all be a vast coincidence, of course, or a product of my own febrile imagination, but I like to think that we are all braided together in extraordinary ways, Raab and Woolhead and the window washers and the firefighters and Petit and beyond, and we are reminded through the art of the pen and the camera that we don't live in a place that permanently burns from the inside out. Rather we get so much of our light from the process of telling our stories, no matter how dark some of them happen to be. Or, for that matter, how bright.

Build the building and shine the lights, too. That's the message. Make it livable and affordable and workable, but also allow it the ability to have the potential to be a beacon for change.

—February 2021

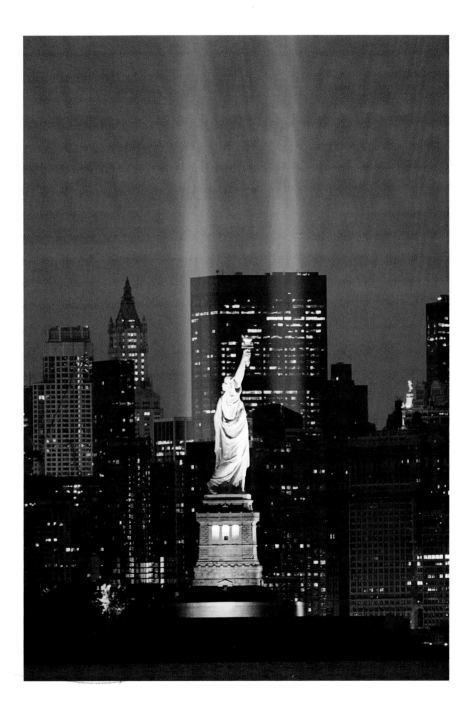

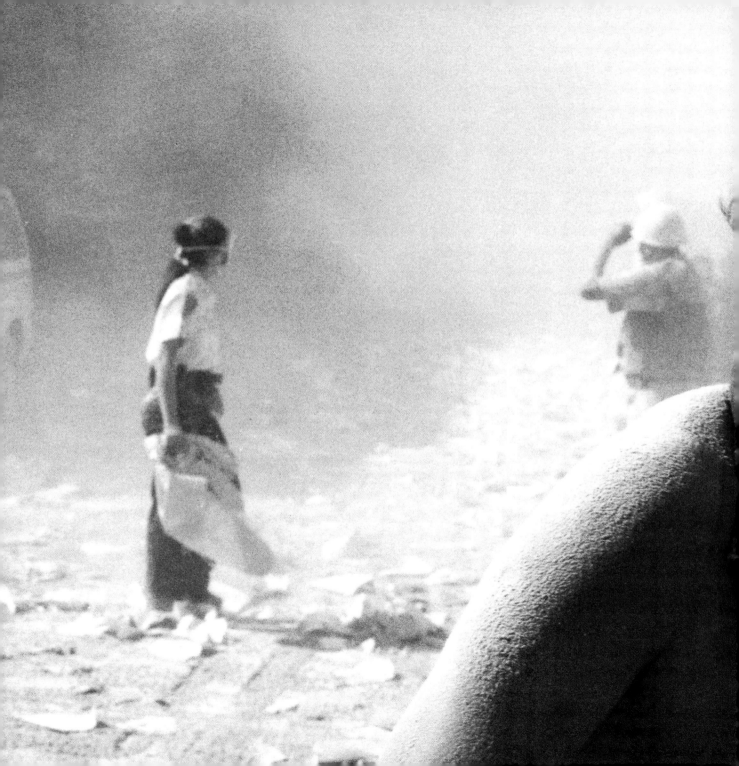

PROLOGUE

JOE WOOLHEAD

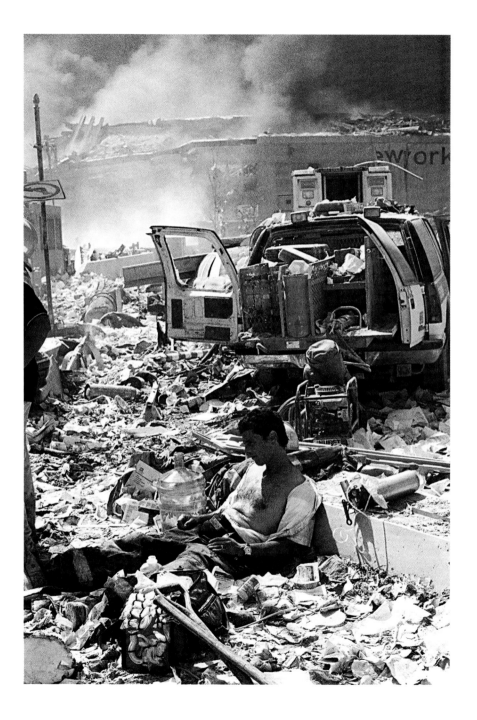

n 1990, I had arrived in the United States for the first time, settling in New York with a couple of hundred dollars and a dream and the determination to become a filmmaker. I had no green card; like a lot of Irish immigrants, I came into the country on a holiday visa. The first year in the city, I took any work to simply survive. Jobs such as busboy, mover, and casual laborer kept me going. In 1992, I received my green card. This gave me the opportunity to find steadier work as a plasterer and a mason. Nothing like cement to keep my future solid, my dream smoldering, and my belly filled.

Then the "Year of the Nightmare" happened, a turn of phrase my mother used to refer to 1996. A tragic family event unfolded in February of that year, when my brother Brendan was a passenger on a London bus that was blown up by the IRA. Being Irish and incoherent due to his injuries, he was initially under police guard and handcuffed to his hospital bed. In the meantime, his name and his likeness were plastered all over the media, accusing him of being an IRA terrorist. With the help of a civil rights lawyer, the English authorities conceded that such accusations against my brother were groundless. Brendan was exonerated, but in October of the same year, he sadly passed away.

On my return home to Dublin for the funeral, I told my parents about my own near-fatal accident. On May 3 of that nightmarish year, my legs were severely crushed by fallen granite slabs at a job in the mezzanine level of the Chase Bank headquarters not too far from the Twin Towers. Apart from my leg injuries, I sustained multiple other injuries, which would take seven years of operations, pain management, and therapy to sufficiently recover from to resume work.

In the meantime, I applied for a film course at Hunter College and was accepted in 1998. I had hoped this degree would help me to brush up on my filmmaking skills, acquired in Ireland back in the eighties. Going back to structured study also spurred on my creative endeavors fueled by my love of photography and poetry.

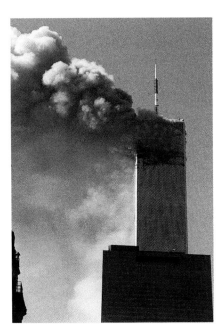 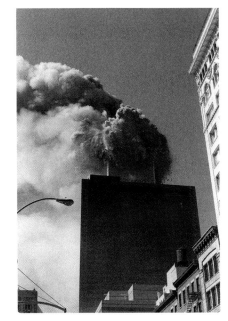 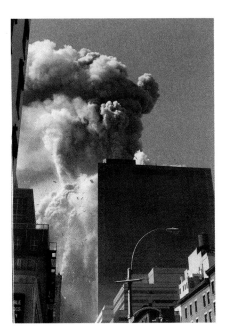

On the morning of September 11, I was living in Corona, Queens, having breakfast in a room not big enough to swing a camera when I heard on the radio that a small plane had crashed into one of the Twin Towers. In those few minutes wondering whether this was an accident or a terrorist attack, I was transported back to that horrible year when my brother died and I was practically crippled for life, and I thought about my life before and after that time, what might have been, wishfully imagining sometimes that the bombing had never even happened, much like the way my mind whirred now whenever I heard of any bombing and I would imagine the wasted potential, the wasted dreams of all those lives lost.

Then I heard another plane had hit the second tower. I grabbed my camera, my trusty Canon AE-1 Program that my eldest brother, Gerard, had bought for me in San Francisco in 1982. I headed for the subway. I got out at

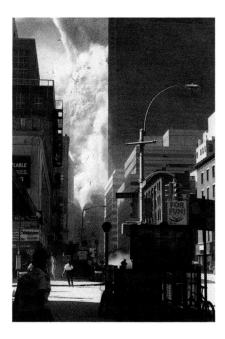 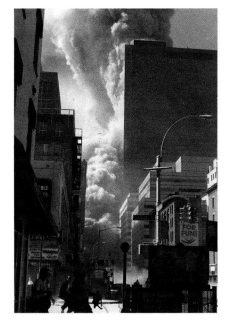 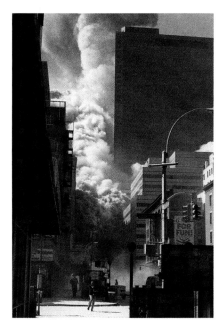

Sunnyside, where I picked up ten rolls of film in a ninety-nine-cent store with my last $10. I got back onto the number 7 train, stuffing the film rolls into my right pocket so that I knew, when one roll was shot, I simply transferred it to the left pocket.

In 2001, cell phones weren't in widespread use, so when I boarded the train, I noticed half of the people in my carriage were oblivious to the terrifying events that had just occurred in downtown Manhattan. There were other passengers who were staring out the window aghast at the black, smoldering holes in the distant towers. I thought of the lines from Yeats's poem "Easter, 1916"—"All changed, changed utterly: A terrible beauty is born"—and thought of the hard new reality the entire world was about to confront.

I photographed the towers from the front window until the 7 train went underground. I transferred at Times Square and went as far south as the subway could safely go, to the stop at

Canal Street, then ran the rest of the way to downtown Manhattan as dazed crowds traveled away from the towers burning in the near distance.

What I witnessed that day, and on subsequent days, can be seen in the photos of people fleeing, the injured bodies, the firefighters running toward the fires, the second tower collapsing, the Winter Garden an unrecognizable flaming wreckage, the collapsed interior of Tower 6, the evening sun over a still-burning ground zero, and frightened, furious faces everywhere I looked. My experience is harder to explain. I'll never forget the feeling of loss and dread, and bitterness and anger welling up inside me during those three days I spent there shooting and how super-real or hyper-real in a visceral sense everything seemed.

In 2002, I returned for the first anniversary to pay my respects. Somehow, I was funneled into the crowd of mourners, first responders, and security who walked down a massive construction ramp into the foundation area seventy feet below street level. Clouds of dust swirled in gusts around the mourners as they converged on an enclosed ring area where flowers were being tossed and prayers were being said. Soon, there was a sea of colors at the center of the site. Truly, on that terrible day of remembrance, all of us wept for our losses.

Two years passed. My old roommate and friend Dara McQuillan called. He was working with Silverstein Properties, the chief developer of the WTC site, and he needed some photographs of the July 4 groundbreaking ceremony for the Freedom Tower. Ultimately, Dara would ask me to document Silverstein's efforts to rebuild the World Trade Center full-time. I knew this opportunity was a once-in-a-lifetime shot to capture the building of a new World Trade Center.

I became obsessed, driven by the idea that the prevailing narrative of the World Trade Center as a place of doom and gloom could be transformed, that people's perceptions could be altered by the visuals of the progress of work at the site and that ultimately, seeing my

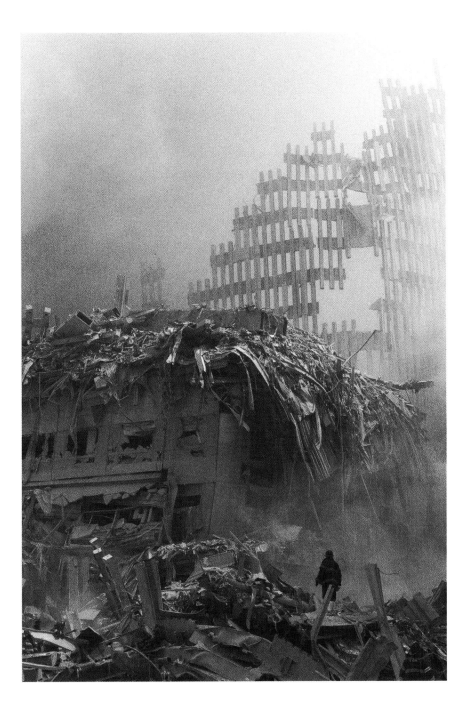

pictures in the news, people would see progress and construction where the old towers used to be, and they would be made aware of the great changes happening on the ground and high up above the restless city streets as steel and concrete were riven together into spectacular form and new towers were seeded into New York bedrock.

I began to latch on to this notion of getting the "big picture" by making many, many pictures and building a mosaic of images that would incrementally showcase the progress of work on-site. I would even imagine this "big picture" as a visual superstructure with the elements or materials made of images, yet, unlike a building, which is solid, my vision would mutate as the real buildings continued to rise around me, floor by floor, conquering space. Another analogy I played with was the notion of a thousand photographers scrambling all over the site and still not being able to cover the multiple critical steps in the development of this complex of buildings.

In the fall of 2006, I was hired by *Esquire* to travel to a shipyard in Virginia and photograph steel arriving from Rotterdam that would serve as the first columns for One World Trade Center. I met Scott Raab in our hotel lobby, two minutes late for our appointment. He huffed audibly and gave me a look that made me feel like a circus flea. He asked me if I was serious about my work as we raced to meet the incoming ship. With minutes to spare, we made it before the ship docked and unloaded its priceless cargo.

While I went below deck to capture the workers rolling off the steel pieces, Scott went to interview the captain. At one point, I stumbled into the captain's quarters unannounced, cutting off Scott midquestion, and he gave me his second withering look of the day. In his next essay, he immortalized me as "the putz with the camera" who barged in on his interview with the good captain, and I was sure that was the end of our brief partnership. Still, I'd never felt so honored, being cursed out in print.

Thankfully, as the months progressed and the foundations began to come together creating floors where

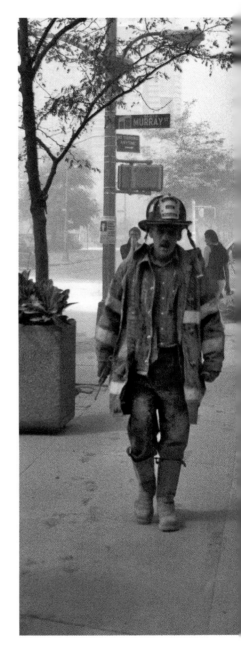

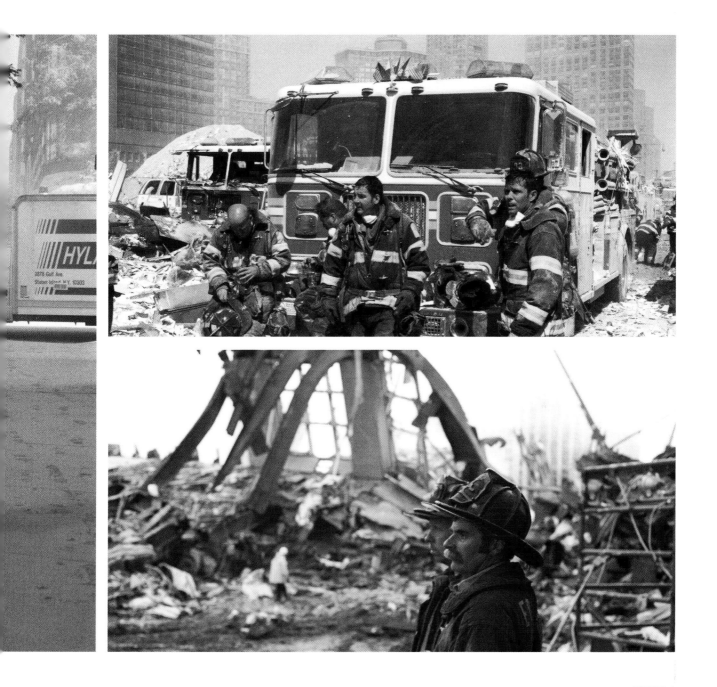

there had only been bedrock, *Esquire* called again. This time, I drove with Scott to Banker Steel, a mill in Virginia that was fabricating the raw steel shipped from Europe. The factory was mesmerizing—all the sights and noises and smells pervading the place. Soon after that trip, Scott invited me to his house in New Jersey for dinner, where I met his lovely family. I ended up staying late, having one of those rare kitchen conversations that go deeper than you meant to go, but when you go that deep, it turns out to be all right, comforting somehow, because you're in great company. We talked a lot about life, and all that it entails to keep things together and to keep on—exactly what he was writing about in his stories about the World Trade Center.

The years passed. The buildings grew up, conquering space, conquering blue sky.

I had developed a strong rapport with the workers on-site. My background in construction put me in good standing with the crews. Since I was

visiting the site so much, one of the ironworkers jokingly referred to me as the "the mayor of the World Trade Center." Being at ease with the workers was crucial. It gave me the freedom to move naturally with the workflow and without disturbing them. Having been injured on the job, I understood the hazardous nature of construction and the importance of minding my own business.

Sometimes, that was easier said than done.

Even though I was officially working for Silverstein Properties, I was still closely watched by site inspectors. I felt like I had a target on my back after being kicked off several times for known and unknown offenses. Fortunately, Dara would smooth things over with the authorities and I would be back shooting in no time. I always managed to fight my way back on-site. Still, there was one time when I thought I would never get back on-site, and that was after I captured the photograph that graces this book's cover.

In 2012, with almost one hundred floors complete of the new WTC, *Esquire* asked me to get a video for their new social media page, a defining image

that was shot within the building itself and captured both the frame of the building and the city beyond. It wasn't an easy request. I spent weeks trying to figure out the right shot. Then, one beautiful morning, on the ninetieth floor, I encountered a supervisor who showed me the shot he had just taken with his flip phone of a crane inspector hanging off the boom of the "slider" crane attached to the side of the building. It was exactly the shot I was looking for.

I raced up to the ninety-second floor for a better view. I ripped away the protective netting on the outside staircase and set up my shot, recording five workers on the crane as they inspected the steel struts for any damage from lightning strikes the night before. After several minutes recording, I had the foresight to shoot four or five frames and then continue recording. The cover shot of this book is one of those frames. Subsequently, the image went viral and took on a life of its own. Ever since, people who see my image have made this unconscious connection to the iconic photograph *Lunch Atop a Skyscraper* (1932) by Charles

C. Ebbets, of workers having lunch on a steel beam during the building of Rockefeller Center. Funnily enough, even though I'm the one who shot the photograph, I just can't see the connection between them. Later, I was even interviewed for a documentary, *Men at Lunch*, about the famous photograph, and I still didn't see the connection!

Unfortunately, as this minor visual triumph was happening in my life, I got the call from the Port Authority that I was barred from the site. I was devastated. I was never given a clear explanation for why they chose to bar me. One excuse they offered was one of the workers pictured was not safely tied off, but that was clearly untrue. It would be over six months before I was granted access again.

After getting back on, I continued to photograph at a furious pace until I had amassed a trove of images—nearly three million. As work continues on completing the WTC master plan, that shot number is still growing. And I still imagine the "big picture" coming into focus as the city rises again.

—December 2020

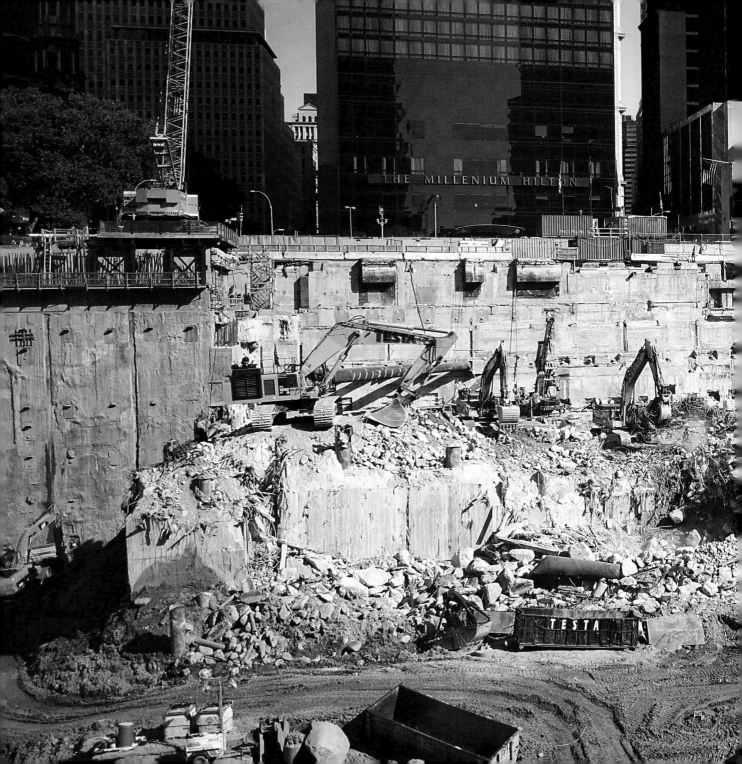

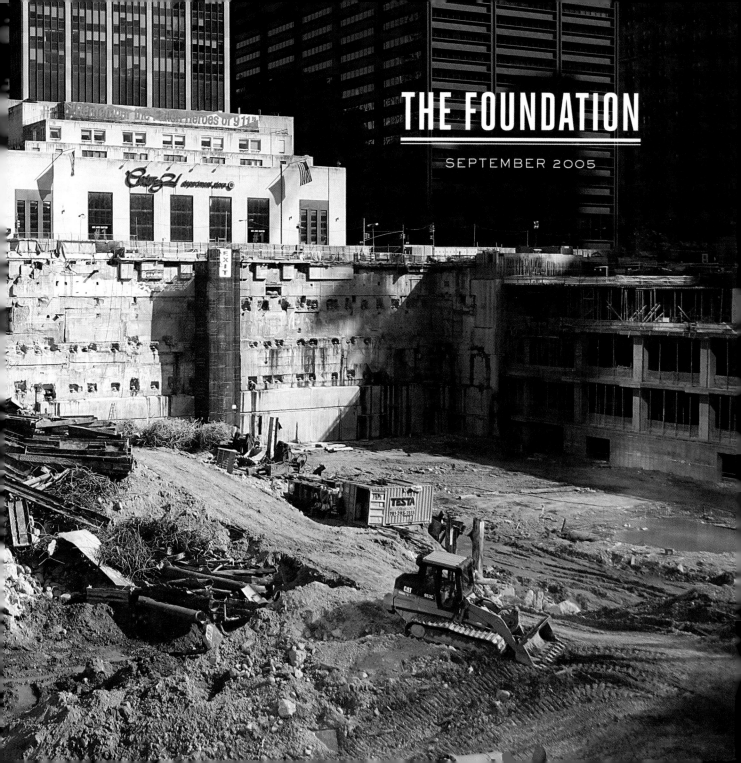

THE FOUNDATION

SEPTEMBER 2005

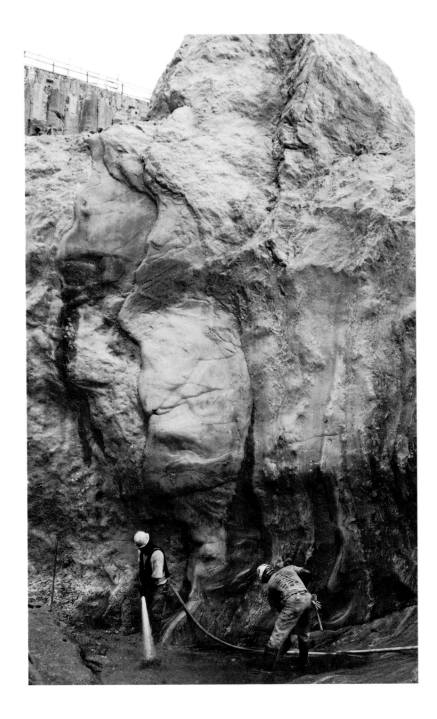

On a warm, wet cotton ball of a June morning, Marc Becker is walking ground zero. Becker's forty-seven, with twenty-six years spent working construction, thick-chested and slope-shouldered, wearing jeans, an untucked short-sleeved denim work shirt, and a royal-blue hard hat. A red-bordered security ID hangs from a cord around his neck.

He's seventy feet below street level, on the floor of the sixteen-acre pit, an off-kilter quadrangle dug forty years ago to hold the World Trade Center.

Four years after 9/11, ground zero is a landscape of damp dirt, rock, concrete, and steel. It is hallowed ground—soaked, like every other square inch of the planet, in blood and sacrifice—but it is not an empty hole, not by a long shot. A 460-foot construction ramp slopes down into ground zero from Liberty Street, the pit's southern border, passing over a covered train track that snakes through the site. Every few minutes, another commuter train from New Jersey curves into the rebuilt station that sits below Church Street, along the pit's eastern edge. Across

from the station, at the pit's western boundary, two trailers sit shadowed by a massive, pockmarked, four-decades-old concrete wall reaching all the way up from the floor of the pit to a construction roadway that runs parallel to the six broad lanes of West Street.

"What you're standing on," Becker says, "was the basement of the whole complex for the towers—the original B6 level, as is. That's why this is like holy ground to people—they were still pullin' stuff out, if you know what I mean. Spring of '02, they were still finding parts down here. Remains."

It's easy to feel overwhelmed by this patch of earth. The last resting place of nearly three thousand murder victims—you feel every moment that it's a privilege to be here, and you worry that it's a sacrilege, too—it's also a spot where steel will rise once more to the sky, and folks will come not only to mourn but also to work.

"We're ready to build," Becker says. "We're ready to go. I don't get involved in politics. All I can tell ya is we're ready to build. I've been here since 9/11; it's very personal to me. I

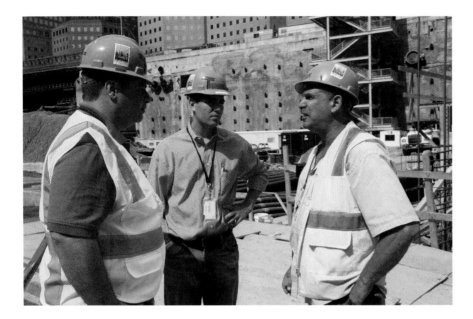

Superintendent at One World Trade Center Marc Becker (right) in a discussion with superintendent Joe Capone (left) and engineer Brian Troast (center) in the foundation of the World Trade Center site. August 2006.

saw all the horrors. I mean, the *horrors*. I saw what the poor souls looked like after they jumped outta the buildings. Whatever got pulled outta the debris, I saw it. It's personal. It's *personal*. I don't forget it."

Becker builds buildings. That's not only what he does; that's also who he is. And in New York City, 9/11 was personal beyond the butchery: The hole in the skyline where the Twin Towers rose is a hole in this city's heart. Here, they build 'em high. Knock down the Twins, they go higher.

"This is slab on grade," Becker says, talking about the scuffed stubble of old concrete and rebar set into the deep bedrock, Manhattan schist, to anchor the Twins. "We hit rock from eighteen inches to two feet down. With the new tower—going by the original design—the new slab on grade was gonna be two feet below. You're right on top of the rock then. We'd take all this out and lower it—bring in heavy machines with hammers on 'em to start breakin' the rock."

The *original design*. Becker's

referring to the 1,776-foot-tall building to be called the Freedom Tower, and the original design for it was trashed in May, a month ago. This is a bad thing for Becker—for a lot of folks—after nine months spent working down here, getting ready to build again.

Back on July 4, 2004, they sank the cornerstone into the ground. The imam and the reverend said prayers. The governor spoke of rebirth, resolve, and sacred duty. Photos were taken. Then everyone took off.

After the holiday, Becker and the crews went right back to work.

Now he points toward Vesey Street, along the north end of the pit, where the jagged concrete slabs and steel support beams of the original parking garage—the B4 level, a floor above the train tracks—have been left jutting horizontally from the concrete wall in a rough zigzag trussed with steel, new and old.

"The slabs were very weak from all the damage. You see the beams that go back to the slurry wall, these cross braces? We had to put all that in. Once that was in, we were able to demo these slabs. They were so weak that you just couldn't chop 'em down—they would collapse on you. There was a whole sequence of how to remove the slabs over that B4 slab and the trains—over an active, running train. It went without a hitch."

This slurry wall, the three-foot-thick, eleven-acre rectangle of scarred concrete within the pit, was built in 1967 to seal the Trade Center's foundation against seepage from the nearby Hudson River, whose eastern shoreline used to slice right down this site. The bathtub, the workers called it, and still do. It was held in place by more than a thousand steel-cable tiebacks fed through six-inch holes drilled through the walls, then grouted and jack-yanked at a forty-five-degree angle deep into the bedrock until the seven basement and subbasement levels of the World Trade Center were erected. The buildings themselves, once raised, held the bathtub in place.

After the WTC buildings were destroyed—not only the Twins but four other office buildings and a hotel—and the 1.5 million tons of wreckage was

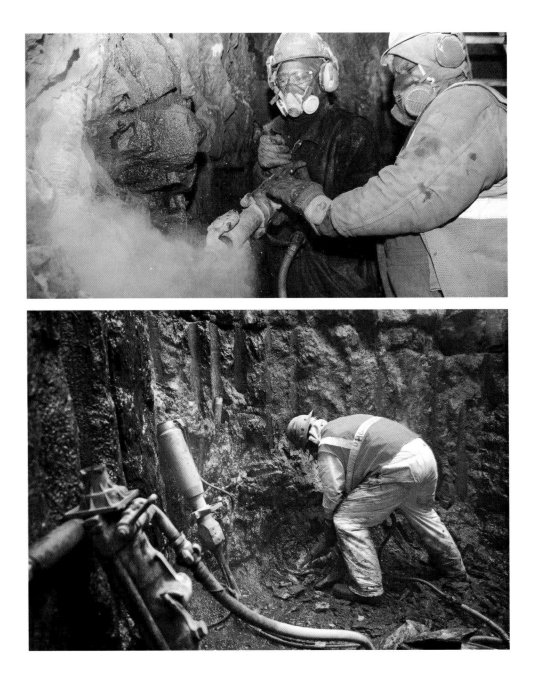

removed, these exposed bathtub walls were what remained. Pocked by its myriad round, rusted iron snouts that had sealed the now-corroded anchoring-cable holes, the slurry wall was in dire need of shoring up.

Becker and the men he works with had to pin back the wall with fresh tiebacks where they could. But here, along Vesey, where the train exits the pit, where the walls were badly hurt, and where the original design placed the north side of the Freedom Tower, they braced the slabs to keep the slurry wall from collapse until they got to work building the new tower.

To the world beyond the bathtub walls, ground zero is a hole, a mournful memory, a symbol. But to the men who build buildings, it's the worst kind of job—a job left undone. They put up the towers that stood right here, they climbed the pile of what was left, and they carted it all away. They rebuilt these train tunnels and tracks, raised this new station—ahead of schedule and under budget—and got the Port Authority Trans-Hudson (PATH) line back in business. They braced these walls and they figured out how and where to plant the Freedom Tower's column footings—the steel-and-concrete bases sunk into bedrock to anchor the rising steel, spread its weight, and keep it from sinking—without tearing up the railroad tracks.

"We had footings literally between the PATH tracks," Becker says, and you can hear the pride and frustration in his voice. "We were building the main tower columns in *between* those PATH tracks."

The bathtub was clean. The cornerstone was laid. Almost four years after 9/11, ground zero was good to go.

And then, just as the first order for the Freedom Tower's foundation steel was drawn up, it turned out that the New York Police Department had serious concerns about the building's design. It was only twenty-five feet away from West Street. The base of the 1,776-foot tower was open, exposing the columns. The NYPD was worried about truck bombs, is what it boiled down to.

All the work stopped, and some very important people looked stupid.

George Pataki, New York's governor. Larry Silverstein, the real estate developer who signed a lease on the World Trade Center six weeks before 9/11 and was ready to start rebuilding on September 12. And the folks over at the Port Authority of New York and New Jersey, the brooding quasi-governmental behemoth that built the old WTC and still owns these sixteen acres. Awfully stupid.

On May 4, Governor Pataki issued a statement pledging "yet another magnificent design that will once again inspire the nation and serve as a fitting tribute to freedom."

Then Pataki gave the architects and engineers a mere eight weeks to redesign the whole thing and move it farther from West Street. On this day, Pataki's deadline is just three weeks away, and Marc Becker has no clue what's going to happen to all the work already done here.

But Becker is sure of one thing. "I know it's gonna happen," he says. "I just don't know when."

He walks over to the cornerstone, twenty tons of Adirondack Mountain granite. It's covered by a tarp and

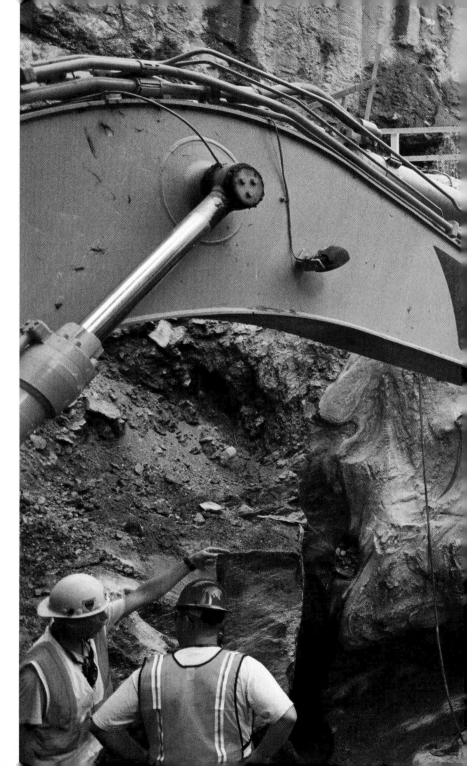

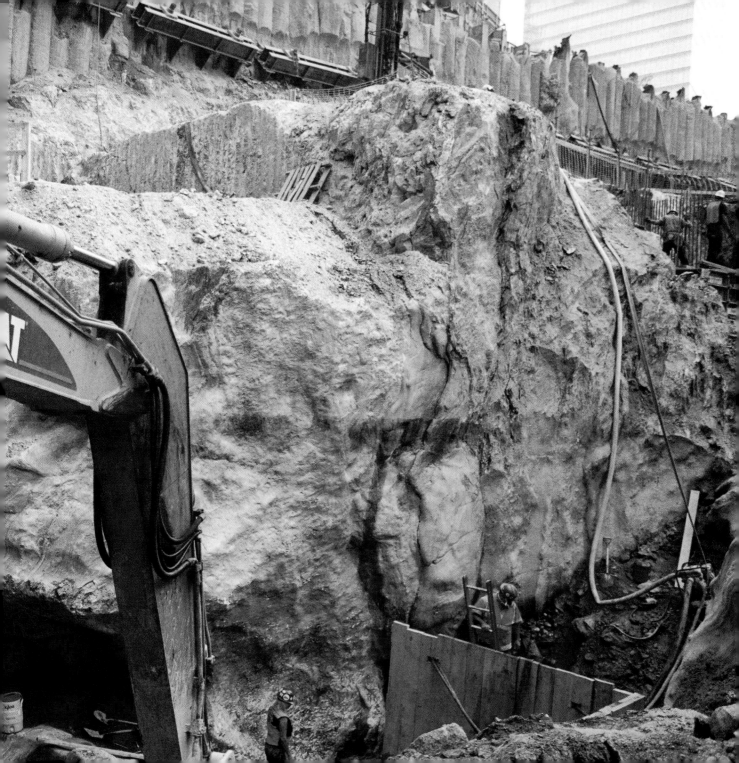

hidden inside a blue plywood box in one corner of a column footing in the southeast corner of the imaginary parallelogram that was going to be the footprint of the Freedom Tower. The rest of the footing—eleven feet deep—is half-filled with pooled rainwater.

Will they have to move the stone?

"I don't know." He shrugs. "I have no idea."

Twenty yards south of the cornerstone, a two-hundred-foot square traces the footprint of the old north Twin, marked with orange-and-silver traffic cones spaced to cover the top of its sheared-off perimeter columns, still sunk into sixty-ton bedrock. Another square of cones marks the south Twin.

Two offset squares, one north, one south, two hundred feet per side—the length of a standard Manhattan street block. Here they stood, and here they slammed to earth.

Nothing will be rebuilt here. Even as the work crews prepped the site, Marc Becker kept the Twins clear.

"No piece of equipment," he says now, "no machinery, no storage in these footprints—always outside of it."

Here the heart aches. It *hurts* here. To stand here knots your throat; it fills your eyes. Here there are no ghosts—everyone's gone for good—and this moment, like every moment, passes.

Even then, you dare not breach those lines. You rebuild, but you don't ever forget. Here they died. Here time stopped.

The best place to view ground zero from on high is atop the new fifty-two-story office tower at Seven World Trade Center—on Vesey, just north of the pit. Once your knees quit buckling and the urge to hug the floor of the roof passes, you can stare past the southern tip of Manhattan from 741 feet. West is the Hudson River, flowing just beyond the pale green, skullcapped towers of the World Financial Center, built on landfill they gouged from the pit when the WTC was built, and on the other side of the Hudson, New Jersey.

To the east, on Church Street, the tour buses idle at the curb as the tourists, thousands each day, clog the broad sidewalk. They gape at the hole in the

ground through the steel bars of the fence put up by the Port Authority; they snap photos of the old rugged cross of scorched steel formed by fate and two corroded beams of the old towers, exhumed and erected by the recovery workers as a gesture of pious defiance; they try to read the unreadable rank of black-and-white signs telling the tale of the WTC and 9/11, affixed to the fence by the PA, which was headquartered in Tower One and lost seventy-five of its own on 9/11.

The pit is below you, the cornerstone a blue fleck at your feet. Looming over Liberty Street is a forty-one-story tombstone, the former home of Deutsche Bank, empty since 9/11, draped in a shroud of black netting, ruined by the plummeting South Tower and snarled in insurance litigation ever since, still awaiting demolition.

7 WTC was the final ground zero building to fall on 9/11—at 5:20 p.m., after burning all day—and now, the first to go back up. They broke ground in May 2002, and they topped the tower out in October 2004. They hung Old Glory on the last steel beam before lifting it to the sky. The governor and Larry Silverstein stood by, watching.

Mike Pinelli stood with them. Pinelli's the Seven project super, meaning he runs the show, a gruff, goateed, fast-talking Jersey guy—pardon the redundancies—and the son of a Port Authority cop. Pinelli left the New Jersey Institute of Technology in '85 with a degree in mechanical engineering and landed his very first job as an assistant on the original Seven.

"Hopefully I'll have the opportunity to get involved in Freedom Tower," Mike says now, sitting in his plywood-framed office on the fourteenth floor of Seven. "But I got my Seven to look at again."

My Seven?

"Talk to any one of the tradesmen—they're gonna say, '*my* building.' That's a piece we all take away with us."

Pinelli was finishing a new office tower up in Midtown on 9/11, hustling to get that site cleaned up in time to obtain a temporary certificate of occupancy from the city. New York City didn't stop on 9/11, and neither did Mike. He walked down to a firehouse

by Madison Square Garden late that morning to check on his brother-in-law, who was just getting to the station. Then Pinelli walked back up to Midtown to keep working the job.

"As the day progressed, you start wonderin' what's goin' on downtown. Should I get down there? This is what we do: We're guys that build. We help. That's our attitude. I hadda stay where I was."

You can still hear what it cost Pinelli *not* to head down to ground zero that day—the guilt and the pain.

"My job's to stay here—build this building and open this job up—and my heart's tellin' me, 'No, you gotta go downtown and see what you can do.' I ended up sleepin' at my desk."

Pinelli spent the next three days at the Midtown building just trying to keep his crew together.

"Everybody's walkin' around with long faces—everybody wanted to go downtown. I was sayin', 'Guys, we can't abandon this job, we can't just peel outta here—we gotta get this TCO.'

"Saturday rolls around, I couldn't even focus anymore. I drove to Midtown,

I set everybody up—and then I said, 'I gotta go down there.'

"Saturday was like 9/11, a beautifully clear day. The smoke and the fog and guys walkin' on piles—you were there, smellin' it and seein' it, but it felt like everything wasn't real."

Pinelli went next door to Seven to help gauge the damage to the thirty-two-story Verizon Building, a seventy-eight-year-old art deco fortress that had a seven-floor chunk torn out of it when the towers pancaked.

"All the telecommunications were fed outta Verizon for Lower Manhattan, so with the collapse, all the data and telephone lines were crushed. We were tryin' to get the telephone lines back up and runnin'—there was a big push from President Bush to start tradin', gotta get Wall Street back online."

But the first thing Mike did when he got inside the Verizon Building that day was climb the stairs to get a look at ground zero.

"I walked up eighteen flights, and I got up on the setback on the south side to get a good look at what was goin' on, and you're lookin', and you're

lookin', and you're lookin'—and I just couldn't believe what I was seein'. We *build* these things. This is our city. To see that amount of destruction was unbelievable.

"The first thing that I did was, I prayed—'cause you knew that everybody died almost instantly if they were in the building when it came down. I prayed for everybody's souls, and then I just looked.

"It was so sunny, so clear, it was almost like—you ever experienced when you go to the Grand Canyon or someplace in nature, when you feel contact, whether you're a religious man or not, you feel a contact with either God or a higher element? Well, there was somethin'—some presence there. You could *feel* it. And you could feel the people who were lost. They were around. They were watchin', lookin', sayin', 'You know what—you guys'll figure this out.'"

Pinelli worked at the Verizon Building late into the night on Saturday and all day Sunday. On his way home Sunday night, he found himself sobbing at the wheel of his truck, not sure whether he should head up to the job in Midtown or down to ground zero the next morning.

"I was drivin' and I started cryin'. What I saw, it didn't dawn on me. You see it with your eyes, but it doesn't sink in—you don't allow yourself to let it sink in. I didn't know what to do. I was by myself, and I felt for all these people that perished. I felt for everybody down there helpin' out. I'm torn."

Pinelli got home close to midnight.

"I figured everybody was in bed. I go into the garage, change my clothes. I go downstairs to get some sweatpants, and as I come up the stairs, my daughters are all sittin' on the basement steps. My youngest was almost two at the time, my middle one, she was five, and my oldest was six.

"'What're you doin', Dad? How's everything?' I was still hazy. 'Dad, the bad guys, they flew a plane into your building, and it fell down.'

"'Yeah, girls, unfortunately there are bad people that do these things, awright? They hit the building, and the building came down, and a lotta people died, but they're in a better place.

Daddy was down there—everything's gonna be okay. You guys have nothin' to worry about. You're safe and you're sound.'

"And then my middle daughter says to me, 'Dad, everything's gonna be all right. We were talkin' about it. You're gonna put it back up again. Your job is to put things back up.'

"Here I am, sittin' on the stairs with these little girls, not knowin' what to do, completely confused—whether to go here or there, when to go back. My daughters had it figured out. They figured out what my purpose was in this whole picture. My daughters told me what I hadda do. 'Dad, your job is to put things back up.'

"I said, 'Girls, you're right. We're gonna put 'em back up.'

"I was cryin' again. I kissed 'em and I put 'em all to bed. Right there and then, I was squared up. They set me straight.

"I went to work the next day and sat down with my guys. There was a meeting with thirty of us. My guys were the same, a little teary-eyed, a little foggy. Everybody felt what I was feelin'. They knew. I explained to my guys, 'We gotta get *this* job done. We're gonna be the first high-rise after 9/11 to get a TCO. This is what we do. We keep goin'. We're not slowin' down. We *build*.'"

Pinelli's smiling now.

"And here we are today—we're back home."

<hr>

Brian Lyons came to ground zero on 9/11 to look for his brother Michael, a firefighter with Rescue Squad 41, stationed up in the Bronx. Lyons is forty-five years old, a sturdy middleweight with unblinking blue eyes, eyebrows that could use a landscaper, and a forceful voice—the sort of blare you need to be heard above the roar of heavy machinery. He's a mechanical-trades super at 7 WTC, taking his lunch break at a card table on the bare concrete of the twentieth floor.

"When the towers came down, I knew my brother was working at the time, okay? Right away I went to his firehouse and they weren't there, so I immediately came down here to search for him. I was down in the hole, lookin'

around for, for"—he clasps his hands—"I was helpin', whatever you could do. I took a leave of absence from the company that I was with and decided to stay down here and work."

Lyons grew up in Yonkers, just north of the city, the son of a carpenter in Local 608. He served eight years in the Coast Guard, came out as a chief engineer, and went to work in construction. In 1989, he got engaged at Windows on the World, the restaurant that was on the 107th floor of the old North Tower.

After six months of grappling and digging down in the pit, Brian Lyons found all there was left to find.

"It was Saint Patrick's Day 2002, underneath Tower Two. There was a lotta firemen there—it seemed to be that that was where the lobby was, because of the depth of where we found 'em, down near the bottom of the pit. It came down so fast that they had no time to evacuate it."

His voice never wavers. Matter-of-fact.

"We don't have a positive identification through DNA—we just have the tools that they carried that's marked

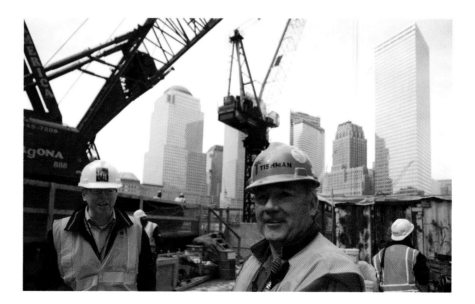

Brian Lyons of Tishman Construction and Scott Thompson of Silverstein Properties. Brian lost his brother Michael of FDNY Squad 41 on 9/11. Scott lost his brother Glenn, forty-four, who worked at Cantor Fitzgerald on the 104th floor of 1 WTC.

from their squad. During the whole process, everyone's tryin' to figure out where everybody was, where they mighta been, what squad and what truck mighta been in what building, and how far up in the building they were, and how far down you were digging. It was guesswork, tryin' to make educated guesses where these people mighta been at. That's all they are—educated guesses."

After the last fallen beam was raised and trucked away on Memorial Day 2002, Lyons supered the rebuilding of the railroad line—an around-the-clock job that took eighteen months and three thousand workers.

"You had this entire bathtub all flat, nothing there, with all the recovery material gone. So now you're starting from scratch. You put in new concrete footings, where the temporary building was gonna go for the station, okay? Meanwhile, new track was bein' laid in the tunnels—all this is happenin' simultaneously."

They cleared the tunnels. They laid the track. They raised the station, roofed it, built a new crash wall, put the escalators in, and turned on the lights.

On November 23, 2003, Brian Lyons rode from New Jersey into the new station on the very first train—four cars long, the same four cars that were the last to leave the old station the morning the towers fell—on its very first run to the World Trade Center since 9/11.

"I was right in the front of the train, the first one stickin' my head outta the door as we pulled into the station."

No smile. No note of triumph—even when he says, "I was proud to show the terrorists that we could get the train runnin' again as fast as possible." Lyons is telling a truth, not taking a position. "It was totally destroyed, and now it's a runnin' railroad to get people back to Lower Manhattan from New Jersey."

But Brian Lyons wasn't done at ground zero: With the PATH train rolling, he got the job at Seven. Put him down for the Freedom Tower, too.

"I know every inch of what was built down at the train station. I built it myself, with a lot of people. I know

that like the back of my hand down there. And I would stay as long as I—till the Freedom Tower's built, absolutely. They wanna build somethin' else, I'd work there, too.

"There's a lotta people that avoid the ground zero area—they just don't wanna see what happened down here. I welcome it. It gives me great satisfaction here at the site, because I came down here for my brother. I know where he was at, where he was found. For me to walk by that spot all the time, I have peace in my mind."

Lyons, Pinelli, and Becker build buildings. So, too, does Larry Silverstein. Nine days before the unveiling of the new Freedom Tower design, Silverstein sips iced coffee in the conference room of Silverstein Properties' Midtown headquarters. His big brass balls are on the long, polished table, resting atop their block of granite.

"That's *Carmen Red* granite," Larry says. "That was quarried in Finland, shipped to Carrara, Italy, where it was cut into massive facade stones, and this material was used for the facade of the original 7 WTC. When the building was done, I was presented with this by the contractor."

Silverstein's balls must weigh twenty pounds apiece. He built the original Seven entirely on spec—without a single tenant—hence his contractor's gesture of admiration. The new Seven, set to open for business early in '06, cost $700 million for Larry to put up, and this time around he already has one tenant signed to a lease—Silverstein Properties.

One point seven million square feet of new office space towering above the pit; one tenant: himself. Which troubles Larry not at all. Born and raised in Brooklyn's Bed-Stuy, he has practiced as a real estate ninja—buying, selling, and building in the city—since 1953. He knows that the Empire State Building itself was derided as the "Empty State" at its Great Depression ribbon-cutting back in 1931, knows that the WTC's first Twin opened in 1970 with a total of two paying tenants.

"There has never been an exquisite building built in this city," he says,

Larry Silverstein working in his new office at 7 WTC. April 2007.

"well designed, soundly built, superbly located—as Seven is—that hasn't ultimately rented. Sooner or later, they *all* rent."

The seventy-four-year-old Silverstein is what Woody Allen's Grammy Hall would call a real Jew, meaning that he could sell Trojans to Pope Benedict XVI—and also that you bet against Larry at your own peril. He filled the original Seven with tenants, set his sights upon the Twin Towers, and on July 24, 2001—after signing a ninety-nine-year, $3.2 billion, 1,160-page lease with the Port Authority—he got the keys to the whole doomed thing.

Since 9/11—Silverstein missed his daily business breakfast at Windows on the World that morning only because his wife made him keep a doctor's appointment—all the chips on the table have been stacked against Larry. His lease means that he is still paying the Port Authority of New York and New Jersey $10 million monthly rent on the WTC site, and that it is also his obligation to rebuild the ten million square feet of office space crushed into the pit—"as expeditiously as possible," he

likes to say. He has had to haggle with more than two dozen insurance companies: Larry's claim that because *two* planes flew into *two* towers, the attack therefore constituted *two* insurable incidents remains unresolved.

In his rush to rebuild the site—Silverstein spoke to the press about doing so two days after the event—he also was playing against public opinion. Silverstein Properties lost four men on 9/11—"They left six kids," Larry says now in a muted rasp, "and that's been the toughest part of everything"—but Silverstein himself became an instant villain, not to mention an easy target, media-mocked for his suits, his ties, and his thinning hair. Since 9/11, he has been called "pushy," "rapacious," and "amazingly slimy" in print.

Not that Larry Silverstein seems to care—"It'd be nice if they extolled my virtues, assuming I have one or two," he says, "but it's an irrelevancy": He's gambling against bigger fish now. Silverstein may have cash and clout, but the governor has been the only man whose will has ruled ground zero. George Pataki and New York City have

never liked each other, but he understood that any political future he hoped to realize—whether he ran again for governor or, as has often been speculated, thought of himself as presidential timber—would hinge on what becomes of ground zero.

And Silverstein—well, Silverstein was a Mario Cuomo guy when Pataki beat Cuomo back in '94. Silverstein is a real estate developer in a city full of them; George Pataki is a three-term governor of New York.

Silverstein also is in thrall to a landlord, the Port Authority—lord of the bridges, ruler of the tunnels, sovereign of the ports and airports that bind the city to the rest of the globe. The Port Authority and Pataki both have stonewalled Larry Silverstein since 9/11. The PA quietly pockets the rent and dickers with Larry behind the curtain about who'll pay how much for rebuilding the vast underground infrastructure at ground zero. Pataki has set the schedule for rebuilding, spending Silverstein's rent money by proxy while also picking an architect with a master plan for the whole site, including the

Freedom Tower Silverstein is paying for—despite the fact that Larry's lease clearly states his right to choose his own architect for the job.

Meanwhile, the Port Authority, created in 1921, plays God, invisible of hand, floating in realms beyond human ken or judgment. Governors and their appointees to the PA come and go; the Port Authority abides. By law, the city and mayor have no say in its affairs. The PA issues its own bonds, backed by the self-replenishing stream of tolls and fees it collects; it may legally condemn private property for its uses, which is how it seized those sixteen precious acres for the WTC in the first place; and, like any deity, it reigns in silence, shunning publicity, checking all bets.

Pataki, the Port Authority, Silverstein and his big brass balls—around and around they all went as the work crews prepped to put up the Freedom Tower. Then—ka-*boom*!—the police, ten months past the cornerstone laying and twelve years after the 1993 truck-bombing of the old North Twin, all of a sudden raise a concern: the

new tower's vulnerability to vehicle bombs.

"Ex*cru*ciatingly frustrating," Silverstein calls it. "I *am* seventy-four—I don't have time for green bananas—and to see this, what transpired, was *singularly* unfortunate, terribly, terribly unfortunate. In the last analysis, it should not have happened. But it did. Governments just didn't get together to focus on what they need to focus on, and so the conclusion of it all is that when NYPD gave us a specific set of standards, it became instantly obvious"— here Larry Silverstein snaps his fingers *hard*—"there was no way we could stay with the original Freedom Tower design. And so I sat with the governor and said, 'We've got to take this, discard it, and start from scratch.'"

By *this*, Silverstein means a building he never wanted to build—an asymmetrical, angular, seventy-story office tower dwarfed by a brutal 1,776-foot spike stuck to its side. *This* was the initial design of Pataki's chosen architect, Daniel Libeskind—a fifty-nine-year-old, black-clad, brush-cut, Polish-born, Bronx-bred critics' pet

whose résumé as an architect featured exactly zero skyscrapers erected. The tallest structure Libeskind had finished, in fact, was a four-story museum. In Berlin.

Larry Silverstein doesn't just build buildings; he also *leases* them, fills them with corporate tenants. That's what he does; that's how he pays for his yacht. Trying to get folks to come back to ground zero to work in a skyscraper would be challenge enough without having to find takers for 2.6 million square feet of office space inside a $1.5 billion glass pile of symbolist crapola.

Facing this utter botch—Libeskind also had designed his cockamamie tower to be built at the pit's weakest point, without regard for the damaged slurry wall, the train tracks and tunnels, or the depth to bedrock—Silverstein had brandished his lease at Pataki early in 2003, asserting his right to choose his own architect. The most the governor was willing to do was accept Silverstein's architect—David Childs, who had studied the site carefully for years—as Daniel Libeskind's design partner. Six months of bad blood later, and $60 million more in rent, Childs

and Libeskind brought forth an even uglier design than the first Libeskind tower.

"This is not just a building," Pataki said of it. "This is a symbol of New York. This is a symbol of America. This is a symbol of freedom."

But once the NYPD went public with its Freedom Tower security worries—the cops apparently had sent the PA a letter way back in August 2004, expressing the department's concern and urging an immediate dialogue; the PA denied it ever got the letter—Silverstein could finally force Pataki to swallow a complete redesign, with no strings to Libeskind attached.

The governor folded, but he set one condition: The complete redesign, which would normally take at least four or five months, had to be done in eight weeks.

Nine days from right now.

Right now, all David Childs has to do is figure out how to move a 1,776-foot skyscraper away from the nearest

Daniel Libeskind speaks at a news conference in 7 WTC. September 2012.

major street, blastproof its base, recon-figure its shape and floor plan, save as much of the prep work done in the pit as possible from having to be done again—and he has to do it quick.

"It's as if you'd asked an architect to design a three-bedroom house," Childs says, "and he'd finished the working drawings and started con-struction—and then you said, 'Oh, no, no, no, what I really want is to have a small hospital here.'"

Childs is behind his desk at the Wall Street office of Skidmore, Owings & Merrill, the world's premier corporate architectural firm. SOM was founded in 1936 and has completed thousands of projects in dozens of countries. The sixty-four-year-old Childs, an SOM partner for thirty years, has built build-ings—office towers, embassies, banks, corporate headquarters, courthouses—since 1967, when he was a young star fresh from the Yale School of Art and Architecture.

Silverstein hired Childs right after he signed the lease on the Twin Tow-ers; Larry hoped that Childs could help spruce up the WTC. After 9/11,

Silverstein asked Childs to design a new tower to replace 7 WTC and to start planning four office buildings for the rest of the site.

"He and I took a lot of grief at that time," Childs says, "because many people felt that this had now become sacred land—*nothing* should be done. We felt right away that it was not only important for the life of the city, but it was appropriate for the honor of the people who were *working* here, to show our resolve and rebuild. That's in our nature, in the nature of most liv-ing things. When you kick over an ants' nest, the ants go back and rebuild it. It's just a natural thing to want to do."

His voice is as soothing and steady as an anchorman's, his tie as carefully knotted.

"We are building an office building. It ought to be iconic and solemn, and yet beautiful and simple. Memorable. But it also has to be something that *works*. It has to be an *efficient* building that can attract people down here.

"I believe in program and func-tion being the forces that create beauty. They've *got* to come first. Tall buildings

are the result of engineering as much as anything. These buildings are formed by a knowledge about what they are to *do*—it's not just an arbitrary sculptural act in which you say, 'Okay, let the engineers figure out how to do it.'

"There's a *lot* of architecture that does that—and some of it's very beautiful. It's not *my* kind of architecture, and particularly in this case, this building has to be much more than just a sculptural gesture."

After 9/11, Childs studied the amount of work that would have to be done to prepare the still-burning pit under the debris—the old slurry wall, the ancient PATH tubes and tracks, the below-grade mix of solid bedrock and Hudson-saturated soil—before any actual rebuilding could begin.

"I told Larry, '*Half* of this is in the water. We've got a *train* under here. We ought to study what all of that means, because if we get *that* right, then what comes out of it will be compelling—it will have its own logic. Everyone's going to rush to design what things should look like in the sky; they're never going to be *built* that way.'"

Childs wanted one landmark tower to reclaim the skyline, but he thought it should be placed in the southeast quadrant of ground zero, on solid bedrock and away from the slurry wall and the PATH tracks. He also told Silverstein to hire three other architects, each of whom would design one of the buildings Larry hoped to rebuild.

"I said that because I think that the nature of New York is a multiplicity of designs," Childs says now. "This will be built over time, and things will change. We ought to allow for that diversity."

Larry hired three celebrity architects to whom Childs had introduced him: one from England, one from France, one from Japan. Then Childs suggested that Silverstein commission one of them to build the first tower—the landmark, the icon.

"Larry couldn't believe it. And when the governor said, 'It has to go in the most complicated portion of the site,' Larry said, 'I can't use an architect from Japan or France. I've got to get somebody who *knows* this site.'"

And so, while Daniel Libeskind

still is the titular "master planning architect" of ground zero—"I never had a bad word with him in my life" is all Childs will say of their brief forced marriage—David Childs alone is now the author of the Freedom Tower. And his deadline has arrived.

Childs leaves his office for a moment, returns with a foot-tall white plastic model, and places it on his desk.

Slender and sloping, the Freedom Tower now rises from a solid cube of a base, a tapering pillar atop a pedestal. The edges of the tower itself are shaved like an obelisk's, forming eight faceted, elongated isosceles triangles. Halfway to the top, it is an octagon. At the top, it is a square again, smaller, rotated forty-five degrees from where it began at the base. A spire, centered and anchored by a circular crown, rises from the top.

"*Dead* simple," Childs says, beaming, his voice full and proud, "so that it can have some sort of memory and identification. And when you look at it from New Jersey, or flying in, or coming across the bridges, you'll know *exactly* where the memorial is. The memorials are the voids, the sadness of what happened. This is the victory—the triumph of the fact that we *weren't* defeated. We came back."

There is something very earnest, almost boyish, about David Childs now.

"I think this is gonna work." He grins. "I think it's gonna be delightful."

As it rises, Childs's new Freedom Tower will echo Midtown's Chrysler Building and Empire State, while the two-hundred-foot steel-clad concrete cube at its base—precisely the size of the Twins' footprints—will be set back far enough from West Street to allay any security concerns. And by shrinking and squaring the tower's base, Childs was able to move the building without undoing what has already been done in the pit.

This is no small thing to Elio Cettina, vice president and general super for Tishman Construction—Tishman has built buildings in New York City since 1898; they were general contractors for the Twins—who has spent most of the past year huddling with engineers, picking out cranes, planning the

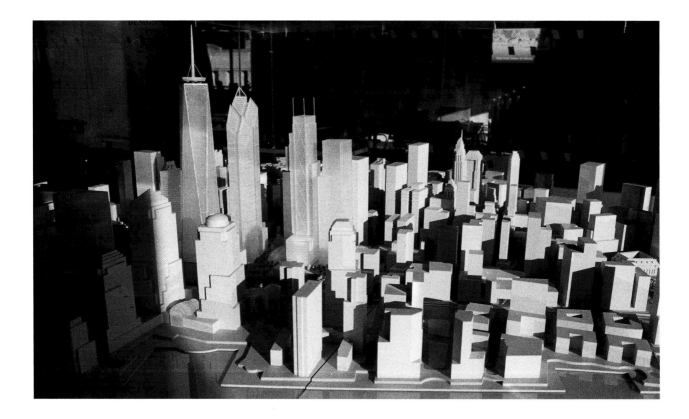

demolition of the old parking-garage slabs and the repairs to the bathtub, and, now, waiting to get back to work at ground zero.

"Let's go!" Elio yelps, laughing. "We're ready to go—we wanna fill the hole up with a couple buildings. That's what I do for a living—I build buildings. *I'm* ready. The *people* are ready. We already have a staff assigned. As soon as we have a final design and commitment, we regroup that staff, put a couple trailers down in the hole, and, *bingo*, away we go. Right?"

You tend to agree with Elio, who's sixty-four years old and solid as marble. He *believes*, and he's the kind of man who makes you believe, too. It was Elio who gave Mike Pinelli his first job at the original 7 WTC—"He's a master

Large context model of the new WTC and downtown Manhattan created by the model makers Radii. 2007.

builder," Mike said of Elio, "but he's an even better man, a great man, a teacher of men"—and it is Elio who oversaw the resurrection of Seven.

"I knew my people were talking to Larry," Elio says, "and I couldn't wait to come back here and rebuild. Gotta put it back up. Gotta do it—and sure enough, we did. Contractors, tradesmen—everybody hadda lotta resolve, and everybody worked together really well. It was a beautiful project."

Cettina, who will build the Freedom Tower, has been working construction since he was a boy in Bologna.

"I was actually born on the Adriatic Sea, near Trieste," he says, and you can hear it plainly—his accent is still strong, even after forty years in America. "My father was a small builder in Italy—one-story factories, commercial buildings. I remember being twelve, thirteen years old and mixing yards and yards of concrete by hand with a long-handled shovel, placing the concrete in buckets, lifting it up with a rope—no mechanical conveyance."

Elio's ready to mix the concrete again—today, *now*. Like Becker, Pinelli,

and Lyons, he's rooted bedrock-deep in ground zero.

"I see the big hole, and I see the street's torn and a couple buildings still shrouded—the evidence is still there. Someday, when the new buildings are up, and there's a park where you can sit and make peace with yourself and think about what happened that day, it'll be easier to reconcile yourself at that point. Gotta fill the hole up with a couple buildings and a park, a plaza—a place you can get down in and meditate. That's what we need to do.

"When that does happen—and it will, no question—I'll be right there. I *belong* there. I will *be* there. We need to rebuild New York, we need to rebuild downtown, and we need to make it bigger and better than it ever was. We can recuperate—no matter what. No matter what adversity is dealt to us, we can stand back up again."

On the morning of June 29, two blocks and a world away from ground zero, a lot of very important people joined onstage in the vast, vaulted ballroom of a

swanky Wall Street restaurant—a building that began life in 1836 as a thick-pillared monument to commerce, built to house a new Merchants' Exchange after the old one had been razed in the Great Fire of 1835, an inferno that had raged for fifteen hours and destroyed seven hundred buildings.

Governor Pataki made his "Sacred Duty" speech, christened Childs's new spire the "Torch of Freedom," and thanked everyone on the stage—plus ten front-row dignitaries—except for Silverstein, who was onstage with him.

"Forgive me," Pataki said, returning to the podium, "you were sitting to the side." And then, turning back to the crowd, "I didn't see him, and I don't want any reporter to try and write something into the fact that I didn't mention him. He has been a *great* partner, our great private-sector partner, *Larry Silverstein*."

Daniel Libeskind followed. "This is a very moving day," he said in his strong accent. "I t'ink de tower vee haff now, efter all de efforts, is even a better tower den vee hadt before."

Silverstein remembered to thank Pataki and gave a shout-out to "the people who build these buildings—the construction workers."

David Childs thanked Libeskind—"Danny," he called him—"not just for his master plan but his very gracious words and his support through this." He thanked Silverstein for being "as much a partner as a client." Then, standing beside a large, lit model of the building, Childs offered a PowerPoint rundown of his new Freedom Tower—designed to reach, before its spire begins, to the precise height of the old Twins.

The Port Authority had no representative onstage. When a reporter noted the PA's absence, Pataki said, "I think the entire Port appreciates that this isn't about any *entity*. This is about our *future*, this is about our *freedom*, this is about *America*."

Not really. This is about New York City, about the $3-trillion-per-year engine of the Financial District purring under our chairs and powering the whole world. America without New York City is Nebraska, and freedom without money is a dirt sandwich.

In the grip of hurt, of horror, of

doom past and yet to come, still and always we work to make the things that make us human—love and children, money and art. We build buildings. That's what this is about.

The pit, meanwhile, is not a metaphor. There, in a plywood box painted blue and covered by a tarp, sits that twenty-ton cornerstone next to a concrete footing half-filled with nothing but rainwater.

Now come the engineers. Designing. Planning. Testing. Integrating. Budgeting. Scheduling. When they've figured it all out, the work crews will come back to the hole, throw a couple of construction trailers down there, and start filling it up. They'll hammer and drill down to bedrock, sink the cornerstone back into the earth, and finally start building to the sky.

THE ENGINEERS

FEBRUARY 2006

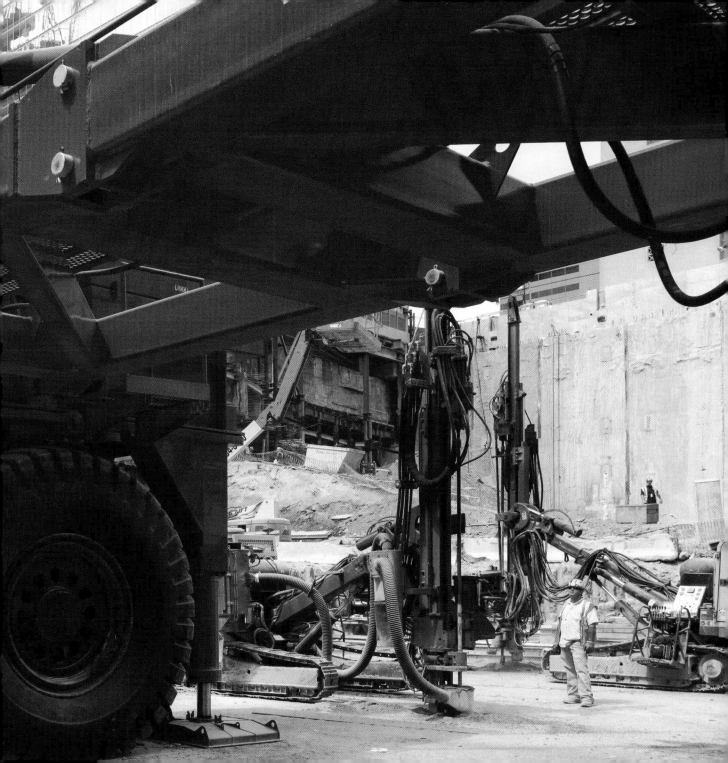

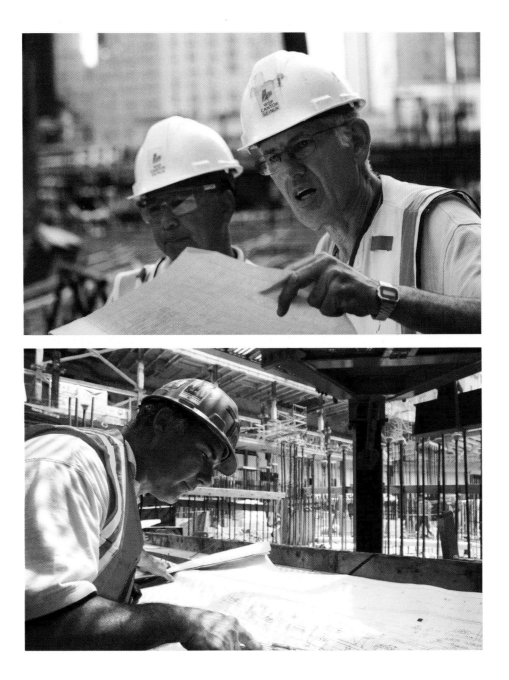

The speechifying is over at ground zero. The ceremonies have been held, some more than once. The bagpipers have piped, the silver bells have been rung, and the ground itself, hallowed or not, has been broken more often than Madonna's maidenhead. What remains of the World Trade Center, capitalism's capital—earth and rock, dust and ash, buried rebar and rusted steel—still feels like a boneyard when the mourners and politicians come to make a show of grief. But healing the heart, individual or collective, takes doing, not grieving. This is no mere mass grave. Two blocks from Wall Street, these sixteen acres are also part of the pulse of Western civilization, which is precisely why barbarians picked this spot for their slaughter. This also is why it is a work site again. And why it is a battleground.

The seismic social forces that first raised up the Twin Towers—politics, power, and money—have poured into the vacuum created by their collapse. If the men fighting for control of ground zero have displayed little of the vision and none of the selflessness we want to see in our heroes—and the empty earth here is proof enough of what they lack—maybe the reality is that what we want to see is only a sweetened version of how history and buildings actually are made by the force of men. Vision and selflessness are fine thoughts, but history and buildings—civilizations—are built on the bedrock of hunger, power lust, and greed. Civil societies are products of savage wars waged by men who, in the present case, sport shiny cuff links while firing great fusillades of flaming lawyers at one another. It is December 2005. At ground zero, it is also the Stone Age, although with better tools.

Someday, these sixteen acres again will be full: The governor has decreed it so. There will be buildings, perhaps too many—a 9/11 memorial and museum, a performing-arts center, five office towers, a train station, and oodles of not just any retail but the sort that the emerald-eyed brokers of Manhattan real estate prefer to call "destination retail," meaning Coach, not Costco.

First, though, will rise the real monument, a tribute to all the forces—

individual and collective, seismic and small—at war on ground zero. This is the Freedom Tower, which will cost $2 billion, give or take, soar 1,776 feet, and contain 2.6 million square feet of office space, plus—down in the basement, of course—destination retail, but which is at present, at bedrock, an engineering problem.

Several engineering problems, actually.

Nonetheless. The speechifying is over at ground zero; in April, the building of the Freedom Tower begins.

Now come the engineers.

The depth and quality of the bedrock beneath the island of Manhattan has defined the horizon of its tallest skyscrapers—clustered toward Midtown and above, and clumped at the narrow southern tip of the island, where the World Trade Center stood. The WTC site has always presented an engineering problem: The east shore of the Hudson River is only a few hundred feet west. Finding bedrock strong enough to anchor the Twin Towers in 1967 meant excavating down to seventy feet below street level—seventy feet of waterlogged muck under a mix of colonial-era fill—and figuring out some way to hold and keep the river out, all while working around a railway line that enters the site from the west through one tunnel, curves south, jogs east, heads north, and then exits west, back under the Hudson to New Jersey through a second tunnel.

Big job. George Tamaro did it. Twice. In 1967, as a thirty-year-old engineer at the Port Authority of New York and New Jersey, which still owns these sixteen acres, George oversaw the job of building a bathtub in reverse, its four sides comprised of three-foot-thick "slurry" walls—so named for the thixotropic soup of clay and water that was pumped into the trenches that held the titanic panels of steel-reinforced concrete that formed them—to seal out the river as the WTC foundations were built up and their horizontal slabs could brace the seventy-foot-deep pit against the Hudson's lateral force. On 9/11, those support slabs were shattered and crushed, and Tamaro

returned to ground zero on September 12 to figure out how to make sure his bathtub—packed with three billion tons of smoking ruin—didn't fail during the recovery work. If it had failed, not only would the stricken WTC site have flooded, but the Hudson would have burst through the two train tubes on the bathtub's west side, rushed through other tubes connecting back to Midtown, and taken out much of the city's subway system.

The walls held—and that's why, among the scores of engineers now working on the Freedom Tower, Tamaro is the éminence grise. In his official capacity, he's a senior partner at Mueser Rutledge, the geotechnical consultants for the new tower's foundations. Unofficially, he's the guru of ground zero, the bathtub builder, the high priest of the pit—a legend.

"Oh, God." Tamaro laughs. "I'm not dead yet. Be kind to me." Balding and bespectacled, George is waiting for the PATH train, the New Jersey commuter line that runs through ground zero. Besides a trek along the tracks, the train is the only way to get a glimpse of the engineering job ahead: The Freedom Tower is going to straddle these railroad tracks. Nineteen of the tower's huge column footings—the concrete bases planted deep into the bedrock to spread the tower's load—will be woven and rooted here, between sets of tracks along a narrow, curving five-hundred-foot stretch, between the trains' crash wall and the north wall of the bathtub.

"Everything begins to converge," George says as the train pulls out. "All the tracks go into one tunnel across the river—and all of those convergences and switches are under the footprint of the Freedom Tower. And they have to be accommodated by jiggling and moving foundations around."

It's early afternoon, twilight outside the windows; the slow-rolling train is covered by a horizontal concrete slab, a remnant of the WTC parking garage, held in place by a forest of columns. At the north edge of the Freedom Tower's eastern perimeter, the four curving sets of tracks switch down to two at a point where the space from the crash wall to the slurry wall is only fifty feet. Out there, too, in the dark—along the

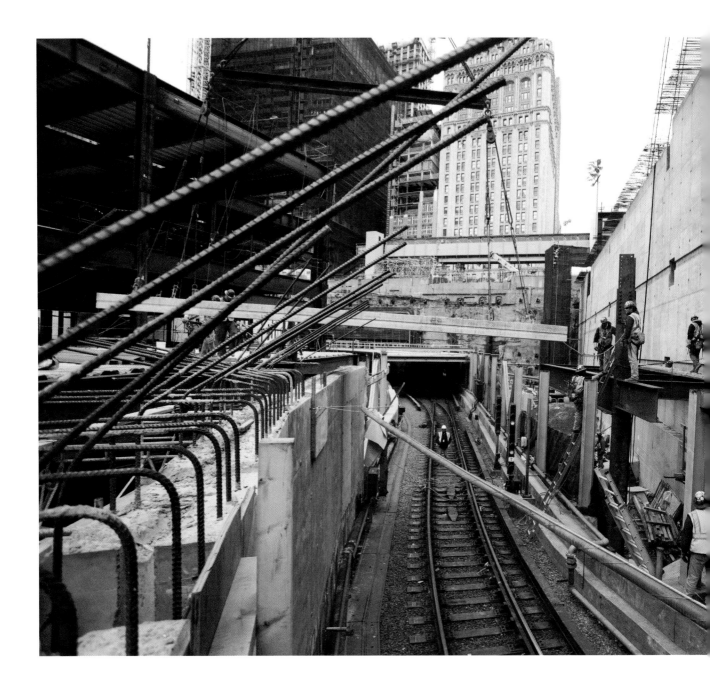

tracks, among the columns, beneath the horizontal slab—are banks of dozens of black conduits, fat as pythons, encasing utility cable and signal cable and communications cable; and the fire standpipe that runs along one side of the tracks, and its hose racks; and the compressed air line operating the interlocking switches that runs along the other side: This all has to be moved—relocated, rerouted, and reconnected—before the footings can be poured.

You can't see much from inside the train, but George Tamaro needs no eyes down here. "There's very little room in here against the wall," he says now. "The tieback heads are protruding, and those are critical dimensions for clearances." He's referring to grouted steel tendons covered by large round metal caps, which now anchor the old bathtub wall to bedrock. Once the new tower's foundations can resupport the slurry wall, the tiebacks will be detensioned and the heads can be cut off.

Each inch and angle is calculated. The train's "dynamic envelope," the entire volume of space it uses as it sways and curves, must be accounted

for at every point. And every stitch of this work—testing the bedrock, surveying and marking the points where the utilities and switch boxes and fire standpipe need to be relocated to make way for the new footings, and excavating and pouring the footings themselves—must be done in the middle of the night so forty thousand daily PATH riders won't be inconvenienced.

In fact, on the train they won't even know it's happening. But George Tamaro will. Riding the PATH with him is like visiting the Sistine Chapel with Michelangelo doing play-by-play.

"Now we're turning," George says as the train curves slowly, gently, almost imperceptibly. "We're gonna turn right—level stretch, we're at the corner, and now we're going down into the tunnel. There we are—we're in the tunnel."

He needs no eyes down here. He just knows how it feels.

"I only go down in holes." George laughs. "I can't take altitude—I get nosebleeds. They don't let me above grade."

Tamaro is a foundations engineer, and when a foundations man sees a

building, he first looks down—to the earth, where bedrock is no metaphor—not up.

"I like to look at a structure," he says, "and understand where the forces are going. If I can't understand where the forces are going, I worry about the structure. Because if it's not clear to me looking at it, it's probably not clear to the structure where in the hell the forces should go.

"I am an engineer. I am a symmetrist. You get some of these gimmicky things, God knows where the hell the forces are going. And you can be surprised. Smart as we are, we can be surprised."

The Freedom Tower will be a monument to many forces—money, memory, money, vanity, money, ingenuity, money, New York City's infinite resolve and resilience, and money—but the primary architectural challenge it presents is a tribute to the forces of modern warfare. The standard line, publicly unspoken, is that the danger inherent to building another symbolic skyscraper at ground zero is a national-security issue, not an engineering problem; in other words, designing and building a super-high-rise office tower to withstand every possible means of attack simply can't be done. Still, nobody's taking any chances with the Freedom Tower. It's designed to meet the security standards of a United States embassy on unfriendly turf—beginning with its blastproof twenty-story concrete cube of a base.

Standing in a Midtown conference room full of architects, engineers, and consultants, David Childs sweet-talks the man at the head of the table, Larry Silverstein. It's Larry's room, Larry's dime, and—for the next century or so, if he can finally get it built—Larry's Freedom Tower. Childs, the Freedom Tower's lead architect, is trying to make it beautiful. Larry, the real estate developer who holds the lease, has to pay for it.

Childs is tall, placid, and moon-faced. His long fingers and gentle baritone stroke the still air. "Materiality," he says. Then, dreaming aloud, he speaks of the "softness of the skin," of

David Childs showcases his designs at 7 WTC. 2010.

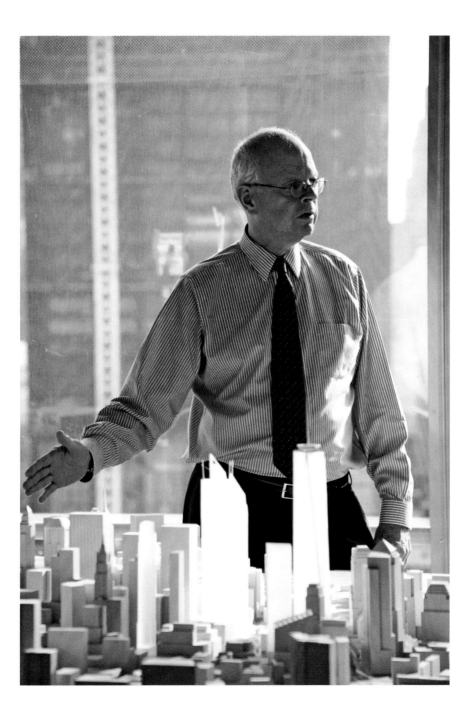

"penetration," of playfulness and se- duction, of titanium and stainless steel, and, shyly, of nickel.

"Nickel," Silverstein barks in the timeless Brooklyn dialect of Nasalese. "Nickel. Hoo boy." At seventy-four, ten years older than David Childs, he's hawkeyed and snappish. He knows that nickel costs; what he wants to know is if the six revolving doors planned at the tower's north entry and four at the south will be sufficient for the foot traf- fic flowing into and out of the building.

Childs says that he believes so, but then he adds—quietly, half to himself— "We'll screw up somewhere."

Silverstein, all ears, is unamused. "Do it on somebody else's building," he says. "Not mine."

Childs is worrying about how to clad the new base so that it looks nice— or, in Childs-speak, "more humane and touchable"—while Larry's fretting over the Freedom Tower's program, the ge- neric term for every numerical detail of a building, from how much the whole thing will cost down to how many pairs of feet will ride each escalator at any given time of day.

As Childs starts talking about fil- tered shafts of light, invoking the vaulted ceiling of Grand Central Station and the Doge's Palace in Venice, Larry asks him about possible snow and ice issues at the entrances—and pigeons.

"I'm always worried about pigeons," Larry says.

These forces—Larry and his lieu- tenants, Childs and a crew from his firm, Skidmore, Owings & Merrill, along with various engineering and construc- tion consultants—collide every week in a process that will transform the Free- dom Tower from concept to building. Today, the Skidmore boys have brought two thick flipbooks for Larry to see, full of illustrations of patterns and textures meant to inspire visions of the base. The books—barely glanced at—sit on the table; Larry is out of his chair and next to Childs at the wall, peering closely at three large drawings, side by side, of street-level entrance arrangements.

Larry Silverstein, Janno Lieber, and Mickey Kupperman of Silverstein Properties inspect a model of the ground floor of 2 WTC. June 2007.

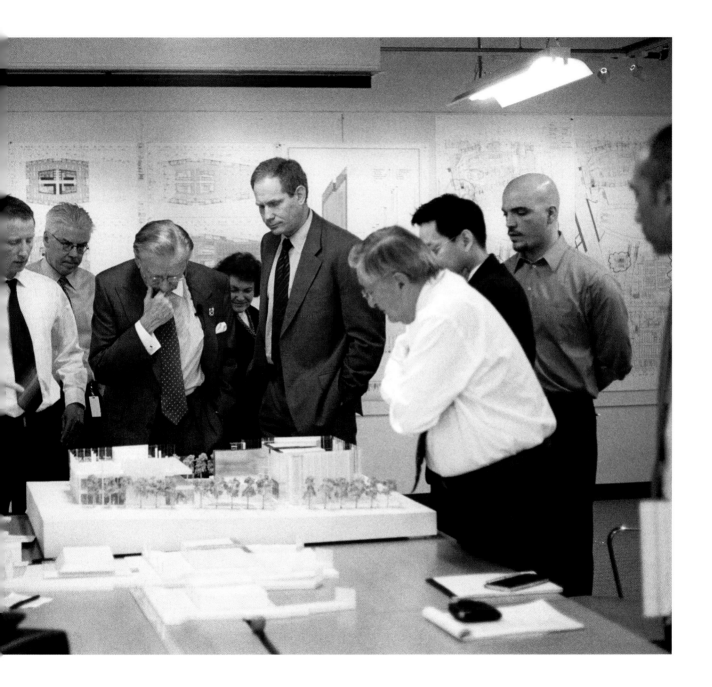

"Will these openings meet the safety criteria?" Silverstein asks.

"Not to evade the question, Larry," Childs says, "but we'll have to check with the security consultants."

"By the way," says Silverstein. "Your neighbor in the Adirondacks"—meaning Governor Pataki—"is gonna want an update next Wednesday or Thursday."

It's hard to tell whether Childs smiles or winces at this. These meetings—with Larry, with the Port Authority, with all the engineering and construction and security consultants—there is no end of these meetings, and of preparing for these meetings, and of trying to make sure that each of these meetings, especially these weekly design meetings with a client who seems focused on everything but design, ends on an upbeat.

Silverstein tries. "You're going in the right direction," he says to Childs, gesturing at the drawings of the building's base. "It seems to me much more capable of being spectacular."

"You know, Larry," says Childs, grinning bashfully, "I've always hoped someday to try to put some sort of grotto into a large space like this, so

folks as they enter can hear the trickling of water." Janno Lieber, Silverstein's senior VP and project director, speaks up for the first time today. "I hear the trickling of dollars," he says.

David Childs never meets force with force. He learned to coo poetry to power in Washington, D.C., where he joined SOM in 1971 and where I. M. Pei advised him that the most vital single piece of any architectural project is the client.

"The client's role," Childs tells me a few days later in his office at SOM's Wall Street headquarters, "whether it's a museum board or an individual who wants to create something and gets involved, is a critical factor in the ultimate result of what we do. Unlike a painter or a sculptor—they fully satisfy themselves, and the critics will have at it and the museums will buy it or not, but they can actually produce their work—we do it through all sorts of strange smoke and mirrors and all that other stuff. You have to be persuasive to get your way. And the best way to do that is not a

head-on fight, but to develop your arguments, and any way you can get there is okay."

Unlike Pataki's vanished architect, Childs is no critics' darling. Skidmore is a seventy-year-old firm, arguably the world's premier corporate architect, and Childs is accustomed to persuading all manner of princes and parvenus. His eyeglass frames don't scream *artiste*, he releases no doves when ground is broken for his buildings—as did the Spanish golden boy Santiago Calatrava at ground zero last September when the Port turned the first shovel of earth for its federally funded $2.2 billion PATH station, scheduled to open for business in 2010 and already called simply, and with hushed pride, "the Calatrava"— and Childs's tie is knotted to the neck even at the SOM office.

"People want to have the architect seen as an individual artist doing his sculptural form. I'm much more pragmatic," he says. "I believe that the fascination of the program, and solving the problem, is part of architecture. First of all, you've got to do that—and then you've got to make it beautiful, rather than making the sculpture and then cramming stuff into it."

Long before the NYPD stepped in, Silverstein and Childs tried to get the governor to move the Freedom Tower to the southeast corner of ground zero—away from the PATH tracks, closer to the Calatrava and a planned subway hub, and farther from the Hudson, where solid bedrock lay near to grade. George Pataki, stiff-necked, refused to budge it. But Pataki dearly loves Childs's new design: A tapering, rotated-square shaft, curtained in glass, mounted on its mighty pedestal and crowned, at least in Childs's public presentations, with a 414-foot broadcast-antenna-cum-light-shooting-spire, it's meant to stand as the Victory Tower for Lower Manhattan, topped by Governor Pataki's "Torch of Freedom" spire.

Pataki's focus on the Freedom Tower, and particularly its crown, has grown especially acute since he announced his decision not to run for a fourth term as governor and began touring the nation starting with Iowa, California, and New Hampshire—to explore what it might take to become a viable candidate for the

Republican presidential nomination in 2008. If he's going to run as the guy who brought ground zero back from 9/11, Pataki must be able to point to the Freedom Tower as his manly legacy—and he needs the tip of the tower to point right back.

"He's a man who can say yes or no on many things," says Childs. "One of the things I'm worried about is the antenna. We haven't touched it. The governor doesn't really know that, and for him this is the most important piece of sculpture in the whole building. This is what's going to give it its crown—it's the great plume up there, a major-size building in itself. Up there and alone in the air, it's gotta be something that has stature to it. This is a very expensive item. How are we going to figure out how to pay for this? That's the real answer. The governor knows that he'll be part of that. It's a question of how much.

"We are at a strange state in this project. It's going to be built, but will it be built well? This is going to be up there forever. Larry knows this is the building on which he's going to be judged, and his intentions are right, but we've got to fight together constantly to get this thing done well.

"The scheme is good, but because it's so simple, it's dependent even more on the quality of its detailing and its construction. If it's done badly—with bad materials—it would be awful. You've got to build it perfectly, with good, basic, high-quality materials—stainless steel, rather than aluminum. We'll see—we're not home free yet."

How much will it cost? How long will it stand? Truth is, George Pataki has spent more hours on the ground in Iowa than at ground zero the past few months—and the Twin Towers, the pyramids of the Port Authority, stood not quite thirty years. Larry Silverstein's lease expires in 2100—at which point Larry will be, God willing, almost 170 years old—and it requires him to top the Freedom Tower with a broadcast antenna, not to fund a pinwheeling, laser-firing feather for some politician's dunce cap.

Which isn't to suggest that these

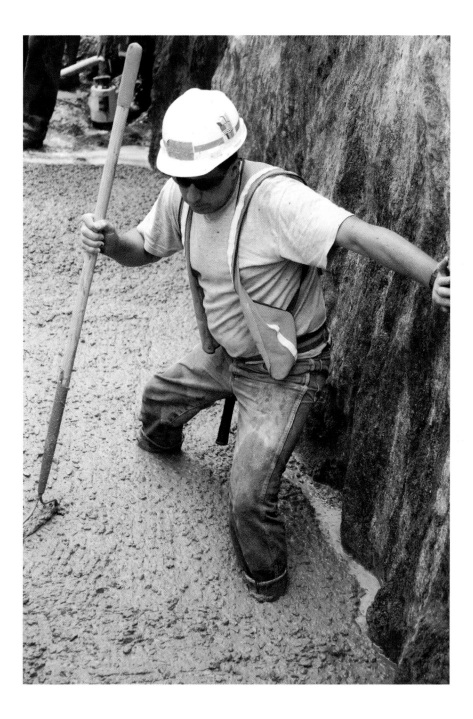

questions don't matter—nobody can keep precise count, but millions of pilgrims already come every year to ground zero, to stand and gaze out into a void—but only to say that the earth itself is not indifferent here. Spindle or sparkler, Pataki's Torch of Freedom, too, will be anchored by those footings—the real base of the Freedom Tower—cast deep into bedrock five hundred million years old.

Outside the crash wall, under the warm September sun, Pablo Lopez shrugs his massive shoulders. "If ya hadda put the building anywhere, this was probably the spot where ya shouldn'ta put it," he says. But it's not a big deal. It's a perfect autumn afternoon, and Pablo and his fellow engineer Andrew Pontecorvo are happy to be out of the office for a few hours.

Lopez and Pontecorvo know the ground of ground zero better than anyone, except for their boss at Mueser Rutledge, George Tamaro. After 9/11, Tamaro mapped from memory much of what lay below the WTC ruins, but at the age of sixty-four, he wasn't going to plumb the depths of ground zero firsthand. Yet someone had to do it—and so he gave Pablo and Andrew the job. They spent eight months together spelunking the voids under the rubble, making certain that the slurry walls, and the rubble pile itself, could withstand the force of the WTC recovery effort.

"That was the mission given to us," Lopez says. "Find out, along the perimeter of the wall and any other places that you can get access to, what the condition of structure is. How much is intact—if there's a portion that's collapsed and leaning against something, identify that—so that they can get an idea, from bottom to top, exactly how each level is being supported."

It was a military mission. On one of his first days at ground zero, an emergency-services cop walked Pablo through the site to steel him for the horror show that awaited below. "He told me, 'I know yer gonna be down here for a long time,'" says Lopez. "'I'm gonna show you everything.' And he showed me everything. He showed me dead bodies, the smells. He said, 'You gotta get used to this.' He broke me in."

Lopez is a husky, loudmouthed six foot four; Pontecorvo is quiet, a trim six-footer. They've got on blank white hard hats and orange safety vests over their shirts and ties. They seem far closer than colleagues; they're comrades, brothers-in-arms. "Before we even stepped down into anything," Lopez says, "we made a promise to each other—we don't go anywhere unless both of us agree to do it. The stuff we were doin', goin' underneath a lot of the collapsed structure—some of the contractors'd say, 'You guys must have a death wish.'"

Now each finishes the other's sentences, they often speak in unison, and as Pontecorvo's voice starts to quake when he tells what it felt like to watch the towers fall from his Midtown office, Lopez steps in with a story long enough for his buddy to collect himself. Once a year, Pablo says, they get tests at a local hospital "to find out if we're dyin' of some strange diseases. Blood tests, urine tests, breathe in, breathe out. 'Do ya have any tremors? Do ya have any night sweats? How do ya feel about the work ya did down there?' I say, 'Fine. We're absolutely

fine wit' it—matter of fact, we take great pride in what we did.'"

"The first time I came down here and walked up to the pile," says Pontecorvo, "you were completely overwhelmed. You looked at it and said, 'Wow—we're not gonna be done with this for years.' The fact that we were done by the following May was miraculous."

"Without losing anyone," Lopez adds. "Without anyone being killed—that was just amazing. I take pride in this because it shows that engineers can do more than just walk around and design and all of this other crap. It was an opportunity to show people that we're not just pencil pushers with plastic pocket protectors. And—just for the record—I have never worn a pocket protector."

"I got one as a gift," Pontecorvo mutters, straight-faced. "But I've never worn it."

Pablo and Andrew are still focused on the forces at the base of ground zero, working with crews from Jersey Boring & Drilling to drill core samples of the bedrock inside and outside the crash

wall at the spots where the structural-engineering consultants want to plant the Freedom Tower column footings. They need to make sure that the bedrock can take the force of the tower's load—as much as 120 tons per square foot.

Outside the crash wall, this is a relatively simple affair: A truck-mounted drill rig—thirty-one feet tall with its derrick fully raised—trundles down the ramp into the pit and, once in position, starts driving a double-tubed coring barrel with a water-cooled diamond bit through the old WTC slab-on-grade of ground zero and into the bedrock just below. The outer tube cuts; the inner tube retracts and holds five- and ten-foot-long runs of core samples, two inches in diameter—long cylinders of Precambrian schist—from as deep as forty-five feet below the bedrock's surface.

Behind the crash wall, it's not so simple. The truck-mounted drill rig is too heavy to risk setting on the old slab over the tracks, so a 1,450-pound trailer-mounted rig is attached to a pickup truck and towed onto the slab

to do the job—after it drills through the slab to clear a hole down to the earth below. And this, too, has to happen between 1:00 and 5:00 a.m., during the PATH's normal maintenance shutdown.

"A pain in the ass," says Pablo.

It's a short hike from the sunlit northwest corner of ground zero into the shade where stacks of pine boxes holding the Freedom Tower core samples sit under the construction bridge that ramps down from Liberty Street at the site's south perimeter. A short hike across sacred earth—the footprint of the old south Twin. But it is more sacrosanct in memory now, and in rhetoric, than in reality. The cornerstone that was laid on July 4, 2004—just in time for George Pataki to host the Republican National Convention—sits boxed in blue plywood inside an empty footing at what was to be one corner of the previous version of the Freedom Tower. All of ground zero is, more and more, a work site.

Andrew Pontecorvo opens a core box, removes a broken half cylinder—seven or eight inches of white-veined,

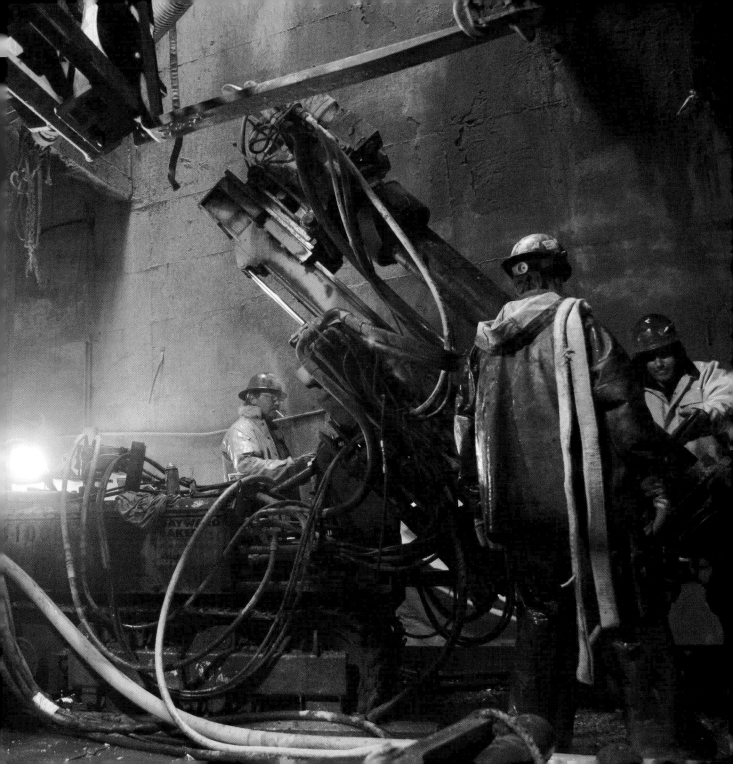

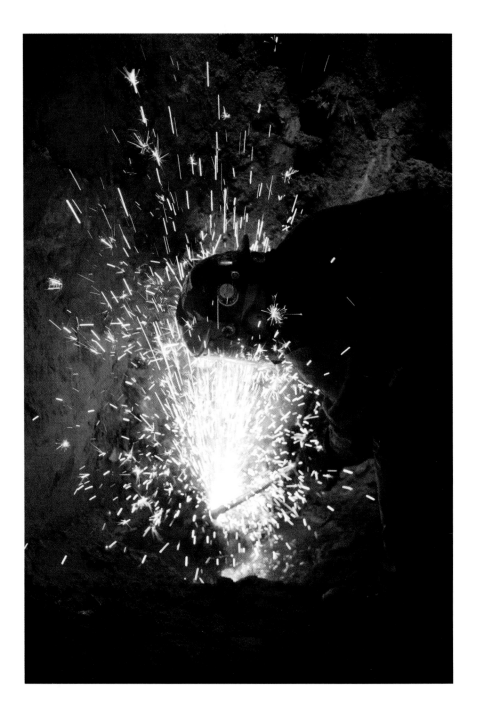

gold-flecked gray rock—and rubs his finger across its exposed innards.

"Feel that," he says. "Feel how that's slick and soapy—that's the concept of what decomposition of the rock is. The inside of the joint is decomposed, but the outside—the piece of rock—is not. This is intact rock. When you do a coring, you'll get back varying lengths of intact rock in the core, and based primarily on the joints—the condition of the joints, how many breaks there are in terms of open joints—you'll give it a rock-quality designation."

Pablo pulls out a three-foot cylinder. "Here you go," he says. "This is a good run."

"Pretty good," says Andrew. "This is a weathered, iron-stained joint—natural."

"One solid-piece core, nice and solid," Pablo says. "We were expecting the top would have some weathering, but as you go down, it's getting better. Based on the length over which the sample was taken, the quality of the rock, and the length that's recovered, you're able to classify this—either Class Type 1, 2, or 3. Class Type 1 rock

means that this stuff can take sixty tons per square foot of compression without having any problems. Once you know what rock capacity it is, when the structural engineer tells you, 'I need so-much-capacity rock,' you can tell him, 'You're gonna find it at this depth'—and he knows how deep to put his footing."

A footing sunk at least eleven feet into Class Type 1 rock can take 120 tons per square foot, the maximum code allowance. When it comes to engineering the Freedom Tower, "How much?" and "How long?" depend on "How deep?" and "How strong?" Because while all the folks are looking up at the Freedom Tower's spire, every load—every gust of wind, every ounce of weight, and, far greater than all that, the timeless pushing of the Hudson forcing itself against the slurry wall for now, but, soon, against the tower itself—must go down: down to its foundations, and down into the bedrock where it stands.

Even after fifty years in the business, Larry Silverstein is hardly the

strongest force in New York City real estate. But there is no object quite so immovable as Larry, socketed to the ground zero bedrock with his slurry wall of a lease. The Port, Pataki, even the dreadnought *New York Times* editorial board—all have tried in vain to dislodge him. He has fought insurance companies in court for years over whether two jets hitting two towers constituted two insurable incidents—Larry's claim—or one; he's still fighting to collect the $4.6 billion in WTC insurance proceeds he has been awarded, money he needs to put up not only the Freedom Tower but four more office buildings at ground zero. Later this year, his ground zero rent goes up another million and a half per month, and he's already out at least $1.5 billion in toto—with nothing to show for it.

Somehow, though, Larry and his lease are still standing.

"I promised the mayor," he rasps, "and I promised the governor, back on 9/11. I said, 'I'll give ya the next ten years of my life to get this goddamn thing done.' And I intend to do it. And hopefully live long enough to see it."

To see him at a design meeting, rubbing his hands as he schemes to snatch more storage from the Port in the Freedom Tower subbasement, you might dismiss him as just some Fifth Avenue Fagin, as the Port and the pols have tried to do, and miss the iron in his spine.

Five years ago, five days before the final bids on the WTC lease were due, Larry Silverstein was crossing a street on his way home when a drunk driver ran a red light and hit him. Silverstein's pelvis was crushed, but as he lay drugged in the hospital, he figured he ought to finish framing the bid, and pushed the bedside button for his doc.

"I told 'im, 'Reduce the morphine and call my office,'" he recalls.

Larry summoned his staff to his hospital room, fixed the final number, and lost, by $50 million, to Vornado, a nationwide realty trust. But Vornado and the Port couldn't hash out the deal, and in July 2001, Governor George Pataki, who forced the Port Authority out of the real estate business and into the WTC auction, handed Larry Silverstein the keys to the Twin Towers.

"This huge roll of cardboard keys," Silverstein says. "They have to be cardboard, or else you couldn't lift 'em."

For an immigrant's son from Brooklyn's Bedford-Stuyvesant neighborhood who started out in his twenties by knitting a few $5,000 investors to buy, refurbish, refinance, and flip worn-down buildings on run-down blocks, it was an unforgettable triumph.

"I said, 'Ach, that's the achievement of a lifetime.' I said to my wife, 'C'mon—whaddaya wanna do with the rest of our lives? Because whatever you wanna do, we can do.' No one ever dreamt of 9/11. So here we are."

Silverstein sits in his spanking-new leasing office on the twenty-fifth floor of 7 WTC, not far from where a four-foot-tall model of the Freedom Tower—its base is a layered, shimmering tapestry of finely etched nickel and steel, its spiraling antenna sheathed by a webbed filigree of woven wire, lacy as a bridal veil—stands under a Plexiglas cover, mounted on a wooden, white-painted pedestal.

Larry's turned out this morning in a navy-blue double-breasted suit with a light-gray pinstripe. You could slice Vermont cheddar on the edge of his pocket square. But his eyes are heavy-lidded, his voice weary. The past few weeks have been unkind. With Pataki a lame duck now, Michael Bloomberg, the city's freshly reelected Republican mayor, has pounced.

Bloomberg spent four years in office deferring to the governor on ground zero, but late in his campaign he pinned the delays at the site on Larry, telling the press that "it would be in the city's interest to get Silverstein out." The Port itself, soon to be free of Pataki's yoke, has just publicly declared its own interest in getting back into the real estate business at ground zero, buying Larry out, and maybe finding a couple of other developers to come aboard and share the wealth.

"I'm happy to work with Silverstein Properties," the Port's chairman told the *New York Times*, "and I'm happy to work without Silverstein Properties."

"God bless 'em," says Larry, whose grasp of the difference in force between lip service and leverage may be gleaned by noting that his personal financial

stake in the $3 billion WTC deal came to only $14 million. "But the interesting thing is, they can't do this without me. They absolutely cannot do it without me. There are a million developers out there who would like to take this away from us, but I'm the one who's paid the half billion dollars in ground rent. I'm the one with the lease obligations. I'm the one with the insurance-company proceeds, which I have litigated. We will rebuild the Trade Center. Period. We'll get it done."

Silverstein says he met with Bloomberg before the election to explain ground zero to him. He told the mayor about the bathtub. About the PATH train. About the Port Authority's timetable for the Calatrava. About the governor's disconnected decision making. He reminded the mayor that the mayor's people had signed off on all these issues more than a year ago.

Now Silverstein shakes his head. "People are oblivious to the realities. At the end of the day, the mayor apologized to me. He said, 'Larry, I'm sorry for what I've said. I really didn't mean to say it, I didn't want to hurt you, certainly, and I didn't have a clue with respect to these details. I just didn't know.'

"I said, 'Okay.' I said, 'I'm still gonna vote for ya. You've done a helluva job, and God bless ya—hopefully you'll do another four years of great work.'"

Bloomberg denies making any such apology and has since gone hard after $3.35 billion of federally financed Liberty Bonds that Larry had been counting on, along with the insurance payout—thereby drawing the wrath of Pataki, whose Freedom Tower plume budget is at risk if the mayor can leverage the bond money away from Silverstein and steer it to other, perhaps more yielding, developers.

"If government doesn't wanna cooperate"—Silverstein shrugs—"this thing will nevah get done. They can't do it without me—and I can't do it without them."

If you're a gambling man, bet on bedrock: Larry Silverstein. On December 15, Larry announced his fancy-pants architect for the tower that will follow the Freedom Tower onto ground zero, Lord Norman Foster. More

important, Governor Pataki announced the day before that he was bypassing Bloomberg and the city to get his new best friend, Larry Silverstein, $1.67 billion of the Liberty Bond money straightaway—to fund the Freedom Tower. Still, if you step into the Freedom Tower's lobby some sweet day, should you bet on hearing the water trickling in David Childs's grotto?

"That I can't say," says Silverstein. "But I suspect not."

It has long since become a ground zero trope that it took only four years after Pearl Harbor to win World War II. That the corpse-strewn rubble in Pearl Harbor itself was largely left to rot in peace below the waves; that it took till 1952, seven years after that war ended, to mount one plaque on a ten-foot stone at Pearl Harbor to mark the spot; that it took yet another ten years to transform the midsection of the sunken USS *Arizona* into a memorial; that Pearl Harbor wasn't exactly the capital of the world; and that if George Pataki had been calling the shots, the Pearl Harbor memorial would today amount to a poi stand and a Port-O-Let: All this goes unsaid in the whining about what's taking so long at ground zero.

A hundred and two minutes is how long it took to destroy the World Trade Center. If everything goes right from this point on with the Freedom Tower, it will be ready for occupancy toward the end of 2010. For people who do nothing tougher or more useful with their hands than write a check, this fact—much like ground zero itself—can be grasped only as metaphor. It must mean something, something grand, something beyond what it truly means and simply says:

It's easier to destroy than to create. It's hard to build a building. It's harder to build a big building. It's extremely hard to build an extremely tall building—and as for planting that building seventy feet below grade, atop working railroad tracks curving through the most contentious sixteen acres in the history of the United States, well, that is fucking heroic.

For the men building the Freedom Tower, just issuing the bid request for

Carmine Castellano.

the PATH utilities relocation work—that request went out November 1; the work will begin this month—is a very big deal. It means the sketching David Childs did on his yellow trace paper with his black Pentel was translated by a team of forty-five SOM colleagues into a set of concepts for the building, and then into the schematic drawings that the structural engineers needed to figure out where and how deep to put the footings, which meant the geotechnical engineers could go ahead and test the bedrock.

It also means that Carmine Castellano won't have to keep painting and repainting the geometric outlines where the new Freedom Tower footings and columns will go, in the gloom behind the crash wall—Day-Glo orange down on the gravel track bed for each new footing, screaming yellow on the underside of the slab above for the columns.

"I'm pretty excited about comin' back and gettin' goin'," Carmine says. "Long time inna makin', but we'll make it betta than eveh."

Holy shit—here comes a train. You hear its horn burst the air beneath the concrete slab between the crash wall and the slurry wall—long, long, short, long—before you see the shine of its headlights creeping along the ancient tiebacks.

"Stay where yer at," the flagman barks, and waves his lamp—up and down, up and down—to signal the train to keep coming. As it grinds by, maybe fifteen feet away, sparks snap underneath each car as its contact shoes—flat metal duck's feet—glide along the third rail. There are maybe more terrifying forces than 650 volts of direct current, but this will do just fine.

"You don't think about it when yer in the train, right?" Carmine asks. "You see the shoe? You stand too close, it'll chop yer legs off."

Carmine's a Jersey guy, flush-faced and black-whiskered, huge as a house. He worked down here with the Port when the temporary PATH station was built after 9/11; now he works for Tishman, the firm managing the construction of the Freedom Tower.

Coming back after the tower was redesigned meant Carmine was down here nights with the surveying crews,

using gray paint to hide the orange and yellow diagrams he'd marked a year ago—and redrawing these new ones.

"We were smart enough to get rollers, 'cuz last time we were up on ladders. The second time around, you get smarter. We evolved—from standin' onna ladder wit' a spray can."

The trains keep shrieking by. The strip-joint rhythm of the automatic interlocking switches—three metallic thumps: *BOOM bumBOOM*—is followed by the banshee hiss of compressed air escaping the pneumatic line. The flagman stands guard along the track as Carmine plays the beam of his own flashlight over the fat black snakes of conduit, twined with metal clamps and gunited to the concrete slab above his head.

"That all hasta come out," he says. "Alla that hasta be moved." He moves the beam down, dancing it along the pull boxes and the fire standpipe that lines the track bed. Behind him, four sets of signal lights standing on posts beside the four sets of tracks that rule this space gleam red as devils' eyes. "These are all the switches that hafta be relocated. Because we have a column goin' right up through here"—his beam goes up again—"and a footing"—down—"right through there."

Because of the limited work hours and its complexity, the utility work alone will take nine months, minimum. The fire standpipe, the pneumatic line, the banks of high-voltage conduit mortared to the ceiling slab—the relocation crews will run whole new sets of lines in parallel, but far enough away to make room for the new footings and columns.

That's the easy part. As the utilities get moved, bank by bank, the crews nestling the new footings between the PATH tracks—and, eventually, threading the new columns up through the slab—will begin by building plywood sheds vertically, from the track bed up to the slab above, shacks big enough for two, three, or four men to work inside, depending on the available space between the tracks at the points Carmine has marked.

There's little room, for error or otherwise. The sheds can't block the view of the PATH operator at any point

along the tracks—and the edge of one enclosure will come within six inches of the train's dynamic envelope.

Working inside the shack, they'll shovel down into the gravel ballast that holds the track ties, then they'll lay in timber-frame supports, piece by piece, to hold the ties in place and keep the holes they're digging clear. Then they'll section out the slab above and put in a ladder to get up and down and to take up the bags they'll pack with the debris they're digging up.

"It's gonna be a challenge," Carmine says. "Just that footing alone"—he points with his beam to the orange outline of a rectangle fifteen by nine feet—"gettin' the ballast out. It's five feet deep. It's gonna be a task."

And when they finally hit bedrock, they'll have to drill and split and chop down into the rock with a jackhammer or, if they're lucky and have room enough, a hydraulic impact hammer.

"You see the footing—see the orange? That's the perimeter of the footing. Which will have to go in some spots twenty-four feet deep inta bedrock, okay?"

When the crew finishes digging down to depth, Pablo or Andrew will do what they call a "visual subgrade inspection," to make sure there are no soft spots. They'll check the hole to see that the bedrock going down is clean and hard. They'll strike it with a hammer or a crowbar and listen for a solid, high-pitched ping and feel how the steel bounces back quick and hard into the hand. They'll bless the bedrock then—and then the hole itself, the rock within, becomes the footing's form: First a rebar grille goes in, followed by the concrete, poured down from the slab above. That's a footing.

"For about a year," Carmine says, "I won't see daylight. It's a lotta work involved, but it'll get done."

It will take as long to complete this foundation work as it will to raise the Freedom Tower seventy feet, to street level. Then in 2007—they can fly: two floors a week, into the clouds.

Long-long-short-long. "Stay where yer at," the flagman says.

"Lotta juice in theh," says Carmine as the shoes spark. "If you hit that, it's only one shot. You don't get

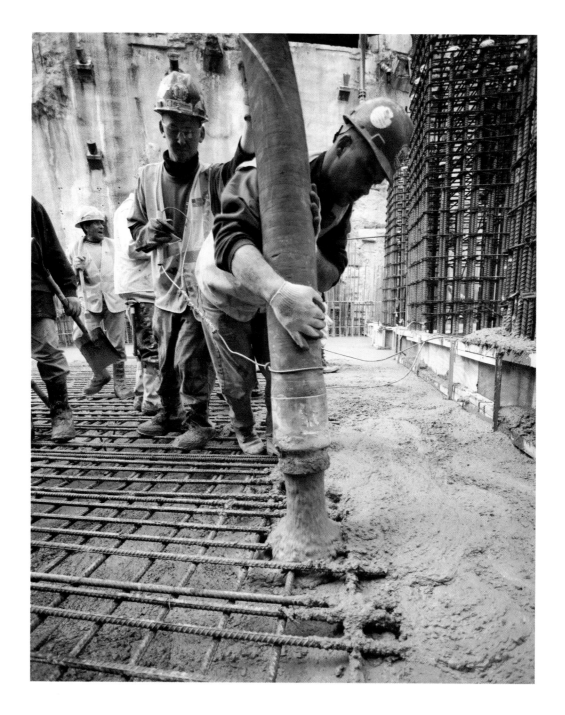

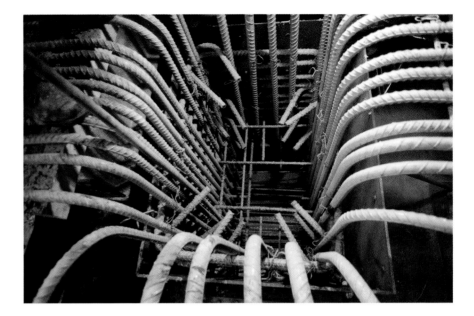

a second shot—it's all ovuh. We gotta work safe. Everybody wants ta go home."

The speechifying is over at ground zero. All of the ceremonies have been held, one of them—the annual 9/11 ceremony—four times. This past September, the toll of the names of the murdered was read aloud by siblings of the dead. Many of them broke down in tears at the microphone on the temporary stage.

Beside the stage, even as the brothers and sisters wept, the politicians were glad-handing, meeting and greeting one another outside their big white VIP tent. Mayor Mike Bloomberg, Governor George Pataki, senators Chuck Schumer and Hillary Clinton, Secretary of State Condi Rice, even Rudy Giuliani, America's mayor, who recommended on his way out of office that nothing but a memorial should be built at ground zero: all of them hugging and handshaking and grinning to beat the band, or, on this

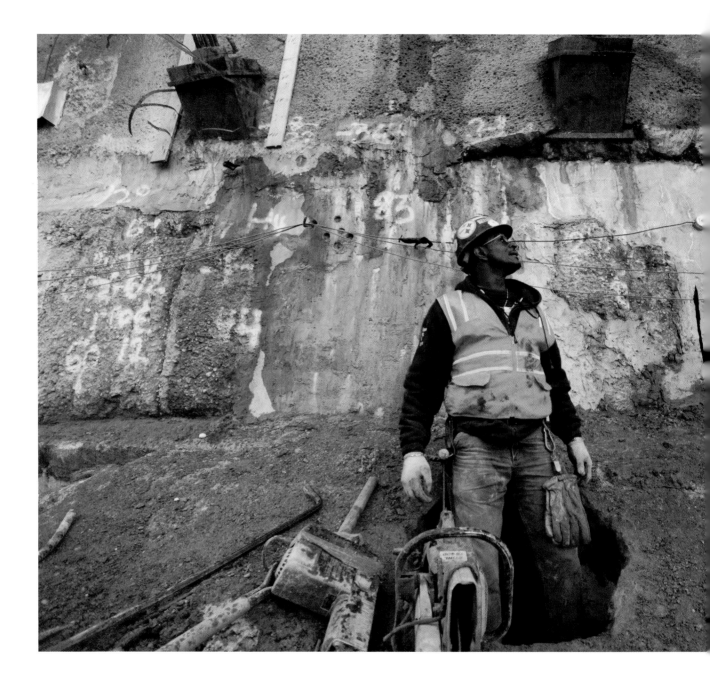

day, the lone cellist bowing a soft dirge as tears fell at the podium.

The force of private grief is immense. It scours the bedrock of heart and soul—"We miss you, Charlie, and we love you, and your boys will always remember"—it cracks and heals, cracks and heals without end. No musical instrument can capture even a fraction of the loss and hurt contained in the swelling and breaking of a human voice.

But that grief made public, pathologized in the name of an abstraction—remembrance, honor, freedom, courage, duty—so that it may be milked for money, power, and political gain is a cruel, crude tool, powerless to heal.

Maybe Rudy was right: Maybe these sixteen acres should have become a tomb. A soothing greensward, a meditation meadow, a healing retreat.

Fuhgedaboudit. This is New York City, the center of the civilized world. Over the next few years, $15 billion and more will pour onto a single square mile around ground zero, pour onto the naked bedrock of human hunger—for wealth, for power, for immortality—that took this island and built Manhattan.

That's how civilizations and their cities and buildings have always and everywhere been made—by the pitiless force of men.

We can avert our eyes; we can ignore the politicians while they prattle about making this spot the Champs-Élysées of Manhattan even as they throttle one another over the gleaming heap of spoils in the treasure chest unearthed by 9/11; and we can pray for the poor souls of the innocent dead, who never knew what hit them.

The hunger for healing and remembrance demands something more. It requires doing, and it requires faith in the hope that long after the politicians and all who died here are forgotten, tens of thousands of people will still come to work in the Freedom Tower every day, and tens of millions more will come each year to see it. It is the real monument. It is the memorial.

Now it has begun. Ground zero is at last prepared for concrete, stone, and steel.

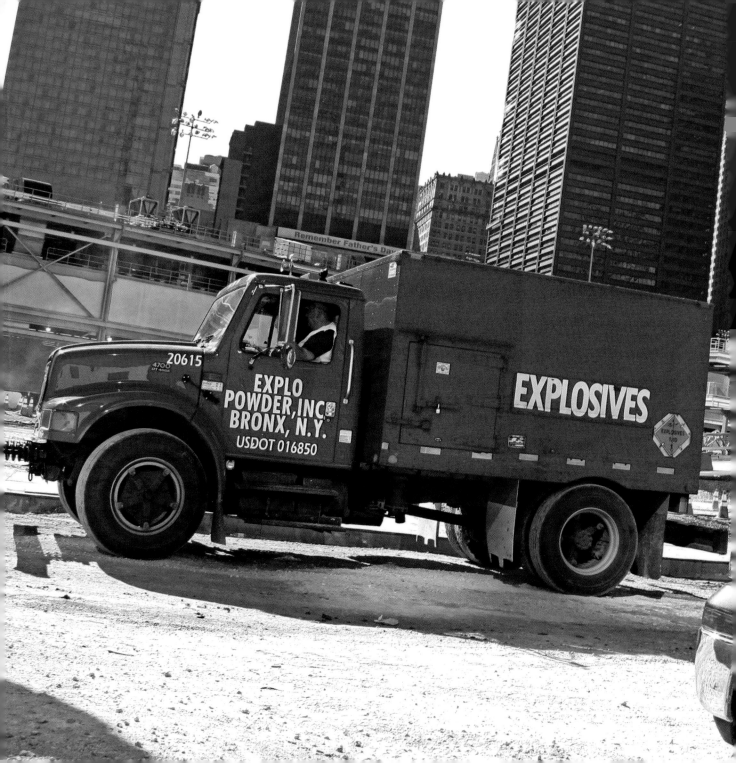

THE BLASTERS

SEPTEMBER 2006

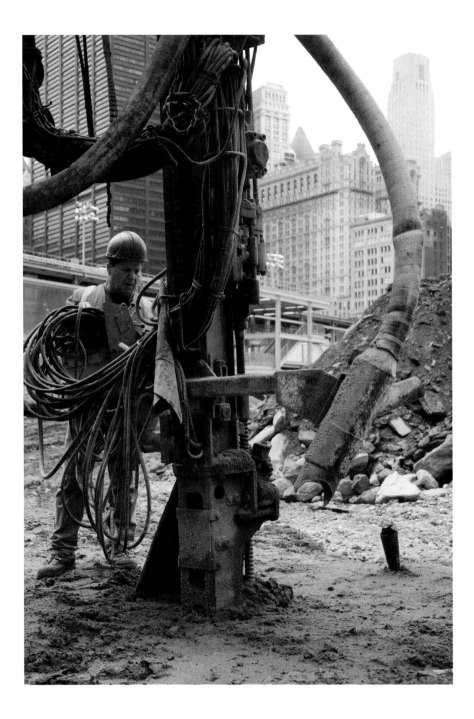

You've never truly heard "In-A-Gadda-Da-Vida" until you've listened to it just past 1:00 a.m. on a sweat-soaked summer night, cranked through the cracked speaker of a boom box perched atop a scaffold set on the gravel ballast behind the crash wall curving along the train tracks at the north end of ground zero—seventeen minutes of heavy metal, two ladders, a cart holding twenty-foot lengths of two-inch glossy black conduit, four electricians, one foreman, two safety inspectors, a construction super, plus the PATH railroad Employee-in-Charge, Alex, a paunchy Russian subcontracted by the owner of this land and this commuter line, the Port Authority of New York and New Jersey, to keep an eye on the proceedings.

"Ziss iz orf," Alex says, pointing down to the nearest third rail. "Ziss iz only vun—you see deh light?—ziss iz *ohn*. Becohs zey verking nighttime, but some of zhem used for deh pletform. Ziss iz used for pletform. Pipple steel come. . . ."

The rest of Alex's safety advisory—you don't want to mess with 650 volts of direct current—is drowned out by Iron Butterfly and an electrician drilling quarter-inch holes through the concrete slab above to hang trapezes for the piping. The air is dead and damp and fouled with dust, and the shift—1:00 a.m. to 5:00 a.m., while the northern PATH tube is closed before the morning rush hour starts and tens of thousands of pipple come—just begun.

Seventy feet below street level, under bare bulbs, these guys are relocating the utilities—rerouting track switches, forced-air lines, fire standpipes, fiber-optic cable—that run the railroad, making way to plant the steel columns of a building that someday will rise 1,776 feet straight up from this pit. Amid the shadows of this tunnel—and the shade of the World Trade Center, the city-within-a-city that once stood a few yards beyond the far side of the crash wall—these guys are putting up the Freedom Tower.

"After all the pipe's in and it's all secured," says Brian Lyons, the construction super, "then they pull new cable through. Put the new cable in, splice it together, get everything up and running

again, and then ya take out all the other stuff."

"It comes out," says Ken, the foreman, "a lot faster than it goes in."

No shit. It took five years, give or take, to build the Twin Towers, and that was back when the Port Authority could seize the land, horse-trade with the political hacks on both sides of the Hudson River, and run the whole show itself. Five years it took to create the World Trade Center, and down it all came in a day, and now, five years of sobbing, stalling, and snarling politics later, the world is still waiting to see what comes next.

What comes next is another twenty-foot length of conduit. Once hung and strapped, its tapered sleeve is slammed into the mouth of the one behind it with a two-by-four and a lump hammer, then sealed at the joint by a two-part epoxy. "It welds the pipes together once it dries," Ken says. "They're strapped every five feet. It becomes a real rigid structure."

For three months the electricians have toiled behind the crash wall—these short nights during the week, with rotating crews pulling Friday-night-to-Monday-morning "super" weekends—and they have three months to go until they're done. Three months of dank air, stepping light over the third rail, drilling and banging, and tinny classic rock all night long: *No problemo.*

"The good outweighs the bad," Ken says. "Money, blastin' in and out of the city quick—no traffic, ya know?"

The commute is quick; the work is slow. Not just drilling holes through twelve-thousand-PSI concrete and notching beams and splicing lines and hanging banks of conduit—they've got the bureaucracy to drill through, too. The electrical subcontractor and the construction firm have to get week-by-week sign-offs from the Port Authority and its railroad division for every stitch of work.

"You're allowed to go so far with the pipe," says Brian. "You can move a signal line. You can dig a trench. Every time you wanna go fast, you gotta slow down because you gotta get something approved."

"In-A-Gadda-Da-Vida" finally ends; not so the dance of regulations and red

tape. "We all got safety managers," Brian says. "The Port Authority comes down here sometimes with two of their safety guys. That's *four* safety guys." He shrugs. "Whatever it is, it is. Go with the flow, roll with the punches—that's what I do. Chip away, chip away, chip away, and it all comes through."

Fifty yards uptrack from the banging and drilling, across from a column bearing the legend *RED SOX SUCK* scrawled eye high in white chalk, a new steel door cut through the crash wall—the PA took several weeks to authorize the door—opens on a short zigzag of metal stairs leading down to the dirt floor of the pit.

"It's different at night," Brian says. "It's very spiritual down here."

He's the son of a carpenter, ex–Coast Guard, a clean-shaven, blue-eyed, straight-ahead guy in his mid-forties. The pit is where Brian took his fiancée to Windows on the World, the swankiest restaurant in Manhattan, to pop the question. Where his youngest brother, Michael, a firefighter, died on 9/11.

Where he himself came down that very night to work on a rescue without survivors, and where he found his brother's gear on St. Patrick's Day 2002, unearthed from the rubble, and where he worked until the pit was clean and the PATH trains were up and running again in late 2003. The pit is where he's helping build the Freedom Tower, however long that takes.

It's plenty spiritual. There's the spire of St. Paul's rising into the night haze, just past the far wall of the pit, and the jutting, shrouded hulk of what was the Deutsche Bank office tower across Liberty Street, bashed to ruin by the toppling south Twin, where work crews are still waiting to get back to the task of taking it down while the bureaucrats puzzle out the protocol for separating toxic dust from bone fragments and other human remains. There's the square footprints of the Twin Towers, formed by the sheared-off tops of their perimeter columns, boxed in plywood now, waiting to be enshrined by a memorial. And here, a few feet away, under a cracked and chipping blue wooden cover, sits the useless Freedom Tower

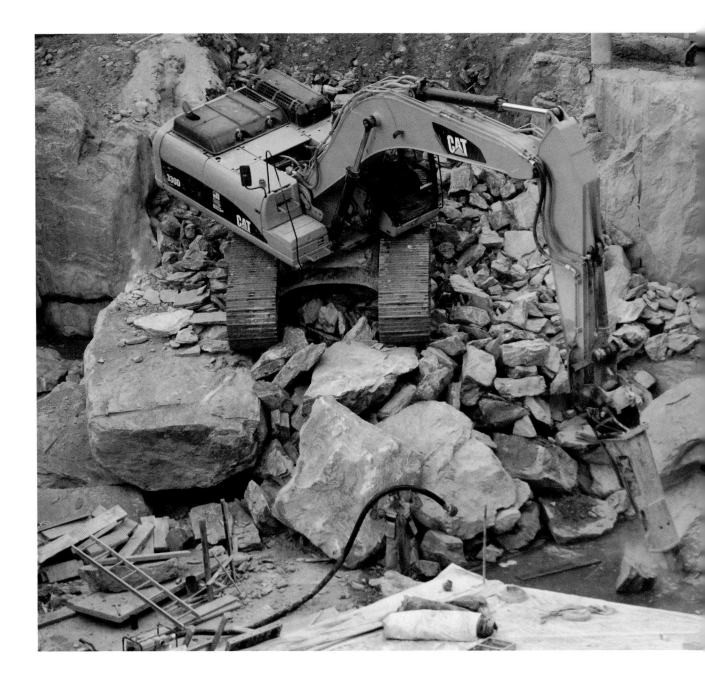

cornerstone, absurdly dedicated on July 4, 2004, before Governor George Pataki and the Port Authority realized that the one sign-off the PA itself somehow neglected to get was approval from the New York Police Department for the Freedom Tower, which in the NYPD's opinion needed to be moved and completely redesigned for security reasons—which cost, in addition to tens of millions of dollars, yet another year.

Which is why the most spiritual—and, quite frankly, thrilling—aspect of the pit is the hoe ram, an elephantine Caterpillar 350, a fifty-ton excavator fitted with a huge hydraulic hammer, asleep next to a hill of rock and dirt. The hoe ram works days outside the crash wall—no tunnel, no tracks, no crapped-out boom box—banging through old slab on grade, breaking rocks, readying the pit to receive the massive footings that will brace the inner core of the Freedom Tower.

"This is where they started the five-foot cut down to bedrock," Brian says. "I love diggin' out here. It's like you're a kid. You're choppin', you're diggin', you're loadin' trucks up—it's just fuckin' great. It really is fun. It's good to have a job that you really fuckin' like and love. It's really good."

You can hear it in his voice, see it in his eyes, feel it in the spread of his arms beneath the night sky—*It's really good*—and you remember him a year ago, just as everything stopped while the work crews waited on the cops and the Port Authority and the architects and the governor to hash out and sign off on a redesign, explaining why he had to get down to the pit and get back to work on the Freedom Tower.

"I felt a compassion to go back," he had said, "and work rebuilding the biggest building in the world as another stickler to give those terrorists—*in your face*, we're gonna build the biggest building again, right here on the same site. I felt passionate that I would wanna be a part of that."

See, that's the thing: This isn't Pearl Harbor. Or Oklahoma City or New Orleans, either. This is New York City here, Lower Manhattan, a couple blocks from Wall Street. Sixteen

billion dollars, give or take, is being spent here—on these sixteen flattened acres—and though getting them vertical and flush again won't bring back one murdered soul, waiting for the hacks and bureaucrats to stamp the forms and divvy up the money and the spoils of tragic glory is a dishonor and a personal disgrace to the men whose battle it is to rebuild. Not for nothing, but to guys like Brian, Osama bin Laden is just a pissant, a drama queen—the robes, the rifle, the stateless head-of-state charade—and it's gonna be 9/11 forever, or at least until their job is done.

Back inside the crash wall, Alex has his flashlight trained up at the slab, inspecting tonight's work while the crew taunts him and Hendrix sings "All Along the Watchtower" through the cracked speaker.

"Alex seen a loose nut up there."

"Is this your first job, Alex?"

"Employee-in-Charge—in charge of what, I still don't know."

"We're all tryin' to figure that out."

"Awright, let's go," says Brian. "Let's wrap it up."

"We're gonna kill ya. There's no downside for us. We're just gonna pound the shit out of you. I hope you're ready."

This—the unpretty message delivered to Silverstein Properties by a city hall hatchet man—is how buildings don't get built. This is how the pit has stayed a pit for five long years. This is how, and power is why.

The hatchet man works for Dan Doctoroff, the city's deputy mayor in charge of economic development and, um, rebuilding. Dan has a degree in government from Harvard, a law degree from the University of Chicago, and a vision for New York City's future—a big vision, much bigger and far more complex than just a sixteen-acre pit. Everyone you talk to agrees on two things about Dan: that Dan's a brilliant visionary, and that Dan never lets you forget for a moment that he's a brilliant visionary.

Rebuilding the pit hadn't been on Dan's mind much since 9/11. It was the Port Authority's pit, and since the PA

answers to the governors of New York and New Jersey, not the city, George Pataki was on the case down in the pit. Plus, Dan had a bigger fish to fry: a vision of titanic development on Manhattan's far West Side, in Midtown, where new office space is all but impossible to build or find. His vision included twenty million square feet of new office space, a new stadium for the New York Jets to come home to from New Jersey, and—dearest by far to Dan's heart—the 2012 Olympics.

As for the object of Dan's man's threat—hell, rebuilding that pit is *all* Larry Silverstein has thought about since September 12. And while Larry doesn't boast Dan's academic credentials, he is an old-school New York City real estate developer, with the hide of a rhino, the guts of a grizzly, a bite like a shark's, and the brain of . . . well, of a New York City real estate developer with fifty years' practice in the not-so-fine art of urban warfare. Everyone you talk to agrees on only one thing about Larry: He won't back down.

Oh, Larry had one other thing, too—a ninety-nine-year leasehold on the World Trade Center, signed with the Port Authority, dated July 24, 2001, fifty days before the barbarians reduced it to ground zero. And so he had the legal right to rebuild, to recapture every last square foot of lost office space on the WTC site—and that, on September 12, 2001, is exactly what Larry set out to do.

For five years, Larry has clashed with the PA over who'll build and pay for what at ground zero. Five years butting heads with Pataki over the Freedom Tower, paying $10 million per month in rent to the PA for the mud at the bottom of the empty pit, suing and getting sued by the WTC insurance companies—five years standing fast upon the bedrock of his lease and not giving an inch.

Larry and Dan had faced off once before, late in 2004, when the city had signed off on Larry's plans to rebuild the WTC. One night during the course of those negotiations, Dan, who wanted new housing built at ground zero, walked out. Fed up with an old *hondler* who wouldn't give, he said, "I'm sick of this shit," and stormed out of the room.

And Larry got up to follow him. "I'll walk with you, Dan," said Larry, and walked him to the elevator. And, very politely, Larry said to him, "If you want to talk more about this, please get in touch with me."

That's *old*-school, brother—and eventually Dan signed off on Larry's rebuilding plan. But that was then and this is now, and in the year and a half between then and now, Dan's West Side dream died, and one of the men who killed it was Larry's political rabbi, Sheldon Silver, speaker of the New York state assembly and assemblyman from Lower Manhattan, which includes the pit. Worse, Silverstein Properties wasn't among the many developers who supported Dan's Olympian dream with gelt. And Larry is as focused as ever on building office space at ground zero, but Dan's big vision still calls for building new housing. And no matter how many times Dan explains his big vision, Larry isn't backing down.

So Dan's hatchet man issues his threat, and it comes to pass that Dan runs a brand-new economic analysis of Larry's rebuilding plan and lets the media know that Larry's plan is rubbish. Worse than rubbish—it might be a *plot*. Dan testifies to the city council at a special hearing that not only would Larry default on his ground zero obligations after building a single office tower—two at most, says Dan—but he might very well scurry off with half a billion dollars in pure profit, "a disaster for the city, state, and Port Authority," says Dan, "and a blemish on the memory of those who lost their lives on 9/11."

When Dan invokes the murdered innocents, you figure that Larry must be hunkered down again at the bargaining table, stiff-necking Dan's vision until Dan's big brain and ass are on fire, but it's truly clear what's what only when Dan shares his new vision with the city council: Larry should hand over to the Port Authority the two choicest building parcels on ground zero in exchange for a reduction in his rent. Dan tells the council that the PA—which hasn't put up a skyscraper since the Twin Towers forty years ago and has already publicly announced that it won't ask its employees to work

in the Freedom Tower—will build its own new headquarters on one of those choice parcels and flip the second one to another developer, presumably one who shares Dan's condominium vision.

Nobody on the council questions Dan's economic analysis—heck, no one outside of Dan's office has ever perused it—but one councilman does wonder out loud why all of a sudden Larry not only isn't fit to rebuild the WTC but is being portrayed as both a blemish and a potential looter.

"This is not personal at all," Dan says. But the venom in his voice— "Larry doesn't have one dime in this project," he sneers at one point—tells you that for Dan this has become very, very personal.

After Dan finishes pounding the shit out of Larry, up step the *New York Times* ("GREED VS. GOOD AT GROUND ZERO") and the *Daily News* ("GET LOST, LARRY"). Then, finally, it is Pataki's turn. After declaring that the negotiations are dead, he tells the world that Larry "has betrayed the public's trust and that of all New Yorkers. We cannot and will not allow

profit margins and financial interests to be put ahead of public interest in expediting the rebuilding of the site of the greatest tragedy on American soil."

And when you hear *that*—the head of the state washing himself clean with the blood of the lambs of 9/11 and fingering the real estate developer as the source of all evil—that's when you know that Larry Silverstein has won.

Day by day, the skin of the pit gets deeper, louder, harder, more crowded. The five-foot slice through the old slab on grade goes down closer to ten feet now, down to better bedrock. The Freedom Tower's twenty-two-thousand-square-foot core will sit here, its thick inner walls and columns anchored to concrete-and-steel footings sunk twelve and fifteen feet deep, into rock hard enough to hold and spread a load of 120 tons per square foot.

Three line drills swarm the surface, insects next to even the smaller, bucket-nosed excavator, screaming as their business ends spiral down into the rock, coring two-and-a-half-inch holes,

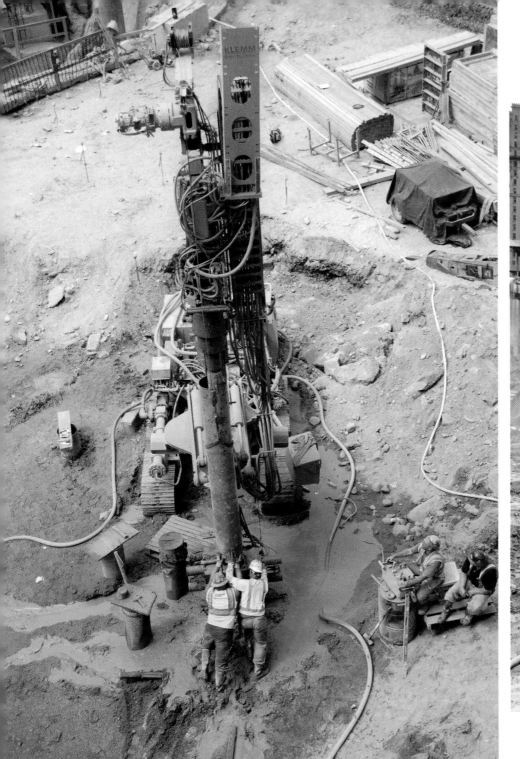
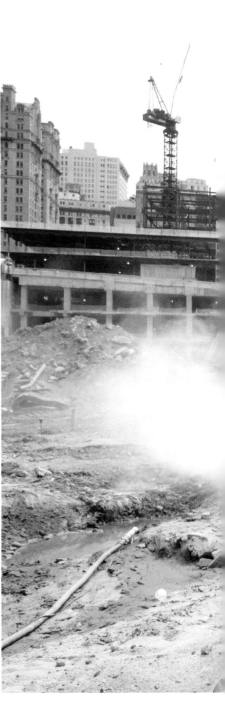

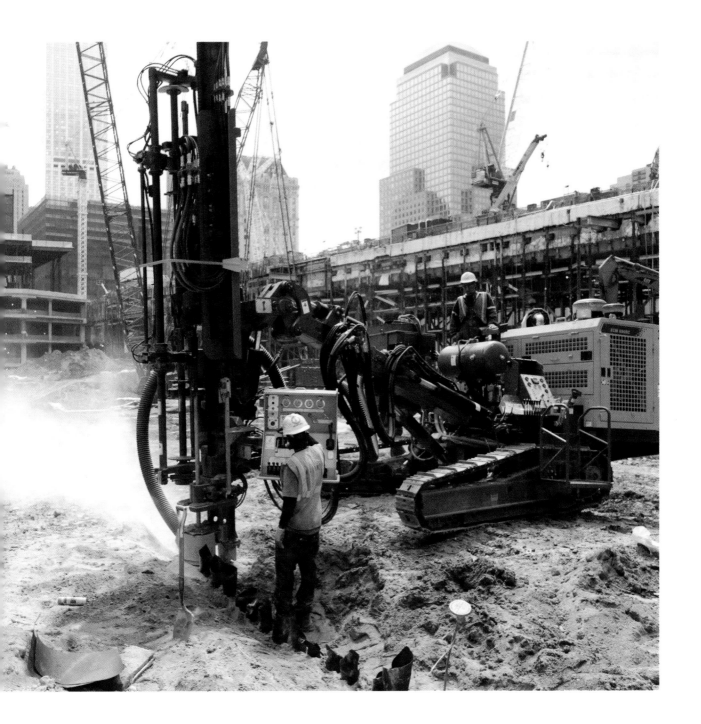

tracing the rectangle of the footings-to-be, flagged in bright orange, so that the hoe ram's hydraulic hammer can punch down and pulverize more easily. And *that* noise—steel stuttering incessantly, relentlessly banging, breaking rock into rock, breaking *that* down to smaller rock—is one long, staccato cataclysm, obliterating from onset to end every other noise down here. The operating engineer sitting up in the hoe ram's cab hauls down six figures a year plus benefits and earns every bloody-eared cent.

The ground trembles ten yards off when the hoe ram shimmies past on its treads, hammer raised, making way for the bucket to grade a hillock of dirt and rock, moving mounds of debris to be loaded onto the trucks that come late in the day to take it across the Hudson to a yard in New Jersey. The grader's keeping the floor of the pit level and smooth enough for the smaller machines to move and work without tipping into a void or seam in the hoe ram's stony wake. Four thick-gloved laborers scramble, climbing the pile to yank out the old rebar, tossing it onto

a pile of its own, where they cut it with welding torches while a fifth man hoses down the dust.

The guy whose construction company was the general contractor on the Empire State Building once said that building skyscrapers was the nearest peacetime equivalent to war. This part of it—foundation work—is like infantry storming the beach.

"The beginning of our job is to get down to good solid rock that will support the immense structure that's going on top of it," Angelo Sisca says. "If we fail, the building fails. It's that simple."

Angelo has been building foundations and superstructures in New York City for fifty years, so when he pauses and adds, "We will not fail. We have not *ever* failed. We take every precaution and make every effort to do it right—exactly right. That's what we do," you tend to believe him. Angelo is a serious guy, still a bear of a man at the age of seventy-two. He's a vice president now, or chief operating officer—the foundation contractor isn't big on titles—but like a lot of the men in the business of building buildings, from developers

on down, he walks the job on a regular basis—for now, every day.

It's a dicey time for Angelo and the Freedom Tower foundations crew: They're blasting at the pit, using explosives to get down the next six or seven feet to 120-ton bedrock. This is standard practice everywhere in the country, including New York City, but not here: not at ground zero, where facts and logic don't apply, not without a tussle; where mourning and ferocious rage, stoked and milked by politicos and the media, still fuel a slew of victims' groups for whom this work site is also a sacred burial ground; where the community board weighs in on every issue, whether anyone's listening or, more often, not; where the NYPD and the New York City Fire Department don't often agree on who has jurisdiction over which activity on these sixteen acres; and where, truth is, absolutely no one makes the rules except the Port Authority, which said, "No blasting," before work had even begun.

"We're not cellar diggers," Angelo says. "We're contractors. We're engineers. We have blasted in the severest of conditions. We're not accustomed to standing back and waiting for people who really don't know what to do, who don't understand what's happening, to make decisions.

"One of the questions asked was 'What is the effect on the slurry wall?'" Angelo's talking about the two-foot-thick, seventy-foot-tall steel-and concrete wall built four decades ago to keep the original WTC foundations from being flooded by the Hudson River, a few hundred feet to the west. "My God, the slurry wall withstood *earthquake* proportions when 9/11 happened. The guy asking the question simply doesn't understand."

So to reassure the PA, they've rigged sensors everywhere—on the slurry wall, on the railroad tracks, on the surrounding buildings—to measure the vibrations, and they've posted surveying crews to make sure that nothing moves, and the FDNY has a fire marshal supervising, and the NYPD's Bomb Disposal Unit is standing by up on the street, and they've brought in a consultant all the way from Cleveland, a heavy hitter known as Dr. Dynamite.

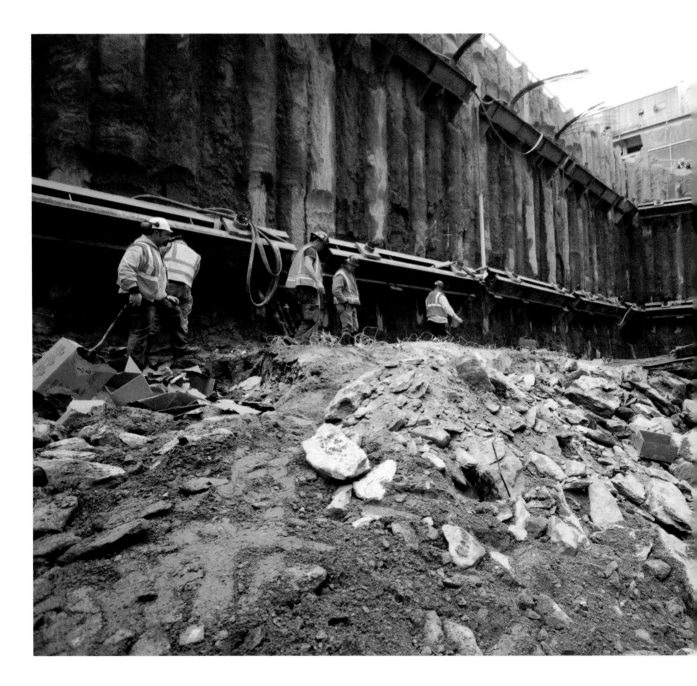

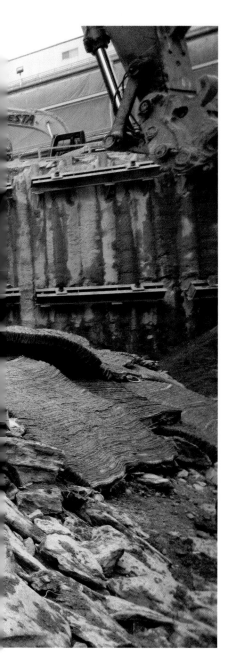

"I have an explosive personality at times," says Dr. Dynamite, whose real name is Ed Walter. Ed's dad, Dr. Edward J. Walter, started the consulting company in 1946, the year Ed was born, and Ed started working with his father as a teenager. "I'm a licensed blaster. I have the federal permits and the state permits. I have the experience and I have passed tests, so I can operate as a blasting engineer or as a seismologist. On this project, it's a little of both.

"If there's a big show, a mistake has been made. This is not Hollywood. The site speaks for itself; it's the most sensitive site in the world, and with buildings all around it, you've got hundreds of thousands of people looking down on you every day. The culmination of this project is gonna make a statement to the whole world: that this is America. We rebuild. We don't accept defeat. And I think that's huge. I didn't solicit this work. I didn't even know it was gonna happen. I was immensely proud that I was asked to be here."

It may not be Hollywood, but it's still one hell of a show, running three times daily. The explosives come in cardboard tubes, looking for all the world like sticks of cartoon TNT, filled with an ammonium-nitrate pudding and tested to ensure they can withstand the force of a 30.06 shell fired from a distance of fifty feet without detonating. The blasting cap is in the pudding. A plastic fuse—a shock tube, Ed calls it, with an inner coating of lightweight explosive—runs up and out the hole to the detonator. The blasters, three guys in brown hard hats, shove the sticks and the shock tubes deep in the holes made by the line drills—a dozen or more holes patterned in a two-by-three- or three-by-three-foot grid within the outlines of a future Freedom Tower footing. Then they hook 'em up to the shock tubes—strands of bright yellow twisting through the pit—and pack the hole with grit and gravel.

Then the blasters stand clear, and the bucket-nosed excavator goes to work, eye-hooking huge mats made of recycled tires and steel mesh onto one of its metal teeth, one mat at a time, lifting and swinging until the mat's dangling above the blast grid, then bowing to let

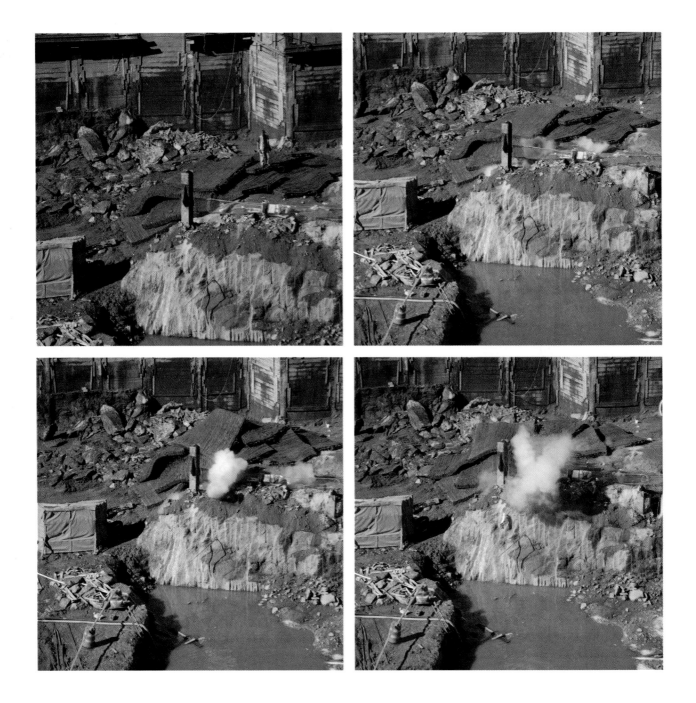

"Dr. Dynamite" and his crew examine the serial rigging of dynamite near the subway box under Greenwich Street. Moments later, a blast of dynamite lifts the mats, creating a cloud of dust and debris.

it *whomp* to the ground, until a rough mountain of rubber and steel covers the grid. Then the excavator huffs off and Carmine, the daytime super, shouts something about one whistle or two whistles; it's hard to make it out with all the noise and the soft little cantaloupe-orange plugs stuffed into your ears.

But you can sure as fuck hear the blaster's air horn blow—that's no whistle; that's God's own shofar—once, loud and long, then a second, briefer yowl, but now Carmine's shouting even louder, waving his thick arms at the Mr. John truck that has chosen this moment to come trundling down the long ramp into the pit, with two blue plastic outhouses strapped to its hind end.

"Ho! Yo! Ya gotta get farther," Carmine hollers to the driver, who backs up toward the ramp he just came down.

And then the air horn sounds again, twice, and you wait. And you wait. And when it finally comes, you feel the ground ripple under your feet a seeming millisecond before you hear the bass note and see the tons of rubber-and-steel matting and a small cirrus cloud of dust leap up over the grid. The matting flops back down, and the cloud lifts and scatters in the summer air. Three all-clear blasts from the air horn and it's over.

"You're good, you're good," Carmine shouts. "Don't get hit by the shitter. Mr. John's comin' back down."

When Dan Doctoroff and the Port Authority and George Pataki and the media had all finished hoe-ramming Larry Silverstein and beating their chests, nothing was left to negotiate but the fine print. Larry never had returned fire publicly, although he did buy a series of weekly ads on the op-ed page of the *Times*, at ten grand per ad, assuring one and all that Silverstein Properties was not only ready, willing, and eager to get the rebuilding going, but also was financially able to see it through to the end. Privately—at the bargaining table—he made plain that he and his lease would sooner go to court than hand over *any* of the best building sites on ground zero.

But if the Port Authority—with an endless money stream from every major

bridge, tunnel, and airport in the metro area, plus the right to issue its own bonds—was so bent on getting into the real estate development business and so fearful that Larry was either dumb or dishonest enough to go bust on sixteen acres of the most valuable earth on the planet, then maybe the PA would like to take the Freedom Tower off his hands?

And that became the crux of the deal: Larry would build the Freedom Tower for the Port Authority on the PA's dime and collect a developer's fee of 1 percent—$20 million or so—for his trouble. The PA also would get the Deutsche Bank site, which it would be free to peddle to another developer to build housing. Larry would get his rent reduced, and he would keep the three prime building sites on ground zero.

Publicly, the deal was presented as an ultimatum: Larry could take it or leave it—no more haggling, which was a good thing for both the PA and Pataki, or Larry might've wound up owning the George Washington Bridge and the governor's pants as well. Larry took the deal in late April 2006, and he and the PA hammered out a six-page

"Conceptual Framework" for rebuilding ground zero, with a timetable and everything, and they held yet another groundbreaking in the pit.

Just as in 2004, the governor proclaimed that "today we are going to build the Freedom Tower," only this time he said it in Spanish. The foundations crew rolled a couple of machines into the pit—the governor wanted a pair of excavators to parade down the ramp together, which would have looked more impressive, until the ramp collapsed—and no one mentioned that the utilities-relocation work had already been under way for a month or that the cornerstone Pataki had dedicated two years ago was still sitting a few yards away in a puddle of filthy water.

Larry was there, too, of course—he never misses a Freedom Tower groundbreaking—and he was beaming. Right next to Pataki. Shaking hands. Nothing personal.

"Listen," Larry says now, "after all the name-calling, we're *still* working together, right? So what does it mean? What does it accomplish? In private enterprise, does this ever surface? In

private enterprise, you sit down together, you work things through, and you get it done.

"When you're dealing with government, they don't have the capacity to function the way we function in private enterprise, so they have to resort to name-calling and things of that sort. I knew it was coming, and it came. Fine. I'm not going anywhere. I'm gonna finish this job. I saw this not just as an obligation, but also a privilege, to rebuild. And I felt—and I feel it—as an obligation to my children, to my grandchildren, that this thing get rebuilt. Government, nongovernment—I'm gonna *finish* the job. We'll get it done."

The man is seventy-five years old now. He has two grown kids in the business, and when he signed the WTC lease in July of '01, his wife was hoping that she and Larry could take their yacht around the world for a year or two—and maybe that would've happened if 9/11 hadn't, but you doubt it. Easier to believe what other people in the business have said: Inside his head, Larry already knows whose leases elsewhere are expiring in 2010, 2011,

2012, and beyond. He's already making those deals in his mind, without any help from Dan Doctoroff's economic analysis.

About the ground zero deal he has little to say. Three words: "I'm not complaining."

That's all—that, and a small grin. But his thin arms are spread wide, just like Brian's—*It's really good*—in the bottom of the pit.

They're casting Freedom Tower steel in Luxembourg now. From Luxembourg, it ships to the port at Camden, New Jersey, where it will be loaded onto trucks and driven to Lynchburg, Virginia, to be customized into fifty-foot column lengths, then trucked back to New York to be assembled and erected in the pit by this year's end.

In Beamsville, Ontario, a shop foreman named Ray rips aluminum extrusions, fabricating 156 small anchors of his own devising to hang glass samples on the mock-up of two stories of the Freedom Tower's curtain wall—the building's outer shell being built atop

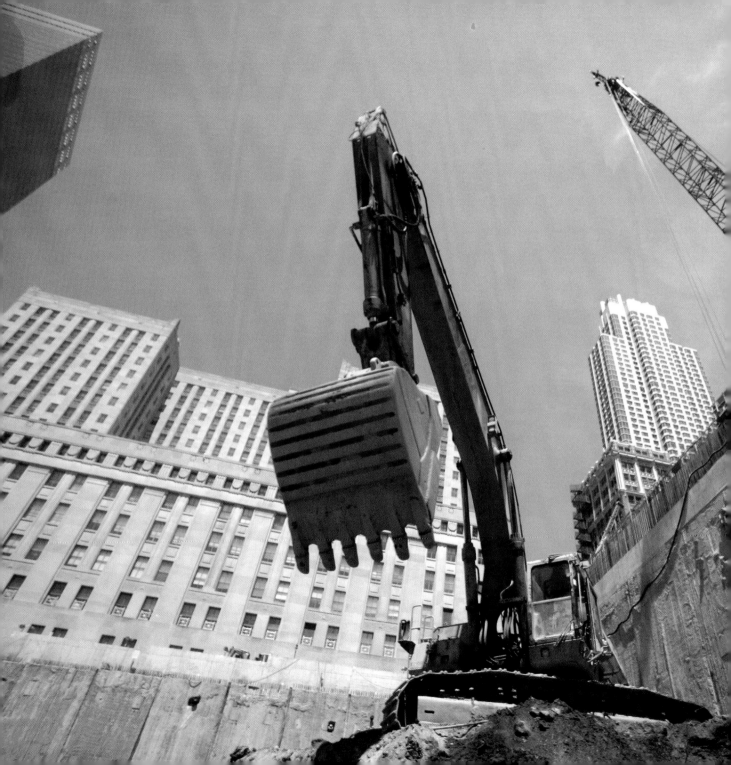

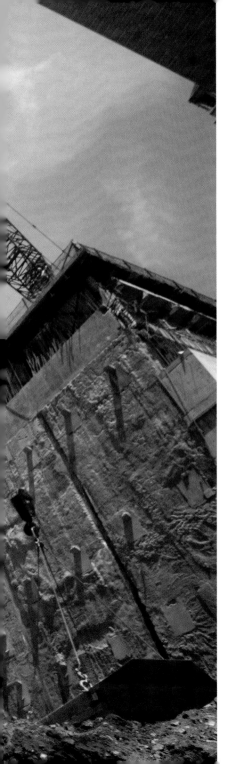

a cement platform behind a warehouse in Kearny, New Jersey.

And soon the mock-up's glass panels—each thirteen feet four inches high, the same as the real Freedom Tower's—will arrive from Italy and from Wisconsin at Ray's shop in Beamsville to be glazed before they make their way to Kearny.

And soon the architects of the Freedom Tower will ferry across the Hudson from their Wall Street offices, journeying to Kearny to see how their tower will actually look when the actual sun glitters off the actual glass.

And soon the foundations crew will plant the footings deep in the rock of the pit.

And soon—soon!—Larry and the Port Authority will hammer out and nail down new leases, and the PA will finally deliver its plans to build the infrastructure Larry needs to get his other towers going, or else, by September's end, the "Conceptual Framework," a six-page, seventeen-paragraph term paper encapsulating the most complex real estate deal in the annals of human history, will turn to dust, and it will forever be September 12 at ground zero.

And soon—soon! it can't be soon enough—pigs will soar out of Mr. John's top-of-the-line crapper, fly straight to the UN building, and teach humankind to live in peace.

Meanwhile, they're building the Freedom Tower yet again in Hoboken. Not the pigs—a couple of guys named John and Adrian, at a shop called Radii, a miniature architectural world of its own behind an unmarked steel door that opens onto a wobbly fire escape barely affixed to the decrepit brick side of a sprawling factory that once housed the leather-goods maker whose name, Neumann, is still the only name on the place.

"People who make it up the stairs really want to work with us," Ed Wood says. Ed's one of the owners of Radii, and his shop has turned out maybe twenty—Ed's lost count—iterations of the Freedom Tower. So far. Radii is where architects come and whisper adjectival descriptions to Ed and his partner, Leszek Stefanski, and their crew, many of whom are architects themselves.

"Prismatic," the Freedom Tower architects tell Radii. "Diffuse. Cascading.

Glowing. Delicate yet strong. A waterfall of light." And they leave behind drawings that Radii scales down and uses to build its wee versions of a 1,776-foot tower.

This go-round, John and Adrian are working on the redesigned Freedom Tower base and plaza, redoing a one-thirty-second-scale version of the building for a public presentation in less than two weeks. A year ago, nearly to the day, Radii was building the Freedom Tower for a prior unveiling, the first since the NYPD had sent the architects back to their drawing boards to move and bombproof the base to U.S. embassy standards. The result, a two-hundred-foot concrete cube of a pedestal, was to be clad in panels of nickel and steel. This year's model replaces those metal panels with three layers of thick-cast glass, an effect Radii is trying to capture with wee panels of acrylic, laser etched, scored, and layered to achieve a moiré pattern.

"They design the building, and we design the model," Adrian says, working the edge of a tiny acrylic prism against a sanding block. "In theory, the light comes in, hits that"—the prism's sanded edge—"and gets thrown out the top." Grabbing a small halogen flashlight, he flicks it on; suddenly, the prism's slopes warm with light as a bright beam shoots from its smooth top.

"A matte surface—a sanded surface—will glow, and on a polished surface, the light will just carry on along," he says. "The edge of the plastic collects light, transmits it along the plastic, and then glows at the opposite edge. You get a lot of control over it that way. One of the problems we run into is, you can miniaturize a lot of stuff, but you can't miniaturize physics."

John's at the computer, taking the architects' model drawings down to scale, programming Radii's laser work on the base redesign. "It's gonna take some fine-tuning. We're still trying to figure what's the exact material—tinted or clear, what layers and what scoring, cutouts or no cutouts—and then we'll cut the real parts. By the end of today or tomorrow, we'll start putting it together."

Quick work compared with the real deal. Last year, Radii had three days'

notice to build a three-foot-tall Freedom Tower model for Pataki—who seems to think he may be destined for a bigger job than governor of New York—to take with him on a trip to Iowa. Unlike physics, you apparently *can* miniaturize politics.

"A simplified version of it," John says. "Very simple. We put it in a nice box with a handle."

John and Adrian's new model will debut in less than two weeks at an American Institute of Architects luncheon hosted by Larry Silverstein at 7 WTC—just off the north edge of the pit, a gleaming new fifty-two-story office tower Larry began planning five weeks after 9/11 and now has finished in the same stretch of time that the PA and the state and city of New York have taken to decide how to begin to rebuild the World Trade Center.

And on the scorching late-June morning after the architects' luncheon, Larry will cool his heels in the shadow of 7 WTC, sitting at the bottom of the pit in the back seat of his Mercedes, the *Wall Street Journal* folded on the seat beside him, making phone calls—doing business—while he waits for the governor to stroll down the ramp to ground zero.

The governor has a gaggle of officials around him at the top of the ramp, trailed by a horde of media. He's here to proudly announce that the feds have agreed to move the U.S. Customs and Border Protection agency into the Freedom Tower when it opens in 2011. This—Pataki wrangling state and federal tenants for the Freedom Tower—is part of the deal the Port Authority and Larry have made: Larry builds it, the Port Authority pays for it, and Pataki rustles up leases for at least one million of its 2.6 million square feet. And lately the PA, chaired by a New Jersey guy who's pressuring the governor for another tunnel across the Hudson, from Lower Manhattan to what the Jersey guys like to call their Gold Coast, has been squawking publicly about how Pataki had better get humping on those leases or the Freedom Tower—and Pataki's legacy—just might get shrunk. Hence, today's press conference at the pit.

If it is delicious for Larry to see Pataki hustling office space—the man

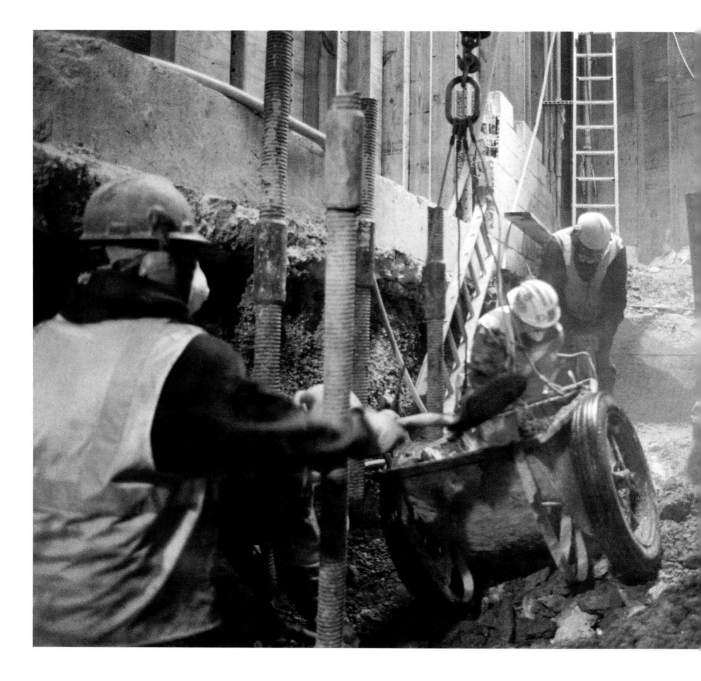

who, despite Larry's imprecations, chose to put the Freedom Tower on the most unbuildable and unleasable spot at ground zero; who, despite the NYPD's fears, named it Freedom Tower; who, despite what it takes to build a superskyscraper, told the world that its steel skeleton would be topped out by September 11, 2006—if Larry enjoys the irony of this lame-duck governor-who-would-be-president reduced to scrounging up tenants like any real-life real estate developer, he's far too busy doing business to let on.

"Is he on his way yet?" Larry asks his assistant as he wraps up another call.

"He's about a third of the way down."

"A third of the way? I can make another three calls, for God's sake."

"Now he's halfway."

"*Halfway?* Gee. That's progress."

You can measure progress all kinds of ways at ground zero. Another length of conduit hung, another footing trough blasted out, another set of models of a building that doesn't yet exist, another photo op. For the men working in the pit, though—the guys in the plastic hats and safety vests, the bung-knuckled guys who show up down here every damn day—one big deal is just getting the fucking cornerstone out of the way.

It takes a lot of elbow room to build a lot of building—room for men, room for machines—and there's not a lot down here. The PA's got a contractor starting work on a new train station on the east side of the pit, and jostling for space is an everyday pain in the ass. The PA covered the old Twin Towers' footprints—Pataki officially declared them sacred in 2002—but the north edge of the plywood cover itself overlaps the south edge of a Freedom Tower footing line, and no one knows yet what the hell will happen at that spot, since the Talmudists at the PA have declared the plywood untouchable, too, although in truth it's just a handy platform for stepping up out of the muck or out of the way, and it's used as such all day every day, and nobody says boo or, God knows, means any disrespect.

Anyhow, the footprints take up an acre each, and the PA's train-station

contractor is on a T&M contract— time and materials, not price—so he can just spread out and relax, because the PA, unlike an actual real estate developer who bids a job for a set amount, is more or less handing him a blank check, and the Freedom Tower guys need room to stage their work, and so it's time for the fucking corner-stone to hit the road.

Which turns into a real cloak-and-dagger operation. Poor Carmine has enough to do as daytime super, what with safety inspectors and the PA inspectors and the fire marshal and the NYPD and the Port Authority Police Department and the union guys and the train-station contractors, everyone and his uncle snaking up his ass every minute, and now he's gotta figure out how to finesse a twenty-ton chunk of granite up the ramp and out of the pit without drawing too much notice, embarrassing Pataki and alerting the locals—who even on a good day much prefer the taste of an Unhappy Meal— to the reality that five long years after 9/11, we're playing three-card monte with the stone.

So they do it early on a steamy late-June Friday morning, during the hour-or-so window between the utilities-relocation crew going home and the foundations crew coming in. And as for the PA and its train-station contractor bitching that yanking the stone is going to hold up their workday, screw 'em.

Carmine arranged to bring down a forty-five-ton crane a few days ago— smallish as these things go—and now a crew of nine or ten are down in the pit, including Louie, the driver of the flatbed, who will chauffeur the stone back to Long Island, where it was cut in 2004. It takes a good half hour to work the two thick yellow straps around the shoulders of the stone so that the crane can fish it out of the footing hole. They take the straps off the crane's hook to get it tight, and two men squat in the sludge on planks of rotted wood to make sure they're snug before the guy standing up by the cab twirls his hand to let the crane operator know it's time to lift.

It's a sad thing to see that stone come up. It looks like hell, stained pale

gray below its waterline, splotched with what appears to be old black paint that ran down its back and dried. It's a sad thing to read the three-line inscription they etched upon it on Long Island in 2004:

TO HONOR AND REMEMBER THOSE WHO LOST THEIR
LIVES ON SEPTEMBER 11, 2001, AND AS A TRIBUTE
TO THE ENDURING SPIRIT OF FREEDOM.

Some fucking tribute is what you're thinking when one of the safety guys, Bobby, who always has a good word, walks up with his camera. "Every little new thing I do, I take a picture here," Bobby says. "Just to have for my grandchildren someday"—Bobby's maybe thirty-five, tops—"just to show 'em I'm buildin' the Freedom Tower."

As the crane begins its turn, four guys mount the flatbed to help wrestle down the dangling cornerstone.

"I'm a little bit of an amateur writer myself," Bobby says. "I'm putting together what's gonna be mostly photos I take—bear with me here—inside the shithouse, inside the plastic shithouses. So it's 'Port-a-Potty Poetry.' I wrote a whole intro, and I've been collecting pictures as I go to different job sites."

You laugh and tell Bobby the honest truth: This is a truly great idea.

Louie's got a brand-new blue tarp, still in the plastic, to cover the stone.

"Put the blankets down first," Carmine shouts. "*Then* the tarp."

So they cover the stone with a couple of old movers' blankets, then the tarp, and they cinch it down nice and tight, and Louie climbs up into the cab, takes 'er easy up the ramp—and just like that, Elvis has left the building. The rest of the crane crew piles into their pickups.

"See you all with the next one," one yells.

Carmine's grinning ear to ear as he walks over to them. "This was a home run," he says. "Thank you."

"Nice and quiet, right?"

"Home run. I appreciate it, guys. No problems. Thanks."

Over across the Jersey barriers to the east, the train-station crew is starting its workday.

"And they were breakin' my balls that I'm gonna be holding 'em up," Carmine says. "When they tell me I hold 'em up, I says, 'Fuck you.'"

In the haze at the bottom of the pit, it feels like noon already, but at least the cornerstone is out of the pit, out of the way, heading back home.

"It's a good thing," Carmine says as the foundation workers trickle in. "Y'know what I mean? It's everybody's stone." He sighs and walks over to the construction trailer. He's got a million phone calls to make and, apparently, an on-site truce to broker between the nighttime union electricians and the foundations contractor, who doesn't use electricians—and whose generators have been not-so-mysteriously unplugged in the middle of the night.

The line-drill crew's getting ready to punch fresh holes in the pit for today's blasting. Bobby comes over. "The day before yesterday, they did a big one," he says. "Blew the mats right off. . . ."

Then the drilling starts, and it's too loud to talk.

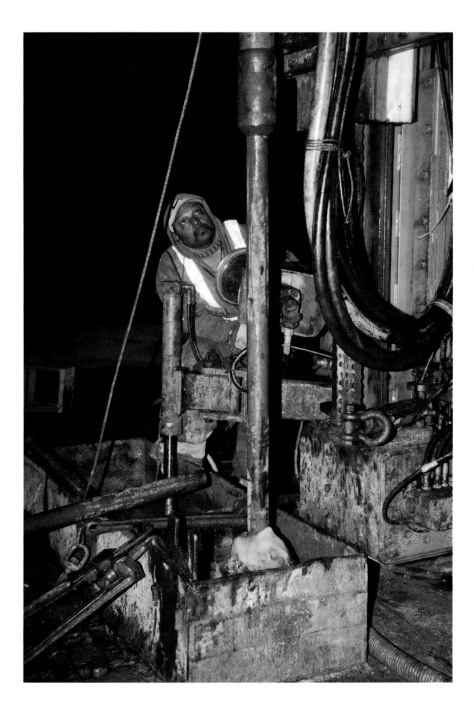

THE STEEL

JUNE 2007

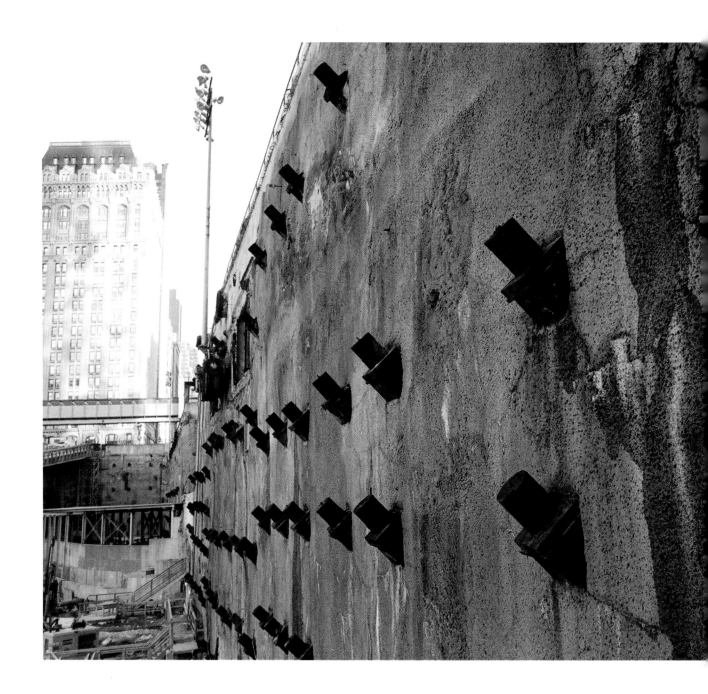

Governor Pataki, the father of the Freedom Tower, is running late—twenty minutes, plus or minus five long years—not that it matters any on this fine December morning. A lanky, whey-faced, round-shouldered man with all the charisma of a poached egg, he's still head honcho of New York State for two more weeks, and this is a special day: George Pataki's last giddyap at ground zero. So what the hey—they'll wait.

They—the work crews, machines, and media—are, yes, waiting. Rock anchors, 165 of them, have been set—long, tensioned three-inch-diameter steel rods lanced and grouted eighty feet deep into 120-ton bedrock—and twelve hundred cubic yards and more of concrete have been poured over curving rebar cages, forming a part of the four-foot-thick shear walls that'll define the Freedom Tower's perimeter and help bear the load as the structure itself climbs, column by column, 1,776 feet into the blue. The climb starts here, in a sixteen-acre pit seventy feet below street level, in the northwest quadrant of the Manhattan plain where, once, the World Trade Center stood.

The climbing, in fact, starts this morning, when George Pataki arrives, at last, after five years and three months of empty promises and endless posturing, of milking mass murder for the sake of politics, of multibillion-dollar real estate hardball, engineering savvy, and knuckle-busting work—and, above all, after five years and three months of stunning stupidity.

It was never going to be a quick and easy job. Even before Pataki picked a rebuilding plan drawn up by an architect who'd never built a building taller than four stories, a plan that placed the tallest building on the site at its toughest spot to build on and put it so close to an eight-lane highway that the NYPD insisted that it be moved and redesigned for safety's sake, wasting another year; even before Pataki, wanting a legacy, named it Freedom Tower—the NYPD just loved that—and before deciding that it, not a memorial, would be the first thing built at ground zero, and before vowing that it would be topped off by September 11, 2006. Even before all that, it was going to be a slog. Because that's how a superskyscraper

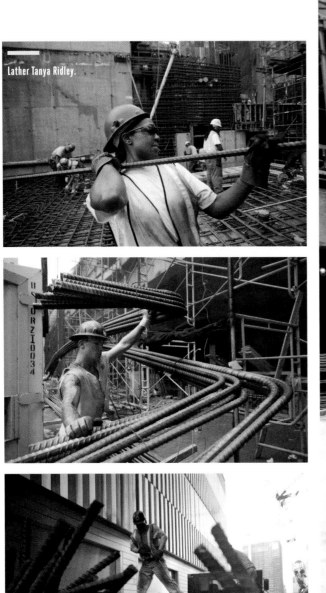

Lather Tanya Ridley.

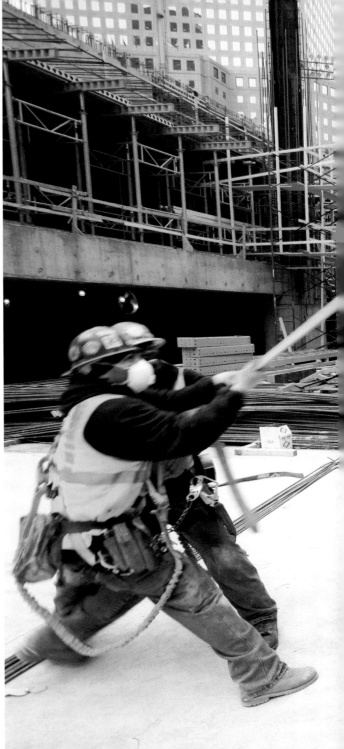

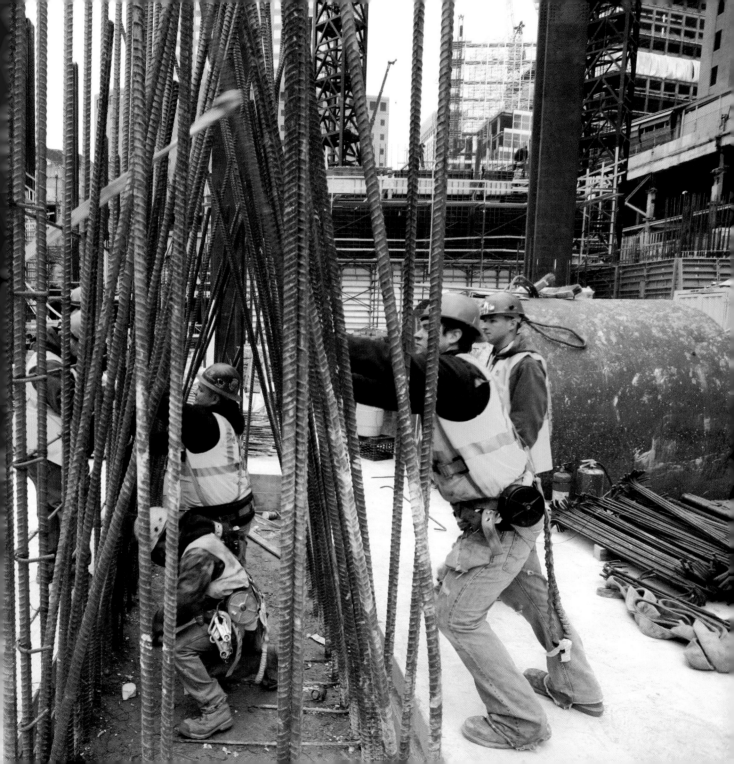

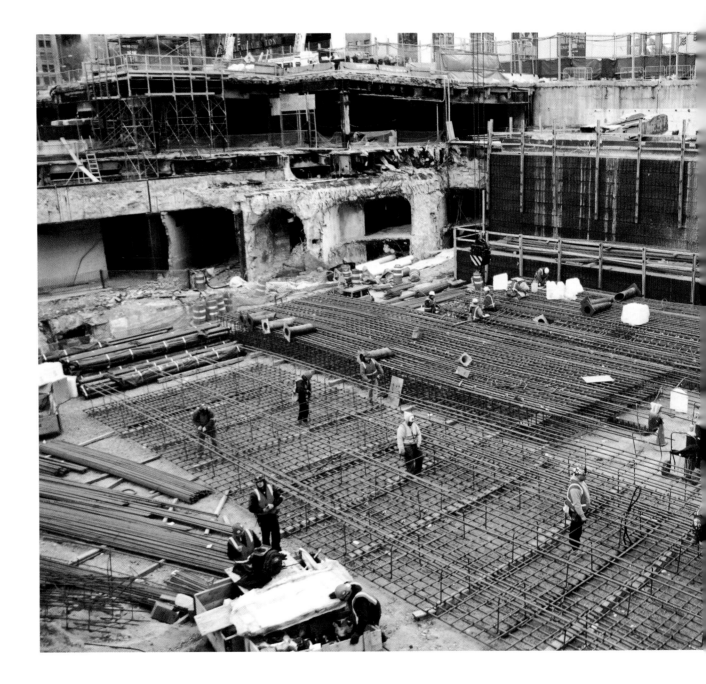

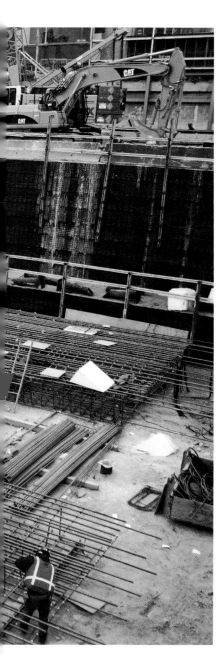

gets designed, engineered, and built under the best circumstances: slowly, precisely, one step at a time.

And that's why today truly is so special: Today, they're planting Freedom Tower steel.

Ground zero has seen few special days since 9/11, and those few have been mainly sad. The yearly anniversaries, when the roll of the dead is read aloud and bells toll to mark the minutes when the jets struck the Twin Towers—and again to mark their separate falls to earth—are heartbreaking. But days like this—when the politicians and cameras return to the empty pit for yet another hollow milestone, and the governor gives the same stale speech, and the memory of 9/11 and the inch by inch and day by day of rebuilding are buried ever deeper beneath a sour crust of cynical, jingo-fueled, pandering dung—days like today tend to be worse, the crib-smothering of hope.

Not today. The wind is whipping, but old Sol has cleared the Woolworth Building, and the chilly air is bright. A brigade of brown-hatted ironworkers is waiting, which says something's going

up. And, best of all, the soaring four-hundred-ton crane is on the Freedom Tower job, and as Bobby the Teamster says, "Till the crane's on the job, it's not a job."

At ground zero, it's a job just getting the crane to the job. Access to the pit is a sloping 460-foot bridge; the crane's forty-two-ton car body alone, without its mammoth treads and its stacks of solid steel counterweights, exceeds the bridge's weight limit. It took a dozen flatbeds—one at a time—to truck the crane into the pit, five of them just to carry sections of the soaring red boom.

But today the crane—like everything else down here: the concrete, crews, and cameras, the governor himself—is a bit player. Three plated steel columns, painted white, at rest on planking, massive, hulking, sitting side by side—*they're* the stars. Two of them are covered with signatures; the third, with an American-flag decal atop the words FREEDOM TOWER—all in huge block capitals running down its length—is waiting for its close-up with the guv.

Brian Lyons has waited a long time

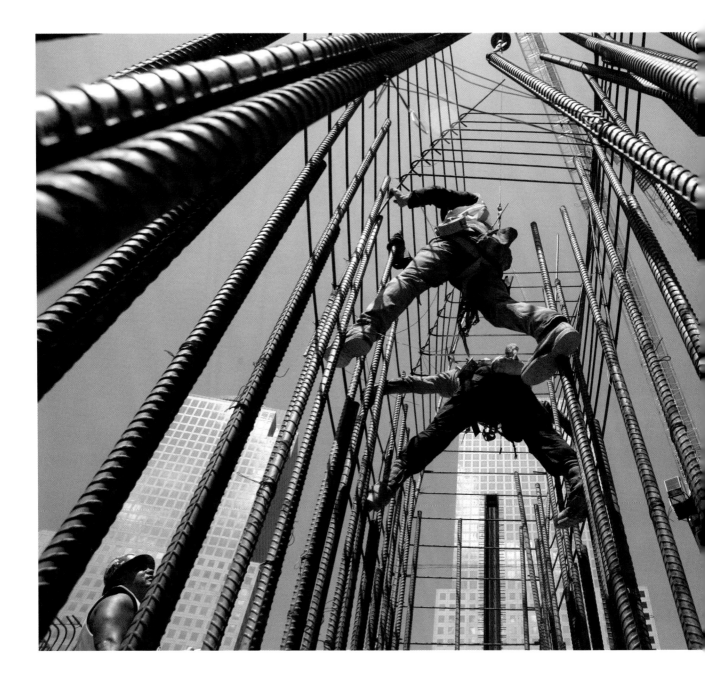

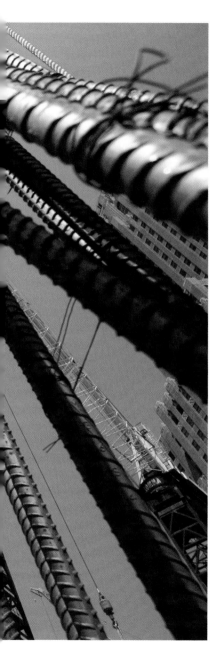

for these columns to arrive. A construction superintendent for the tower's general contractor, Lyons came down to ground zero on 9/11 to look for his brother Michael, a firefighter working out of the Bronx. He found all that remained of his brother's company—their tools—on St. Patrick's Day 2002. He has worked here ever since. A flint-faced, no-bull guy, pushing fifty, with three daughters and two young nieces without a daddy.

"When these beams arrived," Lyons says, "it got to me. It took me like half a day, and then I started to fuckin' break down—'cuz I was here when we took that last beam out, and now I'm here for this, the first beam goin' up—one step closer to gettin' to the top. The world's watchin' this job, especially when this beam goes up. When steel starts growin' outta the ground, it's nice."

Steel springing from the earth itself is not a far-fetched trope. Steel starts as iron ore, rock-plentiful, easy to refine, and thus the most essential element in the evolution of *Homo sapiens* as a tool-using, city-building, sky-climbing bunch of baboons. Iron ore + fire = life

as most of us live it, which is why the universal measure of a civilized people emerging across eons is an Iron Age—and both why and how ground zero will rise again. Acts of building—putting fire to iron ore—are as much a part of our human nature as growing grain. Putting fire to iron is what we do.

And it sure as hell is loud. Where the Freedom Tower beams were cast and rolled, at the Arcelor mill in Luxembourg, in the town of Differdange, they've turned iron to steel for more than a hundred years, and the choir of demonic noise—even with earplugs—and the dust and heat and smoke make it feel like a thousand. It is a roaring aural undulation, a slow oceanic swelling so vast and relentless that chords seem to form and vanish like ghosts.

All of which is music to the ears of Lambert Schmit. Schmit's fifty-three years old and has worked at Arcelor for half his life, as did his father and grandfather. He managed the Differdange mill for seven years; now, he says, he is a communications officer. At six four, he has the long stride and narrow squint of a cowpoke.

"My grandfozzer was smaller," Schmit says, "but my fozzer was very tall. Zere are many big people around 'ere."

It's a landscape fit for giants. In the prep yard, the overhead crane operator, peering straight down like a bombardier, dips his mammoth claw into mountains of metal, sorted by grade—pig iron, automotive scrap, shredded sheet steel: "Very full for ze moment," Schmit shouts. "Zere must be fifty thousand tons"—then loads a bucket, set on tracks, with a hundred tons. The full bucket groans into the mill, where it's capped by lowering what is essentially its roof—the whole becoming a vast electric arc furnace.

"You have no pacemaker or zing like zat?" Schmit asks.

No idle question: The direct-current electrodes inside the furnace pack the wallop of a lightning strike—thirty-five million watts. The accompanying scream—of steel being melted to magma at sixteen hundred degrees—has a certain terror to it, a quality of noise beyond all noise. Flames billow, flinging sparks in long trails, and the heat radiates even to the flight of stairs

up to the door of a command post where the furnace operator sits in an air-conditioned, pale-tiled room, surrounded on three sides by computers, his fitted earplugs dangling from a lanyard, listening to Eric Clapton on the radio.

"We just have a short look outside," says Schmit, smiling, stepping to a side door opening on the volcano, "to give you some impression. It will be quite hot."

Yo. Quite. Fucking. Hot.

Nowhere else does anyone roll the 730-pound-per-foot wide-flanged H beams—"jumbos," Arcelor calls them—that form the heart of the Freedom Tower columns. The liquefied scrap, analyzed and then refined in a second furnace, where alloys are added to bring it to the proper grade, is next poured and cast in a continuous molten stream, molded, water-cooled, and cut by oxygen torches into rough and glowing segments called "beam blanks"—embryonic beams—still throbbing at the core with heat.

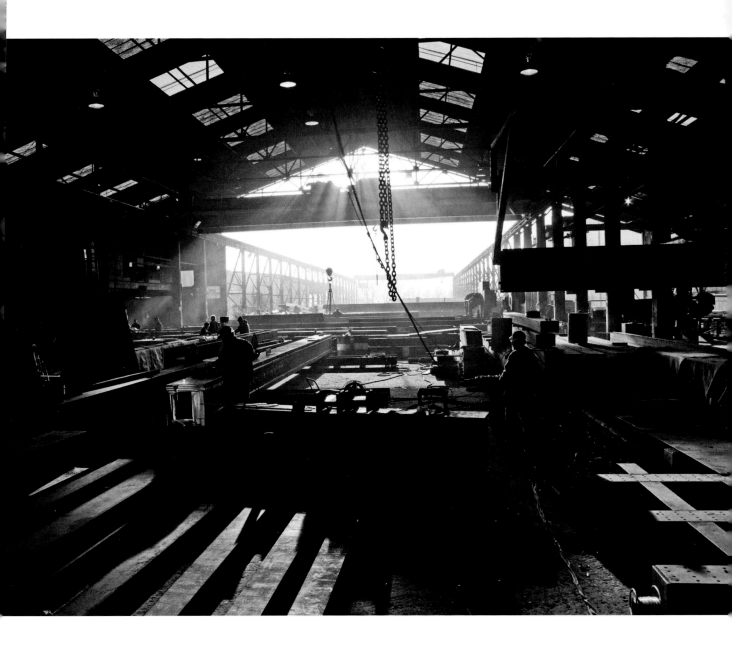

The rolling process shapes the cooling mass of steel to the customer's order. The blanks are squeezed—back and forth, over and over—thundering through sets of automatic rollers, incrementally thinning and lengthening the beam, deforming and recrystallizing the steel's molecular grain as the flanges, web, and chamber are shaved, pass by narrowing pass, slowly into being, giving the finished H beam its enormous tensile strength.

It is this rolling process and the H beams it produces that enable the erection of superstructures like the Freedom Tower. Once upon a time, they rolled them in the United States, at Bethlehem Steel and U.S. Steel. The titanic columns of the Twin Towers themselves were pieced out to smaller steelmakers across the USA when the Port Authority of New York and New Jersey—ground zero's owner, then and now—suspected that U.S. and Bethlehem had rigged their bids back in

The container ship *Atlantic Cartier* prepares to dock at Virginia Seaport after crossing the Atlantic from Rotterdam with the first pieces of steel for One World Trade Center.

the sixties. But American Big Steel is smaller now—hell, they're building a casino where the furnaces at Bethlehem once roared—and its profits come from minimills, not beasts like Differdange. So it's hard not to feel a pang looking at the *Arcelor Loves New York* poster in the office display case at the mill, with a photo of the Manhattan skyline marked by thirty thin lines leading from tall night-lit towers to the Arcelor logo.

"In New York," says Lambert Schmit, "there are a great number of buildings that have at least some of our product inside." Schmit visited the city once, in the spring of 2001.

"My girlfriend told me, 'Let's go to the tower restaurant'"—Windows on the World, on the 107th floor of the north Twin, where, in 1989, Brian Lyons popped the question to his wife. "We went up," Schmit says now, "but we did not have dinner zere."

Across the driveway from the mill entrance, there is a memorial, a bas-relief in bronze embedded in a mortared wall of stone: a muscular young steelworker, naked to the waist, his fists clenched at his sides, his visage baleful.

A row of names is carved into the stone on either side of him—thirty-three in all—conscripts, Schmit explains, seized by the Nazis during their occupation of Luxembourg and sent from their mill jobs to the Eastern Front to fight and die.

A separate plaque fixed to the base of the wall contains six names. *A La Memoire Des Heros De La Greve*, it reads, above *2 Septembre 1942*.

"You see," Schmit says, "on September the second, zere was an uprising. Ze Germans, zey wanted to exploit the works, and ze workers laid down. Zey stopped working. Zey tried to organize a work stop. Ze leaders"—the men named on the plaque—"zey were taken away and shot. Every year zey make a commemoration of this happening. It's still not forgotten."

After the first batch of Freedom Tower jumbos has been cast and rolled and cooled, Lambert Schmit and five younger Arcelor steelworkers in orange jumpsuits and white hard hats gather on the beams for a group photo. They're smiling, talking softly, looking shy and more than just a little proud.

Differdange to the Port of Antwerp is 130 miles or so, an hour-and-twenty-minute drive for a crazed Portuguese cabbie. The Freedom Tower steel—forty-eight beams in all, from thirty to fifty-six feet in length, weighing a total of eight hundred tons—takes the train. And though steel is king at Differdange, once at the port—fourth largest in the world, handling sixteen thousand ships a year—it's just another load on vessels hauling fifty-two thousand tons of shipping containers and break-bulk cargo. Pieced into four lots for the North Atlantic crossing, the beams await their passage to Virginia, where they'll be fabricated as columns—welded and plated, drilled and milled—before being trucked to ground zero.

Twelve jumbos, chained atop three wheeled trailers, are shipping on the Swedish-flagged *Atlantic Cartier*, a ship three football fields long, whose silver-bearded, pink-cheeked king is Captain Jonas Rahmberg, a burly, smiling son of Göteborg, sixty-two years old, wearing dark dress pants and four

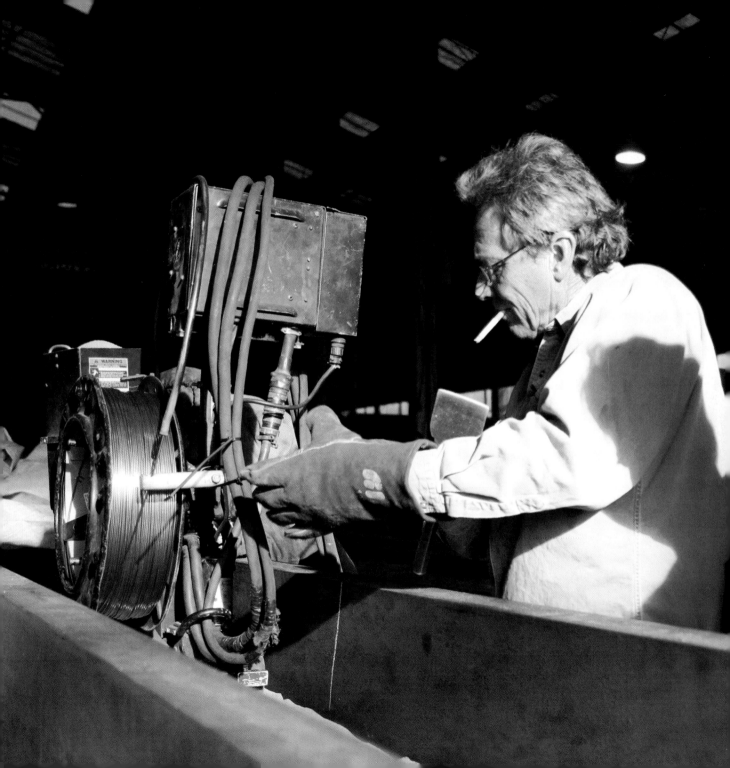

gold bars on the navy-blue epaulets of his pressed short-sleeved white shirt.

"No, no," Captain Jonas insists. "Twenty, thirty, forty years ago, I must agree, the captain was the king. He was, really. It's yoost an ordinary yob now, more or less. I'm the boss, but I'm not God."

Ah, but do you have a cook on board?

"Yah. One chief cook and one second cook."

And if you feel like an omelette or a ham-and-cheese at 3:00 a.m., you can simply call the cook?

"I can do it. But I don't do it. They start six o'clock, so I can wait. Then I got my egg and bacon."

The captain's quarters are way up on the tenth deck, with plenty of wood and windows, a model of his ship under glass atop a low bookcase, a Jack Daniel's desk organizer—much of his yob is paperwork—and a regal view north along the River Scheldt, which links the Port of Antwerp to the North Sea.

Cap has been at sea for forty-two years now, twenty as commanding

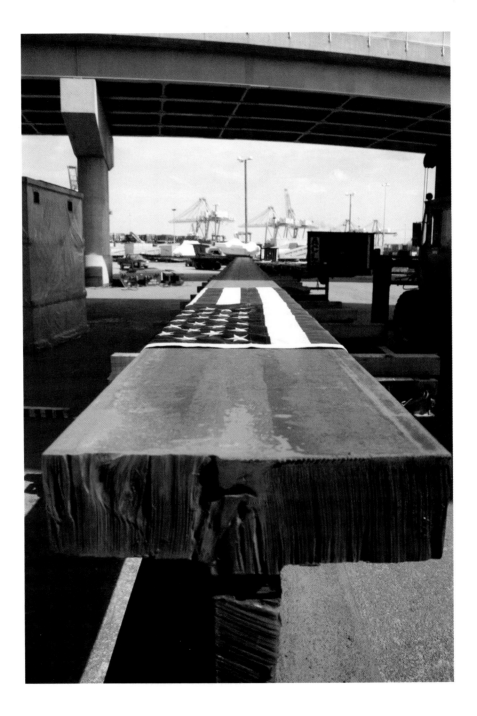

officer, the past fifteen at the helm of the *Cartier*.

"I have a crew of twenty-five. We are four Swedish and twenty-one Filipinos, the junior officers and crew, very nice guys. It's always the same boat and the same route—from here to Liverpool, then Halifax, then down to New York, Baltimore, and Portsmouth, Virginia. One trip is five weeks, and we have twelve to thirteen ports in that time, so we have one port every day and then six days crossing each way. I work five weeks and then I'm home five weeks. That means, if you turn it around, I'm away half the year from home. So you need to have a good wife."

The *Atlantic Cartier* has plied the open sea since 1985—an "old lady," Rahmberg calls her, and she's relatively slow. "Seventeen, eighteen knots. The new Maersk lines, probably they making twenty-five knots. But we have 30,000 horsepower. They have 130,000, plus they burn much more oil, too. It's a good ship. Some ships are shaking like hell, but this one is good."

One seven-hour shift in port, time enough for the straddle carriers and gantry cranes to load two thousand containers on board and for the crew of mighty stevedores to lash down the three enclosed belowdecks full of mixed roll-on-roll-off cargo—including a helicopter, two forty-eight-foot yachts, a gleaming phalanx of Volvo SUVs, a vintage Caprice Classic sporting New Jersey plates, and three trailers of Freedom Tower steel swallowed up like plankton—and Cappy and the *Cartier* are set to sail to Liverpool.

"It's not like you go to work eight o'clock in the morning and home five o'clock again," he says. "You're not locked in one place. It's a free life. It's never the same. After forty years, you don't know anything. The best thing is to be at sea."

Four days after the *Cartier* left Antwerp, New York City marked the fifth anniversary of 9/11. The *New York Times* devoted an entire section to nineteen thousand words of heavy breathing called "The Hole in the City's Heart." Irish tenor Ronan Tynan, whose endless version of "God

Bless America" has turned the seventh-inning stretch at Yankee Stadium into a shrill and absurd travesty, serenaded Laura and George W. Bush with "Be Still My Soul" at St. Paul's Chapel; across the street from ground zero, the 240-year-old stone church somehow was spared when the towers collapsed, and it has done duty as a 9/11 shrine ever since. Then our president paid the mandatory "surprise" call on a firehouse nearby, where he vowed, in case any of us doubted it, never to "forget the lessons of that day."

Bush spoke in front of a bronze bas-relief mural much larger than the one in Differdange—fifty-six feet long, covering the outer west wall of the firehouse, showing forty-six firefighters responding to the burning towers. Below are listed all 343 FDNY active-duty members who died on 9/11.

DEDICATED TO THOSE WHO FELL AND THOSE WHO CARRY ON, it reads, in large block letters on either side of the blazing Twins. MAY WE NEVER FORGET.

And the front page of the *Daily News* contained a single word: "RE-MEMBER."

It's puzzling, as if one lesson of 9/11 might be that it is necessary, five years later, to be reminded to remember 9/11. As if five years were enough just to list all the lessons of that day, much less absorb their fury, grief, and wisdom. As if those lessons were revealed already, done with their unfolding. As if ground zero, the sixteen-acre maw just across Liberty Street, had swallowed itself up, along with the politicians and journalists whose business it has become to hammer home the lessons of 9/11, over and over and over, and to tell us how our hearts still hurt.

As if we had forgotten, as if the horror and pain of 9/11 required refreshment, not long after the fifth anniversary, crews excavating street-level

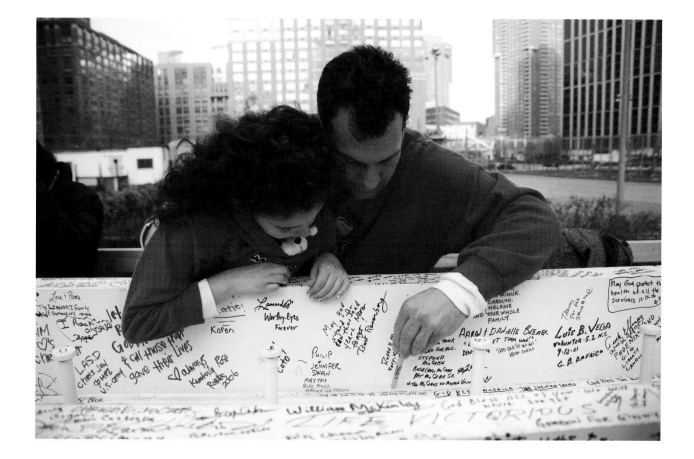

manholes along the west side of ground zero began finding human remains—arm, rib, and leg bones among them—that had been missed in, or buried by, the original seven-month recovery effort.

The elemental lesson of this news—that each inch of our planet is, has been, and always will be an abattoir, with or without a bas-relief memorial—went unnoted in the ensuing uproar, which centered mainly on which callous, heartless son of a bitch or incompetent, unfeeling government agency was to blame for not having sifted more thoroughly through every scoop of soil at and around ground zero. Old outrages—claims that Mayor Giuliani had wrested control of the cleanup away from the fire department and turned it into a scoop-and-dump job, knowing that such haste risked mutilating undiscovered FDNY corpses—merged with new charges that hundreds of thousands of tons of Trade Center debris carted from ground zero to Fresh Kills, an unfortunately named Staten Island landfill, where it was supposed to be combed for remains, had not

been properly searched, and thus DNA evidence that might have helped ID the Trade Center dead wound up being used by the city to fill potholes and pave roads.

Several of the dozens of survivors' groups that formed in the wake of 9/11 demanded a halt to all ground zero work so that the site could be searched again—this time by the military's Joint POW/MIA Accounting Command. No and no, said New York City. The city would search again, using city resources, and construction at ground zero would proceed.

Considering that the remains of 40 percent of 9/11's 2,749 victims have never been identified; that seven hundred–plus human fragments have turned up atop a forty-story tower across the street from ground zero, along with more than five hundred, so far, from the city's ongoing second search, and that not one of any of these has yet led to a new DNA match; that the very process of rebuilding unearthed the hidden bones; that if Rudy Giuliani hadn't taken command of the recovery, firefighters would likely still

be poking through the original debris pile for unvaporized shreds of their fallen brethren; that rebuilding the World Trade Center site is better for the city than leaving it a pit—considering all these things, and considering that remembrance of that day and of its dead does not *require* endless tantrum and vilification, on balance, the city's position seemed quite sane.

Of course, considering that this is New York City, where foaming outrage is mother's milk and people have argued for years already over how the names of the 9/11 victims should be listed at a ground zero memorial that doesn't exist, nobody was surprised when the city's decision to keep building was greeted with protest rallies and the traditional filing of lawsuits.

Brian Lyons, a sane man who knows as well as anyone that ground zero is forever both a burial ground and a workplace, doesn't mince words.

"The stuff at the dump—that's not a good thing. They could dig that dirt up, go to a nice farm, bury it all, put headstones up or somethin', a little memorial. Say, 'These are the remains that were gone through, removed from Fresh Kills, and now they sit on a beautiful apple farm in fuckin' upstate New York.' I dunno. I think that'd help. It's in a garbage dump in Staten Island. There's a lotta people upset about that. Y'know, Vito fuckin' Bazzagaloot, he might be there somewhere—you know what I'm sayin'? *Those* are the guys that belong over there."

A little memorial—that would be nice. Hell, *any* memorial would be nice. We don't build memorials because we'll forget; we build them because we *can't* forget, because we need some place outside ourselves to put the hurt.

As for the pit, the power of the human need to fetishize the dead may be one of 9/11's subtler ongoing lessons, but it's not going to trump the need to rebuild—not on sixteen acres of the most precious real estate on earth, and surely not with billions of bucks to be spent and made.

That's 9/11 lesson number one: Every living civilization plants its feet on someone else's bones, remembered or forgotten. Also, lesson 1-A: Money talks.

When the *Atlantic Cartier* reaches Portsmouth, an FBI detail and a National Geographic TV crew are waiting, here to film a segment about port security.

"All kinds of visitors today, Cap," the container-line operations manager says, up in the captain's quarters.

"They're looking around," Cap says. "They do their yob."

"Leaving this afternoon for New York City?"

"Yah. Two o'clock. Then we leave for Halifax and home again."

"You play any golf?"

"Yah, but not so much as I want."

Just then, the lead FBI agent—with his shaved head and full mustache, he could be G. Gordon Liddy's son—pops in.

"Thank you for having us aboard, sir," he says firmly and soberly. "You and your crew are our eyes and ears, and we rely on what you tell us, and if you'd be so kind as to have an ear to the wall, so to speak—a vigilant eye and a vigilant ear—we'd greatly appreciate it. And I can't say that enough or mean that enough."

"It's okay for me, too," says Cap. "I think all seamen around the world can help you a lot. We're willing to help. That's for sure."

"We appreciate it, Captain," says young Liddy.

The film crew is nowhere to be seen, but another visitor—some putz with a digital camera—takes a picture of the agent with Cap.

Liddy's dark eyes narrow. "I ask one thing, sir," he says. "I don't have a problem with you snapping my photo. Just make sure it does not hit any print media in any way, shape, or form. For personal use, I have no problem with it."

The putz apologizes.

"That's okay," says Liddy, who suddenly seems to have acquired a New Jersey accent. "Believe me, if I thought you were a threat, we'd have a different conversation in a different building."

"It's another world now, that's for sure," Cappy says after Agent Liddy leaves. "If it's bad or good, I don't know. All the safety—it can be too much sometimes with paperwork. You don't need

to love it, but you have to live with it. So what? That's life."

＊＊＊＊＊＊＊＊＊

On the day Captain Jonas and the *Atlantic Cartier* docked at Portsmouth, the Port Authority of New York and New Jersey officially declared the end of its five-year, scorched-earth war against Larry Silverstein, the real estate developer who leased the World Trade Center from the PA seven weeks before 9/11 and who had battled the Port and Pataki ever since to rebuild ground zero.

It was never a fair fight. On one side, you had a three-term governor tag-teaming with the Port Authority, which owns and profits from every major bridge, tunnel, and airport in the New York City metro area, issues its own bonds, and skulks behind a wall of Stalinist bureaucracy—massed to obliterate a Brooklyn-born septuagenarian who had made his bones and his first fortune by buying, burnishing, and flipping distressed office buildings.

For five years, Silverstein paid the Port Authority $10 million monthly rent on the pit, fought the insurance companies on his own dime, and battled Pataki over his harebrained rebuilding scheme. The Port and state wouldn't buy out his ninety-nine-year, $3.2 billion lease and couldn't legally force him out, so the PA, hoping he'd go bust, bled him while Pataki blamed him publicly for the rebuilding delay. And when none of that worked, the governor resorted to the blood libel—Larry was betraying the memory of the 9/11 dead—and in so doing, helped affirm 9/11's most costly lesson: From the Hudson to the Tigris—whatever treasure, truth, and blood it costs—wielding national tragedy as a blunt political weapon is hunkydory.

It was ugly stuff, but it made plain that the war to rebuild ground zero wasn't, and never had been, about honoring the memory of 9/11 or recapturing the skyline or standing up to terrorism—all of the bullshit spouted so relentlessly that it finally became impossible for many New Yorkers to feel any sense of connection to rebuilding ground zero. It was about money and power. And power and money. Not to mention money and power.

In the end, there was no contest: Larry Silverstein kicked Pataki's ass and the Port Authority's. When the dust cleared, Larry retained the rights to rebuild three office towers on the choicest spots at ground zero, while the PA wound up holding the bag that held the lame-duck governor's Freedom Tower—now scheduled for topping off in 2011—a 2.6-million-square-foot cipher that Pataki's sure successor, Eliot Spitzer, was referring to as a white elephant during his campaign.

For the PA, that was actually good news. The bad news was that they hadn't built a skyscraper in almost forty years—not since the Twin Towers. The dog had caught the car. Now it just had to figure out what the hell to do with it.

The first step was a marketing masterstroke: The Port Authority chairman announced that under no circumstances would the PA ask its own employees to work in the Freedom Tower.

The second step was restoring public confidence, which was quickly accomplished when the PA told Pataki that unless the governor started finding Freedom Tower tenants himself,

the Port likely could not afford to finish building his 1,776-foot crown jewel.

For the Silverstein Properties executives who had worked for three years on the tower, the handoff was not without trauma. "It's like seeing your beautiful young daughter turned out as a coke whore," said one. For the Freedom Tower architects, who had created a design for the tallest and most symbolic building in America and who now were suddenly partners with a club-footed government agency specializing in bridges and tunnels, it was a marriage forged in hellfire.

Four days after the PA took full command of the Freedom Tower, an official white Dodge Caravan with yellow lights on top and a load of Port brass inside rode to Kearny, New Jersey, where a two-story mock-up of the tower stood, built so that the architects could see how various glass samples reflected light. The team of architects had been chauffeured from the city in a fleet of Lincoln Town Cars, a half dozen of which were parked on the gravel, waiting for the return trip, when the PA pulled up in its minivan.

"I think," said one of the architects, "this is the sign of things to come."

It's slow, turning beams into plated columns. You have to cold-saw the steel to length and bevel the edges of the beam, then weld six-inch-thick steel plates—twice. First you tack-weld them, to hold the plates on the beam until you can reheat the beam to three hundred degrees with a gas blowtorch called a rosebud, and then you use submerged arc welding to bond the plates to the beam for good and, God willing, ever. Then you mill both column ends to flush planes of such gleaming beauty and polished perfection that you could, without the slightest stretch, call the finished column art.

Were you actually to call it that, though, the Port Authority's inspector here at Banker Steel in Lynchburg, Virginia, would set you ramrod straight.

"That's not done for aesthetics," he says. "That's done for engineering purposes. They mill the end so they are as close to absolutely flat and straight and flush as a human can make 'em. These people are doing very precise work on a *large*, *huge* component. You don't just guess at it. They have drawings. They're not winging this thing at all."

There's more to it, of course—always—attaching lifting tabs for the crane and long studs that help anchor the column in the concrete footing and hole-drilling for the splice plates that will let the ground zero crews attach more columns as the Freedom Tower below-grade foundation rises to street level. And one more thing: "Some of these will get a coat of special paint. Normally they wouldn't, but there's supposed to be some sort of ceremony up in New York."

Yes, indeedy. And Banker Steel is under peculiar pressure, particularly Don Banker, who owns the joint. Part of it is the calendar: Pataki has an '08 presidential pipe dream, and his entire legacy and platform is an unbuilt building—so he's downright desperate for a last photo op with at least one upright piece of Freedom Tower steel. As of today, Banker has less than three weeks to deliver, and the tower's general contractor is busting Don's chops daily.

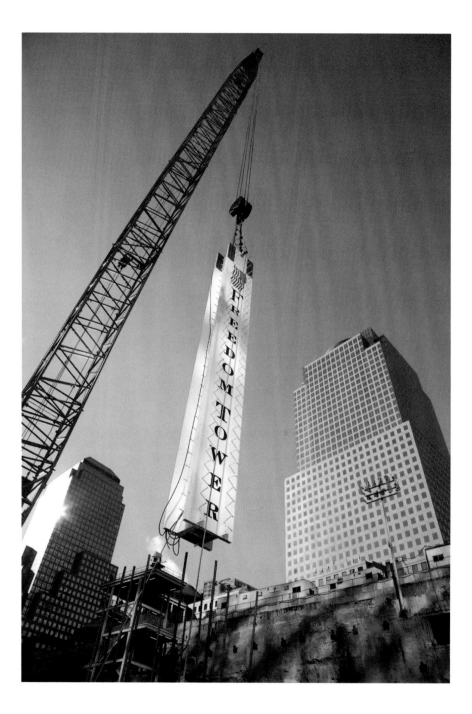

Which fazes Don Banker not at all.

"They're all just as nervous as they could be," Don says, grinning. "We even got an e-mail last night: One of the guys was lookin' for some minute-by-minute step of exactly where we are."

Banker has been in the business for most of his life, and like steel men from Luxembourg to Lynchburg and from Bethlehem to Bremen, he doesn't faze easy. He's a trim, tie-knotted fifty, and with his drawl, his Boy Scout smile, and his square forehead, he could pass for a televangelist, but he's no hickish naif. His shop is doing the steel for the new Goldman Sachs tower, one block west of ground zero, alongside the Freedom Tower job, and he pilots his own jet to Teterboro Airport in north Jersey when he needs to look after Banker Steel's interests in the big city.

Don's problem isn't dealing with the general contractor or getting his columns to the pit on time; his problem is that he has a strong sense of history. And of patriotism. And of what a powerful thing a piece of steel can be, literally *and* spiritually. Banker Steel is fabricating the Freedom Tower columns in the same shop that Montague-Betts once operated, and back in the day, M-B provided twenty-five thousand tons of the steel used for the old Twin Towers. Lynchburg's still proud of that—and proud to be a part of the Freedom Tower.

"This is *soul*," Don says, his voice rising. "This is so important to our *country*. It's not *just* about New York City."

He's right, of course, but Don has also made the mistake—unlike Pataki and his Port Authority surrogates—of acting like words mean something. He wants to let the citizens of Lynchburg sign one of the Freedom Tower columns before it leaves Lynchburg to head north to the pit. In ink.

The Port Authority and the governor's people are having none of any such nonsense, and they told Don so during a conference call a few days ago. He tried explaining about the letters the elementary school kids sent him when they read in the paper about the new beams, and he tried to tell them about the old Montague-Betts welder who belongs to Don's church.

"Jack Moreland," Don says now.

"Just a scrawny little four-foot-tall guy. He said, 'Don, I welded on those first ones. I *got* to sign that beam. You've *got* to let me get in there to sign that thing.'"

No dice.

"They pretty much stopped my conversation. They said, 'You need to clear *everything* through us.' And they haven't paid us a dime. Our September invoice has not been paid yet, and it's gonna be December Friday. They owe us considerably—well, the September invoice was a million bucks, and they owe us a lot more since then."

But Don Banker's not the sort of guy who'd miss a delivery date at ground zero.

"We'll be there when we're needed," he says. "Trust me. We'll be there."

He smiles his Boy Scout smile.

"And our beams will have signatures all over them."

Sure enough: When those first three white-coated Freedom Tower columns head north to New York City, one of them—the one Don trucked over to Lynchburg's minor-league ballpark on a bright December Saturday for the public to write their words of love, hope, and

9/11 remembrance—has ol' Jack Moreland's signature scrawled on it. Along with thirteen thousand or so other folks'.

The columns got to New York City in plenty of time, and the Port Authority held a little Sunday-morning signing of its own, two days before the ceremony in the pit. They laid out a column on a flag-draped pine platform jury-rigged on a patch of gravel not far from ground zero, and they announced that for the first three hours, only family members of the 9/11 victims could sign it.

This had nothing to do with crowd control, much less the privacy and dignity of personal grief—after five fruitless years, your average New Yorker wasn't going to storm downtown to sign a piece of steel—and everything to do with 9/11's unhappiest lesson: Grief has no end. No "meaning." No "lessons." It is always personal, even in a human slaughterhouse and crucible like ground zero.

Death lives in all of us—in life's very heart, and in our own—inseparable from everything and everyone we love.

And death, unforgettable, turns love to grief as surely as fire burns iron to steel.

And so they came downtown—the press, Pataki, and a few hundred mourners—and signed the second Freedom Tower column.

"God bless America," wrote Pataki. "We will never forget."

The family members had much more to say, of course, and many pasted photos of their loved ones on the painted steel. "Amazing in life," one young widow wrote next to a picture of her husband. "More powerful in death. I thank you for having been a part of your life and I thank God for our children. . . . The beams have become a way of life for me. . . . It is all about structure and support. I have all of that thanks to you. . . ."

The governor hits the floor of the pit in full "God bless you" mode, shaking hands with every construction worker he can get his hands on while the crane operator sits in his cab, still reading this morning's *Post*. It's not his party, it's his workday, and he's not lifting a legacy or a metaphor; he's lifting steel. Dozens of Port Authority personnel clump and mingle, shaking hands and grinning like chimps while the erection super—he brought the columns into the pit—shakes his head.

"Oh, they're a pain in the ass," he fumes. "Yesterday we had a little problem here—I'm talkin' 'bout a problem so small—and twenty-five of 'em were standin' here. I said, 'Please, guys—go away. Please. You go away and the problem will go away.'

"Myself and another guy, we were the ones that were the first crane that got here after 9/11. When they told me my company got the job, they said, 'You're gonna get the first crane here.' I took the first piece of steel off this site, and now here I am—I got the first piece of steel comin' in.'"

The television camera crews are perched on an old existing slab from the original World Trade Center, four vestigial stories up, but it looks like every man jack down here brought a camera of his own for the raising of the column. They part like the Red Sea for the parade of suits just behind the

governor heading for the ceremonial column—the mayor, the PA chairman, a couple of architects, Larry Silverstein, and, in a thick pack, a bunch of union officials in shiny orange hard hats, looking like *Sopranos* extras.

Carmine Castellano, the ground zero super for the general contractor, doesn't have his camera. He's busy running the whole show down here, like always, but he's making his own speech to no one in particular.

"I'm pretty excited about today. Today's a big day in the history of America. All the unions, the guys have a lotta pride in what they're doin' today, and my thing is, we're not buildin' *a* buildin', we're buildin' *the* buildin'. It stands for America. It's a long time comin'. And I've been here from the inception, and I'm pretty excited."

Carmine's gotten so good at this speech—better by far than Pataki is at his—that he doesn't drop a single f-bomb. And he *is* excited; you can hear it in his sawmill Jersey drone.

Truth is, you'd have to be half-dead—or some kind of Islamofascist evildoer—*not* to feel at least a touch giddy and more than a little moved. Here is where the Twin Towers stood on 9/11, under the same indifferent sky, in a world that felt entirely different then. Here is where time stopped for all time—and where grieving began—for thousands of hearts.

And here, if the posing and the signing ever stops, a piece of steel is going up.

⁂

And up it goes, just like that, easy as pie. The big crane's engine starts belching, and folks just . . . slowly . . . back . . . away, agape. Even the plain-clothes security guys with the earpieces and the bulging double-breasted top-coats look up, frozen, openmouthed, as the big boom starts swinging and slowly drops the double-looped cable to where the crew of ironworkers can grab it and hook up the column.

Fifty thousand pounds of steel are suddenly chiffon, rising with no more effort than a Frenchman's pinkie. Damned if the operator's not styling, too: Once he has that column straight up and down, he pauses right there,

hanging it for the cameras on their perch to get their glory shot of the whole thing floating in the sky, with FREEDOM TOWER running down the narrow column face, just below the Old Glory decal, which is vertical now that the steel is up, its stripes fluttering downward to the *F*.

Slow and smooth, the column seems to glide over to where its footing waits, and the Local 40 brown hats, their guide ropes threaded through it, top and bottom, ease it gently down. Down past the sprouting rebar, down atop the metal base plate, down at the bottom of a pit that will never again be nothing but the bottom of a pit.

"Don't scratch the paint," someone shouts as they wrench the lug bolts tight, and there's a ripple of laughter, but when they finish bolting down the column, ground zero explodes with applause and whistling for a full half minute.

"*Free*-standin'," Carmine bellows as the ironworkers unhook the cable and the boom lifts off. "That's it, brother. Awright. It's up." Followed by more cheering.

"Nobody push it, please," Carmine says. "Nobody go push it."

"I think it's leanin' already," someone shouts. "Another good job, Carmine."

"It's out an eighth of an inch," Carmine says. "Who shot those bolts?"

He's kidding, thank goodness. What he doesn't know is that the first order of business tomorrow morning will be scraping that flag decal off. According to the official United States Flag Code, the stars must be on the left, which they were when the crew put it on horizontally, but with the column standing up, the stars are on the right. Odds are, Carmine will fling a few f-bombs when he finds that out, and who can blame him for that?

By the time the second column goes vertical a few minutes later, the dignitaries are already up by the TV cameras, their backs turned to ground zero, holding a press conference. It's 11:54 a.m., almost time for the lunch truck to come trundling down the ramp.

Spring's first robin came a few months later, with a hacking cough but still red of breast. By then, the first columns were topped with a second tier, and Governor Spitzer had proffered a faint blessing: "This should not be interpreted to mean . . . that this is how I would have desired it to be built," he said and immediately raised the possibility that the Port could lease or sell the tower to a private developer. On the upside, he also promised he wouldn't call a press conference "every time a brick is added to the foundation or a column goes up."

The Port Authority, meanwhile, granted me an official interview for the first and only time in two years.

"As I sit here today talking to you," said the Port chairman, "it's full steam ahead on the original plan. At the same time that we're working feverishly and Carmine is in the pit laying steel columns, there's a hundred other guys, who have names other than Carmine, who are basically trying to find a way to make the numbers work, so that financially, when Carmine gets to grade, we can just keep going and don't have to stop."

In April, the city began to tear up West Street, the eight-lane highway just west of ground zero, searching for more remains of the godforsaken day the Twin Towers fell.

The father of the Freedom Tower, George Pataki, simply fell off the earth's face. Before leaving office, he hired a former Bush and Cheney aide to raise money for his political action committee, the "21st-Century Freedom PAC," and then he faded to gray, leaving behind not even a bas-relief.

And the Port Authority—already a billion over budget on the tower and panting hard to find some private-sector partner with deep pockets and a masochistic bent—has quietly renamed the thing. Hello, One World Trade Center. Farewell, Freedom Tower.

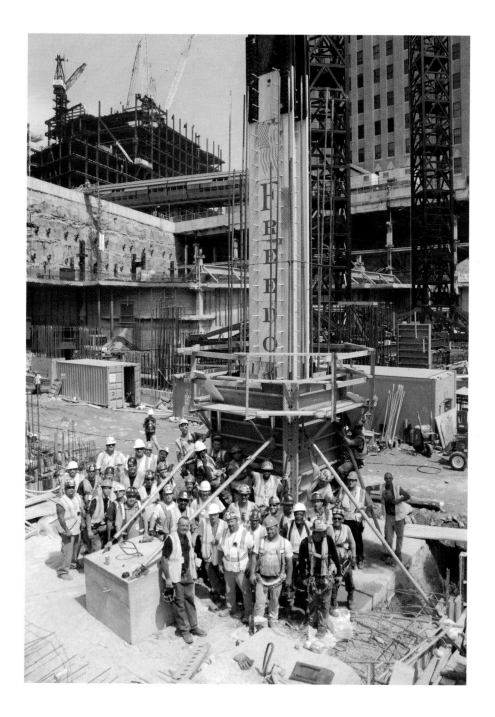

OF TIME AND THE
FREEDOM TOWER

OCTOBER 2008

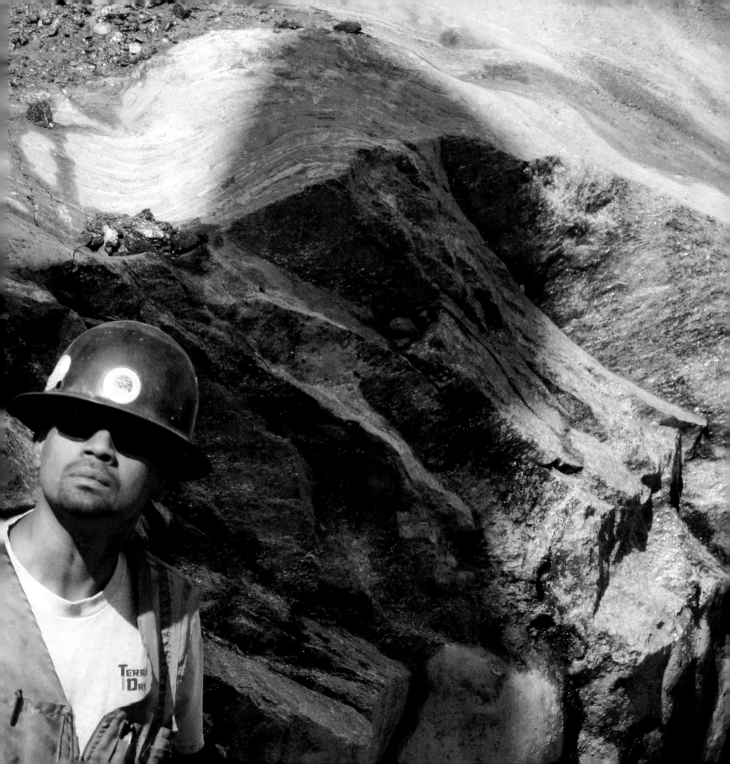

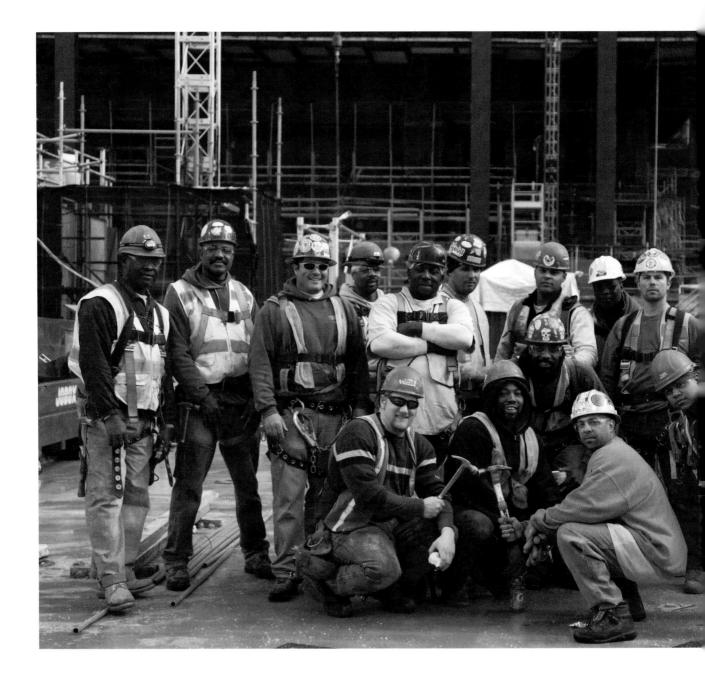

On the morning of September 11, 2001, I was bickering with the wife over an article in the "Health" section of the *New York Times* about babies choking on food, going back and forth about grapes. Judah, our son, was two years old.

My position was, as always, utterly clear: No whole grapes. *Ever.* Lisa's was murky: As the grape-cutter, she cut if she felt like it. I found this intolerable. She found my rigidity and catastrophism oppressive, regardless of the *Times*'s wisdom and advice: Cut the grapes in half.

It wasn't about grapes, of course. It never is. It was about power at the sub-grassroots—about who calls the shots. All politics is local. Domestic, even. Petty as hell, both ways. It gets loud. It gets ugly. Even over grapes.

When the phone rang, it was Mrs. Field, who lived in the big house diagonally behind ours. She and Mr. Field—Isabel and Hank, Brooklyn natives who'd immigrated the twenty miles to Glen Ridge, New Jersey, sixty years before to raise their family—were more than neighbors and friends: They were our boy's babysitters and his surrogate grandparents. Nice, nice folks, smart and sharp and funny the way people around New York City are. You can say that's parochial or clichéd or phony— I don't give a damn, because it's true. The slow and lame and halt don't come or stay here, not often or for long.

Anyway, Isabel told us to turn on the TV: The World Trade Center towers were on fire. By then, both planes had hit. In a few minutes, we saw Tower Two fall. Then Tower One. All gone. Fucking *gone*. Just like that.

We took Judah and drove to West Orange, to Eagle Rock, where we could see the skyline of Manhattan spread out, and we watched the twin pillars of smoke fill the sky, not twenty miles east of where we stood.

I don't recall how long we stayed, don't recall a word we said, if one or both of us wept, or if we even spoke at all—no memory of that. We just stood watching, scared unto numb, as the horizon turned to soot and vapor. Otherwise, an empty, silent sky.

When we got home, I tried to call my friends in the city. I couldn't get through. But even as a catastrophist—

raised in Cleveland by Jewish immigrants filled with fears—I knew that most of my pals worked in Midtown, and I knew no one who lived near or worked at the World Trade Center.

I didn't know yet what the Colls, who lived next to the Fields and had two little kids, had lost. Robert Coll, the dad, worked at Euro Brokers, up on the eighty-fourth floor of Tower Two—the South Tower—and died that day. He died because he stopped on his way down—down the one stairway that led to safety—because a fat lady who was huffing and puffing her way *up* warned that that stairway was impassable.

She was dead wrong, but how could Bobby Coll know that? So he helped her struggle up the stairs, and forever left his two-year-old daughter and ten-month-old son and his young wife. He was thirty-five years old.

In a few months, the Colls were gone, their house sold. Robert Coll is one of seven names engraved on a stone in a small square of green near the stairs that go down to the New York City–bound track at the Glen Ridge train station.

Hank Field died a few years ago, so Isabel moved to South Jersey to be close to one of her kids. Our son—God bless him—just turned nine. Which means Lisa and I don't bicker about grapes these days; we bicker about which pizza joint can deliver the pie in time for Judah to eat before his game.

We'll be dead someday—I was already forty-seven years old when I became a father, and I'm a catastrophist, so this truth is never far from my consciousness—somebody else will live where we now live, and our names will be engraved elsewhere. Meanwhile, little by little and day by day—with all due respect to the inevitability of doom—we build the best life we can and mainly trust the future to itself.

And meanwhile, at ground zero, where the towers fell and nearly three thousand people died, it's the same story: They bicker and build, and build and bicker, and bluster and blame and battle—mainly over who's calling the shots—men with various degrees of vision, integrity, and heft, carrying on not like men inscribing history upon Earth's

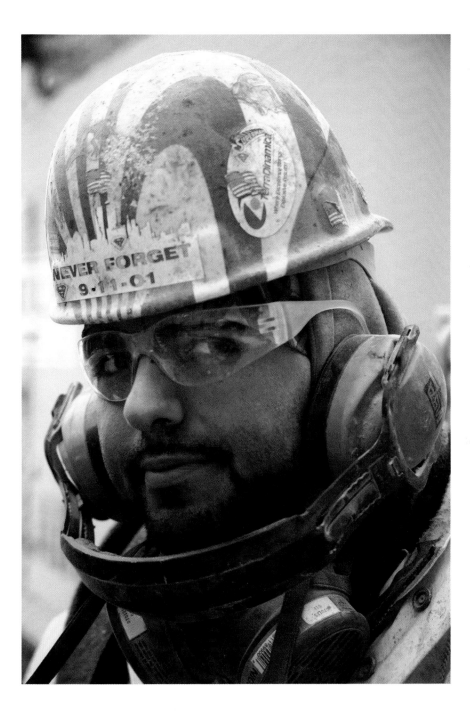

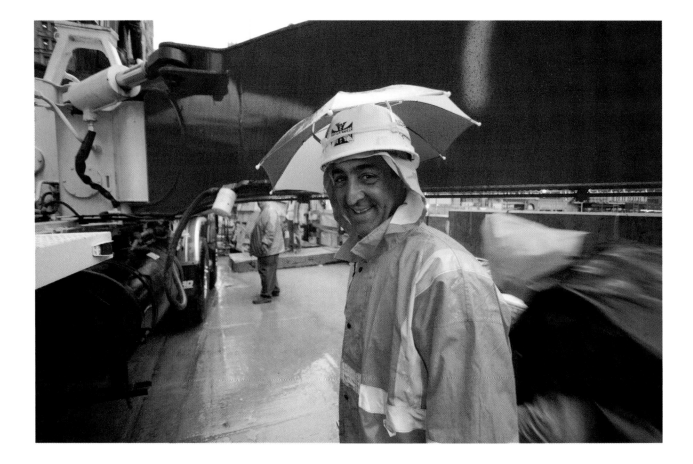

face—little by little, day by day—but like baggy-pants clowns.

Someday they, too, will all be dead and, by and large, forgotten, which may help to explain why they're so busy squirting seltzer on one another: It helps 'em pass the time of day in death's bright waiting room; it makes them feel alive. Power and money don't negate life's cheap slapstick—they only add richness and depth. Hell, history is comedy—in all places, at all times—strutting, preening humankind, heading toward oblivion.

You want tragedy and catharsis? Read Aristotle. You want truth? Stare naked in the mirror at the brute who dreams up gods and bickers over grapes, driven to create and to destroy as he is created and destroyed—pitilessly—who ponders the big bang and laughs when someone else slips and falls down.

Meanwhile, chances are that what gets built because of or despite the Ground Zero Clown Troupe—venal or grand, timeless or transitory, ugly or beautiful; likely, always, all of the above—will stand at least a little longer here than any of us.

Among my favorite ground zero keepsakes—I have covered the World Trade Center rebuilding since 2005, and I have gathered much flotsam—is an architect's dream book prepared for a design meeting in September of '05.

Titled "World Trade Center/Tower One/Base of Building/Texture Concepts," it's five eleven-by-seventeen-inch spiral-bound pages long and nearly devoid of text. It contains a total of fifteen uncaptioned photos of various surfaces, meant to offer the building's developer a visual sense of materials and patterns and historical references that might be evoked by the vast concrete cube that will form the base of Tower One—the "Freedom Tower," as New York's former governor George Pataki named it.

One of the crew of architects handed the book to Larry Silverstein, the tower's developer, at the meeting's start; when it ended, two-plus hours later, the book still sat on the table, unopened. So I asked to borrow it, and nobody has asked for it back. And as the tower has begun—slowly, slowly,

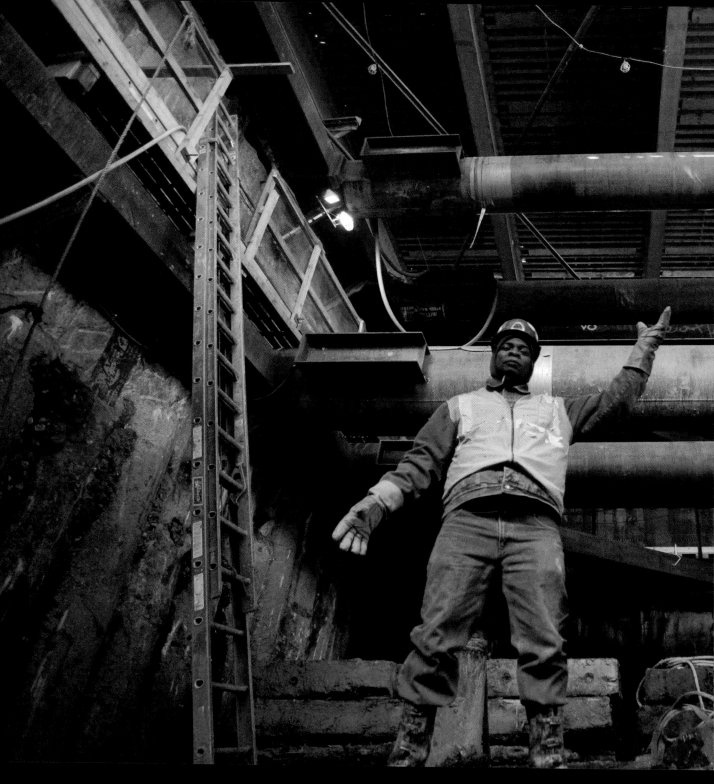

slowly rising from a pit seventy feet below street level—to take shape before my eyes, I go back to the book, to the last picture in it, a section of the Wailing Wall, the two-thousand-year-old ruin of one temple that was built upon the ruins of a three-thousand-year-old temple, right in the heart of Jerusalem's heart—and right here, in a brief book of ground zero spitball visions, sits the holy Wailing Wall, where people still come every day to pray and weep and pound their chests in timeless grief.

I mention this because many of the people who know that I've been writing for years now about the rebuilding of the World Trade Center ask the same questions, including this: Why not just make the whole place into a memorial, where folks can pray and pay tribute and honor to those who died there?

This, in fact, was what America's mayor, Rudy Giuliani, suggested as he was leaving office. Ironically, it was Rudy who also had urged a quick rebuild; who tried to trump term limits by playing the 9/11 card in an effort to stay in office; and who, thwarted in that effort and expecting his mayoral

successor to be a Democrat, conspired with Pataki, a fellow Republican, to control ground zero as a political symbol and to control the billions of dollars that would pour into it.

It's no stretch, looking back, to say that 9/11 was the best day of Giuliani's political career, but it didn't wash him clean—indeed, it eventually helped bare his armpit ethics—and it wasn't footing firm enough to support the presidential bid of a bastard with little to offer beyond his foul temper and two clenched fists. As for Pataki, who, like Rudy, hoped to stand sufficiently tall on ground zero to reach the White House, his five years at the helm of the rebuilding left few marks on the earth there, and none in the public mind.

Which is to say that bucking the forces of history and spirit embedded at ground zero—as puissant as those embodied by the Western Wall of King Solomon's Temple—is no mere walk in a memorial park.

So though you need not be a half-wit or a hayseed to pine for a big park, you must at least embrace, or be embraced by, a lambkin's naivete about capitalism in general and New York City real estate in particular. The Trade Center—ten million square feet of fully packed office space—collapsed upon sixteen acres of the most precious land at the core of the most economically vital city on the planet as the direct result of an act of jihad intended to slaughter thousands of innocent people and cripple our nation—and you want they should turn the whole shebang into a bleeding greensward? To honor whom, exactly—Osama? Blow me.

But I digress. Enough to note that of the many tidal pulls ebbing and flowing through ground zero, the most powerful of all is cash. Americans may be every bit as God-fearing as pollsters say—and as the ancient Israelis, when not making golden calves or changing shekels at the shul—yet as much as even a New Yorker likes green space, we worship where it counts: with our works, and at the altars of green money.

But take heart, Percy: Eight acres of ground zero—fully half the place—*will* be a memorial, complete with a park, plus its own Wailing Wall, a section

of one of the old slurry walls built to shore up the substructure of the original WTC against the nearby Hudson River. There you may daven and weep and mourn to your soul's content—or just grab a bite to eat.

And all around you, rising to heaven, tens of thousands of people will pay their tribute by coming to work each day, in four office towers the size of the Empire State Building, here in the heart of the heart of this most American of places.

Which brings us to the second question everybody asks: Would anyone dare to work at ground zero?

There's a simple answer—not everyone in the United States is a wussy—and a complicated answer, but it's worth pausing to reflect on the obverse version of this question, posed endlessly in the echo chamber of the mass media: Since we won World War II in four years—and built the Empire State Building in only thirteen months, and the Hoover Dam in five years—isn't our failure to finish the World Trade Center

rebuild by now irrefutable evidence of the collapse of can-do America?

Both questions are stupid, but the first one—however silly—is at least honest. The second ignores history for the sake of phony analogy—all of these things are not merely unalike; they're obviously and fundamentally different—but they both presume the same falsehood: The U.S. of A. is a cooked goose. Done. Over. Just a nation full of can't-do clowns and craven braggarts led for the last eight years by a big-hat, no-cattle blowhard.

But New Yorkers long ago settled both questions. Since 9/11, thousands have moved into Lower Manhattan, with their partners, kids, and pets, not as an act of defiance or courage, but because, native or immigrant, the New Yorker sizes up risk and benefit with the same confidence—not to mention a cold eye on the bottom line—that built the town and the nation in the first place. While old Wall Street office buildings two blocks from ground zero are being converted to condos and apartments, Goldman Sachs has now topped off a $2 billion tower, its new

headquarters, a few hundred yards across West Street from the WTC site. And although there are plenty of words for folks who bet against Goldman Sachs, "winner" isn't one of 'em.

The towers at ground zero will rise and fill; millions of visitors will come each year to visit the memorial; shops, hotels, and restaurants will thrive; and the American empire, having survived—knock wood—two four-year terms spent staggering toward fiscal and literal Armageddon, will survive awhile longer.

The more relevant question trembling behind these two others isn't pretty, but it's clear as ice: Will ground zero be attacked again?

The answer is just as plain: Bet on it. Peter Bergen, who has studied and written about Bin Laden and Al Qaeda for many years—a fellow at NYU's Center on Law and Security and a lecturer at Harvard's Kennedy School of Government (and a CNN national-security analyst; Bergen looks marvelous in a kaffiyeh and flak jacket)—told me, "If you talk about a 2050 timeline,

clearly this is going to be—if not the number one target—in the top five. They've attacked it twice—and it seems a target in perpetuity. Somebody will try something, even if it's some halfhearted attempt by somebody merely inspired by Al Qaeda. I wouldn't work there at all. But that's just my personal feeling."

Or, as Daniel Benjamin—coauthor of *The Age of Sacred Terror* and a National Security Council member during Bill Clinton's administration—wrote in a 2004 *New York Times* op-ed, fetchingly headlined "The 1,776-Foot-Tall Target," to build the Freedom Tower at all "ignores the difference between heroic resolve and foolishness. Dangling an iconic and indefensible target in front of terrorists is inconsistent with a strategy of reducing our vulnerabilities wherever possible . . . [careful] calculations—not reflexive bravado—ought to govern planning for ground zero."

Nobody in his right mind could argue with the gist of the Bergen-Benjamin message: Everything built at ground zero will be a trophy kill, and

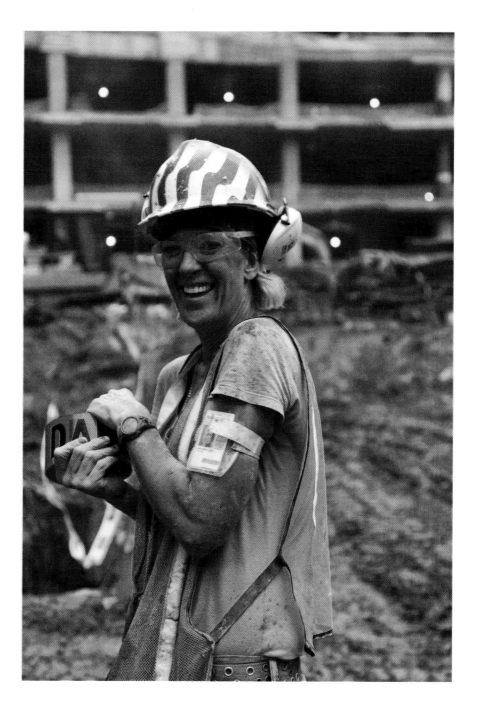

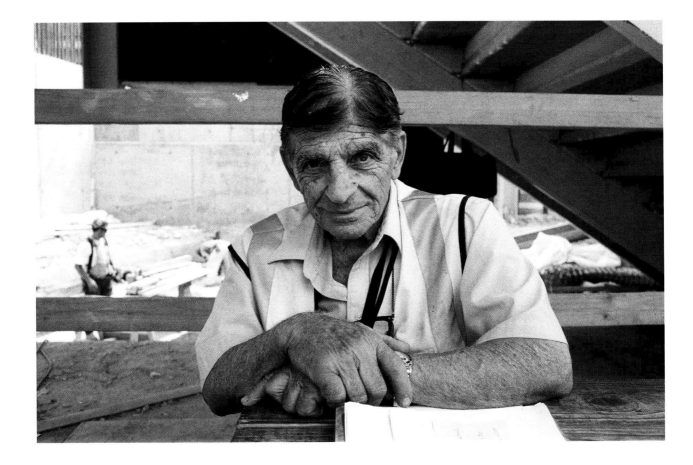

there will be no lack of hunters and no way to guarantee its safety.

And yes, some folks will refuse to work there, and some will feel forced to by circumstance, and some may even say goodbye each day as they head to their offices and wonder if today's the day.

And yet the truth is that vast numbers of New Yorkers—including those who lived through 9/11—will say, *So what?*

Mr. Bergen, Mr. Benjamin, may I introduce Charlie Maikish? Mr. Maikish, a quiet man, a civil engineer who helped build the Twin Towers when he was just out of college and then years later served as director of the World Trade Center for the Port Authority of New York and New Jersey, the bistate agency that built the WTC and is—slowly, slowly, slowly—rebuilding it; and who helped fix the damage after the car-bomb attack in 1993; and who most recently served for two and a half years as head of the command center overseeing the rebuild: Mr. Maikish, sirs, gets it. He saw Ramzi Yousef, the architect of the '93 bombing, in the courtroom, and he knew the war had just begun.

"I was in the courtroom when he was sentenced," Maikish says. "And he said, 'We *will* succeed. The towers *will* come down.' I felt chills go through me when he said it, because I knew that they were zealots and would stop at nothing to see that happen."

When the towers fell, Maikish was at a meeting in Midtown; he didn't get to ground zero until later that day.

"There were eighty-odd Port Authority people that died, forty-five that I knew personally—and tenants and other people at the Trade Center, close to a hundred people I knew that never made it out that day."

Sitting at his desk, his tie knotted tight and his white shirt crisp, with five decades of hard hats lined up neatly on top of his bookcase, Maikish pauses to lick his lips and swallow back the tears.

"There was a real mourning for the loss of a physical place, too," he says. "I said to myself, *This is crazy—why are you so upset, so devastated by the loss of the buildings?* But for a lot of us, it was a very special place. We *built* it. We *lived*

it. It was a very special place, and it *still* is. It really is. It has this psychic energy around it. You can't animate or give a soul to a physical structure, but believe me—you can."

And then Maikish earnestly trots out the most tired 9/11 trope of all, the one about the terrorists winning.

"Would I put my own children in the Freedom Tower? Yes. And I'll tell you why—the terrorists win if they get us to so materially change the way we function that we're no longer a free and open society. *They win.*

"Americans are going to avoid their symbols because they might be targets? That's doing *exactly* what the terrorists want. *No.* Personally? I'd move into the Freedom Tower in a minute."

I'm no neutral party here; I'm going with Charlie Maikish.

I've talked to a lot of folks working on the rebuild—some wearing suits, some in safety vests—who see themselves as soldiers in whatever neo-Orwellian phrase you'd use to mark this precise point in the human animal's endless cycle of slaughter and suffering. I don't know their politics, and I don't want to know. I don't know how to define and gauge the purity of someone else's patriotism. The merry jingoes at Fox News have that beat covered anyway, and have debased it to a cretin's code.

What I know is this: It takes a ration of fundamental heart, of bravery—among other things—to make a country like America and a city like New York. To come here from some other place and make this place your home. To believe that you can build a better life, however you define that, in New York City. To do it—or to fail, or to lose it and to soldier on—that takes stones.

And I know this: Bravado is the opposite of bravery, the pretense of courage where there is only fear and ignorance. Bravado sometimes says things like "Bring it on!" and "Mission Accomplished!"—and it sublets Geraldo Rivera's apartment when he's off on assignment—but it never, ever faces fear or gets a damned thing done. Guys like Maikish do. Or don't. But they don't pretend, and they'll die *trying*. They

Metallic lather Fanta Zephir.

are grown men. They grasp—since they know that they're fated to die—that facing fear with faith instead of running or hiding from danger doesn't make them dumb beasts; it makes them men. And it makes them Americans. And it makes them New Yorkers.

As for that awful "If _____, then the terrorists win," it was drowned in sewage so long ago that everyone to Ann Coulter's left gags any time it's used. But what the hell—like greeting cards and *Tuesdays with Morrie*, it does mean *something*, and not just that you're gagging because you're far too smart and learned to fall back on dire cliché. What it means in part, especially to New Yorkers—even those who didn't help raise the World Trade Center—is that not filling up the two holes torn in the grandest skyline in the world—the man-made horizon that both symbolizes and *defines* New York City—because you're scared of the bad guys coming back is not wisdom, caution, or careful calculation: It's cowardice.

I'm also with Maikish on the soul of ground zero, because I've spent

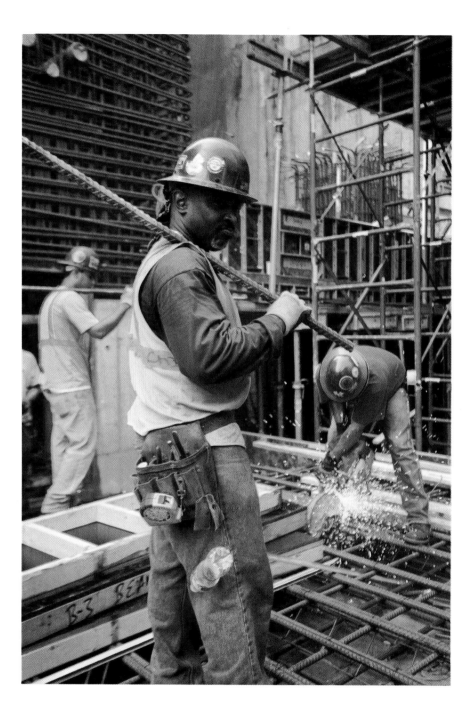

enough hours on the ground there to have felt it. It isn't Little Bighorn, and it isn't Auschwitz, and the truth is that there is no piece of soil anywhere man has lived that isn't soaked in blood shed cheap, and for the ugliest of reasons. But ground zero has a soul just as sure as you and I do, and just as sacrosanct.

When I first came down here and stood in a pit that was little but slab on grade, it felt like a cathedral at the bottom of a vast and empty well, a place where all the push and pull and pulse of living life had died. A battlefield, and worse—a busy field of human workday dreams turned all at once into a silent slaughterhouse. Squares of traffic cones marked the outlines of the fallen towers, and battered plywood painted blue covered a Freedom Tower cornerstone that had been rushed to the site so that George Pataki could make a show of being in charge, but construction had been paralyzed—and would be so for months, because *nobody* was in charge—and the commuter train that snakes through ground zero squealing and shrieking past every few minutes served only to make the naked earth

seem more barren, more like the soul of a small child orphaned.

Now? The future of ground zero is its present, days and nights and land filling with work and money again, its soul no longer small and sad and stagnant. It's big and hairy—it smells like sweat and bangs like steel pounding on rock until rock breaks. It hurls curses at the fucking crane operator as he takes his goddamn time on break finishing the *Post* sports page. It has a thrumming pulse. It feels just like . . . New York.

The toughest of all ground zero questions is: What's taking so long? The reason it's so tough to answer isn't because there are no answers; it's tough because none of the dozens of answers is a sound bite, and trying to parse them is like uncrumpling a train wreck.

Those sixteen acres are owned by the Port Authority of New York and New Jersey, owner and operator of all the major bridges, tunnels, and airports—plus the infamous and eponymous bus terminal—that connect New

York City to the rest of the world. It was the PA, born in 1921, that begat the World Trade Center—thanks to its endless flow of cash from its bridges, tunnels, and airports, its ability to issue bonds, and the vision of one Austin Tobin, an autocratic former PA director who built the Twin Towers and promptly died.

Under Tobin, who ran the show for thirty years with an iron fist—and with no fear of any elected official—the Port was a powerhouse, savvy enough to steamroll any obstacle and confident and competent enough to put up what used to be the two tallest buildings in the world at once.

Those days are long gone—and so are the PA's political independence, competence, and confidence. What's left is an agency full of frightened bureaucrats run by hacks handpicked by the governors of two states whose fierce rivalry—rooted in greed and lust for money and power—was the problem the PA was created to solve in the first place.

Nothing happens at ground zero without the Port's say-so. And nothing happens at the PA unless the New Jersey boys get to wet their beaks, which means that nothing gets built at ground zero without the guarantee of a new multibillion-dollar tunnel from Lower Manhattan to New Jersey, a joyous prospect for any real estate developer in certain precincts of New Jersey.

But that's only one aspect of ground zero's paralysis. There's also the private real estate developer who inked a $3.2 billion, ninety-nine-year lease on the World Trade Center seven weeks before 9/11, Larry Silverstein, the seventy-seven-year-old whiz kid from Brooklyn who gets trashed for all that goes wrong with the rebuilding—and who couldn't care less about that. All Larry cares about is getting the thing rebuilt before his time, or his lease, runs out. But despite his determination and experience—and this guy has spent fifty years cutting deals and greasing wheels in New York City—and a phalanx of lawyers, Silverstein and the PA keep lurching in lockstep from stalemate to stalemate.

The politicians involved have been horrible. From Pataki's empty promises

to Eliot Spitzer's venereal arrogance and Mayor Mike Bloomberg's calculated detachment, no officeholder has cared enough to do ground zero a damn bit of good.

Then there's the not-so-little matter of the master plan, chosen by Pataki, to rebuild the site. Five office towers in all, and a brand-new train station, a memorial and museum, a performing-arts center, plus a half million square feet of retail shopping—all packed into a parcel of sixteen urban acres, with a commuter train and two subway lines running through it—conceived in such a way that no part of it can *literally* be separated from the rest. Under the very best of circumstances, it would take years of planning and building to get it done.

And then there are the victims' families, whose sons and daughters and husbands and wives were murdered in cold blood on those sixteen acres—hundreds of whom have no remains to bury, and view the site itself as sacred ground. Pieces of the lost are still turning up, and different groups are still spatting about the "right" way to list the names of the dead on a memorial that won't be done by 9/11/11.

But the best possible answer to the question of what's taking so long is another question: What's the rush?

I'm serious. Why the hurry? I mean, all due respect to Oklahoma City, but here you can't just set some chairs on a lawn and call that a memorial. And not for nothing, but Pearl Harbor waited ten years just for a stinking plaque—plus ten more for a memorial. Are we so devoid of historical memory—and so frightened of the time passing—that we can no longer recognize and live with reality?

This is reality: Austin Tobin, too, had to make peace with New Jersey—that's how the PA wound up running its own railroad—and with the Rockefellers to get the Twin Towers built. The PA condemned those sixteen acres—seized them via eminent domain from folks who'd lived and owned shops there their whole lives. Power, profit, politics: All the forces that shaped the World Trade Center forty long years ago—including the Hudson River, including the private real estate barons

whose outrage at a publicly funded agency building office towers to compete with their own led to lawsuits and ugly public-relations campaigns—haven't changed. Nothing has changed.

I'm not saying that's a good thing. I'm just saying that in 2050 no one will care how long it took, how much it cost, or who blamed whom for what—same as those who come to Rockefeller Center to work or gawk at the Christmas tree don't care about John D. Rockefeller or the nine years required to finish its construction—with one man of stupendous wealth in full command.

I'm saying that these forces are both inevitable and necessary, and that accidental, organic splendor blooms when the predations of capitalism, government, and art—or at least, architecture—are composted, day by day, by time and fate. This, too, does not change.

So figure five more years to get it done—and enough already with the kvetching. Or else the terrorists have won.

Getting it done is one thing; doing it right, which takes more than mere money and time when it comes to putting up a superskyscraper on this patch of land, is another. Any emirate with a purseful of petrocash can sink a slab of steel tubing into sand, stand it upright, and call it the Burj Dubai—but, damn it to hell, we're talking the Freedom Tower here.

(Yep, it's a silly, stupid name—why else would the hush-hush Port Authority quietly anoint it One World Trade Center many moons ago, while assiduously denying they'd renamed it?—but what's left of poor George Orwell's skull has already exploded a million times, which isn't to say that Orwell wouldn't finally toss his pen and lunch, were he alive, and weep in fury, but what can you do? Freedom Tower it is—and shall be for the foreseeable future.)

At the Skidmore, Owings & Merrill office on Wall Street, a two-minute walk from ground zero if the goddamn tourists would stop clogging the sidewalk, George Pataki's Excellent Tower of Maximum Liberty has always been

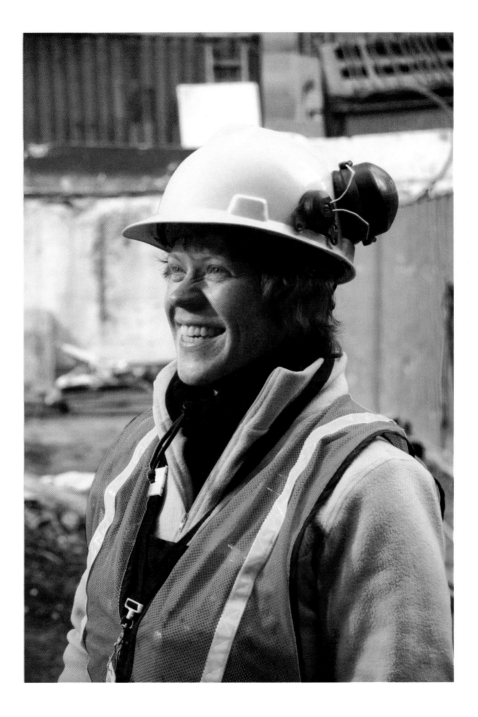

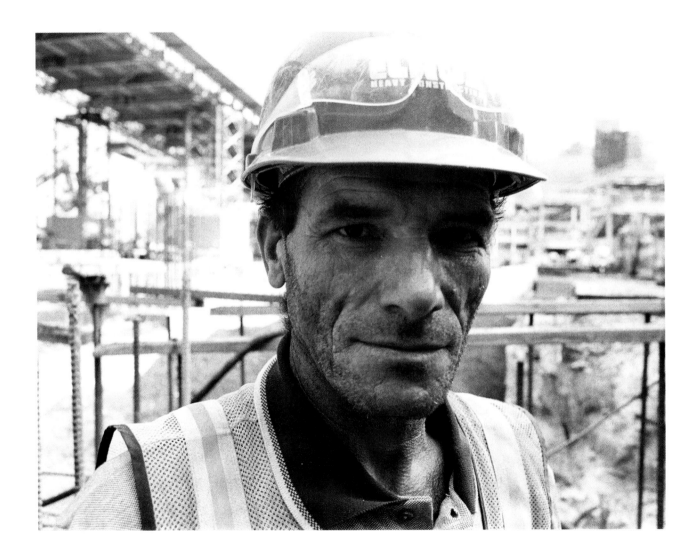

known as Tower One. SOM has been the premier corporate architecture firm in the world for decades—the Burj is its baby; so was the Sears Tower—a North Star of sanity in a starfucking galaxy of spinning prima donnas whose ridiculous self-regard oozes down from their thick-framed fashion eyewear all the way to their cowboy boots.

Back at SOM, where they've been walking the Tower One wheel, the grown-ups wear dark suits and white shirts with calm ties, the youngsters dress for the jobs they want—many are headed to hipper shops, in search of the daring and edgy—and the most vital statements speak of profit and loss. And here at SOM, they've been walking that wheel for seven years, through three governors, two complete redesigns, and a relentless barrage of critical derision.

None of which means anything to David Childs's colleague Carl Galioto, head of SOM's tech group. Owlish, mild as milk, Carl's the architect who works most closely with the engineers who have to find a way to build the building envisioned by the architects—on time and under budget, if possible, sustainable, and safe.

Carl can rhapsodize, quietly, about many things—from the three city-bus-size natural-gas fuel cells that will supply up to one quarter of Tower One's electricity to the sorry state of the New York Mets. But the most riveting area of Carl's vast expertise is the one he can't speak freely about, because of the bull's-eye the Freedom Tower wears: Carl Galioto is in charge of the tower's life-safety and security systems.

That's why, not long ago, he found himself in the New Mexico desert, watching as technicians blast-tested a full-scale mock-up of several upper floors of Tower One, using a load of explosives so powerful that Carl saw it only through a periscope, from an earthen bunker a quarter mile away.

"The typical weather-performance tests—the airplane propeller, the wind and everything—I've done that dozens of times. But watching a blast test was something I had never done. I'd seen a film of it—we design federal office buildings—but I had never personally witnessed one before. I wouldn't miss that."

For security reasons, Carl can't discuss the blast load itself, although when I tell him I have heard that the new Goldman Sachs tower was engineered to withstand the detonation of a small nuclear bomb, he blinks and says, "I know what that building was designed to—and I can assure you it was not a nuclear device."

And not even Carl is so circumspect that he can't permit himself a small smile at the memory of New Mexico. Part of it is that the Tower One blast test confirmed the computer simulations and the engineering calculations. And part of it was just the thrill of a big-ass explosion.

"The entire bunker shook," Carl says. "It was just terrific."

⸻

One door down sits David Childs, the Freedom Tower's design daddy. In a working world wan with weltschmerz, where a critics' darling must fulfill some academic ideal of sculptural perfection and buildings serve as mere fodder for cultural analysis and triggers of emotion—architecture has long attracted pompous political theorists whose self-regard is matched only by the contempt they drip on their peers—Childs is every inch an old-school gentleman, brimming with boyish cheer even as he approaches age seventy, and even as his Freedom Tower—a gently turned octagonal shaft that tapers to the exact height of the Twin Towers, topped by a 408-foot lighted spire—has been derided as a monument to fear because of its 180-foot concrete cube of a base.

"This *nonsense*," Childs fumes—over the years I've seen him fume before, but he fumes like the Yalie he is: with dignity and circumspection. He fumes about the Port Authority's Calatrava-designed train station, budgeted at $2 billion but now slated to cost maybe twice as much: "There's no *purpose* to the building. It's a receiving hall. You can't get a ticket there, you can't get a Coke there—it's a *vestibule*. And any possible way that you calculate it, it's the most expensive building ever built by mankind. And it has no *purpose*."

His angst is understandable. Childs inherited the Freedom Tower from

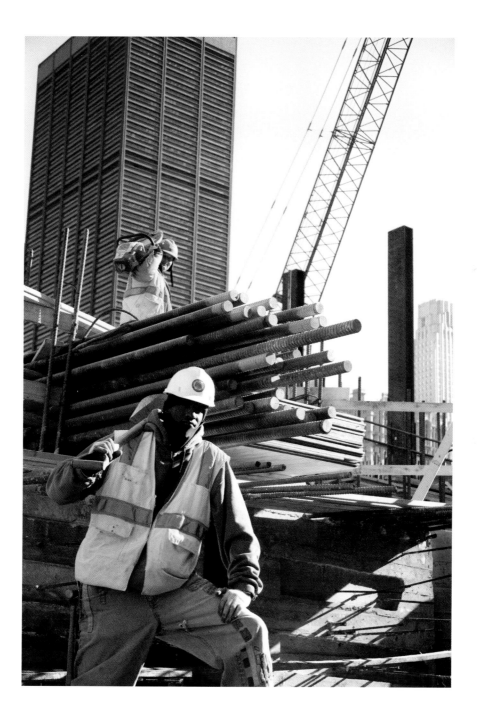

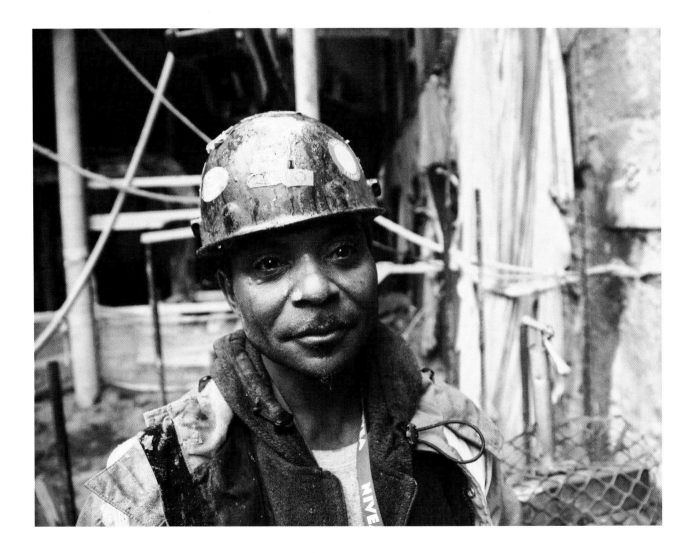

another architect whose press clippings would stack up taller than anything he's ever built, and the job of designing a 2.6-million-square-foot office tower to meet the same security requirements of a U.S. embassy on unfriendly soil—while simultaneously creating a symbolic lighthouse in the sky—would give Vishwakarma pause. The only building completed at the Trade Center site since 9/11 is 7 WTC—a glowing trapezoidal office tower that is nearly filled with market-rate tenants. Childs designed it and Larry Silverstein built it—with no help from the Port Authority or politicians, which is why the thing got done—but Childs gets no credit; instead, he gets hammered about the Freedom Tower's base.

"When somebody attaches a phrase to something and it sticks, like 'the concrete bunker,'" he says. "Well, we know what that looks like: It's *all* concrete, with a little hole in it, and it looks terrible.

"In fact, this building's base is smaller than the original design, and it's much more porous. From the lobby level up, it's all open. And behind, it's got big trusses that you read through. You look through this fabric of the surface skin—it's open. And when the glass is on it"—Childs's design has the whole base wrapped in two-inch-thick prismatic glass—"the faceted glass, it will cause prisms of light to break. I think it will be truly beautiful. All the light going through and bouncing back—it's really going to be quite amazing."

Maybe. Problem is, after Silverstein and the Port went to the mattresses, the Port wound up in charge of putting up the Freedom Tower, which is like asking Stevie Wonder for a lift to LaGuardia. In a Yugo. And Childs doesn't just *know* that; he's riding shotgun.

"If we get our glass," he says. He's not fuming; he's pleading now. "*We've got to get the right glass.* A simple building is not tolerant of cost cuts. It is dependent on the detailing, on the right materials. You *can't* fool around with it."

He shakes his head in woe.

"And they're going to screw it up badly. They've already changed the stainless steel to aluminum—all the spandrels. We redesigned it so that the spandrels aren't important, but we lost a piece

of our very short vocabulary by having to do that. Now they want to change the glass."

Childs knows that this is how it goes with architects and their patrons, always. He speaks of Francesco Borromini in seventeenth-century Italy, and his Oratorio dei Filippini, the timeless product of a thirteen-year grudgefest with *his* client—the cardinal of Rome.

"Ah, God, he couldn't get his right stone, and it was all compromise—it was all the same stuff we deal with every day. *Nothing changes.* That's why you have to struggle and fight. Once you take this tower and you put it in its *place*—you've got to do it right. It has this memory, this cerebral role to play. This is a good office building, and the structure works. But there's another thing that this building aspires to— that other, final, symbolic, proportionate, light-filled thing that inspires you. You'd better damn well do it right."

Nothing changes—human nature least of all. The sacred and profane, the artistic and commercial, the genteel and brutal: These forces collide on ground zero just as they do in each of us—if we're lucky—and shape us all, and all we do, to one universal, inevitable end. We live in space—in a world we can touch and try to master—but we're here for just a while before we're devoured by what we can't touch or master: time. *We* change. We die.

What we leave behind—if we're lucky—is love. What Bobby Coll and Hank Field left behind wasn't their love for family and friends; it was the love their family and friends had for them. Nothing built by human hands lasts forever; only love can redeem us to ourselves. These are the gifts we're given: a little bit of time and the capacity for love, to make connections of such depth and passion that they somehow redeem our venal, clownish selves.

Otherwise, parenting is just a biological imperative. Otherwise, a city is just an economic and demographic construct, and an office tower is just another beehive, and the blues and baseball and Hollywood—and skyscrapers—are just products of a barren culture that fooled itself into thinking

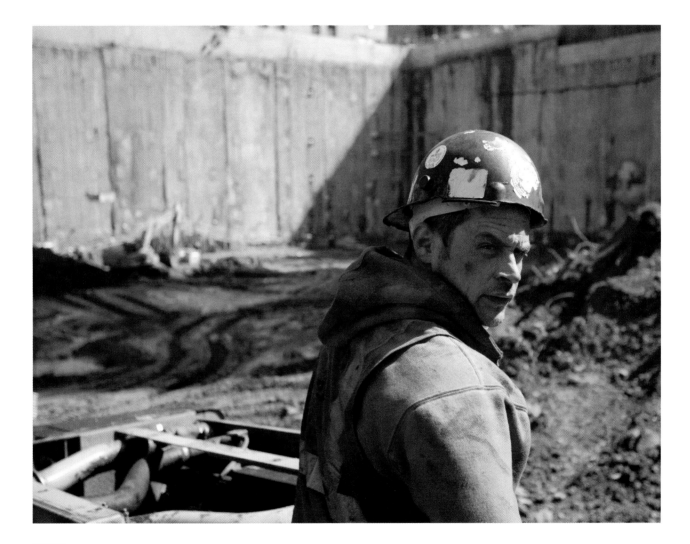

Operating engineer Ritchie Fiskaa.

it stood for something beyond the bottom line.

Could be. I've got a small, round stone from ground zero sitting right by my keyboard, holding down some notes—one of countless perfectly spherical stones formed in what geotechnical scientists call a kettle hole; they found this one as they were digging for bedrock strong enough to support the footings for one of the towers.

A kettle hole is formed as a glacier melts—as the water forms a whirlpool that slowly carves a hole in the bedrock, little by little and day by day. The hole is round and smooth as silk, rounded and smoothed by the pieces of rock cut out by the swirling water—as those pieces of rock are rounded and smoothed, little by little and day by day, in the process.

I'm not saying it's a symbol or a metaphor. I'm saying it's a rock—and it took a lot longer to make than any building at ground zero, and it will last more or less forever, and it will still be nothing but a fucking rock, with all the capacity for love of a fucking rock.

I'm saying that I decided when I started going down to ground zero that I wasn't going to keep a cool intellectual or "professional"—or political—distance from my feelings about the place. All the awful stupidity in the wake of 9/11—the gutting of the Constitution, hundreds of thousands of people killed, the apparently endless fearmongering—have zilch to do with the place itself or, in truth, with the actual events of that day.

What happened that day was plenty bad enough. But it's nothing that this city hasn't long since recovered from—and I see that every time I go down there.

As for love, well, it's not easy to write about, but like paintings of sad clowns and *The Five People You Meet in Heaven*, it must mean *something*. I love New York City, and ground zero, and—God help me—the Freedom Tower. Like David Childs, I know they'll get it wrong, but I know it'll turn out better than this fucking rock.

What will it mean a century from now? A soaring paean to the resilient soul of a nation—or George W. Bush's spike of idiopathic overreaction

to Islamofascist terror? Misbegotten relic—or slender, faceted, simple pointer beside a memorial to a dark day stitched forever into human history? Just one more anthill of faceless paper shufflers—or a jaw-dropping ode to form and function?

The only right answer is: Yes. Of course. All of the above.

And when they finally get it done, it will inspire its own version of the reaction almost every other man-made New York City landmark has endured, including the Twin Towers—*and* the Chrysler Building, *and* the Empire State Building, *and* Rockefeller Center: Everyone will piss on it with fervent scorn—and then, sooner or later, it will belong.

It will be loved.

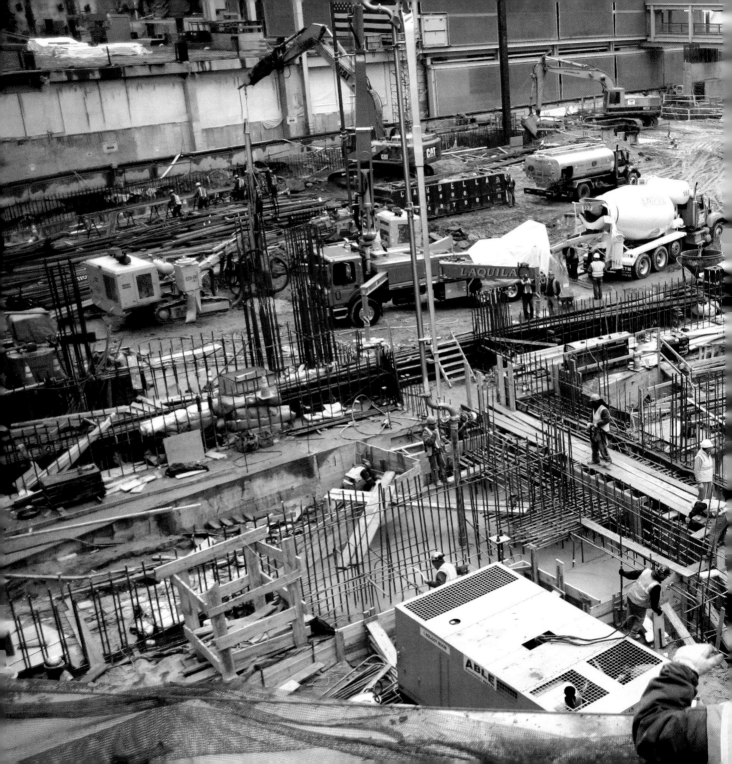

GOOD DAYS AT
GROUND ZERO

OCTOBER 2008

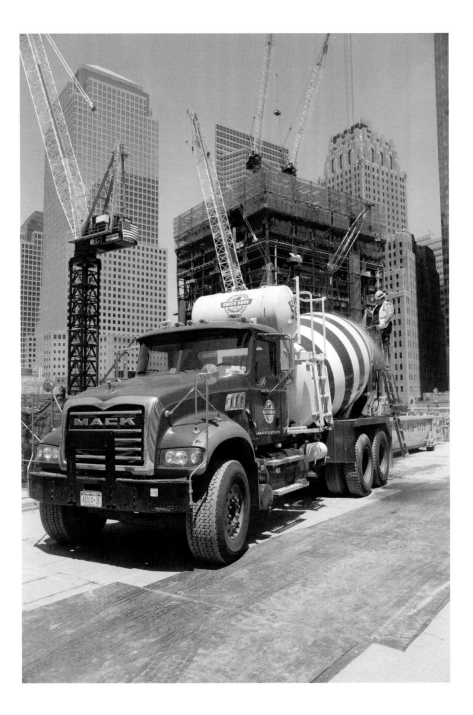

'll tell you this about New York City during the summer of year nine of our nation's engagement in the holy war triggered by Osama bin Laden and now affixed to Orwellian permanence: It's hot—ungodly hot—the woolen air a haze clinging to every pore. This morning brought a downpour not long after dawn that felt less like relief than ten minutes slumped against the wall of a shvitz getting pissed on by goats. Not that I'd know.

"You don't mind the air conditioner, do ya?" Lenny laughs, planting himself behind the wheel of the truck. He's hauling concrete from Brooklyn to the World Trade Center work site in downtown Manhattan.

"This is ten yards on board," Lenny says. "This is a twelve-yard truck with normal concrete—a sidewalk mix, whatever. This is twelve thousand PSI, much heavier a mix, much looser. That's why we only carry ten yards."

The worlds within the worlds within the world of concrete? Forget about it. I can tell you that a yard of concrete is twenty-seven cubic feet—the volume of concrete sufficient to fill a cube measuring three feet by three feet; that after thousands of years—the Egyptians used concrete to build the pyramids—it still takes a mix of water, sand, stone, and cement to make up a batch of concrete; that adding substances—a whole range of chemicals and industrial by-products—to the mix changes the properties of the concrete to fit the job it needs to do; that while fire and the wheel get the glory, civilization uses more concrete than any other man-made substance. I can tell you that much of the concrete poured at the World Trade Center is the heaviest, strongest concrete ever poured anywhere. And I can tell you that Lenny has under ninety minutes from the time his truck is filled to deliver his ten yards to the site.

Actually, Lenny's the guy who can tell you all that, not me. But Lenny grew up in Brooklyn, in a neighborhood called East New York, and lives in Staten Island now, and his accent is thick. In fact, everything about Lenny is thick, including his passenger this morning, me. Between us and the concrete, this truck's going eighty thousand pounds, give or take.

Except that the truck's not going anywhere. We're stuck in the two-mile-long Brooklyn-Battery Tunnel, the world's longest underwater traffic tunnel, and by "stuck" I mean "stopped cold in the morning rush hour." The only thing moving is the drum of concrete spinning slow behind us, keeping its load loose.

"Backed up in the tunnel?" Lenny says after five standstill minutes. "Have some Ex-Lax."

Sour dills do it for me.

"It's like Groucho Marx said—a clown's like an aspirin but twice as fast. That's how you feel sometimes when you go up to the Trade Center. You know what happened there, but you kid around and the humor helps you out."

It's a six-mile circuit from where the trucks load, hard by the Gowanus Canal, to the work site. They start loading a little after 6:00 a.m. and hit the truck route ten minutes or so apart. There's a 260-yard pour at Tower Four—we're in the middle of that now—and a smaller pour at the memorial in the early afternoon. Other concrete companies are pouring Tower One and the new train station.

"Not for nothing," Lenny says, "but they used to have booths here—the cops used to stay inside the booths. No longer. Today you got modern technology. That's it"—one thick finger jabbing high on the windshield—"right there in the ceiling. Cameras everywhere. Everywhere you go."

We all right timewise?

"We'll be okay on the time. The job is close enough where even if you lose a half hour you're still in good shape. Unless you're really warming up."

Whatever the weather, concrete produces its own heat as the water and the cement bond; on a morning like this, each batch mixed in the central drum that fills the trucks includes enough ice—shredded and blown into the mix from three-hundred-pound blocks kept frozen in a trailer nearby—to get it down to sixty-five degrees or so when it's loaded.

"Without the ice," Lenny says, "it'd be in the low eighties. The customer wants it to be seventy-five degrees. No problem."

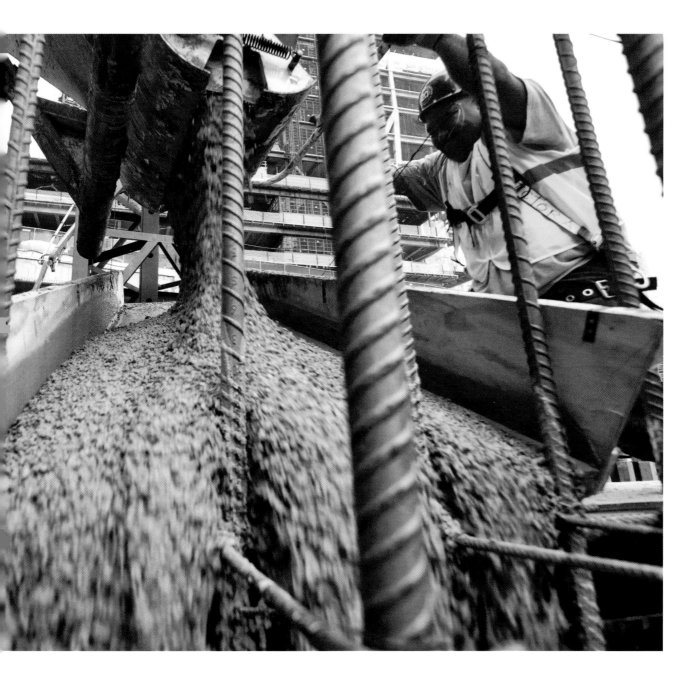

Fifteen, twenty minutes, the tunnel loosens up, and we bounce into Lower Manhattan. The spotter at the gate at the northwest corner of ground zero sees Lenny a block and a half away, sitting above a long row of cars at a red light.

"See to the left? He's washin' truck eighty-four—seventy-eight should be at the pump now. The guy out in the street there"—that'd be the spotter—"he saw this truck. He just told him I'm here. He's dumpin' him out. He's gonna empty out that truck so they're gonna be ready when I get in there. It's like a drive-through here. Watch this."

Sure enough. By the time we reach the site, 84 is on its way back to the tunnel, 78 is getting cleaned up, and Lenny has 103 backed up under one of the Tower Four pumps, ready to take his load up to the crew pouring another floor.

"That's Tony Junior," Lenny says. "He's in charge. That's Good-Lookin' Pete right there. Guy to the left, his name is Larry—he's the Teamster steward on the job."

It's a tight-knit bunch, although—

for the record—Pete isn't really looking all that good this morning. A lot of these guys go back together before 9/11—in New York City, the construction business is a very small world—but the shared experience of that cataclysmic day and its aftermath cured and hardened their bond into something like concrete.

"I realized the other day—I was talking to one of the contractors who was there, too, all that time—I said, 'You know, we've been here almost ten years now.'"

Lenny shakes his head, remembering.

"Thousands of people—I remember we had to shore up Church Street. The fire underground—they had steel plates across Church and Liberty—it was all torn up. Sitting in the trucks, waiting to go into the site, the heat underground, it actually melted the tires off the steel—three, four months after. I'll never, ever, ever forget that smell. Never. I'll never forget how it smelled."

I got here five years ago, in the spring of 2005, long after the smell was gone. I'll never forget how it looked: barren,

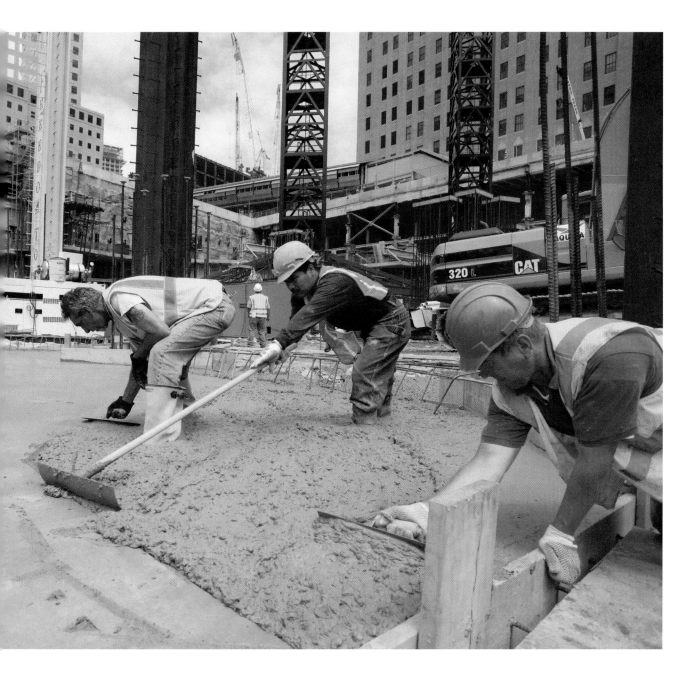

battered, bereft, a broken place sitting seventy feet below street level, with one long ramp running down into it. Three empty construction trailers, a couple of old beams waiting to be trucked up the ramp, and two large squares outlined by orange construction cones marking the footprints of the fallen Twin Towers. A cornerstone—boxed in wood, sitting in a pool of rainwater, nothing but a politician's prop—for a building that would never be built.

By then—nearly four years after 9/11—it had become clear that no one was in charge at ground zero.

You had a pit, variously described as a hole in the ground and in the city's heart, a national disgrace, an insult to the 9/11 dead, and proof that the terrorists had won.

You had promises that weren't kept, deadlines that weren't met, villains on all sides.

What you never had at ground zero was the one and only thing that was ever going to make a difference—the thing that you have there now: effective leadership of an actual construction project.

A living layer cake of building—four superskyscrapers, a memorial plaza atop a museum, a transit hub, a subway line, each at a different stage, all separate yet inseparable.

It is, in toto, vast. The size and noise of it hit you in the face as soon as you're within the gates. You need earplugs, water to cut the dust in your mouth and throat. It's too big to see when it's all in front of you. You need a guide.

But Lenny can take you only so far. Where Lenny's truck has dumped its concrete is at the southeast corner of the site, where Tower Four is beginning to rise above the stump of its base. Crews are beginning foundation work for Towers Two and Three; both sit due north of Four, in a row that descends from the crew pouring concrete for the twentieth floor of Tower Four down to the excavators sitting seventy feet below street level at what will become the base of Tower Two.

That's only one slice. The subway line, the transit hub—the train station known hereabouts simply as the Calatrava—and a portion of the street-level

plaza form another slice, just west of the row of towers.

The other slice—roughly half of the site—consists of the memorial and Tower One. At street level, the memorial will be a pair of fountains—each a waterfall of thirty feet—within the footprints of the Twin Towers, lined by parapets etched with the names of the victims of 9/11 and set off within the site by a maze of trees and walks.

This is all happening right now, in real time, and it's enough to make a patriot's heart thump. On a good day at ground zero—and they've all been good days for some time now—it's a hoe-ram symphony, a crane ballet, a three-dimensional tribute to patience, pure grit, and engineering genius.

So tell me: How come all these asshats are still calling it just a hole in the ground?

Chris Ward, executive director of the Port Authority of New York and New Jersey, is my guide today, and the dress shirt under his screaming-green safety

Christopher Ward, Port Authority executive director.

vest makes him no less a ground zero warrior-hero. The Port's purview includes all the major bridges, tunnels, and airports connecting New York City to the world; Ward's in charge of six thousand employees and a multibillion-dollar annual budget, and he answers to the New York and New Jersey politicians who traditionally have used the PA as a cash cow, patronage pit, and whipping boy.

Ward's immediate predecessors were hacks—Pataki's puppet was a guy from upstate New York who once ran his family's car wash and bowling alley—who mainly hid from public view while the boss overpromised and underdelivered. Ward, a barrel-chested egghead whose résumé includes a master's in theology from Harvard Divinity School, is a straight-shooting leader.

Within weeks of his appointment as the Port Authority's executive director in May 2008, Chris Ward did something no less heroic for being necessary: He called bullshit on the whole damned thing. At the behest of New York governor David Paterson—who hired Ward after inheriting the governorship from the crusading whoremonger Eliot Spitzer—he delivered a thirty-four-page report that boiled down to this: Ground zero's budget and deadlines were so at odds with reality that it would take three months more just to figure out a realistic schedule to finish the rebuilding.

"Myopic monumentalism wrecked this project," Ward says. "You can't have a monument in a day. You don't define the project by that at the beginning. You have to build it—and that requires patience. It requires hard work, and it requires deadlines.

"We know every single day how much steel has to be placed, and how much concrete has to be poured, and we are driving every contractor for that level of completion. It is getting done.

"And let's just step back here. We've done a lot—we've built seven hundred thousand square feet below grade, we're building an air-conditioning system for 1.8 million square feet of public space. It's a kids' game of pickup sticks—they're tied together. You can't touch one without touching everything else.

"We'll go down in the PATH station so you can see the open-heart surgery that's going on to keep the PATH trains running while we're tearing down the platforms."

Through an unmarked door inside the temporary PATH station—the railroad loops through the site, toting tens of thousands of commuters around the clock and seven days a week from New Jersey—and down, with Ward in the lead, into another world framed in steel and concrete, lit by bulbs hung from metal poles, mapped by countless plywood pathways laid by countless work crews as, day by day, they build a new World Trade Center from the ground up.

"Look at that," Ward says as a PATH train shrieks past. "That train curves and you're about six inches from the new shear wall that we're literally now pouring."

Once the train passes, we walk toward the center of the site, through a maze of utility work—in addition to public space, the rebuilt Trade Center will host ten million square feet of office space—and pump rooms.

"That gray steel over there is the floor of the foundation," says Ward. "We're gonna bring it all the way over to the top here. So while there's still work being done down here, the PATH station ceiling will be there—more importantly, the floor of the memorial'll be there, so we can plant the trees and finish the fountains. We're building from the top down."

This is a point of great pride with Ward and the Port Authority engineers: In order to get the memorial ready for the tenth anniversary of 9/11, they redesigned the job and turned it upside down, so the memorial pavilion—the plaza that itself forms part of the PATH station's ceiling—can be built first.

"You can't say the memorial's the most important thing, so put your shovel down and let's wait on the transit hub. The mechanical systems that drive the memorial fountains, the air-conditioning, and the lighting for the memorial are in the basement of the hub. So I had a difficult conversation with Santiago. He's not used to difficult conversations—it was hard to get a word in edgewise—but we made it clear

that he is building to an owner, not to himself."

Here Ward grins. Santiago Calatrava is an international superstar, a consummate artist, an engineer as well as an architect, and he had designed—to universal acclaim—a stunning hall entirely free of columns, all space and light, clasped by ribs of curving white concrete. It was an engineering marvel and, at the original budget of $2 billion, the most expensive train station ever built.

But once it became clear that both the cost and the complexity of building it were going to bust the budget and the rebuilding timetable, Ward had no choice but to ask for a sit-down with Calatrava. He could not have felt comfortable as a nickel-nursing, git-'er-done politburo hack putting the squeeze on Santiago. But that's precisely what Ward did, and he looks back at that fondly as one of the rebuilding's turning points.

"Literally, right here, is where all of these backspans and trusses are gonna be, and the way he designed them, you literally had to bring them in and drop

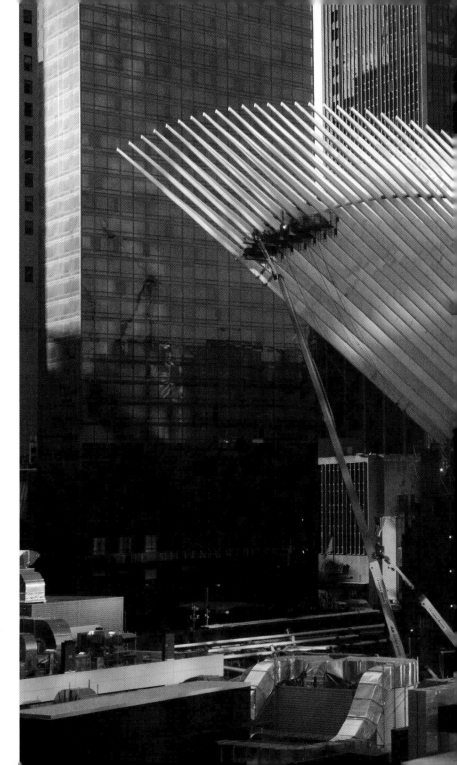

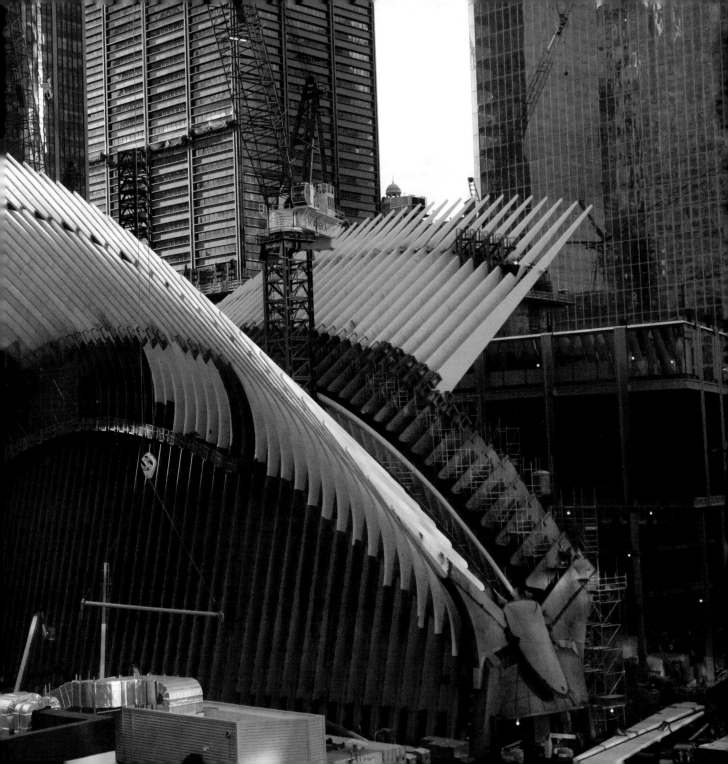

them, and the steel would bend to a point and form where it was supposed to be. But that could've been incredibly costly and risky if you had to keep placing it. This huge truss that goes down the middle of the Calatrava hub—the thing is like welding forty plates together because it holds up the whole ceiling.

"He came to the table with some very, very creative ways of solving a lot of the construction complexity. So we've done four columns. You can't even really tell they're there."

Crossing the site toward Tower One in the far northwest corner, we climb a few wood stairs until we reach a level even with the memorial footprints.

"That's the lower void of the South Tower. Look at these pumps. Sixty thousand gallons a minute for the memorial. The pavilion is almost overhead—instead of building from the bottom up, we flipped the memorial staging structure so the memorial will be done by the ten-year anniversary.

"We'll have the fountains working, the names on the parapets of those who were lost, and 80 percent of the trees fully planted.

"We made a commitment to the mayor, we made a commitment to the two governors—that memorial will be done on the ten-year anniversary. That's the only thing that matters."

From Ward's lips to God's ears: If the Port Authority can't get that much finished by 9/11/11, it may be his last day on the job. And he knows it.

The voids where the Twin Towers stood have long been ground zero's spiritual center. When the site was cleared of debris, they immediately were declared off-limits to vehicles and equipment, and they have retained a certain solemnity throughout the rebuilding. The crews lining their floors and walls with black granite wear black hard hats, which seem to be impossible to obtain for the not-so-few collectors among the rebuilding throng.

It is artisanal work, befitting its character and purpose.

Nobody will forget that this patch of land—as wrenched by dispute as any in the world—also is, literally, a mass grave.

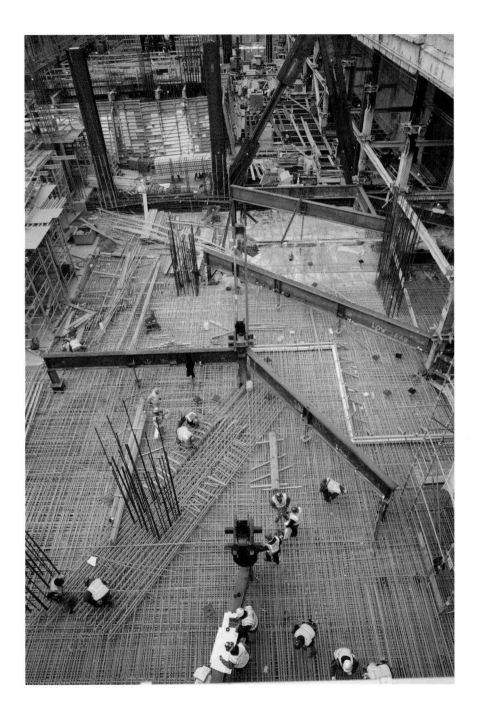

Lather Lou "Louie" Daniels works inside a cage of rebar.

And the memorial—even now, in its infancy—is breathtaking.

"Come on," Ward says. "Let's go over to One World."

That's what the Port Authority has renamed the Freedom Tower. So far, no good: Everyone else still calls it the Freedom Tower.

"We're just about to hit the standard floor, which means every floor plate is like the one on top of it, so the guys can get some momentum going and start punching 'em out. By this year's anniversary, we should be around fifty or fifty-five, and then by the ten-year anniversary, we should be topped out at ninety."

On my first trip to the pit, in '05, I met Marc Becker.

"I know it's gonna happen," Becker told me then, speaking of the tower finally rising. "I just don't know when."

I could almost hear his teeth grinding as he said it. His blue Tishman hard

hat—Tishman Construction helped put up the old Twin Towers, and it's running the Tower One job for the Port Authority now—was covered with stickers, his 9/11 battle ribbons, marking him as a veteran of the rescue and recovery efforts. He was patient with my questions, all nuts-and-bolts stuff about pumping water out of the pit and figuring out how to build a skyscraper's foundation around a working railroad track, but I could see him getting flushed as I kept trying to make sense of construction basics that were second nature to him.

"All I can tell ya is we're ready to build," he said finally. "We're ready to go. It's very personal to me. It's not just a job."

Back then, nearly a year after Pataki had dedicated a cornerstone, crews were still waiting for the Port Authority, the architects, and the NYPD to figure out how to secure One World Trade's base.

"It's personal. It's personal. I saw all the horrors. I mean horrors. From day one."

And then he choked up and couldn't talk anymore.

Now we're sitting in a small construction trailer fifty yards from Tower One, at street level. Through the small rectangular window, the titanic seventy-foot trusses rise at its base, painted with a dull red epoxy, awaiting fireproofing.

Above—day by day, a floor a week—750 men are busy raising Tower One.

"We're goin' vertical," Becker says. "Pretty soon you'll be able to start to see it in the skyline. We're actually getting ready to start erecting thirty-three and thirty-four. We just finished thirty-one and thirty-two."

He's a strapping Brooklyn cowboy with a wrangler's mustache. He fills a construction trailer all by himself. It isn't his size. He's still that intense.

"I'm attached to the building. When I hear some of the negativity, I take it personal. But people don't understand. Oh, yeah, I explain it. Absolutely. I tell them they don't know what the hell they're talkin' about. People don't understand the magnitude of the below-grade structure—almost fifty thousand cubic yards of concrete. That's almost equivalent to a thirty-story building. We were building footings around an

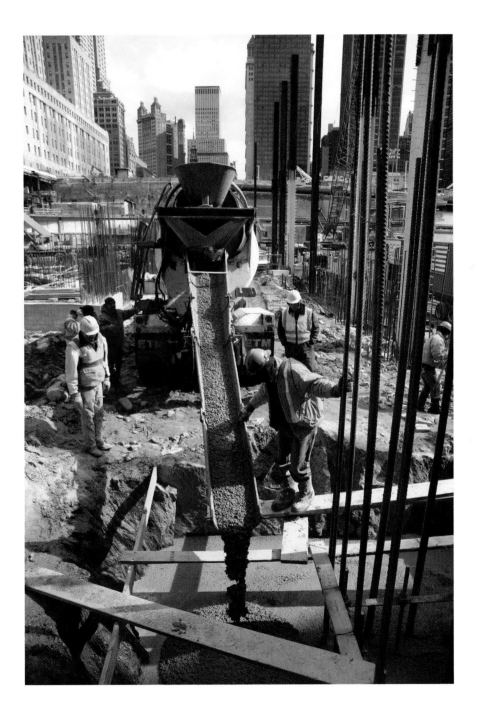

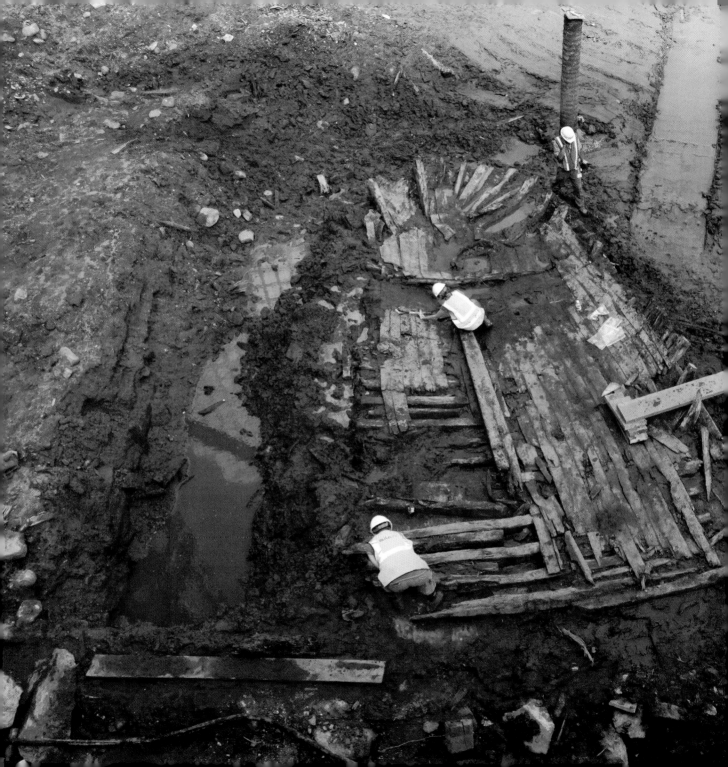

active railroad track. When people walk below grade—I'm in awe myself when I walk around. The magnitude of the concrete—it's massive. Massive. People don't understand."

The lack of understanding is compounded to this day by pundits fond of pointing out that the Empire State Building took just over a year to build, as if the two projects were in any way comparable.

Never mind that the Empire State site had not been attacked, that its predecessor was not destroyed, that its designers had no need to harden their building against an ongoing jihad. The Empire State's builders also didn't have to dig down seventy feet to hit bedrock strong enough to support their skyscraper, and then build its foundation atop a commuter railroad.

In fact—as opposed to ignorant punditry—the World Trade Center is a mere few hundred feet east of the Hudson River—in July, crews working on the foundation of the vehicle-screening

The remnants of an unearthed seventeenth-century ship.

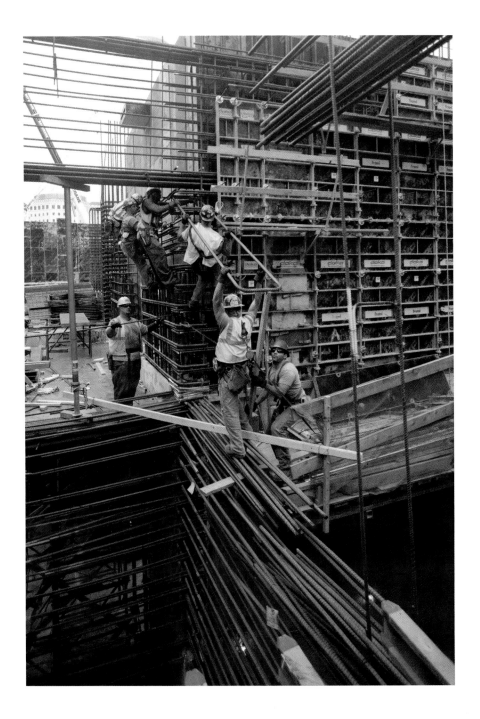

center unearthed a ship's prow dating to the late eighteenth century—and the old Twin Towers towered over Hudson River landfill, which is why the Port was forced to dig so far for bedrock, and why it also had to first build a concrete "bathtub" around the towers' site to keep out the river and to hold fast against its push. The bathtub's walls had to be repaired after 9/11; even as the site was being cleared of millions of tons of debris, workers rushed to shore them up to prevent a potentially catastrophic flood.

Then there was the matter of rebuilding the PATH lines. The tracks, equipment, and utility lines were destroyed on 9/11, and the ground zero "master plan" that had so dazzled Pataki with glorious symbolism and monumental soar—concocted by an architect who'd never had a building built that stood taller than four floors—blithely sited Tower One on the worst possible spot on the entire sixteen acres, which is why Becker's crews had to weave column footings around a working commuter railroad.

They did it—all of it—day by day, piece by painstaking piece, while the politicians and pundits prattled on. Same way they're doing it today.

Two huge tower cranes operating between One World Trade's central core and its perimeter are doing the heavy lifting. Each one is equipped with a hydraulic-jack system that enables the crane to raise itself as the building goes up. You with me? The cranes jump themselves as the building goes up.

The building goes up in a continuous cycle. The ironworkers are on the top deck, erecting steel—first in the core, then the perimeter columns, then all the beams. When the steel's done, they deck the floor. Then the concrete is poured. It's a two-week cycle: By the time a floor is far enough along to be poured, the ironworkers should be beginning to erect the core and perimeter steel six floors up.

"You're doing two floors every two weeks," Becker says. "As you go up the building, the other trades follow—the spray fireproofing, the curtain wall, the mechanicals."

Becker looks out the little window, over to the tower.

"I think it's one year ago next week

that we set our first tower column," he says. "The job right now is running six days a week. There's two shifts for the concrete guys, and sometimes it goes to seven. We need to be topped out with steel at the end of 2011."

The thought alone makes Becker almost smile.

"This is once in a lifetime," he says. "It's goin' up."

To me, the voice of ground zero belongs to Brian Lyons. Another Tishman guy, Lyons was my first interview down here. He came down to ground zero on 9/11 to look for his brother Michael, a firefighter, and searched until he found all that remained of his brother's company—in the ruins where the old South Tower collapsed—and just kept on working at the site on whatever needed doing. He was supering at Tower Four most of the summer; now he's running the transit-hub job next to it, across the site from where we're sitting in Becker's little trailer.

"Workin' hard, man. I'm beadin' sweat all day."

This Ward guy made a big difference down here.

"I know Chris. Very nice guy. He helped navigate a lotta this stuff and get this thing goin'. And everybody's workin' hard to try to make that happen for him. Now it's a construction site. All the things in the past are past—we're ready to go, and there's a lotta work. We're here to build now."

It took a while, I say. Lyons shrugs.

"Every job has all that BS. You build your own house, there's always some mysteries going on. There's always that kind of stuff. It's construction. It's taken a long time. It's turned the corner. Now you're seein' the fruit of that tree comin' up outta the ground, which is beautiful. Every inch of the site is bein' worked on. We got our head above the street. Now we're towering towards the sky, and that's what this is all about.

"Nine years have gone by in the blink of an eye for me. I've been gettin' off that train and comin' in that gate for nine

Lather Erica Kane.

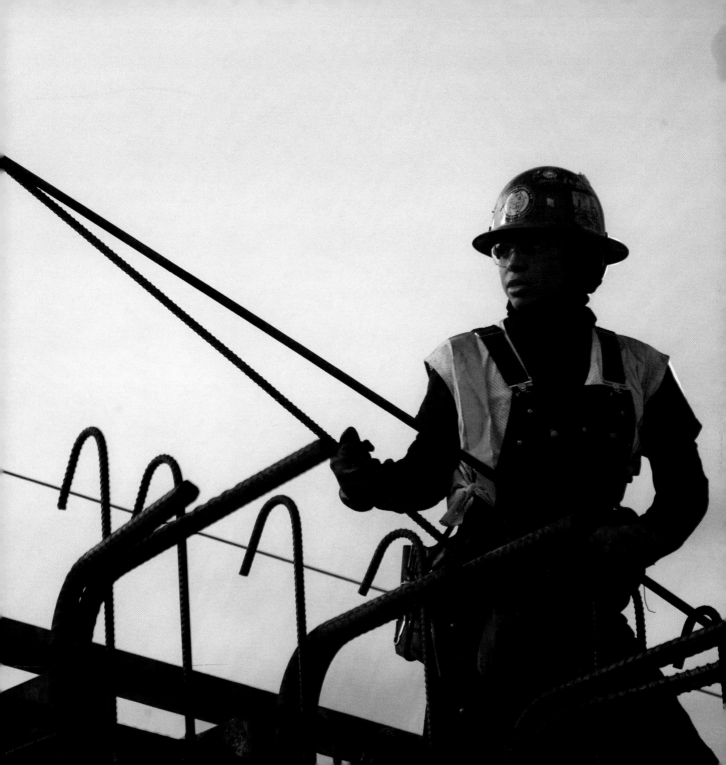

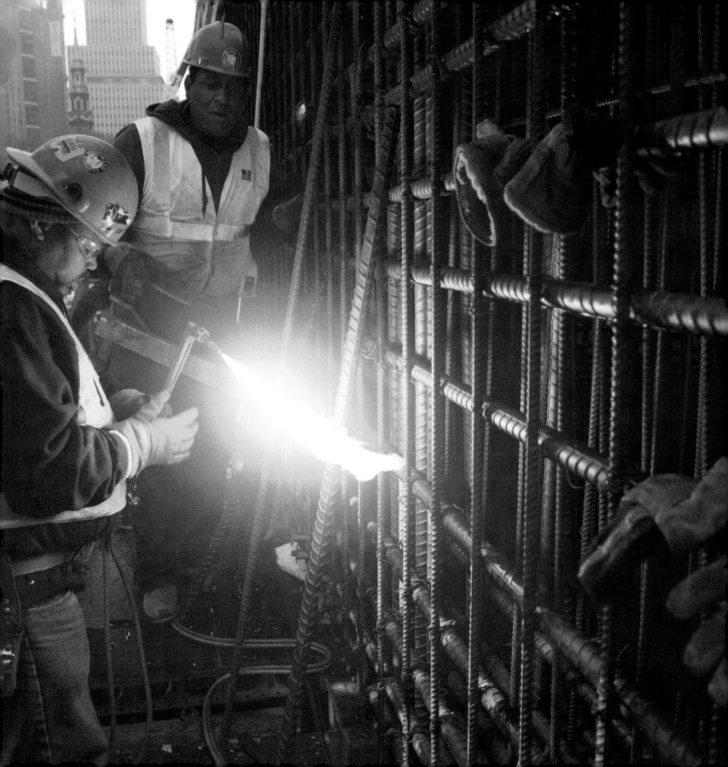

years, man. Every day—six, seven days a week. I go home exhausted every day. The kids are growin' up. And another anniversary's comin' up here soon. The delis, the pizzerias—they all have business now. When we were gettin' started, they were suffering. Now they're busy, they're feedin' their families, the stores are full, tourists are coming. There's a whole different buzz downtown."

A small park sits right across the street from ground zero, across the front door of New York's least-sung skyscraper, Seven World Trade, where you can grab lunch at any of several dozen nearby places, find a seat in the sun in front of Seven, and watch Tower One going up and up.

There are more places down here to eat than ever. More folks looking for a spot. Like Lyons says. More noise, more ancient wineheads panhandling, more hawkers of 9/11 kitsch, more residents walking their dogs, more taxis—a whole lot more New York City. You can see it, hear it, and feel it. And that really is the headline at ground zero:

The terrorists lost.

New York City won.

Not just because the pit is full. Not just because Tower One is climbing. Not just because anyone says so. Nobody needs to say a goddamn thing. The evidence is everywhere down here, and it speaks for itself: They can't win. They'll keep trying, and it won't matter. The spirit that built this place—New York City and the United States of America—the spirit that is rebuilding the World Trade Center now, can never be crushed by terror, whatever its creed.

We fucked up once. That's all.

All due respect, and not for nothing, but we fucked up. We didn't know—partly because we didn't want to know—we were at war. Al Qaeda let us know. They felled the towers, scarred the Pentagon, slew three thousand innocents, inflicted terror upon the people of a nation shielded for generations from war's hell by luck, geography, and a fearsome arsenal, all that, but it dishonors neither the dead nor America to speak the truth. It was a classic sucker punch, and it hurt plenty,

but it was not a crippling blow. Not even close.

America's unfolding political and military response is a subject for historians to parse, although I myself wish that Osama bin Laden had found fewer willing partners in jihad among our own ideologues and media mullahs. They share the same strain of nativist hatred that holds weaker nations together, that trusts fear more than freedom. We're either better and stronger than that or no better or stronger than our sworn enemies.

New York City's response to 9/11 is simpler to measure—mainly because the city was ground zero and hence forced to respond—and yet crucial to our vision of ourselves as a nation. And not simply because New York City is the best of America, but because—red state/blue state be damned—it is America. One of every fifteen Americans lives here, in the metropolitan region; for much of the rest of the world, New York City is the face, the living definition of who we are as a nation. And rightly so.

Besides, what New York City did in the wake of 9/11 is no different in essence from what other war-torn places have done under circumstances far more dire and with far fewer resources.

We cried. Prayed. Mourned our dead.

We went back to work. Building. Rebuilding.

We said everything that had to be said, without words.

This time, we're going higher.

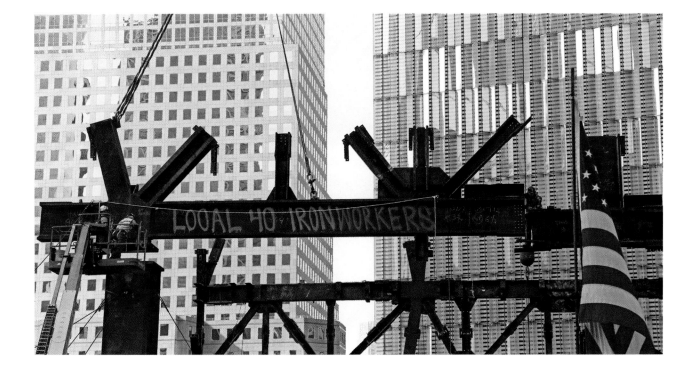

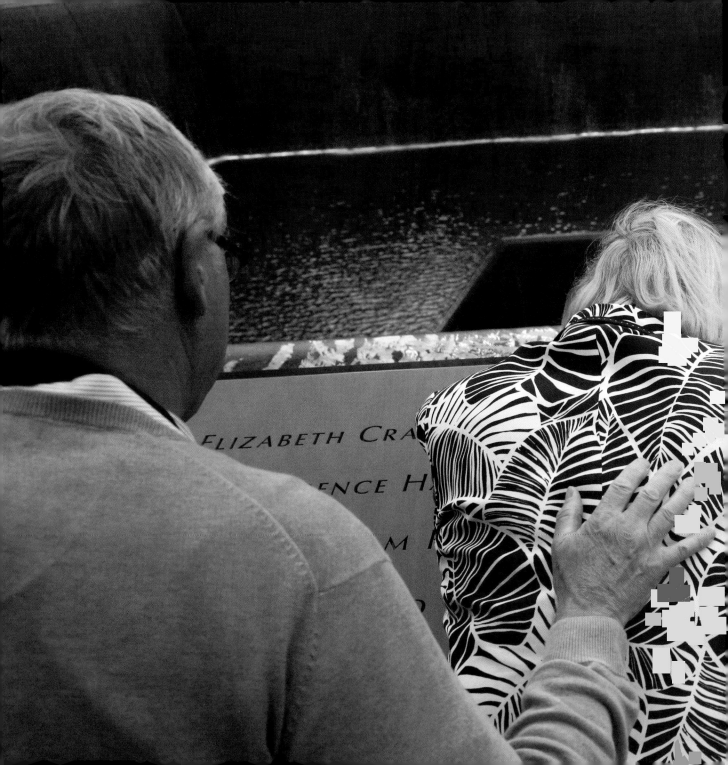

THE MEMORIAL

SEPTEMBER 2011

MARK SHULMAN

MICHAEL JOHN CAH

CHAEL CAPRONI

MARIA JAKUBIAK

INIA ELIZABETH FOX

JAMES EDWAR

DOUGLAS JON FARNUM

LY

LEXANDER H. CHIANG

PHYLLI

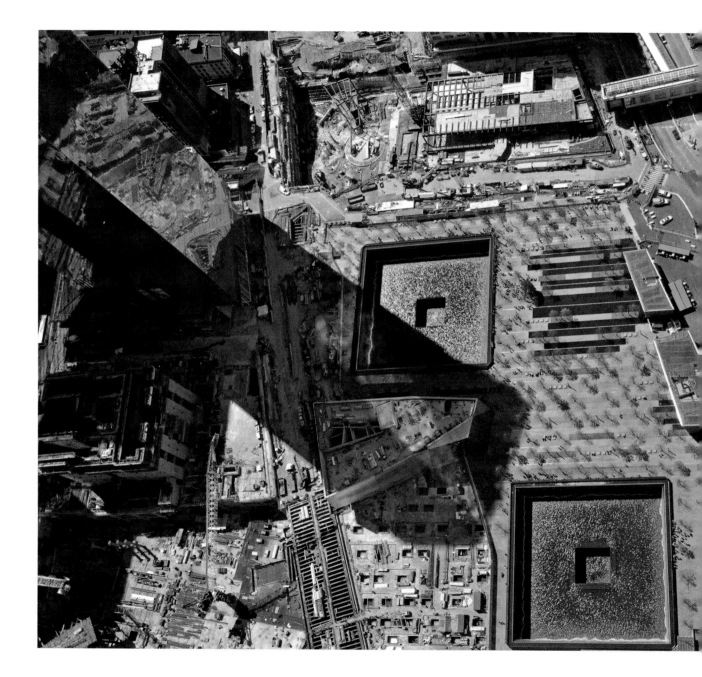

A gorgeous morning, but Katherine is uneasy. She asks Charlie to put the television on, just to distract her. From what? He doesn't know. He'll never know.

"Would you mind turning the television on? My mind is not at ease."

The same words he remembers her saying then he now repeats—ten years after that Tuesday—with the faintest trace of Katherine's Welsh accent.

Charlie hails from Buffalo. He met Katherine here in Greenwich Village, on holiday with a corps of London-based musicians who swapped visits over the years with a light-opera group Charlie had joined.

"I simply must get to know that woman," Charlie remembers himself saying to a friend after he first spoke to Katherine in a church basement during a rehearsal. Charlie sounds like Cary Grant the way he hits "simply must," but that's more his attitude than an accent: Charlie is a bon vivant. Charlie Wolf didn't settle in New York City by accident. No one does.

So that Tuesday, Charlie clicks on the TV for Katherine. He's at his desk, online, working. A tiny apartment in a good building on a nice block in the Village with a sushi joint to die for down the street. Thirteen years they've made their home here, all of Manhattan humming and thumping around them.

Katherine's leaving for the subway to work early—8:06. She left yesterday at 8:14. Charlie notices this sort of detail, mentions this to her. Katherine doesn't want to hear it. Something else is bothering her.

At dinner on Friday, Charlie had brought up the subject of trying to make a baby. Could that have been on Katherine's mind? A few years before, she had talked about getting pregnant in two years, and there things had sat ever since.

Letting things sit isn't Charlie's way, and now Katherine is past forty, and so he feels it's time for them to make a proactive decision: Yes or no? Not that the question was resolved at dinner, but it was back on the table.

"She's about to walk out without kissing me goodbye," Charlie remembers. "I would stand here"—on the second-topmost step leading up to the

kitchen area—"and she would stand right here, which would put us about even height. And I would give her a hug—a hug and a kiss—and then walk her out the door. Our normal routine."

Katherine takes the E train. Hers is the third stop: Spring, Canal, World Trade. It's the beginning of her third week at Marsh & McLennan, on floor ninety-seven of the North Tower. A good job for a Fortune 500 outfit, excellent benefits, a steady salary. Nice folks. The week before, her boss asked if she could come in at eight thirty instead of nine—not an order, a check-with-your-husband request. Not a problem. A half-hour head start on the day. Of course.

On the bulletin board above Charlie's desk, a small Stars and Stripes is tacked above a small Union Jack.

He and Katherine married twice: quietly the first time, in Swansea, her hometown, in 1989, just to get the immigration process rolling; then again the following year, at the Cathedral Church of St. John the Divine, with a forty-five-voice choir from the light-opera company singing along with

Charlie as he serenaded her with Sigmund Romberg's "The Desert Song": "I'll sing a dream song to you, / Painting a picture for two."

They hug and kiss and Charlie goes back down the stairs to his desk. Turns off the TV, goes back to work. The sliding-glass balcony door is open to the cool air; the traffic noise from nearby Bleecker Street is the usual background. From out of nowhere, a metallic yowl—too low, too loud, directly overhead—has him on his feet and out on the strip of balcony.

He's on the third floor and sees nothing in the sky, and so he steps back inside and just then hears the thunder of American Airlines Flight 11 as it hits the North Tower at 440 miles per hour, carrying ten thousand gallons of jet fuel. The impact zone stretches from floors ninety-three to ninety-nine, all occupied by Marsh & McLennan.

Charlie's thinking sonic boom. Then he hears a woman on the street shout, "Oh, my God, a plane's just gone right into the World Trade Center."

Charlie runs downstairs in his pa-

jamas, out into the middle of the street. The North Tower stands at the end of his sight line with a gaping hole near its top. He thinks about rushing to find Katherine, imagines the chaos, and goes back to their apartment.

"She'll come down. She'll come down without her purse, which is where her cell phone is. She may not remember my cell number, but she will remember the home phone number. Two moving targets can't find each other. I will be the stationary target."

Charlie tries Katherine's work and cell numbers. Then he gets the phone book and calls the FBI.

"I had to do something. I said, 'That was no accident.' I said, 'That plane was going full throttle—it was no accident.'"

Charlie hangs up, then realizes the FBI might not believe him. So he calls again.

"Listen, I just called. I want you to know I'm a pilot." Charlie has a pilot's license. "I know the sound. Those engines were maxed out."

Charlie turns the TV back on. The phone starts ringing—Katherine's parents, his parents. He sees the South Tower get hit, the pilot banking so steeply just before impact.

"I believed one, but I couldn't believe two. Then I watched Tower Two fall. Then I heard all kinds of commotion outside. People running. I stayed right here. The door was closed. The television was on. I stayed here waiting for her call."

Charlie remembers the moment he knew that Tower One was doomed, too.

"Ten twenty—it's off the vertical. I said, 'It's going to go.' I was sitting here watching this thing—and I just watched it come down. I said, 'Well, I guess I've got to start my life over again.'"

Charlie starts getting hungry in the afternoon. Katherine made peachy pork picante last night, and there's a portion left over in the fridge, but he can't bring himself to eat it, and so he walks to Bleecker Street, to Ottomanelli & Sons, where he and Katherine buy their meat. The doors are locked and the store is dark, but when the men inside see Charlie, they let him in.

"They opened the shop for me. They always tease me about the fact

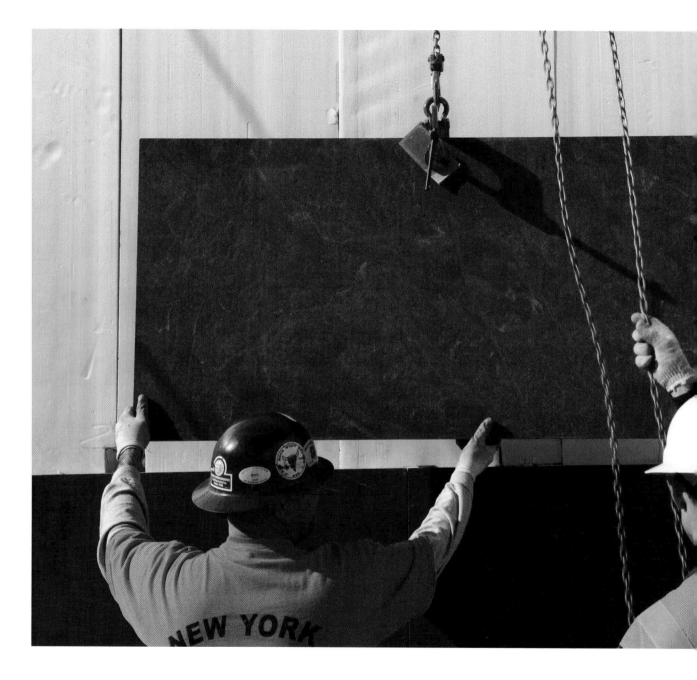

that I asked for a receipt, just like I always do. And I went home and I cooked dinner for myself. The peachy pork picante sat in there for a couple of weeks, then it got thrown away. I couldn't eat it."

On Wednesday, Charlie goes to a building on the East Side to fill out an official form for those missing loved ones. On Thursday, he bags Katherine's hairbrush and toothbrush and takes them to another building, where the authorities are collecting DNA samples, and there he sees the sandwiches—cardboard boxes and picnic hampers full of homemade sandwiches. And the sight of those sandwiches—of kindness incarnate—cracks open his heart. He cries at the Armory, weeping on a policeman's shoulder as the policeman comforts him, and thinking that this much kindness must mean that evil hasn't triumphed, God has.

By Friday, Charlie realizes that Marsh & McLennan lost its entire tower workforce—355 souls—on impact. He is comforted by the thought that Katherine didn't suffer long—"She was vaporized," Charlie says—yet he also understands that there will be no remains, no DNA match, no grave. Nothing.

Charlie goes back to the apartment and packs the clothing Katherine had worn to work on Monday into plastic bags.

"I took her bra, everything. Oh, yeah. Everything. I wanted so badly to retain her smell for as long as I could. But it didn't last."

On September 11, 2011, Charlie Wolf will join with other family members of the murdered and walk the tree-lined plaza to the heart of ground zero—to the twin pools, north and south, that mark the voids left vast and eyeless where the fallen towers stood, lined now in black granite, bordered by bronze panels with the names of all the dead, and alive with water falling in a ceaseless thirty-foot cascade from the parapets on each side—a walk that began ten years ago. For the first time since the slaughtering, something timeless—not temporary, not tossed up and taken down like the tent raised like a stage prop each 9/11 to shield the VIPs—something created to embody

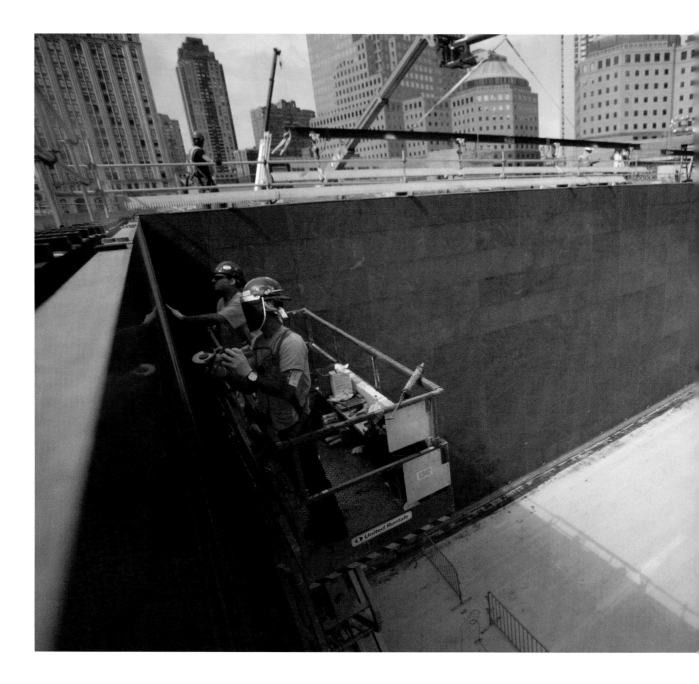

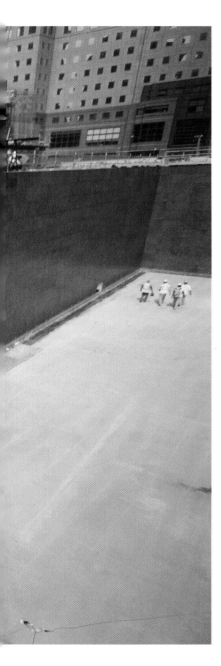

a collective sense of memory, loss, and hope, something built to last, will finally grace this patch of land.

Two days after Christmas 2001, Mayor Rudy Giuliani delivered his farewell speech at St. Paul's Chapel, just across the street from where crews were still clearing wreckage from ground zero.

"Long after we are all gone," he said, "it's the sacrifice of our patriots and their heroism that is going to be what this place is remembered for. This is going to be a place that is remembered a hundred and a thousand years from now, like the great battlefields of Europe and of the United States."

Rather than rebuilding office towers, Giuliani urged New Yorkers to "think about a soaring, monumental, beautiful memorial that just draws millions of people here that just want to see it. And then also want to come here for reading and education and background and research."

But this was no battlefield—the Twin Towers long had been an international symbol of the audacity and ambition that beckoned the rest of the world to rush over and grab its share. Nor was this Oklahoma City, where the creation of a memorial for the victims of the terrorist bombing of the Murrah Federal Building had taken five full years of headache and heartache.

This was Manhattan—three blocks north of Wall Street—and a construction project that would bring in tens of billions of dollars, untold thousands of jobs, and a chance for New York City to pick itself back up, restore its pride and its skyline, and flip off Al Qaeda. The notion of turning the World Trade Center's entire sixteen acres into a memorial was never a possibility.

Giuliani, in fact, understood this perfectly. Within three weeks of 9/11, just before a mayoral election that most folks assumed would put a Democrat into city hall, he and Governor Pataki, a fellow Republican, created the Lower Manhattan Development Corporation, engineered to give Pataki decisive power over the rebuilding process—and over the billions of dollars sent from Washington—and also as a shield to deflect any controversy away from Pataki, up

for reelection the following November. The governor would make the ground zero promises; the LMDC would either make them good or take the heat.

The heat was relentless. By March 2002, before ground zero had even been cleared of its wreckage, wrangling among the LMDC, the Port Authority, Silverstein Properties, and various community groups was a daily news staple. In April, gubernatorial hopeful Andrew Cuomo had dismissed Pataki's ground zero leadership publicly. "He stood behind the leader," Cuomo said. "He held the leader's coat." It was a ghastly call back to those days right after 9/11, when Rudy Giuliani became America's mayor, and it sank Cuomo, but it also reflected the impatience and anxiety surrounding the rebuilding.

Among some of the families of the 9/11 victims, that impatience and anxiety, fueled by grief, turned fiery. There were screaming matches at public meetings, lawsuits, and a media atmosphere that amplified every angry word. Groups and causes multiplied, and not for nothing. Some were enraged when WTC wreckage was removed to a landfill, where it was supposed to be sifted for evidence of human remains. Some insisted that each inch of those sixteen acres was sacrosanct, off-limits to anything but a memorial. Some spoke of civil disobedience to stop construction. Some blamed the Port Authority's exemption from meeting the city's building code for the collapse of the towers. Some hounded Congress to investigate the attacks. Some wanted a separate ground zero memorial for the 343 firefighters and paramedics who'd died there.

Some of the most contentious aspects of the rebuilding of ground zero—foremost among them the question of what to do with more than nine thousand pieces of human remains recovered from the site and still unidentified—are impossible to resolve to everyone's satisfaction. You put an office park on a fresh graveyard and you're going to royally piss off some folks, particularly among the eleven hundred victims' kin like Charlie Wolf, who never received remains of any kind. But from the very beginning, the

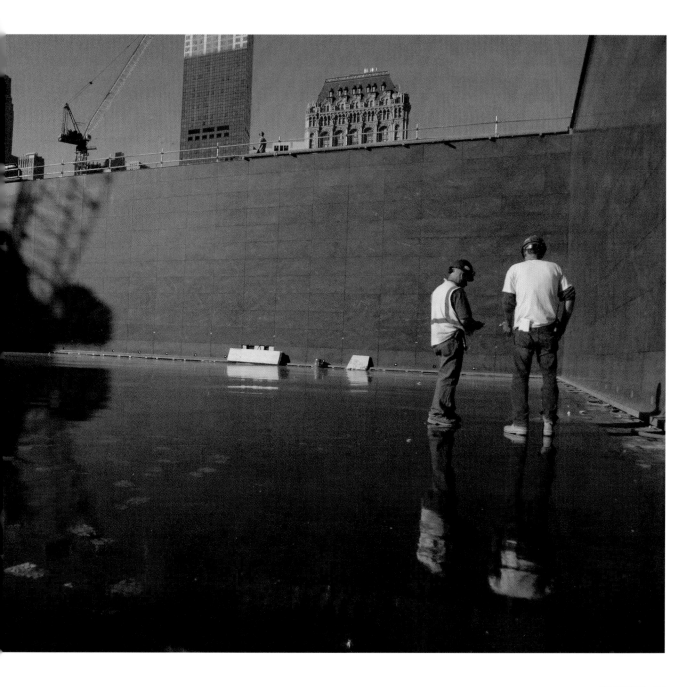

details of the controversies hid a larger truth about New York City: All of the public pushing and pulling—all of the yelling and questioning of others' motives, all of the posing of politicians and the editorial harrumphing—all of this was, and is, the healing process writ large, city-wide.

This was the world's greatest city putting back the pieces of its collective life the only way it could—at full roar, elbows out, ready to scuffle. If fighting back from shock and grief and fear required some refracturing, some bumping and shoving, some fighting words, some insult, amen. In New York, it must always be so. By definition. Ask your cabbie.

Michael Arad did it. Arad was thirty-two years old, an architect working for the firm of Kohn Pedersen Fox, son of an Israeli diplomat, a Dartmouth grad and an Israeli army vet, and a bit of an outsider after only two years living in the city—until 9/11, when from the rooftop of his apartment building

Michael Arad, architect of the 9/11 Memorial & Museum.

he saw Flight 175 bank and plow into the South Tower.

"That day made me a New Yorker," he says. "Not just that day—the week that followed, seeing how people came together. I'd sort of stayed on the cool surface of being removed from New York, not being part of it. All of a sudden, that just shattered."

Arad is forty-two now, tall and lean and quick. He walks the memorial site in his yellow safety vest and black hard hat as if he owns it, and right now—eighty-seven days before 9/11/11—he does. Crews are still installing the last of the bronze panels bearing the names of the dead, still painting the bottoms of the pools, still testing the waterfalls, still planting the trees.

"At this point, it's not about a design—it's about making sure everything gets done."

Ah, but for a visitor, even now, it certainly is about the design. We're at ground zero, under a sky dark and thick with storm clouds, hard by the north pool, where Tower One once stood. The void is itself a few feet smaller than the footprint of the original tower, yet it seems vast, a bottomless, black-clad pit where the plaza and the surrounding city fall away to reveal its cored heart, an open wound, forever unfillable.

The parapets rise waist-high, their panels—nineteen per side—angled so that the hand is drawn to touch the letters cut from the bronze to form the names of the dead. The air, heavy with heat, electric, seems to pull at the sky. The south pool sits in the near distance—impossibly far somehow—the second footprint, the other Twin, also bordered by seventy-six bronze panels.

The scale and symmetry pack a shocking wallop; you will find no mercy here. Six summers ago, on my first visit to ground zero, I stood—not here, exactly; seventy feet below, at the bottom of a pit scraped raw of all it had held except the sheared tops of the perimeter columns, outlined in orange traffic cones, of the Twin Towers—stood and felt my throat knot. The site has risen, slow and inexorable—always in dispute, always with the absolute certainty that New York City would finish the job, that whether good and evil exist in the sense meant by Charlie Wolf is

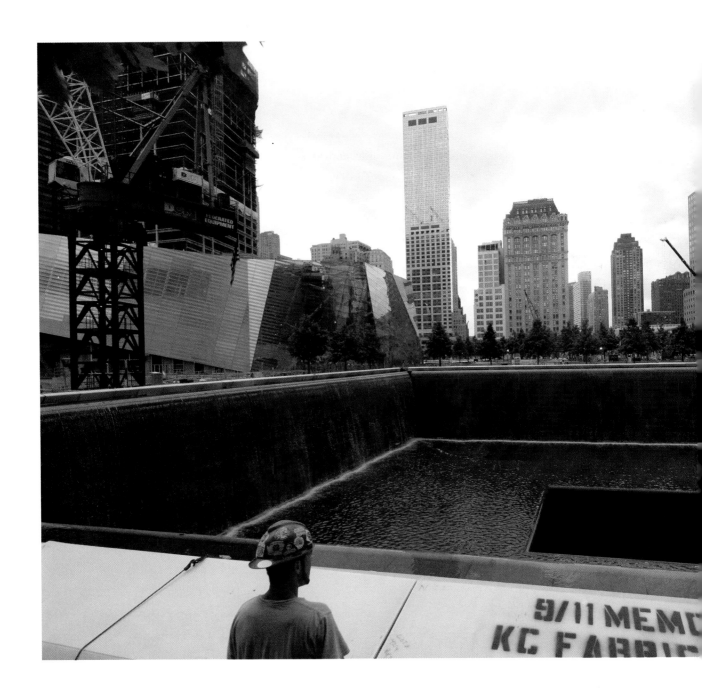

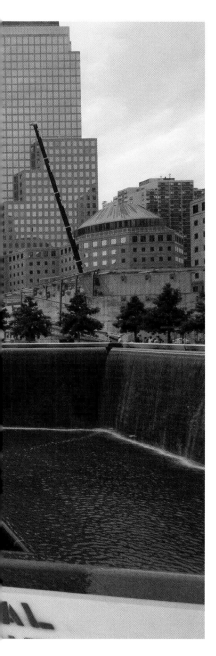

moot, because the human soul of this city and this country is in its essence beyond the reach of terrorists—and now, at last, with a completed memorial at hand, and with the Freedom Tower just a few yards away and already seventy stories high and climbing, I feel an overwhelming awe and sadness, as if the sky had kept falling after 9/11.

"It's like going to Gettysburg," Arad says. "It's like going to Pearl Harbor. It's like going to the National Mall. This is part of America's historical fabric now."

Yes, but raise your eyes only slightly and the downtown skyscrapers claw at the clouds, and the old, narrow streets run south to the tip of this island empire, and there it is, the rush of life and spirit that pulses at the city's heart, even here.

Even here, if only you lift your eyes.

"I always thought of this entire site as the memorial plaza, which a lot of people disagreed with when the design was unveiled—'No, your memorial is *on* the plaza; it's not the plaza.' But it had to be the entire plaza. The moment you step off that street onto it, you feel this sort of charge. You sense it now,

when you stand on that pavement. It's one of New York City's blocks, and that's what it should always be."

The LMDC chose Arad's design in January 2004 over fifty-two hundred other entries in a global competition. And so began another round of the years-long skirmishes that came to define ground zero. Arad battled the LMDC, which insisted he work with a landscape designer. He wrestled with the landscape designer over the number, kind, and placement of the trees. He fought with Daniel Libeskind, the architect whose ground zero "master plan"—chosen by Pataki—called for sinking the entire memorial thirty feet below street level. He clashed with family groups over the arrangement of the names on the panels and the placement of the pools.

Arad was fighting for his vision; the Memorial Foundation, which included family members, was trying both to placate all parties and to raise funds to build and maintain whatever was finally built. Every change and delay meant a rise in estimated construction costs. What was planned as a $350 million

project rose to $500 million by 2006, at which point the foundation president decided to halt fundraising until the memorial and its cost were more clearly defined. At which point Mayor Michael Bloomberg replaced the foundation president, under whose direction only a little more than $100 million had been raised, took upon himself the job of fundraising, negotiated with the Port Authority to share some costs and supervise the memorial's construction, and helped finalize the design details.

Arad lost as many fights as he won, but he doggedly preserved the vision put forth in his contest entry statement, of a memorial site that served as a sacred memorial ground and as a large urban plaza.

"We have to make this part of the city again. It has to be alive. You have to bring people in. The people in these office buildings should be able to walk out, cross the street, and sit under a bench on a normal workday. But it also has to work for the people that come here once in a lifetime, like a pilgrimage. How is it an urban park and a national landmark at the same time?"

It was a battle more subtle than listing the names. The master plan called for ten million square feet of office space at ground zero, plus a new train station, plus a performing-arts center and a cultural center, all while keeping sacred the old towers' original footprints. The goal, in short, was to build a new, better World Trade Center complex on eight acres rather than sixteen.

The jigsaw-puzzle aspect was three-dimensional: In terms of access and below-grade infrastructure, each individual building project on the site was linked. This meant that the memorial plaza's underside was part of the roof over the transportation hub's concourse, and Arad's wish for the plaza and the streets around ground zero to form a seamless whole meant keeping the plaza at street level, even if raising it made room below for an extra level of retail space.

"At no point do you have more than two or three feet separating the surrounding sidewalk from the memorial plaza. You can walk right off the sidewalk onto the plaza. The streets won't

continue onto the plaza, but they'll bring that flow of people."

In New York City, that flow is no small thing; it's an integral part of Manhattan's persona. And at ground zero, where the original World Trade Center was built on a "superblock" that deliberately set itself above and apart from its surroundings, the plaza represents the restoration of a connection severed forty years ago, a literal rebirth of these sixteen acres with the rest of downtown.

"It really was about mending the urban fabric, and if this is a scar, it's a scar that's still visible. But it's not a scar that's concealed or hidden—there's no desire to hide it. There's a desire to make it whole again but not erase the past. It unifies this entire plaza as one entity, this vast urban plaza cut by these two massive voids. You feel it, right? The sky, the wind, the water—but you also need Lower Manhattan to feel this place. You're not going to forget that you're in the city."

As Arad speaks, the storm breaks and we cross the plaza and duck inside a construction trailer until the rain lets up.

"I've never been out here in the rain," he says. "I had imagined it, but actually seeing it, the rain flowing on the names, it's beautiful. It's another way you feel it—you graze your hand across the names. When you have light reflecting from under it—at night it's illuminated from within, so you'll see light coming through the letters—they look like shadows during the day, but at night they'll glow from within. It's beautiful. It's going to be powerful."

"It's powerful now," I say.

"Yeah, but it's going to really be powerful once people are a part of it. That's what's going to charge it. Once people come here, it'll make this place alive again. Standing here in the presence of others is such a key component. It's really about not being alone in the face of this, about being a part of a much larger community, which, in my mind, is critical to facing the history of that day. That's how I got through it"—he's referring to 9/11 and the days after—"by going to Washington Square Park and standing next to other people. You don't need to talk to them. You just need to be in the presence of others."

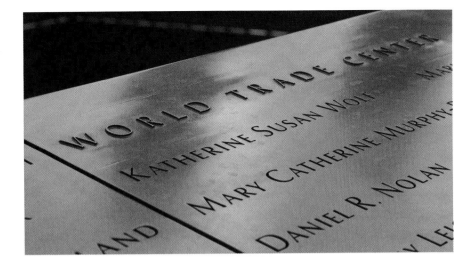

Facing page: Charles Wolf stands next to the nameplate of his wife, Katherine Wolf.

Right: The nameplate of Katherine Susan Wolf, the first name chosen to be next to the sign of *World Trade Center*. January 2021.

Charlie Wolf's computer is another memorial: On it you can read a history of ground zero, a narrative of its undoing and becoming, and of Charlie's. Over the years since 9/11, Charlie has taken to the battlefield for a number of causes. Early on, he campaigned against the Victim Compensation Fund—created by Congress as part of legislation to save the airlines from bankruptcy—for underpaying the victims' families. He also worked with Take Back the Memorial, a family group that successfully pressured the foundation, the governor, and then-senator Hillary Clinton to put the kibosh on the International Freedom Center, a vaguely defined "cultural center" to be built on the memorial plaza.

The IFC immediately became a political football—and a competitor for ground zero funds and attention. The effort to stop it was public, political, and vicious enough to play out on the editorial pages of the *New York Times* and the *Wall Street Journal*. Under sustained pressure from Take Back, Pataki offered the Freedom Center alternative space elsewhere on the site; the IFC declined and declared itself defunct; and a lot of folks involved in the rebuilding worried

aloud—and off the record, always—that a mere handful of 9/11 family members had shanghaied the process.

Charlie's conservative, but hardly knee-jerk or rock-ribbed about it, and his objection to the IFC was mainly that it literally encroached upon the 9/11 museum's turf.

"You give a memorial wide berth," he says. "I think they honestly thought they were doing a good thing. They were basically promoting freedom— which is a great thing in itself. Wonderful subject matter. But it didn't belong next to the memorial. It doesn't belong there."

The most interesting facet of the IFC affair and its aftermath was the umbrage taken at the nerve of a group of family members who refused to take their compensation and grieve privately, quietly. Here you had two politicians— George Pataki and Rudy Giuliani—hoping to forge a ground zero legacy that might launch a White House bid; a real estate developer and a landlord—Silverstein and the Port Authority—who saw the site primarily in terms of dollars and cents; a federal government

endlessly milking 9/11 for political capital; an array of architects and construction firms cashing in on rebuilding an area where human remains still revealed themselves; and broadcast and print media harping on discord and minutiae.

All of this unfolded year after year after year, long after disinterested parties—most New Yorkers included—had tuned out ground zero and its rebuilding completely. Family members who did more than trundle to the site each anniversary for the reading of the names weren't villains; of all the players, their agendas, however overwrought, were by far and demonstrably the purest. The memorial, for many of them, will be the only grave site they'll be able to visit.

"I wasn't exuberantly happy with it," Charlie says of the memorial, and then cues up cell-phone video of a test of the waterfall in the North Tower footprint.

Charlie's opinion has changed.

"Look," he says. "Isn't this gorgeous? The more I've seen it—it's grown

A young boy, John Fisher Timson, has a moment of reflection after arranging flowers around nameplates on the plaza at the 9/11 Memorial & Museum. September 11, 2019.

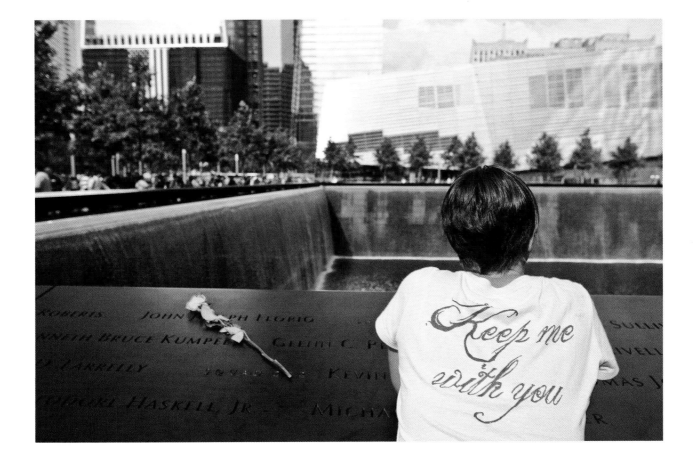

on me a lot. I supported it, but I didn't think, *My God, this is wonderful*. Then I really got it. It's an inversion of the towers. It's great—it really is."

His phone rings: another family member consulting Charlie about the upcoming move of the family room from the current memorial and museum offices to the museum itself next year—there may not be enough room to bring over all of the mementos that have accumulated over the past ten years.

You're a go-to guy, I tell Charlie.

"I am," he says. "And some people have a problem with that. But I don't have a problem if they have a problem with that, because I do the best I can. I am proud of the work I've done. I'm proud that I've tried to stand up for things that are right."

Chris Ward, executive director of the Port Authority of New York and New Jersey, made two utterly astonishing things happen: He restored the PA as a credible ground zero entity, and made the Freedom Tower so attractive a property that Condé Nast, the fashion-mag empire, agreed to lease a million square feet of a tower that for years had been dismissed as a white elephant, a hive for government drones.

"That took my breath away," Ward says. "Four thousand young creatives, people who want to live in the city—we made downtown real for them. It takes everything people think and flips it."

The memorial was tottering when Mayor Bloomberg stepped in, and Ward and the PA stepped up.

"The mayor made it real," says Ward. "He raised $350 million on his own back, navigated through all the difficulties and the families. He delivered it. Pretty incredible."

Despite his leadership—or maybe because of it—Ward's post-9/11/11 future is shaky. New York's new governor, Andrew Cuomo, may hand the job over to his own appointee; the silence from Albany on this issue, given the tangible evidence of Ward's performance on the ground, says that Chris Ward's sell-by date is any day after the tenth anniversary. It's not a subject he wishes to address in any depth, except to say that he'd like to see the job through—and

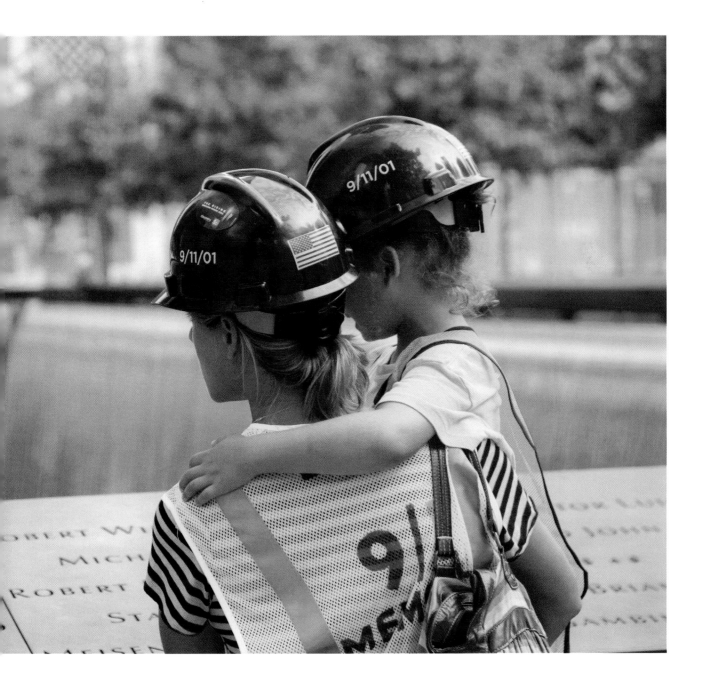

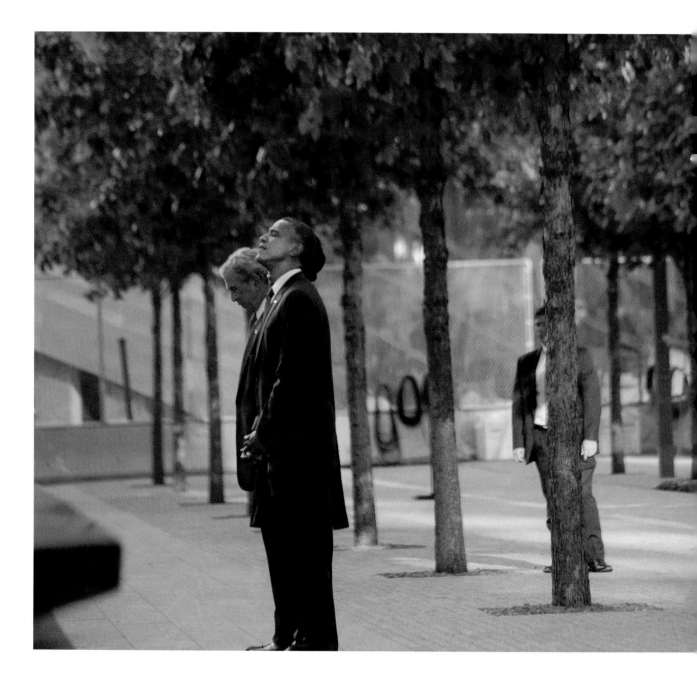

President Obama and President George W. Bush at the dedication ceremony at the opening of the 9/11 Memorial.

that he's proud that the memorial plaza will be ready as promised.

"The remarkable thing that I think is going to happen after this ten-year anniversary is that New Yorkers in particular, but also the rest of the world, are going to realize that it doesn't have anything to do with what they've been told it is," says Ward. "The whole site has been so burdened with expectations and definitions—politically, culturally, socially—from that world that creates political agendas and says, 'This will be a place of strength against terrorism,' or 'This will be a symbol of that'—no. It's going to be about what they want it to be.

"It's going to be about Charlie Wolf finding time to go there without having an elected official tell him what it means. And it'll be his moment of quiet. But it'll also be somebody who works there, or who goes down to the park on a spring day and has a sandwich, or somebody cutting across on a rainy day.

"Is it a remembrance of an event? Is it a place to meet a date? Is it where you work or go shopping? And that's what'll make it great for New York—it won't be defined by anything but the people who go there. That's going to be what's beautiful about it."

On May 5, 2011, four days after the killing of Osama bin Laden, President Obama came to the memorial plaza to lay a wreath. The day was sunny, cool, and clear; the mood was wondrous strange. Ground zero was no longer a pit, a hole left unfilled by earnest, empty promises and proud, pointless ceremonies. Tower One—the Freedom Tower—rose nearly eight hundred feet above the site, Tower Four nearly five hundred feet. No one was working construction here, but the sky was full of cranes, and the plaza's sweep bound the buildings to the land and to each other and to the city visible rising on every side. Time stood still here for too long. No more. Now the ironworkers on Towers One and Four are racing one another to see who tops off first this coming spring.

The president and a fire-department

official placed the wreath on an easel beneath a pear tree—the Survivor Tree, scorched on 9/11, nursed back to health in the Bronx, then returned to ground zero, not far from the south pool—and then Obama bowed his head for a long stretch of silence. He had no speech to make; earlier, visiting a firehouse for lunch, he'd said, "When we say we will never forget, we mean what we say"—and now he turned and walked toward the woman standing a few yards from him, a 9/11 widow with her daughters, and hugged her tight.

A fine day at ground zero for Obama, who spent a good long while meeting privately with family members; a great day for New York City, whose collective ability to survive—to thrive—in the face of terror is proof of its undying spirit. Any sense of triumphalism over Bin Laden's watery corpse is not only the result of the horrible injury inflicted by 9/11, but also a heartfelt reaction to the insulting belief that any act of terror could break this city's will.

For Charlie Wolf, this is an especially good day. At a gathering of family members after the ceremony, he has a chance to meet the president, to look him in the eye, shake his hand, and thank him for avenging his wife's death.

Charlie brings along a small photo of Katherine and hands it to Obama, who looks at it, beaming, and gives Charlie a big hug.

"Thank you," Charlie says, full of tears. "Thank you. Thank you. My wife told me she would be sitting on your shoulder today."

"That's fine," says the president. "She can come sit on my shoulder anytime."

Glen Ridge, New Jersey, my town, lost seven people on 9/11. Their names are engraved on a stone that sits in a small square memorial that appeared near the train station in 2004. Above their names, it says:

WE SHALL NEVER FORGET OUR FAMILY, FRIENDS AND
NEIGHBORS WHO LEFT WITH US THAT MORNING
BUT DID NOT RETURN WITH US THAT NIGHT.

I didn't know any of them. In the course of writing about the rebuilding, I've met a few folks who lost family members on 9/11, but Charlie's the only guy I've ever sat with and listened to and thought about at any length.

He's a little wacky, Charlie, in a good way—wide-open, a free spirit. We go to dinner one night at a seafood place in Midtown, and Charlie makes it an event—an oyster tasting, long and detailed wine consultation with the beverage director, flirting with the young Russian woman who serves us. A great night.

Charlie, I say, you're like a kid. Pure of heart.

"I am, yes. You're right. That's one of the reasons that Katherine and I worked so well together. She had a childlikeness to herself. I was wondering back then whether I was ever going to find somebody. I was really wanting somebody, and it was just—I am not a normal guy."

Charlie's had one long-term relationship since Katherine died, but it fizzled out, and he hasn't dated anyone in a couple of years.

"I said, 'They may have gotten my wife, but they're not getting the rest of my life.' I was determined—around March of '03, I started pushing myself out the door. But I don't play the games. I don't know how to play the games. I didn't know there were games to play. Women can't figure me out if they're looking for a game I'm playing—especially the older women. I get along best with women who are in their twenties and thirties."

Not exactly a curse, Charlie.

"No. If God will allow it, I'd love to have a family someday."

I'm listening to Charlie, but I'm thinking about my wife and son. If my wife never made it home one day, out of the blue like that, I don't know if I would have the gumption to keep going. My kid, too? Forget it.

Charlie's making yummy noises over dessert, a pink champagne cake.

I'm taking you to all my restaurant meals, I tell him.

"What you see is what I am," he says. "I'm not putting on an act."

Enjoy. We can do the interview stuff another time.

Charlie gives me a look, a Bill Murray look—lips pursed, eyebrows arched.

"I love telling this story. My wife and I planned our wedding together. This was as much mine as hers. Katherine was a fantastic piano accompanist. She worked as an accompanist for the Philbeach Society in London. She was good. She was very, very good."

His eyes close for a moment.

"I sang for my wife at our wedding," Charlie says. "And then the same song that I sang to her at our wedding, I sang to her at her memorial service."

What song?

"It's called 'The Desert Song,' from the show of the same name, by Sigmund Romberg," Charlie says. "At the memorial service, I didn't know if I could—it was very emotional. It was October 2, 2001."

Charlie remembers. We shall never forget. And then we do forget. We die and so do those who remember us. Stones on our graves, stones at the train station, bronze panels at ground zero: We do what we can to remember. We do the best that we can. But we can't live in the past—let the memorial do that for us. We live in the moment, the only moment we truly have.

"I told the organist—the same organist who played at our wedding—'I don't know if I can. The only thing I have to do is make my thank-yous to people.' And I got up there and talked for about ten minutes, and I just decided to do it. I said, 'There's something here I'm going to try to do.' And I did it a cappella."

And damned if Charlie doesn't start singing right there at the table, too, his eyes closed again, his baritone light and sweet.

I'll sing a dream song to you,
Painting a picture for two.

Right there at the table. And damned if it isn't the most beautiful thing ever, long after Charlie's last note drifts off into the night.

Yvonne Salerno and Patrick Swift, family members of 9/11 victims, embrace.

Following spread: Rob O'Neill, former Navy SEAL Team Six, who shot and killed Osama bin Laden, stands inside the "In Memoriam" room at the 9/11 Memorial & Museum.

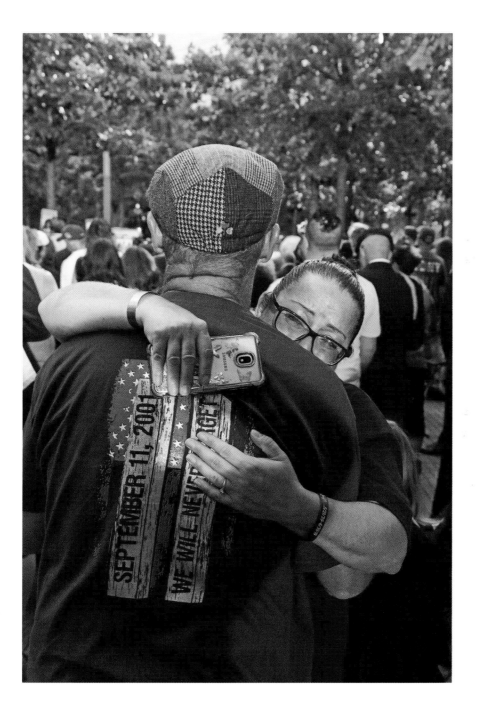

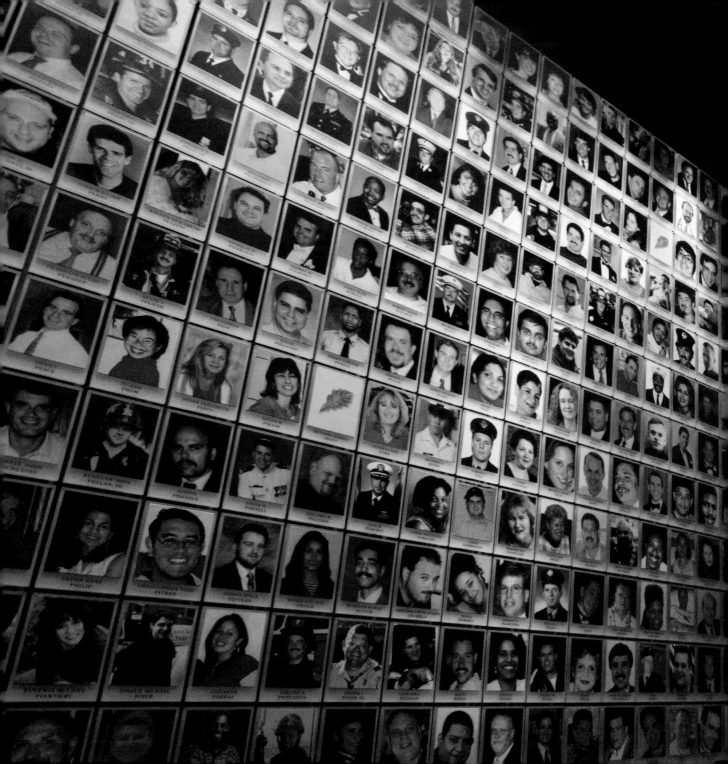

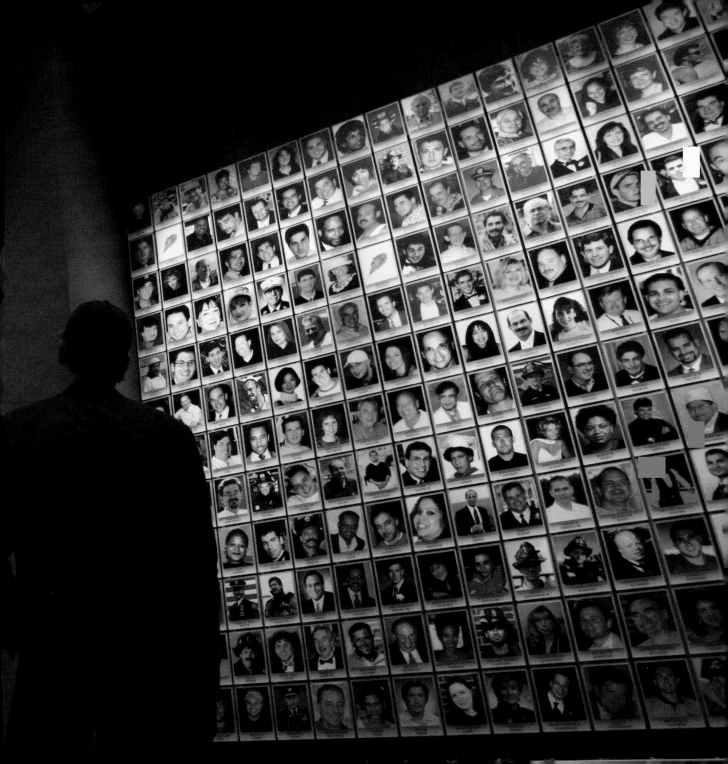

THE TRUTH ABOUT THE WORLD TRADE CENTER

SEPTEMBER 2012

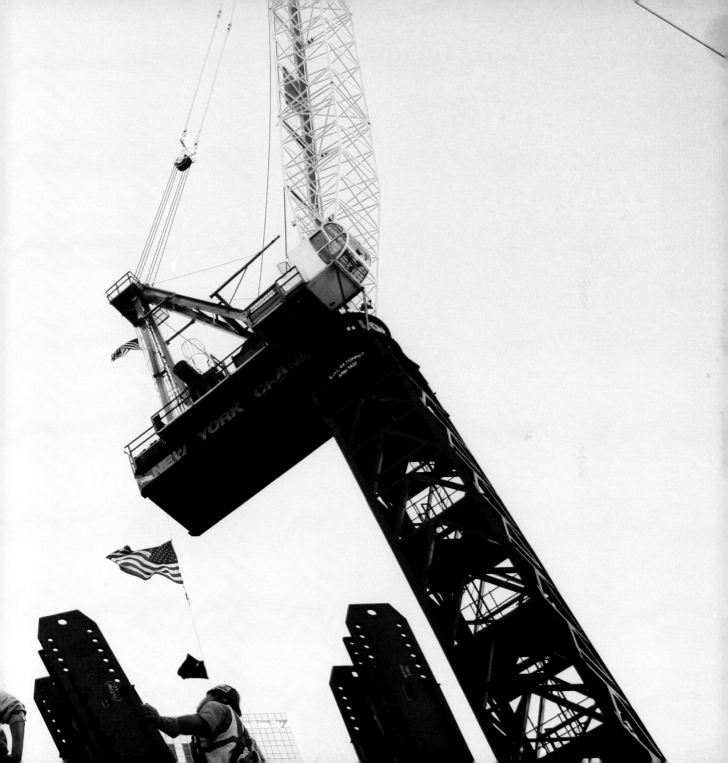

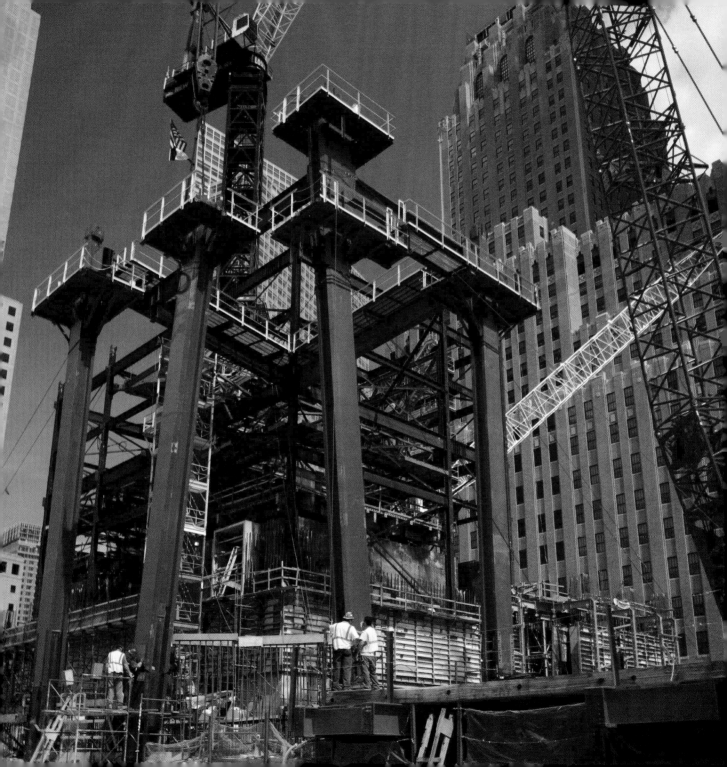

On this September 11, 2012, for the first time, no public official will speak at the ceremony at ground zero. This may be due to last year's tenth-anniversary event, when the crowd offered George W. Bush a brief yet rousing huzzah and gave Barack Obama the silent treatment. It may be that like the Oscars, the 9/11 commemoration tends to run long, what with the reading of nearly three thousand victims' names, and stilling the pols will save time while offending absolutely no one. New York's mayor, Mike Bloomberg, suggested the names need not be read, since each is etched into the parapets surrounding the memorial pools, but those names, read aloud by friends and family, will echo again across the sixteen acres where they died.

Last year, the memorial plaza opened on September 11, the first completed project on the site and one of very few feel-good moments during a decade of rebuilding marred by blown deadlines, public backbiting, and billions of dollars in cost overruns. The plaza finally provided the kin a mourning place, and

it also seemed like solid evidence of momentum.

That momentum died not long after last year's ceremony, when the Port Authority of New York and New Jersey, led by Andrew Cuomo and Chris Christie, the governors of the two states, stopped paying the contractors trying to finish work on the memorial museum, which was scheduled to open on this year's anniversary. Forget the details for now and focus on a simple fact: The Port and the politicians who run it are pigs.

The memorial means nothing to them beyond winning a fight for control of the museum's money and operations—the same fight that every project on the site has inspired.

That has been the underlying and unyielding truth of ground zero since September 12, 2001.

This is truly the best reason for dumping the politicians: Ground zero is not so much a place of remembrance and honor as it is a battlefield. Last year's ceremony featured readings by Obama, Bush, Christie, Cuomo, Rudy Giuliani, and the two

sad-sack governors who held office in 2001, New York's George Pataki and Donald DiFrancesco of New Jersey. Pataki is the yutz responsible for nearly all that has gone wrong in rebuilding the site, but they couldn't *not* invite him. DiFrancesco's connection to ground zero was why he fled office: He took a large low-interest loan from a pal he helped put on the board of commissioners that presides over the Port Authority. DiFrancesco was not invited to last year's observance until Governor Christie threw one of his many tantrums and Mike Bloomberg agreed to stick DiFrancesco at the bottom of the batting order.

Poor George Pataki: Never the brightest bulb in the chandelier, he once had hoped that the rebuilding might lead him to the White House. So it was understandable that he might be feeling proud—maybe even a little wistful—at last year's ceremony. The dignitaries are assembled by the stage, waiting for Obama and Bush, when one of them overhears Pataki say to Cuomo, "Isn't this a great day? Just beautiful— and look how this has all turned out."

And Andrew Cuomo says to Pataki, "This is the biggest waste of money anybody's ever seen. Who would have ever spent this money? If we'd known what this was going to be like, nobody would have ever done this."

Six bucks buys you a seat on the ferry from the Hoboken train station to Lower Manhattan, but don't sit. Take the stairway to the outside deck and then take a gander—at the "Freedom Tower" (known officially, for leasing purposes, as One World Trade Center) reaching a thousand feet and more up into the morning sky, at the Statue of Liberty due south of Ellis Island, at American history writ huge and stuffed with symbol. Ten minutes across the Hudson River, knitting New Jersey and New York, to the ferry's slip a quick block's walk from the World Financial Center; ten minutes of wind, water, and sun: You could take a PATH train from Hoboken for $2 and ride under the river in a packed and ill-lit car, but then you'd feel no wind, water, or sun, and none of the awe.

The awe has nothing to do with symbolism. The Freedom Tower's force is its 1,368 feet, exactly the same height as the old North Twin Tower. The building's spire—still being assembled in Canada—will lift it to 1,776 feet. Even now, though—with its top floors yet unclad by a curtain wall of mirrored glass, with two cranes rising with it from its core, waiting to raise that mast piece by piece when it arrives—its naked thrust is knee-buckling.

There will be taller towers in the world when this one is finished—the latest fond hope is early 2014—but they weren't built atop a mass grave. Their perimeter columns were not sunk seven stories below street level, threaded among the tracks of an active commuter railroad. Those other towers were designed and built by men and women working unburdened by the memory of carnage—and by the certain knowledge that their tower will also loom as a thrilling bull's-eye. Here, a short walk from Wall Street, and at last, it stands nearly finished, an office tower and a pillar whose shadow can't be measured truly by mass alone.

David Childs is seventy-one now. He works fewer hours, travels less, and isn't wearing a tie. He watched from a window in this Wall Street office as the Twin Towers fell eleven years ago. SOM lost one employee that morning, a forty-five-year-old architect calling on a client at the World Trade Center.

"I used to walk over there and look at the site and think about it. People would go in and look down and it was sad. Now they go and they look up and they're smiling. There is this piece that says, 'We did it'—and that's what that tall tower is. People fly over it, they drive, they come across on the ferry and they look at it and they feel good. They smile. I feel good about that. We came back and we rebuilt it, and we should feel good about it."

He himself sounds unconvinced. Worn-out. That would be understandable if so: Less than a year after his final design for the Freedom Tower was approved, the long ongoing war between Larry Silverstein and the Port reached a temporary detente, and a deal was

struck: Silverstein would build three smaller office towers on the WTC site, but not the Freedom Tower. That belonged to the Port Authority again.

Childs is disinclined, by nature and professional diplomacy, to detail the resulting woe. Long story short: Pataki begat Eliot Spitzer, Emperors Club VIP, who campaigned and took office harrumphing about killing the tower, changed his mind a month later, and resigned after little more than a year as governor, so foully disgraced by his penis that he recently was forced to seek refuge in Al Gore's wingnut protection program, Current TV. Spitzer in turn begat David Paterson, who confessed his own adultery one day after his inauguration. And Paterson begat Andrew Cuomo, the current governor.

Each had his own political agenda; each appointed a PA executive director of his very own; each viewed the World Trade Center rebuilding—and the Freedom Tower above all—as a redheaded stepchild. As the estimate for completing the tower rose past $3 billion, the PA struck a deal in 2010 with a city real estate developer,

the Durst Organization, to help finish, manage, and lease the tower: For $100 million, Durst received a 10 percent equity interest in the building, plus a $15 million management contract that gave Durst 75 percent of any monies saved by cutting construction costs up to $12 million, and a mere 50 percent of every penny cut thereafter.

To nobody's surprise and David Childs's despair, Durst found costs to cut, particularly at the top and bottom of the tower. The prismatic glass chosen to wrap the base of the building was replaced with a cheaper version, requiring that the corners of the tower's first two hundred feet be squared off *after* those corners had already been tapered to meet the thousand-foot isosceles triangles of the curtain wall. Then Durst took its meat-ax to the tower's 408-foot spire: By simply scrapping the radome—a sculpted shell of fiberglass and steel designed to sheathe the antennae and maintenance platforms atop the building—*shazam!* $20 million saved.

Childs learned from a Durst press report that the radome had been whacked, and issued a statement expressing his

disappointment and his hope that SOM and the Port could find an alternate design. Durst claimed its radome decision was strictly about maintenance cost and safety, not money. Patrick Foye, current PA executive director, agreed, adding, "What was designed was impractical, unworkable, and quite frankly dangerous."

Considering that SOM has somehow managed to build and create maintenance plans for skyscrapers in many places for many years; and considering that Douglas Durst himself paid to place full-page ads in New York City newspapers in 2007, urging the new governor, Eliot Spitzer, to murder the tower; and considering that without the radome, what was a spire may be discounted as an antenna mast by the Council on Tall Buildings and Urban Habitat—the arbiter of building heights—which would mean that the Freedom Tower won't officially stand 1,776 feet tall: Regarding all this, David Childs is mum. Circumspect. Or plain worn-out.

"The simple, pure form—I'm proud of that," he says, and falls silent.

PATH stands for Port Authority Trans-Hudson, the railroad winding seventy feet below the World Trade Center site, carrying commuters to and from New Jersey at a loss of almost $400 million per year. When it started running in 1908, it was the Hudson & Manhattan Railroad and turned a profit. Then the PA built the Holland Tunnel, which opened in 1927, the very year Austin Tobin joined the PA's law department, followed by the George Washington Bridge, opened in 1931, and the Lincoln Tunnel, in 1937. Soon the old H&M was running deep and forever in the red; thanks to the PA's devotion to the automobile, its ridership plummeted from 113 million in 1927 to only 26 million in 1958.

As the H&M sank into bankruptcy in the fifties, New Jersey asked the PA to take over its operation. The logic seemed solid: The railroad was a crucial regional transportation link, and the Port Authority's purpose was to manage the region's transportation fairly, and the PA had clearly destroyed

the railroad. Austin Tobin preferred not to, strongly, and *his* logic, while entirely self-serving, made sense: The PA had never been in the railroad business or in the business of losing money.

Grasping these few simple facts of regional history is fundamental to fully comprehending the economic and political calculus of rebuilding ground zero. They explain why the PA is still viewed—by New York and New Jersey, and by bond traders, too—as a fount of infinite wealth: Even at the Great Depression's nadir, the Port Authority was proudly swinging its money and might like a cudgel. They also became the bedrock of northern New Jersey's belief that the PA is and always will be biased toward New York City, a faith fortified daily for New Jersey commuters, who pay a $12 cash toll to motor into Gotham through the Lincoln or Holland or over the GWB, while their ride home is free—not exactly a token of respect and equal standing.

And so it came to pass that when Austin Tobin began dreaming of a World Trade Center in Lower Manhattan, he chose a spot near the East River, inaccessible to commuters riding the H&M. And when he sought the necessary approval of the governor of New Jersey, New Jersey told Tobin to go pound salt and, like Tobin with the H&M, refused to budge.

And so Austin Tobin—less famous than Robert Moses but every ounce as determined to create monuments to himself—made New Jersey an offer too sweet to refuse: The Port would buy and maintain the H&M, spend an immediate $70 million to upgrade it, and move the WTC site west, to the Hudson River side, right where the H&M's Lower Manhattan terminal stood.

Which solves at least one ground zero mystery:

Why is the Port Authority building a new PATH hub there that will cost around $4 billion by the time it's finished?

Because that's part of the price the PA paid to persuade New Jersey to say yes to the entire project. But only a part.

And it really begs a much tougher question:

How in the world can an eight-hundred-thousand-square-foot transit station cost $4 billion?

Amazing, no? The Freedom Tower, which will offer tenants *2.6 million* square feet of office space—and which has been fortified against any future attack by means and material of unprecedented scope and expense—will end up costing the same, give or take, as the PATH hub. And not—as they like to say in the Garden State—for nothing. Because from day one—years before the Port pried the Freedom Tower loose from Silverstein—this was to be the PA's Golden Fleece, in every sense, the only construction project on the sixteen acres that would give, and give, New Jersey ample opportunity to freely, fully wet its beak.

It was always meant to be wildly expensive: It was initially budgeted for $2 billion, with the entire bill footed by the Federal Transit Administration. So the PA commissioned a starchitect of the first order, Santiago Calatrava, to design it—many folks still refer to it as "the Calatrava"—and the much-loved Spaniard designed the hell out of it. His central hall began fifty feet below street level, a vast ovoid beneath a soaring dome of glass and steel—Calatrava called it the Oculus—ribbed by narrow white arches, curving as they rose and reached beyond the building walls, like the fingers of clasped hands.

But there was more—much more. Calatrava sketched the hub as a bird taking flight from a child's hand and designed the dome roof to retract mechanically—he was also a civil engineer—so that its arches would seem like spreading wings as the roof opened.

"This is the Port Authority's gift to New York City," said Calatrava.

All of New York said thanks, including architecture critics. "With deep appreciation," wrote Herbert Muschamp of the *New York Times*, "I congratulate the Port Authority for commissioning Mr. Calatrava, the great Spanish architect and engineer, to design a building with the power to shape the future of New York."

Our pleasure, said the Port Authority, perhaps especially pleased that nobody seemed to notice that its $2 billion jewel of a PATH hub would serve about fifty thousand commuters daily, a sliver of Penn Station's six hundred thousand or Grand Central's seven

hundred and fifty thousand—and that no one was unkind enough to mention how much money the PA was already losing on the railroad each and every year.

"I have become very, very fond of Santiago," said Pataki's Port Authority executive director, who'd come a long way from his upstate car wash and bowling alley. "The guy's a genius. But the first thing that hits you in the face— he gives you a hug."

Never let it be said that New Jersey guys won't hug back. On the Federal Transit Administration's $2 billion dime, the PA had hired the so-called poet of transportation architecture, Calatrava—try saying it aloud; it fairly dances off the tongue—and he had poured out his ode of concrete, steel, and glass, and everyone had sung hosanna.

There was some concern, of course, about constructing the actual building. Those wings might prove tricky, the dome's expanse of exposed glass could pose a security risk—given the dark attraction of ground zero—plus the hub's specific location meant that much of its belowground ceiling would also be the floor of the yet-to-be-built memorial plaza, not to mention that one of the wings, when spread, would come perilously close to a yet-to-be-built office tower next door.

How fortunate, then, that two of the Port's New Jersey guys, commissioner Anthony Sartor, who chaired the Port's World Trade Center subcommittee, and Anthony Cracchiolo, the PA's director of Priority Capital Programs, made time for a trip to Europe to study some of Calatrava's finished work. Even luckier: Like Calatrava, both men are engineers and so were able to offer professional assurances, after completing their tour, that there was no need to worry—Calatrava's hub construction would be smooth sailing.

Construction of the PATH station began on September 12, 2005, and was officially scheduled for completion in 2009. Calatrava came to the ground-breaking ceremony with his ten-year-old daughter, Sofia, who released two doves into the morning air. Officially,

Ironworkers Langston Donaldson and Richard Brown on the deck of 3 WTC take the strain on a steel column as ironworkers Gary Holder and Tommy Hickey guide it into place.

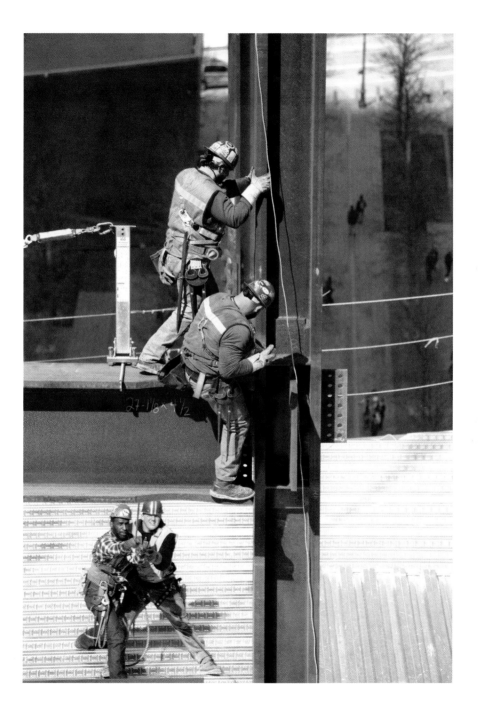

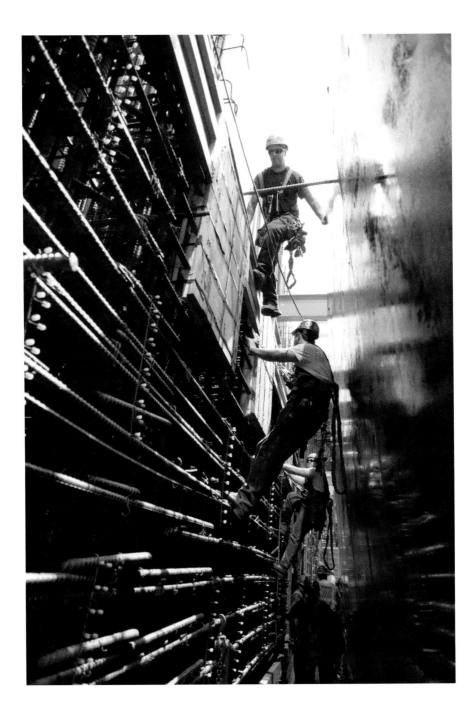

according to the Port, they were doves. Truth is, they were homing pigeons.

By July 2006, Federal Transit Administration consultants keeping tabs on the hub were already telling the FTA that the project was being crippled by constant design changes and would take far longer and cost much more to complete. Every three months, the consultants issued another update reporting problems with design, scheduling, and oversight.

In early 2007, the PA admitted the hub's cost could climb to $2.5 billion. In May 2008, the Port stuck to that figure, and Commissioner Sartor vowed that it "will be completed and functioning in 2011," noting that the PA was "working collaboratively" with Calatrava on design changes to ensure it would be so.

The conflicted extent of that collaboration became news a few weeks later, when it came to light that STV, one of the firms that was working with Calatrava on the hub—and on other ground zero projects—was also in talks to purchase an engineering company that Sartor ran. Sartor and the PA denied

any conflict of interest, although it certainly looked bad: STV was part of the Downtown Design Partnership, a joint venture that included Calatrava.

Not to worry, said the PA: Sartor—did I mention that he also chaired the Port Authority subcommittee in charge of rebuilding the World Trade Center? Or that STV's New York City office was located in the same office tower as the PA's headquarters? Or that STV made a habit of hiring former PA employees, like Tony Cracchiolo, the PA official who went to Europe with Sartor to see Calatrava's work, and who joined STV in 2006 as senior vice president and director of design, taking with him a six-figure Port Authority pension?

Where was I? Oh, right—no worries, said the PA: Commissioner Sartor had notified the Port of the STV negotiations to buy the engineering company he ran, and had recused himself from all PA votes related to STV's work on the site.

Not that Sartor's recusal mattered: Every PA board resolution for at least the prior two and a half years—including contracts totaling nearly $400

million awarded to the DDP and STV for work on the PATH hub and other ground zero projects—had already been approved. Unanimously.

———

Chris Ward is sitting in a conference room at his Midtown office; he's executive vice president for major projects at Dragados USA, a subsidiary of an international construction firm based in Spain. Down the road, if the firm bids for some PA work, he'll abstain from the process. Strictly business—not that he doesn't still feel connected to ground zero and his work there.

"I'll always be defined, and I will define myself, by those three and a half years. No doubt about it."

That's about the limit of Chris Ward's sentimentality. Business is business. He knew his days at the PA were numbered after Andrew Cuomo became governor in 2011 and ignored ground zero completely. Cuomo saw no upside for himself downtown—just a PA executive director making decisions, getting public credit. There were no meetings, no phone calls, no e-mails between the two about ground zero. When the press asked about it, the governor's office issued a statement saying he had no plans to replace Ward "at this time." Of course not: If he got rid of Ward before the tenth anniversary of 9/11 and anything went wrong with the race to finish the memorial plaza, Cuomo would rightly be the fall guy. But with those three words—"at this time"—Cuomo declared what most insiders already knew: It was now open season on Chris Ward.

That much had already become clear when, at a PA board of commissioners meeting soon after Cuomo took office, Tony Sartor—whose STV deal had died a quiet death soon after it became public—responded to another hike in the price of the PATH station by telling Ward, "I would like to get a true assessment of what the costs are going to be, for the hub and the rest of the project," as if Ward were the one who'd sired the Calatrava and then blown smoke for seven years about its costs and construction.

Any plausible doubt about Ward's doom was sealed when New York

City's mayor, Mike Bloomberg, asked Cuomo personally to let Ward finish the job of rebuilding the World Trade Center.

When I ask Ward about that, he laughs.

"The mayor joked, 'You know, I probably cost you your job because I said twice what a good job you were doing.'"

Cuomo owed Bloomberg nothing, and Bloomberg, a lame duck, had no leverage. The mayor's ground zero interest was limited to the memorial plaza and museum; the plaza was rushed to completion after PA engineers found a way to build it even though the plaza itself would also form a part of the roof of the unbuilt PATH hub, and the museum was supposed to open on 9/11/12. Bloomberg's fear was that if Ward left, the museum would be orphaned.

That's precisely what happened. With Sartor leading the way, the PA started threatening to shut down funding for the museum if the museum didn't pay a larger share of the infrastructure costs. Ward had suggested negotiating

the difference to keep the museum on schedule and avoid yet another cycle of ground zero woe. To no avail: With Ward out of the way, the PA's negotiating tactic was simply to stop paying contractors to finish the work, and to blame Ward for poor management and playing politics with the Port Authority's money.

How much money? Depends on who you ask. Chris Ward believed it boiled down to no more than $50 million, tops. Anthony Sartor said $150 million—petty cash compared with a PATH hub overrun climbing toward $2 billion on a project that he promised could be finished for 2.5. But it was Sartor's New Jersey colleague, PA commissioner David Steiner, who reminded everyone that the Calatrava—not the Freedom Tower, not the memorial museum—was ground zero's true icon. And so the memorial museum won't be ready as promised, and nobody knows when work on it will resume. But it's a safe bet that once Mike Bloomberg leaves office—and Andrew Cuomo will be able to take credit for riding to the rescue—another bargain will be struck with the New Jersey boys.

"We're gonna go back to that kind of world?" Chris Ward says now. "I thought we'd gotten rid of that when we said, 'Let's just get it done.' It would unfold, and its story would be told and retold. Until you finish it, you're never going to have that story. And now? Now you're back to fighting.

"The Port Authority is one gigantic business negotiation that goes on forever and never ends—there's always a transaction going on. And the only way to lead the Port Authority is by understanding that."

The truth about ground zero is that nearly three thousand people died here and millions of visitors have already come to the memorial plaza and stood at the reflecting pools and seen their names and carried away stories that have nothing to do with politics and plunder.

The palpable truth about ground zero is inscribed upon these sixteen acres each day by the men who work here.

Mike Pinelli and Marc Becker have been here from the start, supervising the Freedom Tower's construction. The politics mean nothing to them, nothing worth saying.

"I know it's gonna happen," Marc Becker said in 2005, standing at rock bottom of the empty pit, where construction had stopped dead before it ever really got started. "I just don't know when. It's very personal to me—I saw what the poor souls looked like after they jumped out of the buildings. What they pulled out of the debris, I saw it. It's personal. We're ready to go. We're ready to build."

Pinelli came home after 9/11 and found himself sitting dazed, in tears, trying to explain to his three young girls what had happened, when his middle daughter told him to buck up.

"Everything's gonna be all right. . . . You're gonna put it back up again. Your job is to put things back up."

She was five years old then. She'll turn sixteen in a couple of days, Pinelli says. His oldest is seventeen now.

"To this day they talk about it," he says. "They follow the progression of the building closely. They get excited, their friends are excited."

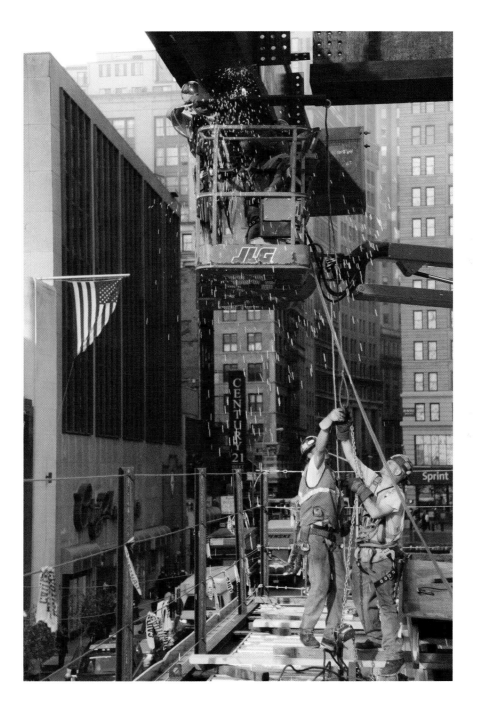

Pinelli and Becker are both New Jersey guys. Pinelli's dad retired as a Port Authority cop. The Freedom Tower, it's still personal.

"Every day we come to work at sacred ground," Pinelli says. "We have that in our hearts. It never leaves."

"Pride and honor," says Becker.

Pride, honor, and duty.

"The job is a marathon," Pinelli says. "You break it down in pieces. Set milestones. For myself, for my team. When you hit a milestone, you celebrate a little bit, circle the wagons, and start back up. It was a big accomplishment to finish the foundation. The core was a bear—the sheer volume of the concrete core. Then the push to get the building into a one-week cycle. Next week we're going to top out 105.

"The antenna's going to be here in the fall. The interior work, the MEP systems—the backbone of the building—are all coming together. Third or fourth quarter. 2013, we'll be right there."

"The antenna will be the exciting part," Becker says.

"Marc's trying to figure out a way to climb it. He's working out."

No shit.

"I've actually started running again," Becker says.

He's fifty-four now, Becker. An ox. He was out to dinner with friends Saturday night down the Jersey Shore— Sandy Hook, forty minutes by ferry from Manhattan—and looked out the window and saw it shimmering across New York Harbor and started texting photos to Pinelli.

"Look who I'm having dinner with," Becker says, laughing. "Our baby."

Pride and honor.

"That's the truth."

A TARGET IN PERPETUITY

SEPTEMBER 2013

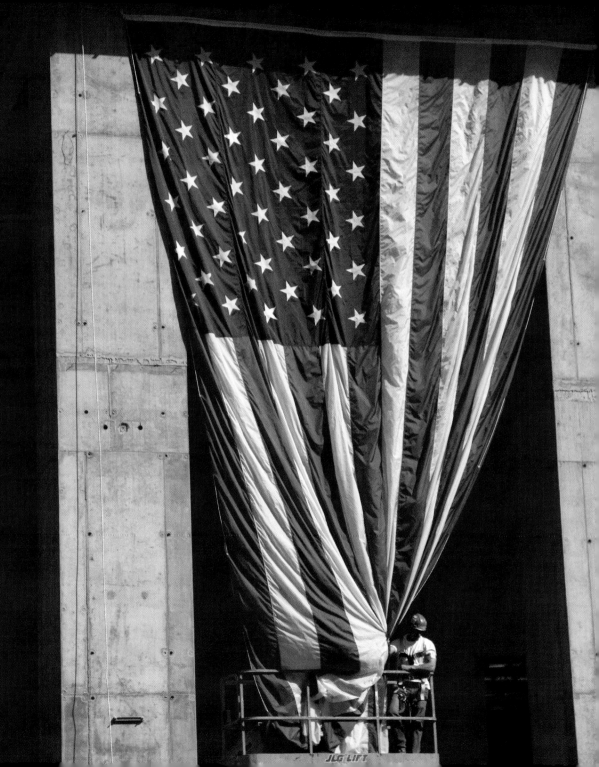

walked the World Trade Center memorial plaza not long ago as a tourist—one of the eight million or so who've come since the plaza opened on 9/11/11. It was noon on a Monday of tropical humidity and fat rain; street vendors were hawking umbrellas along with the usual schlock, and the smokers huddling under each building facade en route to ground zero stank like wet mutts.

You're not supposed to call it ground zero anymore. The phrase is fine in reference to Hiroshima, its place of origin, but it bums folks out here in downtown Manhattan. Not everyone, but the real estate agents for sure, and plenty of the neighborhood residents and some of the bridge-and-tunnel commuters toiling here. Whatever you call those sixteen acres, though, 9/11 remains fresh, a daily memory. In Glen Ridge, the north Jersey town I call home, the tablet sitting in a square of shrubbery by the stairs to the NYC train, chiseled with the names of the seven locals who never came home that evening, is flanked by three American flags, suddenly planted just after Osama bin Laden was bagged and buried at sea, the one and only clear-cut

battle won so far in a war of fog that lifts and falls and lifts and falls again, a winding sheet forever rising from ground zero.

Likewise the Freedom Tower, which was officially branded One World Trade Center in 2009. Despite the reverse-marketing mojo, the *Wall Street Journal* ran a story the week before I visited the memorial about how tough it is to get people to stop calling it the Freedom Tower. Whatever the impetus for this absurd attempt at rebranding— "It's an office building and not a memorial and not a monument," moaned one of the real estate mavens working with the Port to sign tenants—its utter failure is a rich tribute to George Pataki, who clocked twelve years as governor of New York and vanished into the ether the very day he left office, devoid of legacy beyond the name he bestowed upon the skyscraper he'd hoped would prove his presidential timber. Pataki came up with the Freedom Tower moniker in 2003 while he was pledging that the building would be ready by 2006. If you're a gambler, the PA is now saying it'll open the joint in early 2015.

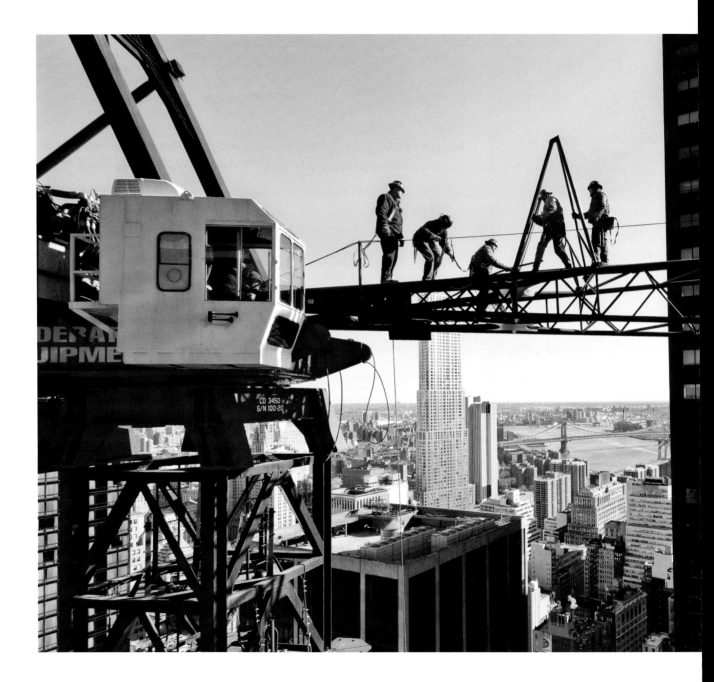

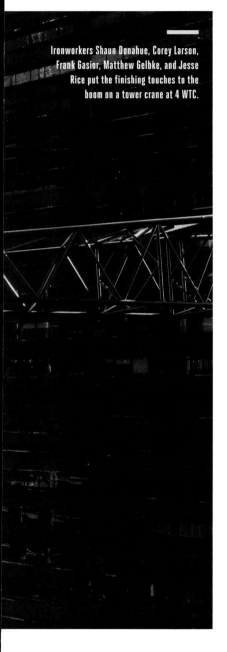

Ironworkers Shaun Donahue, Corey Larson, Frank Gasior, Matthew Gelbke, and Jesse Rice put the finishing touches to the boom on a tower crane at 4 WTC.

Still, speaking as a tourist, not a guy who's spent the past eight years writing about the rebuilding, the whole place looks fabulous. Seriously. The memorial alone is eight acres, the beating heart and open soul of the new trade center, two vast pools, each bordered by parapets with the names of the murdered cut from their bronze, two wounds carved within the footprints of the fallen Twins, two voids of water falling thirty feet with a steady, whispered roar that drowns out all other New York City noise.

Across the plaza from the north pool, fenced off, the Freedom Tower soars 1,776 feet—the number a smack-dab symbol that made Pataki swoon. Fashioned as a modern obelisk, beveled on each corner, turning as it climbs, a spare and simple marker and an object presence in a skyline ripped empty of everything but loss: To see it—up there—bent me backward, and I fumbled with my phone to snap a photo. In doing so, I stood my briefcase on a parapet, and a guard stepped out of nowhere and asked me to remove it.

I think he called me "sir"; I know that I apologized and moved a few steps back from the tower and set my briefcase on the gray paving stones, and then I spotted Robert Coll's name among the others on the panel where I'd stopped. He'd lived just around the corner with his wife and two small children and worked in the South Tower, on the eighty-fourth floor, and died right here on 9/11 at the age of thirty-five. We didn't know the family beyond a literal nodding acquaintance, and not long after 9/11, his widow and the kids were gone, and that was that.

But that is never only that, particularly not in New York City. All around, under their umbrellas, pushing strollers, hobbling on canes, speaking tongues I've never heard, hundreds of pilgrims from every pinprick on the globe have joined here for an hour or two. Last time I came here, a few weeks before its opening, the young architect who designed it, Michael Arad, said he wanted it to be an "urban park"—not only a memorial but a place of community.

"It's going to really be powerful once people are a part of it," he said. "Once people come here, it'll make this place alive again."

Absolutely right. For all the scarred solemnity—the hush of water arcing forever downward in the space where the Twin Towers stood and fell; the found poetry and mortal pain of three thousand names carved from glowing bronze; the new tower, looming; the weeping, sunless sky—for all of this, the city's pulse is throbbing here again. After so long—years of pissant politicians mouthing baldfaced lies, of siphoned dreams and wasted dollars—New York City is a smaller world now than ever, and an even softer target. Including right here.

The Freedom Tower as built is, per NYPD recommendations, about one hundred feet from West Street, and the concrete poured to fortify its core is the strongest ever mixed. But the most critical, fundamental part of protecting the World Trade Center from terrorist attack has little to do with engineering or architects. The 1993 truck-bomb blast didn't topple the North Tower—and had the airlines heeded their security consultants and anted up for stronger flight-deck door locks back in the seventies, when their craft were often hijacked, a 9/11 scenario could never have unfolded. It's too late to defend ground zero against past attacks.

What may come next is anybody's guess—but every so-called terrorism expert I've talked to agrees that, sooner or later, ground zero will be targeted again.

That's New York City, kids. Full of folks who calculate their odds from dawn to dawn—taxi? Subway? Local or express?—and whose vigilance starts on the sidewalks. People still arrive here every day with no money, no English, and no doubt that they'll find a way to survive and succeed. If eight years spent covering and pondering ground zero has taught me anything worth calling wisdom, it boils down to this: Our national response to 9/11 has been disastrous.

Think first about how useful 9/11 has been to the politicians who trade in fear and piety, whose power at the federal level of our government has grown vast enough to include torture, indefinite detention, secret surveillance of the citizenry en masse approved by a secret court, and the program of

Ironworker Mike O'Reilly on the one-hundredth floor of One World Trade Center.

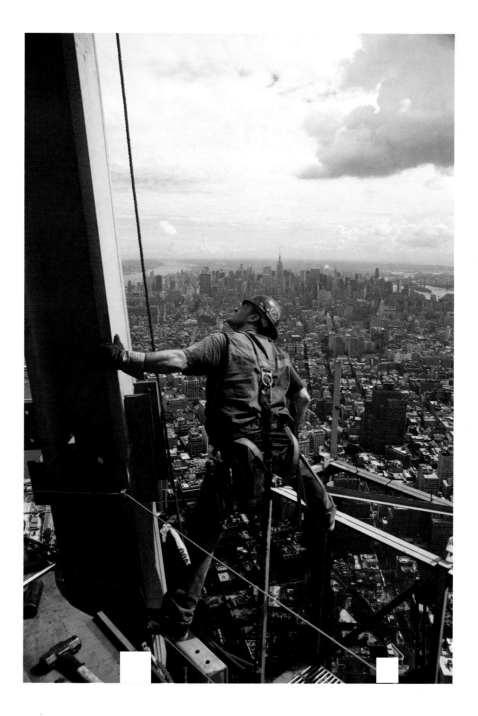

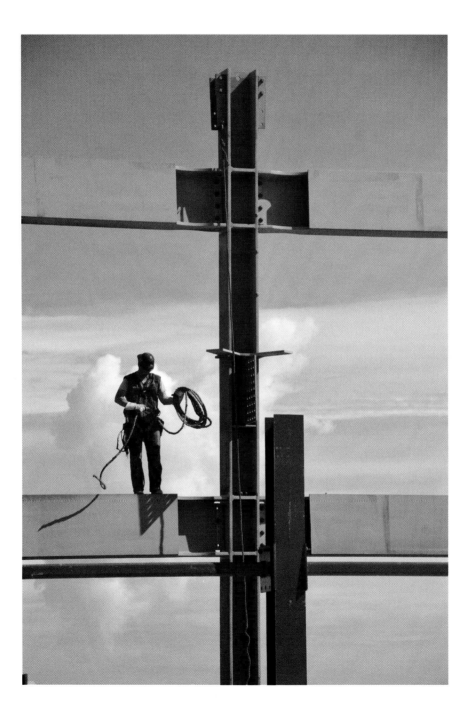

inflicting death by drone despite the collateral damage, human and political.

I'm not suggesting any conspiracy to bring down the World Trade Center beyond that enacted by Al Qaeda. I'm not talking about any black helicopters or Hollywood fantasy. I'm referring to the damage done to America not by terrorists but by our own response to one horrific attack—which, by the way, was but another version of what people around the world have gone and still go through. Gutting the values and principles that we like to think define us as an exceptional nation—you know, that whole Bill of Rights deal—isn't the response of a country confident in its freedom. It's the cowardice of a nation too fractured by fear to face the truth about the human condition: We're *always* vulnerable—all of us, together and alone.

It takes courage to accept that vulnerability and not let it rule our lives, private and public. That's exactly what the rebuilt World Trade Center demonstrates already, already filled with people courageous enough to embrace life and liberty as a matter of fact, not foofaraw. In short: Americans.

Ironworker Aaron Levy coils up rope on the one-hundredth floor of One World Trade Center.

It's just this plain and simple: Safety at ground zero will primarily depend upon the agency responsible for its day-to-day security to plan and execute strategies of prevention and response. That ain't rocket science or brain surgery; at the World Trade Center, it's far more challenging a task than either of those things. That's why it's vital to review the post-9/11 dustups between the Port Authority and the NYPD—and to revisit the role politicians have played, and will continue to play, in deciding who guards ground zero.

Start here: In 2008, the Port Authority and New York City negotiated an agreement to give the NYPD primary control of ground zero security instead of the Port Authority police, whose jurisdiction it had always been. This arrangement made sense for reasons obvious to anyone familiar with the city.

The PAPD is big—the forty-first-largest police force in the U.S.—and its seventeen hundred officers are paid far more than their NYPD counterparts, while working shorter shifts.

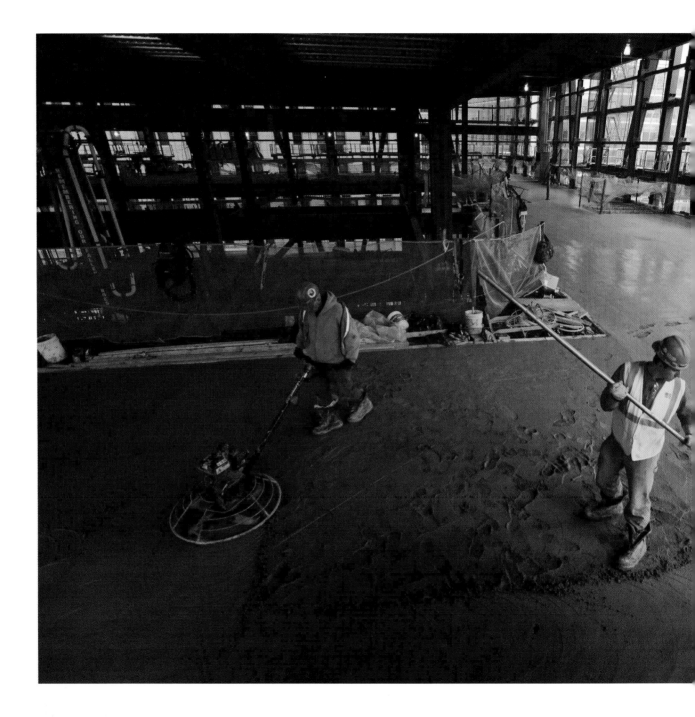

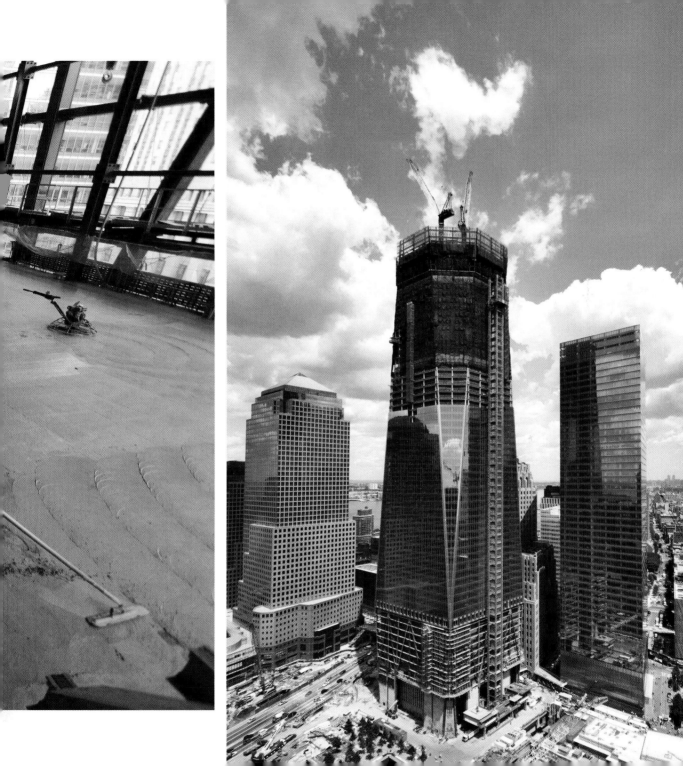

They police the airports, the bus terminal, the bridges, and the seaports, and over the course of decades they have earned an ignoble reputation, to put it kindly. A Republican candidate for New York City mayor put it far more harshly this past May, when he responded to a question about airport security by referring to the PAPD as "nothing more than mall cops," which immediately triggered plenty of angry posturing by politicians—nearly all of whom invoked the memory of the thirty-seven PAPD officers slain on 9/11—and speculation about whether the nation's mall cops were sufficiently organized to sue for defamation.

The NYPD has about fifty thousand employees—more than the FBI—including upward of thirty-four thousand uniformed officers. It has focused on counterterrorism relentlessly and globally, with personnel stationed in Germany, France, and Israel. NYPD Commissioner Ray Kelly assured *60 Minutes* that his department could, if necessary, blow an airplane out of the sky, which prompted New York's mayor, Mike Bloomberg, when asked about

Kelly's comment, to say the NYPD "has lots of capabilities that you don't know about and you won't know about."

This means of fighting terror—creating an urban army complete with an intel arm that has already abused its power by conducting surveillance of citizens guilty of nothing more than practicing Islam—surely raises profound and urgent questions about what should and must be done to balance liberty and security and to cement civilian control of a military force camouflaged as a police department. Still, if you're shuffling papers in your cubicle at ground zero, such issues pale beside the one question of paramount importance: Who'll do a better job protecting your ass?

That 2008 security deal reached by the city and the PA answered that question. The NYPD would create a World Trade Center precinct staffed by six hundred city police officers—making it the city's largest precinct—each trained in counterterrorism. The NYPD would also design the overall scheme for securing the WTC, and it would control access to the site. The PAPD would be in charge of security at the Freedom

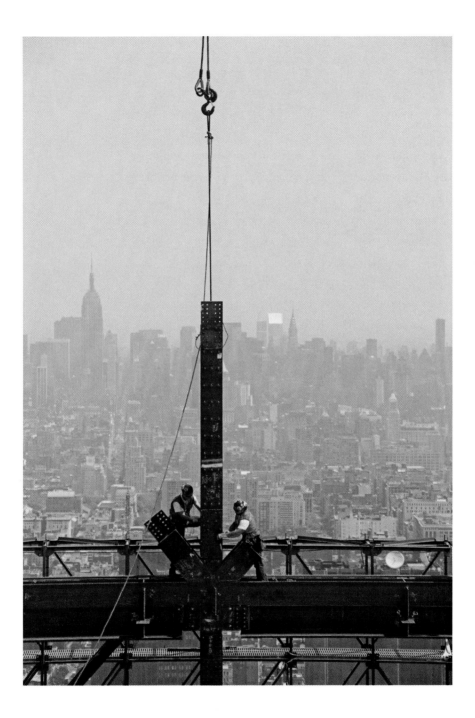

Tower and the years-late PATH station, which, like the Freedom Tower, will cost almost $4 billion, nearly twice its initial price, by the time it finally opens, in 2015 or 2016.

It took months to hammer out the deal, and doing so helped clear the logjam at ground zero, where the rebuilding has long been held hostage by the peculiarity of the site's relationship to the city. Like the Vatican, it is an entity both separate from New York City and a literal, integral part of it. The deal was announced in July 2008, after it was approved by the Port Authority board of commissioners, and signed the next month. So it was quite a shock, more than four years later, when Chris Christie, New Jersey's battering-ram governor, vowed to a cheering crowd that "never—not ever on my watch—will there be any other police force who will patrol the new World Trade Center other than the Port Authority police."

Somewhat less surprising—all right, much less surprising—Christie, running for his second term, was speaking to an audience of Port Authority police at an event held to announce that the PAPD union was officially endorsing none other than Chris Christie.

That's *not* New York City, kids. *That's* New Jersey.

Nature abhors a vacuum; politicians love 'em. Chris Christie took charge of New Jersey from a rumpled suit containing a cipher named Jon Corzine; Christie's tag-team partner in reweaponizing the Port Authority, New York governor Andrew Cuomo, inherited his big chair from David Paterson, a nonentity who happened to be serving as lieutenant governor when his boss, Eliot Spitzer, fled Albany due to excessive whoring.

To men like Cuomo and Christie—insanely ambitious politicians whose eyes are forever on the next prize—the PA, including ground zero, is little more than a means to a discrete end: the acquisition of more power. This was no less true of George Pataki, too, but he was an amiable dunce. Both Cuomo and Christie are far more calculating, and both struggle to keep their meanness under wraps. Cuomo cost

Ironworkers Gary Holder and Mike O'Reilly getting "up on a turfer" as they disassemble a derrick crane on 4 WTC.

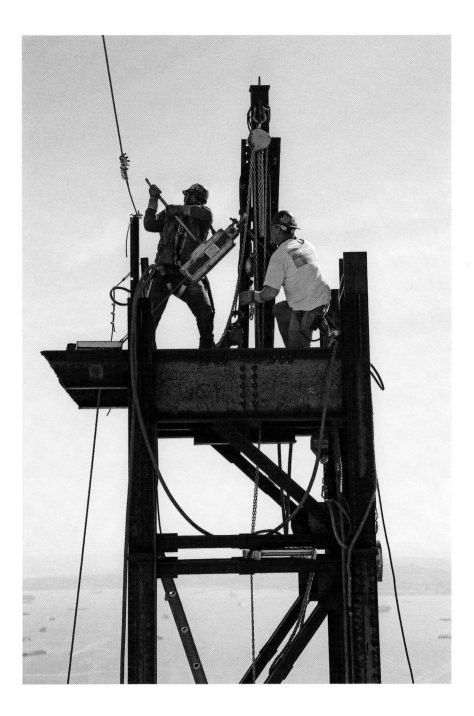

himself a chance to become governor in 2002 when he made sport of Pataki's post-9/11 leadership by referring to him as the guy who stood behind Rudy Giuliani and "held the leader's coat." Christie isn't nearly that nice; I once saw him take loud umbrage at and great delight in lambasting a high school lad at a town-hall meeting for the sin of asking Christie to explain why the governor sent his own children to private schools.

The Port Authority is slowly—very, very slowly—building the most expensive train station in the history of the world. The new PATH station is so much more than a mere train station: It is the tribute paid to New Jersey, the price of doing business, the envelope packed with cash passed hand to hand. Not everyone can run for governor, but that needn't mean that friends of friends can't share the wealth.

Chris Christie and Andrew Cuomo are more than friends—they're partners in the business of what's-in-it-for-me, and they faced two obstacles at ground zero: New York mayor Mike Bloomberg and the PA's executive director,

Chris Ward—who just happened to be the same two guys who nailed down the Trade Center security deal in 2008.

Bloomberg's other sins were numerous. His NYPD spied on New Jersey Muslim communities. He's heading the 9/11 museum, a crucial, costly part of the memorial. He ran the anniversary ceremony on 9/11/11—when the plaza opened—and forbade the politicians from speechifying at the ceremony. Worst of all, Bloomberg won and wielded power free of political ideology or debt. He's a billionaire who bought his office, including an illegal third term, and he seems to love not playing nice with politicians he has no reason to fear and doesn't respect.

Bloomberg is doomed to obsolescence by term limits, but all that meant to Christie and Cuomo—two angry and impatient men—was an exposed jugular waiting to be slit. Using the PA as a straight edge and its cost as a cover, they killed construction work at the museum, which was scheduled to open on 9/11/12—when Michael Bloomberg would still have held office and been able to take public credit for it. The

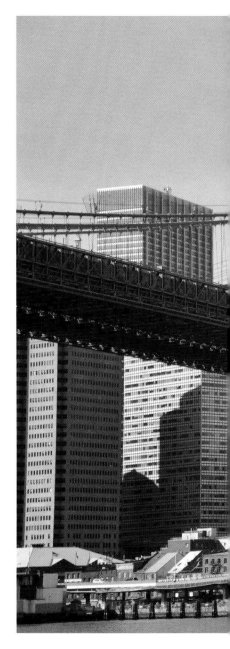

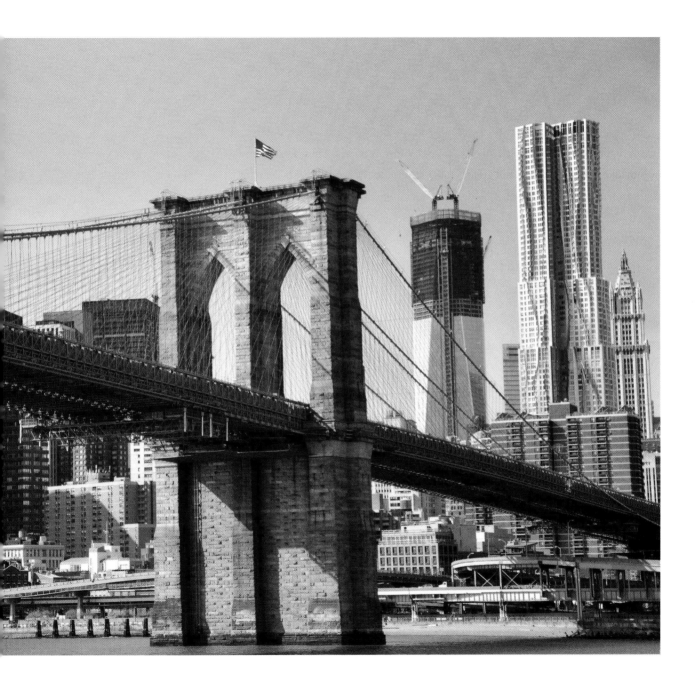

museum's now due to open in 2014—after Bloomberg departs. No doubt Cuomo and Christie will host the ceremony, speak lovingly of the 9/11 dead and our nation's core values, and wallow in glory.

In fifty or a hundred years, who'll know? Hell, the old WTC broke ground in 1966 and never made it to forty. I've come to love this place, nastiness included. Without all of that—the political warfare, the moneygrubbing, the perversions of honor and betrayals of trust—well, I'm unsure what you'd have here, but it damn well wouldn't be New York City, the version of America I cling to and love best, where all the forces of hope, harmony, and a hot knish are still somehow in play, and flesh still comes in every color and costume, right here and right now—which just happens to be the only time and place we ever truly have.

Right now, right here, you've got hundreds of pilgrims on line, waiting to get into the memorial. We're on a public street, a New York City street, a shuffling bunch of bull's-eyes to anyone who may have bought a rifle and shells upstate and driven to ground zero for a little headline hunting. Which is why the NYPD has a force of two-hundred-plus right here right now, keeping an eye on the place around the clock.

It's anybody's guess what'll happen when Mike Bloomberg leaves office, or when Ray Kelly follows him out the door. Nobody knows how the battle over official ground zero jurisdiction will play out—nobody's paying much attention, what with A-Rod's PED woes and all the excitement of Eliot Spitzer and Anthony Weiner, the dynamic duo of dick, running for office again. But that's New York, too. The city that never sleeps also has serious attention-deficit disorder.

Meanwhile, what better place to be? This plaza, swept by rain and gouged by history. This town of endless tumult and tumbling dice. America: half preening oaf, half huckster, always at the table, all in. We're shooting craps down here, everyone's invited—and the only losers are the fools who think they have anything to fear, or to lose.

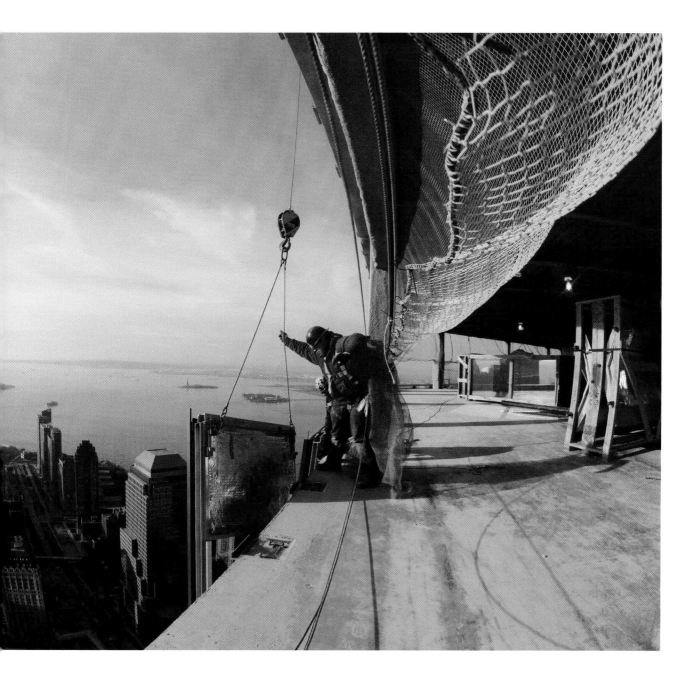

THE FREEDOM TOWER IS
AN ABSOLUTE MIRACLE

JANUARY/FEBRUARY 2015

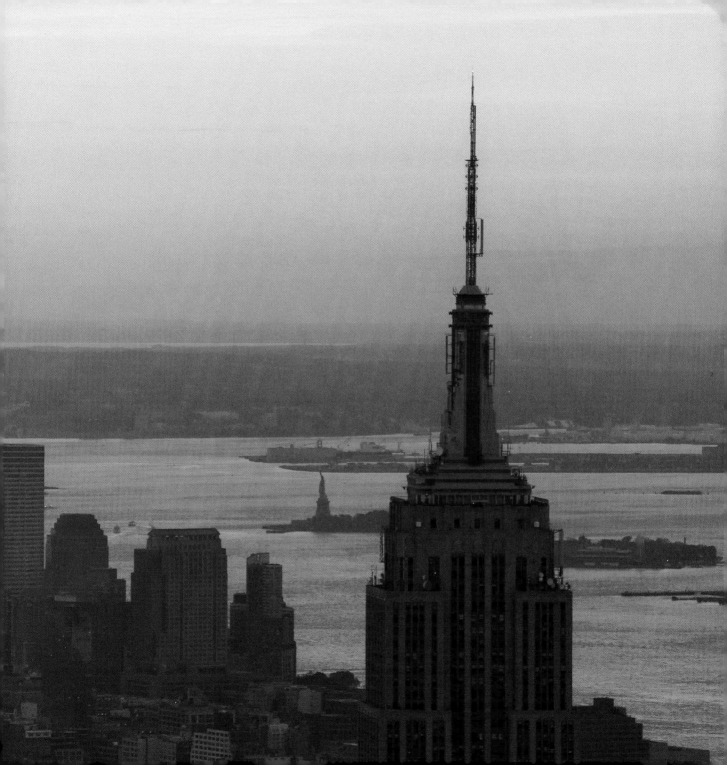

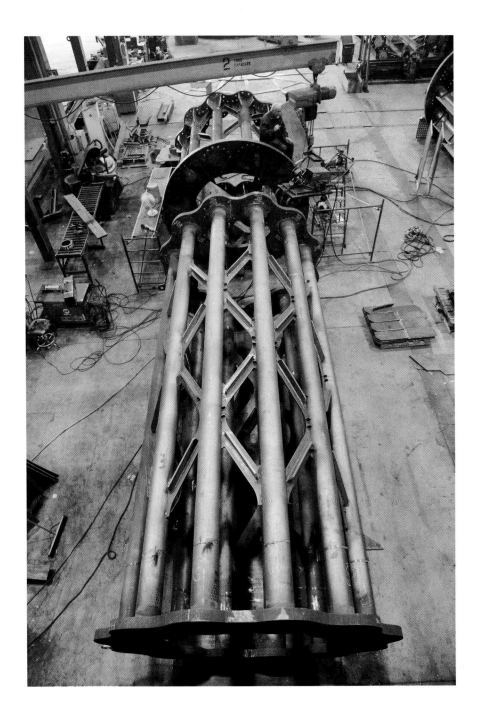

You really ought to see it for your-self—yes, you: Come to New York City; visit ground zero. Skip the museum: There the dead are deafening, a pandemonium of grief, a mausoleum with escalators, complete with human remains, recordings of mass murder, and a gift shop where the commodified fetish of massacre fills the shelves and the cashiers are trained to beg each customer for an extra buck—on top of the $24 entry fee. Mourning and reflection are yours for free on the plaza. Bear in mind that death and met-aphor and symbol are the same forces that tore the old place down—wielded by fanatics for martyrdom, and by poli-ticians for power, and by one and all for profit, because neither the Dutch set-tlers nor anyone else dug in and stuck it out to go see plays and museums. Sure, these sixteen acres are a battle-field, a mass grave, a mud-caked trough of capital and corruption—pretty much what you'd call any patch of land on the planet at one time or another—and now, again, they're a place where peo-ple come and go to work.

I first stood upon ground zero in 2005, when it was still a ruin, a slab-on-grade pit seventy feet below street level, with a single 460-foot ramp leading in and out. Two squares of orange traffic cones outlined the perimeter column stumps where the Twin Towers had stood. A couple of construction trail-ers, locked and empty. A cornerstone—a Freedom Tower cornerstone, twenty tons of Adirondack granite dedicated on July 4, 2004, inscribed to honor the 2,753 souls killed here on 9/11—hidden under a warped and leaking plywood cover painted blue. Nothing came down the ramp. Nothing moved at all.

The problem wasn't that the pit was empty. The pit was by then too full—stuffed with sorrow and human remains, clogged by rhetoric and meta-phor in the service of political ambi-tion, and flooded with tens of billions of dollars up for grabs the moment the old World Trade Center fell. This was never going to be quick or pretty—not here in New York City; these are six-teen acres of the most precious, profit-able land on the globe, at the heart of a world capital on a perpetual wartime

footing. Bombed in 1993. Vaporized in 2001.

Guess what: It's back. They opened the Freedom Tower at last, on November 3, 2014. You've got your memorial plaza now, and the museum, and a pristine Tower Four, opened the week before—and now you've got the big boy. Two-point-six million square feet of office space, 1,776 feet tall, 104 floors of fortified concrete, the most costly office tower ever built atop a mass grave. Too soon? Sacred ground, I know. But would you have this city build a sixteen-acre crypt? Not here. Here, you go to work. That's why people stream here from around the world and all the states—to get their ass to work, to make a buck. Closure is beside the point: Some losses can never be made good. And there's no honor in a monument to existential dread, no chance of redemption without work. Not here, in this city. And not here, where so many died, at work.

Here, finally, people are coming back—to One World Trade—this morning. To work. In the Freedom Tower. I'm actually a bit verklempt. I saw Freedom Tower steel poured molten and then rolled in Luxembourg, jumbo H-flanged beams, and I signed one in Zuccotti Park just across the street here. I saw the bedrock blasted here, rode with concrete drivers and watched 'em pour. I witnessed that cursed cornerstone, muck-stained and forgotten, loaded onto a flatbed, cinched inside a dollar-store tarp, and hauled up the ramp one Friday morning, never to be seen again. And I watched this tower get built, built by $4 billion and union labor, plus the force, cosmic and commercial, that through the green fuse drives the fucking flower.

The Freedom Tower holds a warm place in my heart, you could say, but the rest of me is cold. The sky this November morning is low and flat and gray; the Hudson River wind smacks of early winter; and of course we must suffer through yet another ceremony. But this is the strangest ground zero ceremony of all. Tomorrow is Election Day, and nobody who's anyone is here to preen. Not the governors of New York and New Jersey, Andrew Cuomo and Chris Christie, who share control of the Port Authority of New York and New Jersey,

which owns these sixteen acres and built this tower; not Barack Obama, who stopped by in 2011 to lay a wreath a few days after ordering Osama killed and returned to sign a Freedom Tower beam in 2012; even New York City's new mayor, NotMikeBloomberg, stayed away.

The Port Authority threw this party. With 40 percent of Freedom Tower office space unleased, they were hoping for a grand opening; there was even talk of Alicia Keys warbling the local anthem. But the PA takes its marching orders from Cuomo and Christie, and—not for nothing: It was Christie's Jersey crew that shut down the George Washington Bridge and pillaged the PA for years as Cuomo looked the other way—both governors declined to attend, leaving this morning's ceremonial duties to the anonymous gent in the topcoat stepping out of an idling chauffeured Mercedes and strolling to the microphone to greet the smallish media throng.

"This is a terrific day for Lower Manhattan," he says, "a wonderful day for New York City, and an absolutely great day for Condé Nast. Thank you all for being here."

"Who are you?" shouts a reporter. "I'm Chuck Townsend."

Somebody else asks who's in Chuck's car, perhaps hoping for a dignitary less minor than Chuck himself. He's the CEO of Condé Nast, publisher of glamour magazines, which signed a twenty-five-year, $2 billion lease in 2011 for twenty-some lower-level Freedom Tower floors. This blessed morning, a cadre of execs—financial analysts and such—are due to move in as the vanguard of a glossy force of thirty-four hundred. Maybe there's a celebrity editor keeping warm in the Mercedes and handy with a quote—Anna Wintour, the lioness of *Vogue*, say.

"That is my driver, and he drives me every day," Chuck says. "Thank you very much."

Chuck steps back two paces as a burly man steps up. He's Pat Foye, the Port Authority's executive director, and he's all bundled up in his winter jacket, ass-length, tan, buttoned to its brown corduroy collar. Pat looks like he just stopped by to rake some leaves.

"Look, a terrific day for New York," he begins. "The New York City skyline

has been restored. Welcoming Condé Nast to One World Trade Center"—and here Pat loses interest altogether. "Uh, restoration of the city skyline, uh, creation of thousands of jobs." This is a verbatim transcription, and I nearly feel sorry for him. Like almost every PA executive director who came before him, Foye's a hack. Cuomo, his patron, took office in 2011, knifed Pat Foye's predecessor—nobody's hack, which is why Cuomo had no use for him—and stuck Foye with the PA job. It was far too late for Cuomo to earn credit for anything good that might happen at ground zero; Foye's main job was to mind the store and see to it that nothing big went wrong. Nothing did, until one morning in September 2013, when it finally came to Patrick Foye's attention that the world's busiest bridge, the PA's George Washington, had somehow been hijacked and held hostage by Chris Christie's thug brigade for four days before the PA's executive director knew dick about it. It's rare to see Pat Foye out and about these days unless he's giving testimony.

None of that matters much this morning. I'm here to kvell upon the guest of honor: the Freedom Tower. On a clear day, I can spot its slender finger from my attic window in north Jersey, fifteen miles away. The closer you come, across the Hudson or East Rivers, by ferry or train, bus or car, the better it looks—a tapered, twisting obelisk whose curtain wall of glass mirrors the sky. The tower was designed three different times, each version simpler than the one before it; from a distance, it's a perfect signifier for the site. On the city's west horizon, it dwarfs even the Empire State Building; from the streets of Lower Manhattan, it looms. Close-up, it feels like the Twins—and like any other superskyscraper—too big, too blunt, too much mass upthrust too high, impossible, inhuman.

The Freedom Tower's particular burden is its base, a two-hundred-foot cube of concrete and metal covered in thick glass and stacked twenty stories high, meant primarily to absorb and survive the next attack. In 2006, the PA proclaimed that it would not ask its own staff to return to work in this building, saying they had already suffered enough trauma and horror at ground zero. Two

Ironworkers Tim Conboy and Mike O'Reilly finish hanging an American flag on the top section of the spire for One World Trade Center moments before it is "picked."

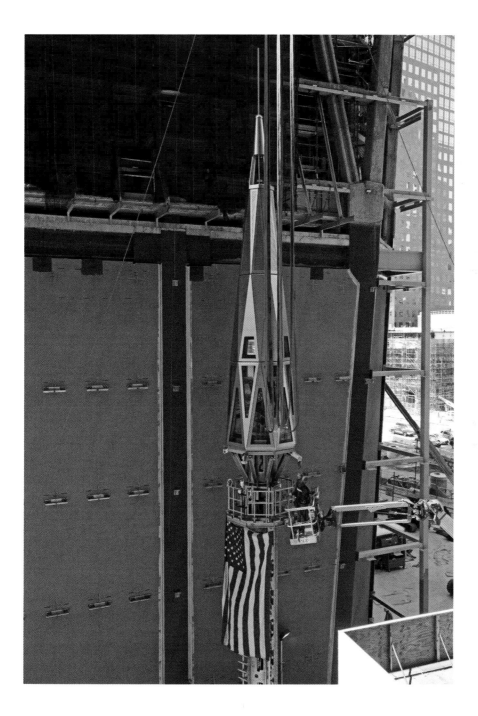

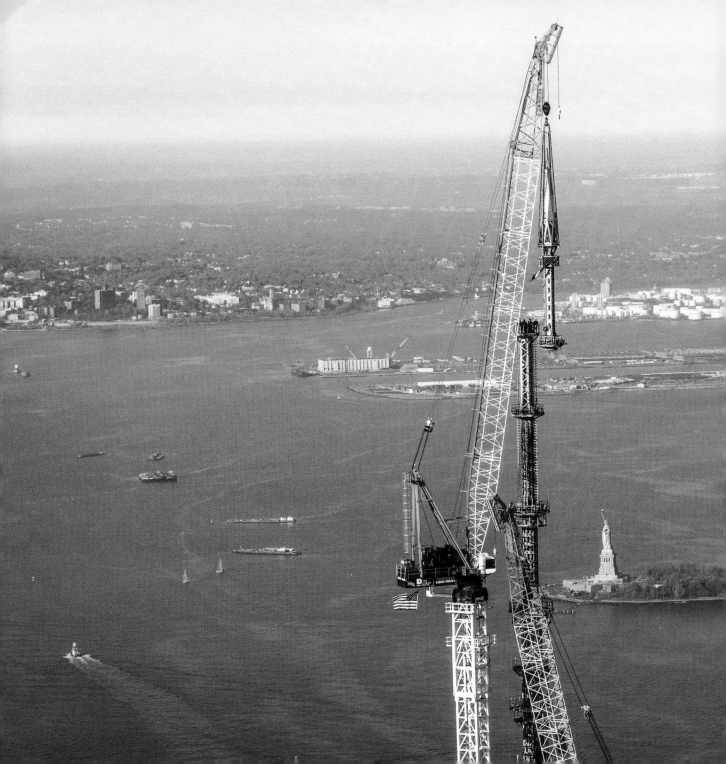

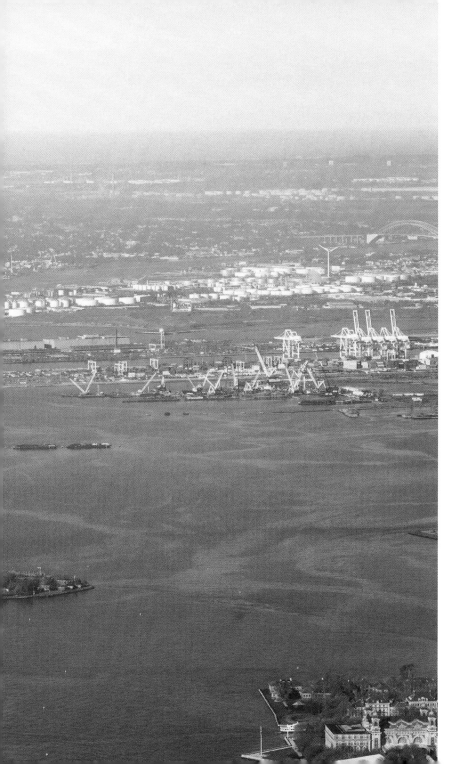

nights ago, during his *Saturday Night Live* monologue, Chris Rock suggested renaming the building the Never-Going-in-There Tower, wondered why it wasn't sponsored by Target, and asked if the tower could duck. Now a reporter asks Pat Foye about Rock's riff.

"Didn't see it," Foye snaps. "Next question."

There is no next question. There is only the same question rephrased, fielded by the Port subaltern who follows Foye to the microphone.

"As Pat Foye said, we're truly the safest place in America, if not the world."

On the memorial plaza, a few yards away and separated from the Freedom Tower by nothing but the forbidding force of that base, the square footprints of the old Twin Towers, precisely where they stood, are each a vast waterfall, each plunging thirty feet, each surrounded by parapets etched with the names of the 9/11 dead. Fifteen million pilgrims and more have come here, and

Ironworkers Jim Brady, Ryan Gibbs, Tim Conboy, Mike O'Reilly, John Collins, and Tim Scally prepare to top out One World Trade Center with the last section of the spire.

at least a hundred or two walk there this morning, but not one has strolled over to see what all the fuss is. In part this is a tribute to the solemn, splendid beauty of the plaza—a perfect piece of ground zero and a stroke of urban genius: After thirteen years of chain-link fencing and manned checkpoints, human beings can now walk onto and through these sixteen acres from the city streets around them.

But the tower—that behemoth of a base—is too close to see, too abrupt, too huge to approach. It sits apart, across a narrow lane blocked by a guard booth and retractable metallic dragon's teeth to force vehicles to halt. With no sun in the sky, the Freedom Tower still throws a fearsome shadow.

⸺

David Childs, the architect who designed the Freedom Tower, was not invited to its ungrand opening, nor was anyone else from Skidmore, Owings & Merrill's Wall Street office, a five-minute walk from here. SOM issued a press release on November 3 and announced a contest inviting the public to submit photos of the tower, with the prize a scale model of it.

"I'm sort of persona non grata, which is so surprising to me," he says. "These things become very personal. You get all wrapped up in it. I felt often like the Ancient Mariner, having to tell my story, living it on and on. I just wish that it would be over, frankly—it's haunted me for a long time. All these problems—I knew it was going to be difficult, but I didn't realize that by the end there'd be so much difficulty piled on, in a very intense way, a way that was unnecessary and very damaging. I'm floored when we haven't been welcome on the site."

The first time we met, in 2005, Childs was sixty-four years old and so tickled with the Freedom Tower that he excused himself after a few minutes, returned to his office with a plastic model, one foot tall, and set it on his desk.

"*Dead* simple—so that it can have some sort of memory and identification," he said at the time. "And when you look at it from New Jersey, or flying in, or coming across the bridges, you'll know *exactly* where the memorial is.

The memorials are the voids, the sadness of what happened. This is the victory—the triumph of the fact that we *weren't* defeated. We came back."

Most architecture critics, a bilious lot, found the design dull; at worst, there was a general consensus that the base evoked paranoia and perpetual war, with the *Times* critic, who hated the thing base to spire, writing that the tower was "fascinating in the way that Albert Speer's architectural nightmares were fascinating: as expressions of the values of a particular time and era."

Childs was less irked by being compared to Hitler's architect—tough town, New York—than he was by those dismissing his redesign as just one more ho-hum skyscraper or a missed opportunity to make a bold artistic statement.

"We are building an office building. It ought to be iconic and solemn, and yet beautiful and simple. Memorable. But it also has to be something that *works*. It has to be an *efficient* building that can attract people down here. I believe in program and function being the forces that create beauty—they've *got* to come first. Tall buildings are the result of engineering as much as anything. These buildings are formed by a knowledge about what they are to *do*—it's not just an arbitrary sculptural act in which you say, 'Okay, let the engineers figure out how to do it.' There's a *lot* of architecture that does that—and some of it's very beautiful. It's not *my* kind of architecture, and particularly in this case, this building had to be much more than just a sculptural gesture."

———

Governors, developers, and architects come and go; the Port Authority of New York and New Jersey abides. It sprang to life in 1921 because someone had to do something: New York City is mainly three islands, and the two states, filled then as now with aggressive, ambitious assholes, could find no way to manage the flow of goods, services, and humanity—or to fairly split the profits therefrom—without lawsuits and sporadic gunfire. Thus, by law— an interstate compact negotiated by the two states and enacted by the U.S. Congress—the PA was designed to run itself and live forever.

A century ago, this was a Progressive-era leap of faith in benign, expert governance shielded from public whim and political predation. A twelve-member board of commissioners—six appointed by each governor—would shape long-range regional transportation policy. New Jersey would choose the board's chair. New York would choose an executive director, the hands-on CEO who'd guide its operations day-to-day. The PA would knit the competing interests of the separate states into the commonwealth, ensuring a network of cost-efficient transportation systems—entirely self-funded: zero tax dollars needed—to make the very nation's economic engine purr and hum.

In the real world, hid from public view or vote, led by an entrenched emperor—Austin Tobin, its executive director from 1942 to 1972—the Port Authority amassed incredible wealth and power. It owns and runs the three major airports that connect the world to New York City, the major bridges and tunnels, the major seaports, and the commuter railroad to and from ground zero. Its annual operating budget—more than $8 billion in 2014—and its capital planning are entirely funded by the tolls and fees and fares and rents that it collects and by the long-term bonds it issues for sale, based on its semi-infinite revenue stream. Politicians at every level rightly came to fear Tobin's power and do his bidding; no one else knew who the fuck he was. Nobody said no when he settled on a grand legacy commensurate with his reign and—because the PA had the right of eminent domain, too—condemned and seized that sixteen-acre parcel in Lower Manhattan and built the World Trade Center, complete with the two tallest buildings in the world at the time. It was an outrage to the city's private real estate developers, who all of a sudden were bidding projects and competing for tenants against a quasi-governmental behemoth with money to burn: tough shit for them. Tobin bought off the New Jersey side of the PA by placing the WTC on the west bank of the Hudson and taking over the Jersey-owned commuter railroad, which—thanks mainly to the PA's bridges and tunnels: Austin Tobin hated trains—lost money. In short, the

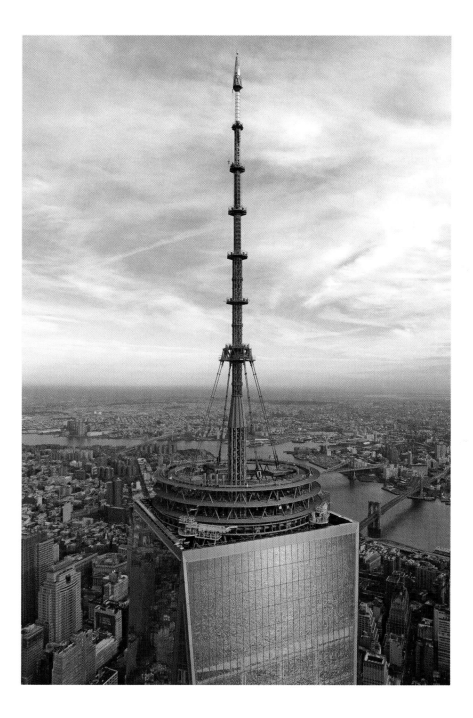

WTC was exactly the kind of project the PA was built not to do: a complex, costly, endless distraction; decades passed before the Twin Towers were filled with tenants—the World Trade Center had next to nothing to do with transportation, and was a money pit.

Tobin died in 1978. The agency he built into an empire is now a local joke and an international disgrace. The way the PA fulfills its core mission is in plain view 365 days a year. LaGuardia, JFK, and Newark Liberty airports all are train wrecks of disrepair and dysfunction, any one of which would shame a public agency that gave a shit, which the Port demonstrably does not. The PA's train line loses $400 million a year. Its reeking Midtown taint, the Port Authority Midtown Bus Terminal, has been riddled for decades with filth and crime. The Port shrugs, shrouds itself in silence and opacity, and answers to no one but its stewards, the governors of New York and New Jersey. That's how Andrew Cuomo and Chris Christie came to run it in a manner befitting the Gambino and Genovese families making common cause of a bistate titty bar. And that's why George Pataki's "Torch of Freedom" had to die.

By the time Pataki left office, on the final day of 2006, David Childs was working for the Port. The governor had held his last ground zero ceremony less than a fortnight before, to witness the welding of two Freedom Tower columns to its concrete core. It had taken a year and a half just to bolt two pieces of the tower's steel upright—better than nothing but not much, not near enough to make Pataki look like a contender. The rebuilding was gridlocked, paralyzed. Silverstein controlled the Freedom Tower in ground zero's northwest corner and three other skyscrapers—also office towers—to be built along the eastern boundary of the site. The Port Authority controlled the memorial turf—fully half the sixteen acres, more or less in the middle of it, including the footprints of the Twin Towers. The PA also had a fancy new train station planned, squeezed between two of the eastern office towers. The station, designed

by megastarchitect Santiago Calatrava, amounted to a $4 billion winged-white-concrete wetting of New Jersey's beak— the most expensive train station ever almost built, already six years late and still under construction, serving a train line losing hundreds of millions of dollars every year.

The rebuilt ground zero would be packed so tight at street level that the Calatrava station's wings, which were supposed to open and close—his young daughter released two doves at that groundbreaking, which turned out to be pigeons—were clipped after engineers realized that they might not clear a neighboring tower. But the real problem sat seventy feet below street level: The entire infrastructure was interlocked. Each Port project connected to one of Silverstein's; building on separate sites separately was impossible, and every aspect of the foundation work that had to be done before building actual buildings could begin became a ferocious, protracted land-lord-tenant battle.

Silverstein—still paying the Port its monthly $10 million Trade Center rent, still fighting his insurers, still willing to defend his lease in court if that's what the PA wished—took an ugly public torching. Pataki's days in office were numbered, his ground zero legacy an orphaned cornerstone sitting in a puddle of brack at the bottom of a chest wound still weeping with human remains. The governor and the PA declared an end to negotiations in April 2006, and Pataki told the press that Silverstein had "betrayed the public's trust and that of all New Yorkers. We cannot and will not allow profit margins and financial interests to be put ahead of public interest in expediting the rebuilding of the site of the greatest tragedy on American soil."

It was perfect political tradecraft, a fog of stupidity and jingo echoed by the *Times* ("GREED VS. GOOD AT GROUND ZERO") and the *Daily News* ("GET LOST, LARRY"), and it was born of Pataki's desperation to have something—anything—to show as evidence of leadership. The Port made Larry an offer he couldn't refuse: It sliced his rent and agreed to speed up foundation work for Larry's three

eastern office towers. It was a good offer; those towers would be quicker to build and easier to lease: They were much closer to the train station and not nicknamed by a politician. What made it a great offer was that all Pataki and the PA asked in return was the Freedom Tower.

Larry let them take it off his hands. And when the governor invited him to the ground zero ceremony to mark the passing of the "Torch of Freedom" to the Port Authority, Larry was glad to show. We're talking about a guy whose pelvis was crushed by a drunk driver five days before his bid was due to lease the WTC in 2001, when he was seventy years old; he had his doctors dial back the pain meds, brought his real estate team to the hospital, and kept working. Being called a traitor by the governor of New York was small potatoes.

"Listen," he said after the ceremony, "after all the name-calling, we're still working together, right? So what does it mean? What does it accomplish? I'm not going anywhere. I'm going to *finish* this job. I saw this not just as an obligation but also a privilege, to rebuild. And I felt it—and I feel it—as an obligation to my children, to my grandchildren, that this thing get rebuilt. We'll get it done."

The deal was sweet for Larry—"I'm not complaining," he said—but not for David Childs. By 2006, Childs and Silverstein had finished 7 WTC, a trapezoidal beauty, 750 shimmering feet, fifty-two floors, and 1.7 million square feet of office space—all now fully leased. Childs designed it to let Greenwich Street come back through—the old Seven blocked it—and he put a small park steps from its front door. New York City real estate developers don't typically spend money on such things unless an architect can convincingly explain why they're so vital. Silverstein nursed every nickel, but he also knew the historical heft, and the spiritual demands, of the Freedom Tower. Childs's SOM team and Larry and his boys had bonded over countless Freedom Tower design meetings, putting dollars on the architects' renderings, hammering out the details of an office tower the same way developers like Larry Silverstein do it every day: to a nub.

"He listened," Childs says. "He cared. He wanted it to be his legacy. He had a certain amount of faith."

Not that the Port Authority gave a rat's ass about any of that crap after Pataki left. The PA hadn't built any sort of skyscraper in forty years; its engineers weren't worried about inspiring anyone but the Port's financial analysts, and the financial analysts were inspired solely by the murderous mounting costs of the whole rebuild. It was standard practice for contractors and suppliers to wait months for past-due PA payment; the agency was cutting whatever it could. The memorial museum and plaza were holy. The train depot—always "the Calatrava"—had rabbinical supervision on both sides of the Hudson River. The Freedom Tower? A foundling, a mewling orphan with a Godzillan appetite for cash.

George Pataki's brief successor, the whoremongering Eliot Spitzer, came into office threatening to scrap the whole thing. Instead, the PA stripped it, piece by piece—starting with the cube.

Side gardens? Dead.

Pool? Dead.

Broad steps, where folks might sit and eat their lunch? Dead.

Stainless-steel spandrels? Shot through the eye like Moe Greene.

Again and again, David Childs went back to the drawing board. By 2008, he was clinging to his prismatic glass. Barely.

"This is a good office building, and the structure works. But there's another thing that this building aspires to—that other, final, symbolic, proportionate light-filled thing that inspires you. When the glass is on it, the faceted glass, with all the light going through and bouncing back—it's really going to be quite amazing. But we've got to get the right glass. A simple building is not tolerant of cost cuts. It is dependent on the detailing, the right materials. Once you take this tower and put it in its place, you've got to do it right. And they're going to screw it up."

In 2010, as the Freedom Tower's projected cost passed $3 billion, the PA put a piece of the building up for sale and struck a deal with Douglas

Dara McQuillan, chief marketing officer at Silverstein Properties, leads a school group tour of 7 WTC.

Durst. For a lousy $100 million, the Durst Organization obtained a 10 percent equity interest in the tower, along with a $15 million management contract whose fine print made plain the Port's one true priority: If Durst could find costs to cut, Durst would pocket 75 percent of every penny it could save on the job up to $24 million, and less above that. Durst didn't outbid other developers who wanted in—there were five—but it had something special going for it: Condé Nast was already Durst's tenant in a tower at Times Square and—who knew? Who even coulda guessed?—might relocate downtown, for the right price.

Surprise: Durst found costs to cut. It got rid of Childs's glass tout de suite and set its eyes upon the spire. That forty-story radome—the sculpted, tapered cable-and-fiberglass shell, shielding and concealing the broadcast antennae and tower mechanicals, its web of interlocking triangles climbing the sky: What the hell was that piece of shit doing up there, besides costing $20 million?

Childs was helpless, frozen out. Douglas Durst is a third-generation real estate king; his father had waged a public war against building the old World Trade Center, and Doug himself put a full-page ad in the New York City papers in 2007, urging new governor Spitzer to bury the Freedom Tower. It was Durst's building now. Andrew Cuomo and Patrick Foye had no investment in the Torch of Freedom. His new boss saw no reason to give a moment's thought to Childs's pleas to spare the radome.

"I was so eager to try to get to Durst," Childs says now, "to understand what he thought was wrong, and I realized right away that he didn't want to talk to me, didn't want to see me, didn't want to take me up on my offer to redesign the spire or to solve problems. He just wanted to go in there with his ax."

Childs was informed by a press release that the Torch of Freedom's vest slept with the fishes; Durst told the press that the radome had to go because of potential maintenance and repair issues, which was bullshit. David Childs took bold—and, for any architect, exceedingly rare—action: He issued a

statement of his own, expressing disappointment and offering to work with the PA on a redesign. "Eliminating this integral part of the building's design and leaving an exposed antenna and equipment is unfortunate," he wrote. "We stand ready to work with the Port on an alternate design that will still mark the One World Trade Center's place in New York City's skyline."

But $20 million saved was at least $10 million earned for Durst. Childs's statement did have some effect: The Port told David Childs to shut the fuck up. With his loose talk about "exposed antenna and equipment," Childs was jeopardizing the Freedom Tower's status as the tallest building in the Western Hemisphere. Because the Council on Tall Buildings and Urban Habitat, which is the international decider of these things, it has rules, goddammit, and while it'll include spires as part of a tower's height, "antennae, signage, flag poles or other functional-technical equipment" don't count.

No worries. When it came time to present the Freedom Tower's 1,776-foot case to the council, Port Authority executive director Pat Foye was on it. Even better, Foye knew just the right person for the job—David Childs.

After losing every design battle with the Port Authority and Durst, Childs stood up for the Freedom Tower one last time.

"I had to go at the request of the head of the Port to Chicago, to argue why this sad little piece of steel up there was really a spire. And I swallowed my pride, and I won. And was there a word of thanks? No. And do you think I was welcomed back on the site as a prodigal son? No."

There were times, says Childs, when despair made him want to walk away from the project, and each time he told himself, "This is bigger than that—get in there and make it as good as you can." He also understood that the Freedom Tower is finally no one else's public legacy but his.

"I don't want it to be the thing that I'm remembered for, because in fact I've done a lot of things that I'm much prouder of. They're up. They're built. They're finished. And I have great relationships with the clients. But you

don't get to choose those things—that obituary's going to say, 'One World Trade Center.' I'm impressed—I'm surprised, actually—that there are still so many people who call it the Freedom Tower. I still do, out of spite. That name stuck because at least it's a name. One World Trade Center fell down."

Childs went to his office on November 3, 2014, as usual. But he would've been happy to join with Pat Foye and Doug Durst to greet Condé Nast. Gladly—just to see people coming in to work.

"The whole idea wasn't to rebuild buildings—that's the architectural drive, but I always felt very strongly that the idea was to come back and prove to the world that we had returned, and returned better than before. And that's all about people gathering together. We are an animal that wants to be together. We are very social, and that's why architecture is such a social act. We want to be together for worship and play and trade, all those things. This is a marketplace and a gathering of people. Seeing them going to work in a normal situation really meant we'd done it."

Done. The last time I walked ground zero, almost Thanksgiving, that is exactly what I'm thinking: *Somehow they got the motherfucker done.* It's dusk, cold, and spitting rain, getting darker by the second, and when the LEDs behind the glass light up, the base warms up a little. But not much. There's still nowhere to sit—no terraces, no stairs, just a long tall fortress wall facing the six-lane roadway, protecting the concrete moat surrounding the cube.

Tourists walk the memorial plaza. There are places on this earth where the dead speak louder than the living; now New York City, which never, ever shuts the fuck up, has one of those.

I've spent time at others—Sobibor, the Lorraine Motel in Memphis, Little Bighorn—but this place is louder, including the dead. They haven't been here long. The young architect with me, Jeff Holmes, was on David Childs's Freedom Tower design team—he left SOM a few years back to start his own firm—but hasn't been down here much. He pays tribute to Arkady Zaltsman, a

colleague killed here on 9/11. Zaltsman was at an 8:00 a.m. client meeting on the 105th floor of the South Tower. He was forty-five years old, with a wife and daughter, when he left home that bright blue morning, on his way to work. He's a gathering of letters now, a name engraved upon the parapet that guards the old towers' void.

"It is about the people," says Jeff Holmes. "Most of the stories aren't. They're about all kinds of things, but not about the people on the ground. To finally have people in the building—I just came from a meeting with one of my guys, and I asked him how he felt when Condé Nast moved in, and he teared up on me. It's emotionally draining, the challenge of a marketplace that's meant to be a memorial to an incredibly awful event. Both at the same time—it's impossible to be both. But it is—there's the building, and there's the old footprint. It's just good, good for it to be coming back together."

Finally, truly, good is good enough. Knowing that the world will outlast us doesn't matter. The fear that comes with knowing—that's the cube—matters nothing. We're alive. We laugh. We love. We go to work.

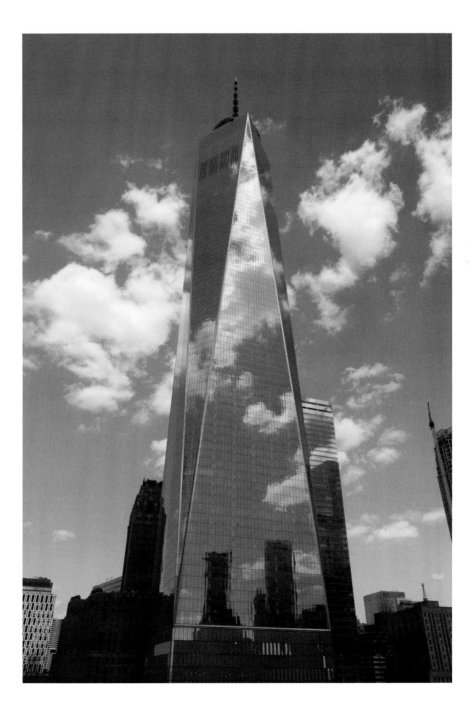

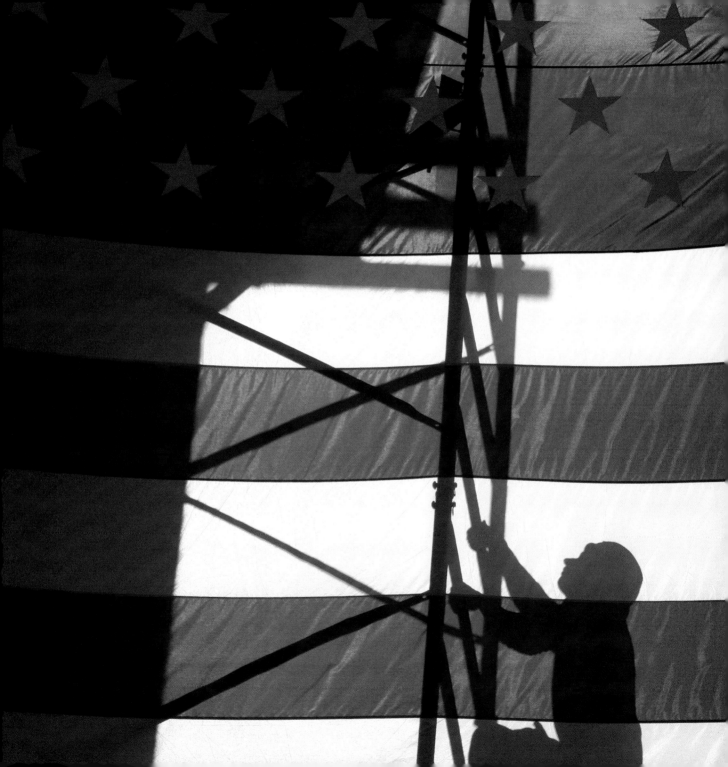

EPILOGUE

SCOTT RAAB

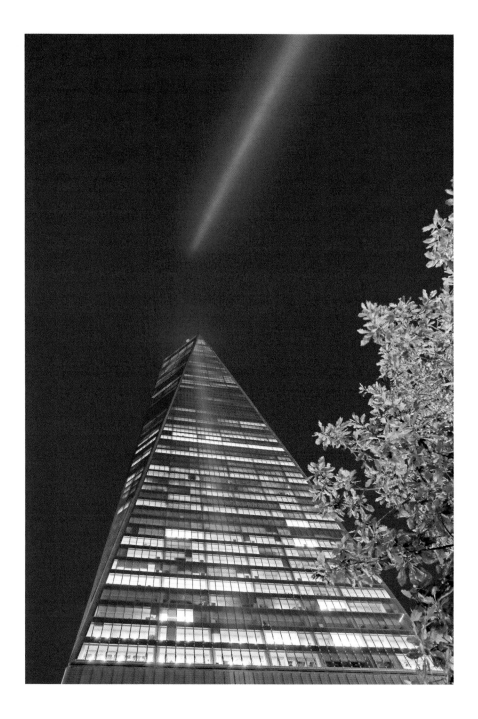

Previous spread: Worker Vincent "Gorgeous" Conca climbs a scaffold behind a giant American flag after work recommenced on 3 WTC.

Through my attic window here in Glen Ridge, New Jersey, the World Trade Center's glow spreads the night clouds, and, through winter trees, I see the tower's spire.

Darkness falls early these days. A literal plague ravages the land; its death toll has risen again, thousands of victims—an epic slaughter, a 9/11—every day. The American body politic roils in bloody disunion unseen since the Civil War, and though I am the grandson of four immigrants, truly grateful for all my country has given me and mine, I am no optimist. These days, I take comfort near—in my wife's laugh, and in her arms, in imagining the next time we'll be able to see our son, in each meal, movie, and book.

Faith and hope rise fifteen miles away, where the Freedom Tower soars. It is not a symbol. It is not a metaphor. It is a spire atop an office tower surrounded by other office towers. The faith and hope I feel seeing it isn't abstracted patriotism or spiritual pap; it's a practical belief and an existential proof: If we got *that* bastard done, we can do *anything*.

The key word in that last sentence isn't "anything" or "that," despite their italics; the key word there is "WE."

Corny? I think not. I'm a cynic, by nature and by trade, and covering and living the rise of the Freedom Tower for ten years didn't change me. The rebuilding was a clown show, a shambles, a mockery of all of the civic values mouthed by every politician who paid lip service to 9/11 and its victims to amass power, and heaven knows it wasn't only the politicians looking for an angle, the next play, aflame with desire and ready to fight for more leverage, money, power—it was the business machers, too, the land barons, bankers, armies of litigators, plus the media, which uses—and is used by—all of them to shape and tell public stories that pass for history.

It took me all of those ten years to learn and relearn that this massive endeavor, with so much at stake—hundreds of billions of dollars, the torn soul of a proud city's skyline, the thousands of lives taken and families ruined—this absurd pie fight was the *only* way the rebuilding could be accomplished

because it was also the essence of New York City itself—and of our raucous, tribal, mutant union, these beloved United States, the collective We that New York City exemplifies, amplifies, distills, and anchors.

We Americans are an ornery, ignoble bunch, quick to take umbrage, quicker to incite it, ever fractured, never beyond healing. The best of us under the worst of circumstances can maybe find a way short of mayhem and mass murder to get some healing done, but maybe only if and when we suffer enough to love our freaking neighbor.

Now—the eternal now, yes, but especially today—would be a lovely time for that healing grace. A spire is a spire is a spire, yet through my attic window you can also see the underlying bedrock truth of our American faith and hope:

We rise, or fall, together.

Following the Freedom Tower build from beginning to end was *Esquire* editor Mark Warren's idea, in 2005; the building was on a five-year timetable as far as we knew, which was not far. Mark and our editor in chief, David Granger, decided to run two stories a year until the job was done, and trusted me to write them.

I was thrilled and grateful, for the size and gravity of the story and *Esquire*'s commitment, and also for the job security. You're only as good as your last story; I was already in my fifties, with a young kid and twenty years of magazine writing behind me, feeling like maybe my prime was past, and now I had a fresh shot at something special, unique, even important—something that might last. To me, this was a miracle; you hold it in your hands.

Two facts became clear as soon as I started: The Port Authority, owner of the World Trade Center, was not going to grant us access to the site, their plans, or their decision makers; and construction of the Freedom Tower would not begin for . . . no one knew. Months, for sure.

This turned out to be a lucky break. I had time to start reading about the complicated histories the site, the Port Authority itself, and the building

of the Twin Towers. Warren—the most passionate of editors, not to say the most deranged—was obsessed with the sheer complexity of erecting a building so tall, and the task of doing it at a place still flooded with meaning and fiery with emotion. The meaning and emotion made the story worth writing; what worried me, a guy whose Cro-Magnon manual skills don't go beyond lefty-loosey righty-tighty, was trying to understand and to explain in words all it took to literally build the damn thing from bedrock to 1,776 feet.

As for access, we caught an even luckier break: Dara McQuillan, who works for Silverstein Properties. Warren and I met with him a couple of times to explain our commitment and ask for his help. Without his yes, with no foot inside the door, I had no chance to close the deal.

There was no quid pro quo, no favor I could promise, in exchange. Yes, in the real world of journalism, writers protect sources, tread lightly, pull punches, and in the real world of human feeling, we like the folks who help us do our business, and tend to consider them as very fine people despite any flaws. Dara understood my mission—to write an accurate, truthful history of the rebuilding, more or less as it happened; he also knew the magazine's fabled history. I've known him for fifteen years now, and consider him, despite his flaws, a true wizard.

What I'm saying is, judge all you want, but trust me: I never pulled one punch, and Dara never gave me grief but once, when I referred to Larry Silverstein's continual portrayal in the New York City print media as "the Fagin of Fifth Avenue," and that's only because Dara's Ireland born and bred, and so has read many, many books. And you can trust me on this, too: Even without Dara, I would've found some way in. I always do, and not with charm or talent: I'm lucky.

Take Joe Woolhead. I met Joe through Dara. Our first date was a four-hundred-mile drive to Portsmouth, Virginia, where the Freedom Tower steel I had seen rolled in Luxembourg was arriving to be fabricated before

Joe Woolhead, official photographer of the World Trade Center. *Credit: Anthony Ribando.*

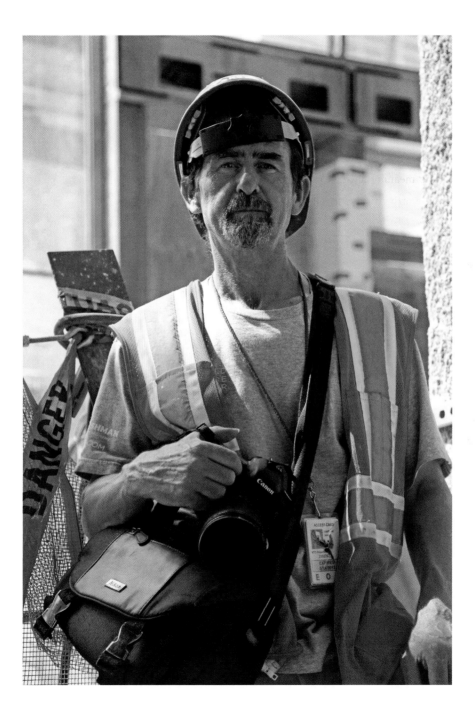

delivery to the World Trade Center, and I was so transfixed by Joe's raving lust for Thin Lizzy that a Virginia trooper pulled us over and handed me the first and only speeding ticket I've ever gotten.

Next morning, Joe was a few minutes late for our departure from the hotel, and I was having *none* of that, not on this job. *"We,"* baby. *Not you, not me: we.*

I referred to him as "the putz with the camera" in one story—but by the time I wrote that, we were already friends. Like Dara, Joe's an Irishman; like so many who come from all over to give New York City their best shot, he's known tough times without ever giving up on himself or the world. Joe didn't give up on me, nor I on him—far from it. We got the Virginia job done and drove home hungry, to my house, and we ate dinner like a family, and that was all right in all the right ways. E. M. Forster wrote, "Only connect!" and that's still the basic rule of building human friendship and love—and stories, photos, and office towers.

Joe's a big-hearted, honest man.

His guerilla style, founded on personal knowledge of doing construction work, put him in the trenches every workday, every month of every year. He's nimble, tireless, and never in the way. His photos of ground zero and the human army rebuilding those sixteen acres are a repository of American history and glorious illumination of the sole indisputable, absolute, and literal truth: inch by inch, day by day, downtown has been reborn and New York City's sky reclaimed. Joe scrambled on-site in the first days in the toxic smoking pit; twenty years later—even now, at COVID o'clock—Joe's there shooting pictures. New York City rats can't outwork Woolhead.

Five years of *Esquire* stories grew into ten. This was a great thing from my point of view. I got to do what everyone else working at the World Trade Center was doing: building something strong and lasting, floor by floor. I worked the rebuilding story on the phone, on the road, or in a source's office or coffee shop for an interview. I broke news

once in a while—when the Port Authority decided to officially rechristen the Freedom Tower as "One World Trade Center," and when former New York governor George Pataki had a three-foot-tall model of the Freedom Tower built for him to tote around the country in 2008 as he raised money for what became a stillborn presidential run.

The Port Authority and George Pataki denied these relatively meaningless truths, by the way. This is one of the great truisms of journalism and society, and not merely in our time and place: Never, ever, under any circumstances, trust any politician or spokesperson to place the truth above their own best interests. Because I had the unique luxury of spending ten years on one story, and the support of a great magazine, I built a body of knowledge and a network of sources to depend upon and trust. I could also judge without worry the sorry parade of ground zero–adjacent politicians that came and went—Pataki and Giuliani and Spitzer and Bloomberg and Cuomo and Christie among them—kings for a day, building little beyond their own personal empires.

Ten years, ten long stories—hundreds of hours of recorded interviews, thousands of photos and news clips. What I learned about construction, engineering, architecture, and New York City politics, I learned on the job, but what stick are the feel of the place and the people who trusted me enough to let me ride along on their knowledge, insight, and wisdom. I tried my best to repay them and do justice to the place and its various meanings as I went along, telling the stories with fidelity to the truth as I saw it unfold, with all the feelings fit to print—the least I could do for the privilege and honor of doing my share with what tools I have. I'm no historian, barely a journalist, and certainly not one if that term involves "objectivity"—an abstract psychic distance from the story that shields a reporter and writer from bias and judgment. That's not how the human brain works—history's not written by machines; human objectivity is an intellectual sham—and it's not how I've ever worked a job, especially the World Trade Center. To spend ten years writing and reporting about that patch of land did not make me less passionate

about the place; quite the opposite. On a planet soaked in blood and suffering, ground zero was an open wound, a void, a nullity embodied by its emptiness. It is healed now. Yet the scar still speaks to me, and always will.

Funny, in a New York City way, but those towers were distinctly unloved before crashing to earth, neither admired nor respected by the critical arbiters of the 1970s. Lewis Mumford saw "purposeless giantism"; Ada Louise Huxtable dismissed them as "General Motors Gothic"; Jane Jacobs called the WTC urban "vandalism," and not for nothing, these narrow, redundant towers upthrust from a so-called superblock, hedged by lesser, duller buildings that turned through streets into dead ends to form a barren concrete plaza shredded in cold weather by vortices of bitter Hudson River wind.

In life, they were at once impossible to miss and, to those living in and around the city, invisible. The Twin Towers were there and *not there*—seen a thousand times a year in movies and television shows, in millions of photos, instantly recognizable, globally iconic, and all but unseen in the city's daily life: tall wallpaper; the towers served as a compass in the downtown sky, an isolated destination for office drones and tourists only. There they stood—fewer than thirty years—until the morning of 9/11.

That day, across the planet, two billion people watched the news and saw them gashed and burning, then collapsing—vanished into gales of dust. Sixteen million Americans tuned in live on TV as the helicopters circled over the human beings atop the towers, scores of whom, trusting gravity to spare them the fire, arced to their deaths. It was reality TV, an endless sunlit nightmare of carnage inescapable, unbearable.

And yet the plainest historical lesson of 9/11 was quickly obvious: New York City would overcome, prevail, abide. Within days of the attack, the politicians, the landlord and the tenant were dueling for power over the rebuilding and the billions of relief and recovery dollars that would flow—business as usual in New

York City. The bustle paused while the city and the sky went literally silent, but never the hustle, not here. There was no shame or falsity in that; the shock, outrage, grief, and fear following that sudden and vast destruction and death were no less real; there was even a certain reassurance: The towers were down, but the city was standing, the pigeons were pooping, and the power brokers were busy angling for an edge. Wall Street reopened for trading by September 18. George W. Bush asked a wary citizenry to keep the faith and keep shopping, lest the terrorists win.

In and around New York City, the grief hit hard and lasted, and the fear ramped up beyond anything the city had felt after the WTC was truck-bombed in 1993, killing seven people. The scale of human loss and the immensity of destruction on 9/11 were indeed terrifying, so the fear was fixed upon whether more attacks were imminent; there was never any fear that New York itself had been fatally wounded in substance or spirit, no doubt that we'd survive, rebuild, and thrive—none. Eight million people in the five boroughs,

twenty-plus million in the megalopolis, the cold heart of capitalism, complete with a $2 trillion–plus GDP and more billionaires than anywhere else in the world, not to mention the secular capital of everything sublime—and satanic—in the worship of dollars, culture, and pastrami: New York doesn't bluff, fold, or bet against itself.

And so twenty years later, as forensic scientists still parse bone dust, still search for DNA clues in the remains of hundreds of victims not yet identified, whose kin still hope for whatever closure may come, and as the "Tribute in Light" beams still pierce heaven dusk to dawn each 9/11—two brilliant blue-white shafts, ghosts of the departed icons, resurrected and heaven-bound, rising and revered—the work goes on. Another Silverstein-owned tower's on the way, plus a performing-arts center that's been more or less on hold for a full two decades. The creative genius and tragic flaw of humanity—our innate drive to build wedded to our urge to destroy—are not just visible here: They fill to bursting the eye—up close, they fill the cosmos—and the heart.

f we got *that* bastard done, we can do *anything*.

We.

The tensile strength of the city's spirit transcends the magnetic force of money, because it is forever replenished, refreshed, and inspired by those who come from other places. New York is where humanity has arrived for centuries, bringing new life—language, food, music, and hope, ambition, energy, and courage—to add to the most ethnically diverse populace anywhere. Our country's arms still open here. The citizens of seventy other nations died at ground zero on 9/11, and whether they sought this shore for any Lockean notion of liberty or just to freely chase a buck is beside the point: The courage and creative force they bring makes and keeps New York City true to the best of America's best dreams. Every newcomer redeems the covenant with our collective self—the same compact joined by our own ancestors who came as strangers and struggled and stayed to become Americans.

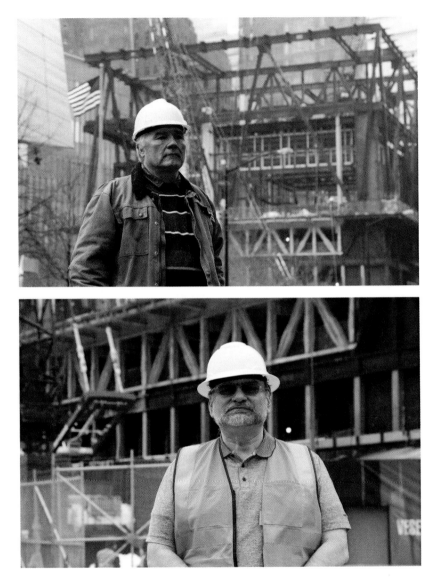

Top: Brian Lyons, World Trade Center. February 2021.
Bottom: Pablo Lopez, World Trade Center. February 2021

Top: Andrew Pontecorvo, World Trade Center. January 2021.
Bottom: Marc Becker, World Trade Center. February 2021.

New York City is where that pioneer promise still gets kept. It was pure political silliness that inspired George Pataki to call it the "Freedom Tower," but seeing it shining down the harbor toward Ellis Island and the Statue of Liberty doesn't register as patriotic kitsch. Here the New World still beckons, more real, more joyful, older and truer than any parchment under glass. These are living markers of a sacred love born of scripture and lived right here:

Welcome the stranger. Love thy neighbor. Don't paste bills.

Humans being human, these are aspirational precepts; the goal, in theory, is to strive to live up to them. New York City is tribal in the usual ways, divided by race and class, but with three million foreign-born denizens and a population density of twenty-seven thousand people per square mile, this is a place where the striving is a matter of daily practice on the streets. It works out, more or less, because the stress of making a go of life in a world capital requires enough effort without paying a lot of attention to other folks' business, and because a vast majority of humans—in New York

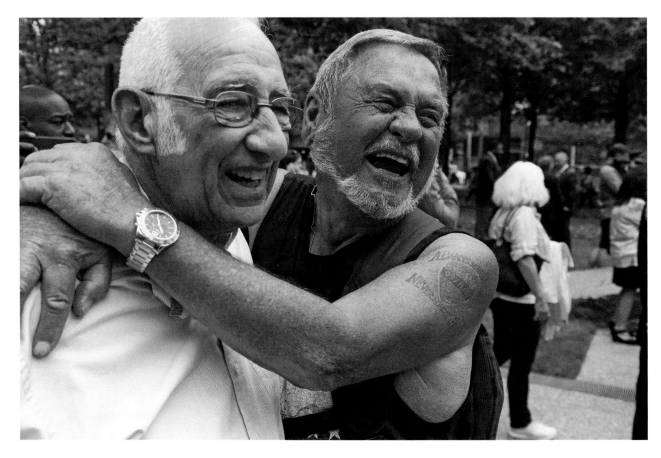

First responders Dennis Frederick and Dick Durana reunite at the dedication ceremony for the Glade at the 9/11 Memorial & Museum.

City as elsewhere—are decent or better folk trying hard to get through the day with some measure of grace, and absence of friction.

On 9/11, during the darkest hours of the most horrific day in the city's history, New Yorkers united with loving kindness, feeding and consoling each other, searching for the missing and gathering in reflection and prayer, enacting a loving community that finds its echo in the civic suffering of these days.

Nothing reveals and defines the soul of a community, or a country, more clearly than tough times. Now, twenty years after 9/11, facing a collective grief, suffering, and outrage on a scale beyond anything we've known in our lives, the Freedom Tower's spire reminds me that nothing—no act of terrorism, no natural disaster, no pandemic: *nothing*—is stronger than the human spirit of community.

—January 2021

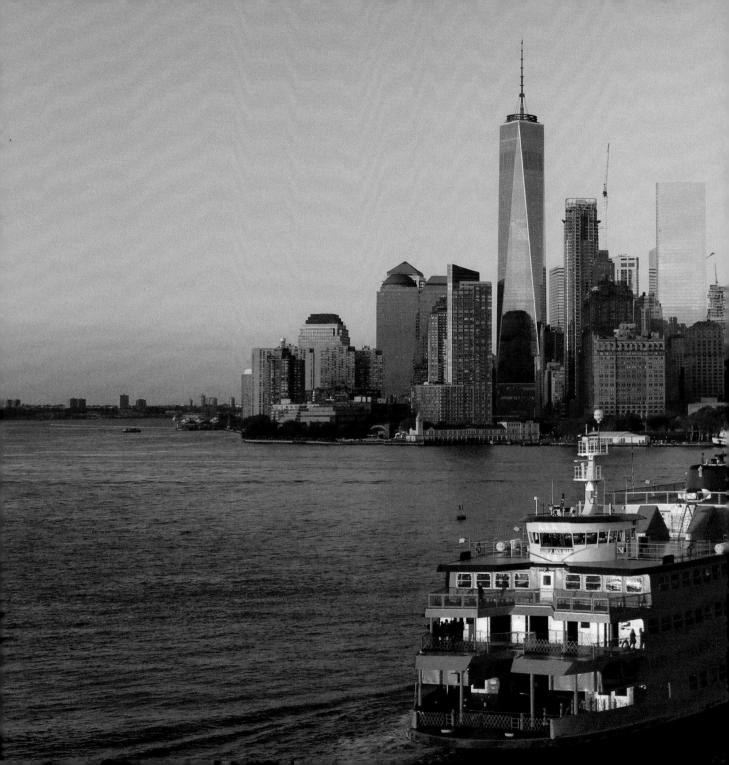

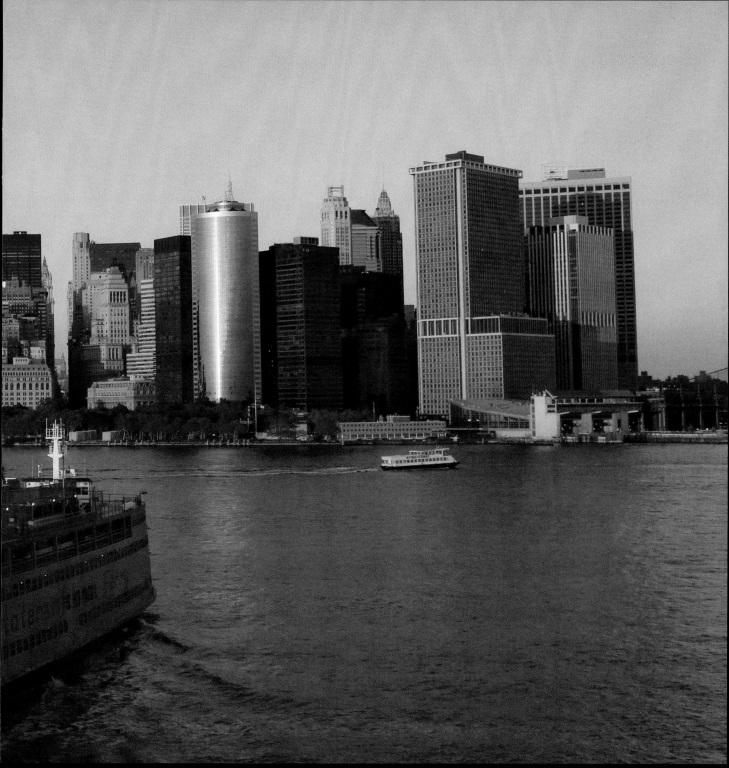

SCOTT RAAB:

Gratitude first to *Esquire* magazine, to Mark Warren and David Granger, to John Kenney, Bob Scheffler, Kevin McDonnell, Andrew Chaikivsky, Tyler Cabot, Michael Norseng, and Tim Heffernan. And shame on me if—due to the passage of years and my brain cells—I've omitted anyone who helped me get it right.

Thanks also to Liz Kubany, Ken Lewis, T.J. Gottesdiener, Richard Kielar, Mel Ruffini, Michael Frazier, Joe Daniels, Michael Arad, Mike Marcucci, Marcus Robinson, Stef Libbrecht, and Sasha Bezzubov.

I'm particularly indebted to Larry Silverstein, Dara McQuillan, Jenny Chao, Janno Lieber, David Childs, Chris Ward, and Charlie Wolf for their help and for their trust.

Thanks, too, to the sources who remain nameless for their own good.

This book exists because of the vision and assistance of Sean Manning, my friend.

Thanks above all to Lisa Brennan, my wife and partner, and to our son, Judah.

JOE WOOLHEAD:

First and foremost, I would like to acknowledge my family, the Woolhead clan from 80 Clancy Road, Finglas, and most especially my father, Joseph, "Joe," and my mother, Marie (nee Bruen), whose love, strength, courage, and determination I can only hope to emulate. (I hope I made you proud, Ma and Da).

I would like to thank my three exceptional sisters Anna, Veronica, and Mary, who have always guided and supported me. I deeply appreciate their love, knowledge of humanities and the arts, and their life-giving wisdom. I just wouldn't be the man I am today without my brilliant sisters backing me all the time.

I thank my great big brother, Gerard, for helping me along the way; in simple and profound ways, he'll probably never understand the depth of my gratitude for all he has done. Truly, I'm grateful to him for imparting a passion for photography because without that gift, I wouldn't have the means to express myself in the visual sphere. The pictures in this book are as much his as they are mine.

ACKNOWLEDGMENTS

I thank "the black sheep" of our family, my brother Brendan, for so many wonderful times shared as kids and, later, for taking me under his wing during the rough times in London. (You were the strongest of all of us and those who knew you were deeply saddened by your passing, going on before us, laughing always, joking around, and playing your guitar. To say you will be missed is to admit you're gone and that would be wrong. You still exist because you still live within us, your spirit next to our hearts.)

I would also like to thank my greater family, including the finest of in-laws, kind neighbors and relatives, and good friends throughout these many years living in Ireland, London, New York, and elsewhere who pushed me to go do greater things than I had ever imagined doing.

I thank my wife, Ozioma, for her love and eternal support. No matter how heavy our burden has been, she has always had my back, and all my sides covered. Her spirit is all love as she lights up a path to my soul every day. (Come on now babe, just your laughter sets me off, sets my heart aflame, and is this a poem, must I go on, my love!).

I thank my son, Chet, for all the great things he does and all the great ideas he has. This side of a greening Earth, you're the funniest little fella whose imagination is gold, whose spirit is bold.

I also appreciate the love and the support of the Obinani family, of the blessed matriarch Ngozi Obinani and her lovely children, Ojay and Ona. They are truly wonderful to me and our family both here and in Ireland.

I would also like to express my profound gratitude for the fine people of Finglas, Dublin (you know who you are!) who raised me rough enough and tough enough to survive when things ever went belly up and down the tubes! No matter how far from home I go or how hard I travel with others or solo, I always remember the amazing times growing up in such an incredibly close, kindhearted community.

I would like to acknowledge both institutes of learning I attended, the College of Commerce in Rathmines, Dublin, and Hunter College in Manhattan.

Both of them provided me with such great nurturing environments for ideas to take root and bloom. My teachers and my friends in these marvelous colleges had a great impact on the direction of my life and the course of my thinking. My mother always said that learning builds a path to the future, to a world you get to build upon. Both of these places fulfilled my mother's promise.

I'd like to thank the wonderful Mr. and Mrs. Larry and Klara Silverstein and their family—Lisa, Tal, and Roger. It has been the honor of a lifetime to work for Larry, the quintessential New York Mensch. When 9/11 happened, Larry knew what had to be done and with great determination, energy and vision, he rebuilt what this city lost, and made it better in the process. It has been my privilege—and mission—to document the many beautiful buildings he developed in Lower Manhattan, along with the people in them.

In addition to the Silverstein family, I'd like to thank the broader Silverstein organization—some of the most talented and accomplished real estate, development, and construction executives in the business. Thank you to Marty Burger, Mickey Kupperman, Dino Fusco, Jon Knipe, Bill Dacunto, Jeremy Moss, Leor Siri, Lisa Bevacqua, Debra Hudnell, Brian Collins, and David Worsley.

To David's team at the World Trade Center—the men and women who spent years, and decades, building the towers that I photographed: Janno Lieber, Sean Johnson, Scott Thompson, Malcolm Williams, Michiko Ashida, and Carlos Valverde.

I wish to thank my colleagues and my collaborators at the World Trade Center, the building staff, architects, engineers, on-site workers for helping and supporting me throughout the years of hardship, of unrelenting work, of triumph. Without my great, well-weathered friends here at the WTC, in Ireland, and around the world, Dara McQuillan, Jenny Chao, Mike and Rob Marcucci, Lorenzo Brusasco, Anthony Ribando, Luisa Colon, Gillian Cox, Alex Cox, Fiona Whelan, Alessandro Bossi, Nino Bossi, Fionnuala Greene, Bobby Grandone, Kevin Rutigliano, Richard Drutman, Stefanie

Moreo, Jessica Schoenholtz, Gianna Frederique, Rebecca Shalomoff, Boopsie, "Mugsy Seagull," Nygel Obama, Jeanette Oliver, Molly Mikuljan, Kelsy Chauvin, Denise Shanks, Anna Colavecchio, Colette Bosque, Courtney Squicciarini, Matt Kapp, Shari Natovitz, Gerard Flynn, Gabriela Tusu, Daragh McCarthy, Robin Lynn, Deirdre Murphy, Deirdre Walsh, Neil McManus, Susan Arhensmeier, Constance Harris, Enda O'Callaghan, John Locke, Bren Murray, Mary Casey, Edel Brosnan, Paula Leane, Dearbhla Walsh, Colm Mooney, Peter Nicholson, Helen Earley, Kirsten Zimmerman, PJ Dillon, Angela Glass, Sir Steven O'Rahilly, Ronan Gibbons, Martin O'Gorman, Eugene O'Brien, Dicey Reilly, Brian Grehan, Maurice Noble, Joe Whelan, Nicky Monks, Dave Gibbs, Ten Gibbs, Stephen Burke, Sian Quill, Brian Grehan, and Conrad Stojak, I would not have kept going, strong and steady, documenting this mammoth project.

I would also like to thank my interns over the years, Natalie Weiss, Erika Koop, Michael Calcagno, Vivian Chau, Ginny Stroby, Christina Alvarado, Emily Efraimov, Aisling Gregory, Alexandra Rupp, Steve Dabah, Emma Beuster, Carly Bornemann, Katherine McKinley, Naamah Azoulay, Steven Sypa, Karina Kabbash, Pia de Soiza, Raffaela Feyrer. And a big thanks to Lucy and Lana Kovalenko for creating such strong and stirring visuals to advance the story of the World Trade Center rebuilding.

I am also grateful to the Maybach Foundation for creating the World Trade Center Arts Project back in 2008 to advance the idea of opening up the documentation of the WTC site to young photographers. The Foundation was instrumental in finding such brilliant mentees (Nicole Tung, Vicky Roy, Ben Jarosch, and Marika Asatiani) to collaborate with and to bring on-site to document the work and the workers. I also appreciate the stellar work of Borough of Manhattan Community College (BMCC) for recognizing my work in 2011–2012 when they hosted an exhibition of WTC images to honor the opening of their building, which was destroyed on 9/11, and Aisling Gregory, who organized the whole show.

I would like to thank the news

media, the journalists, photographers, publishers, editors, and writers that I had the pleasure of bringing on tour at the WTC site. I always happened to capture some snappy insights just walking, talking, and shooting, especially from photographers Mark Lennihan, Allen Tannenbaum, Tim Griffiths, Marcus Robinson, Todd Stone, Anthony Behar, Bryan Meade, David Handschuh, Todd Maisel, Sean DeSerio, Abhi Inamdar, Tim Hetherington, Chris Hondros, Peter Kaplan, Carl Glassman, and Michael Bowles; writers Helen O'Rahilly, Judith Dupre, David Stanke, Matt Kapp, and the always brilliant Scott Raab; publishers Mark Warren, David Granger, Grace Capobianco, and Deborah Martin. Thanks to everyone at Sipa Press for taking me in and thanks to everyone at *Esquire* for not throwing me out! I'd also like to thank everyone at the 9/11 Memorial and Museum, especially Michael Frasier, Joe Daniels, Alice Greenwald, Lynn Rasic, Shanell Bryan, Kim Wright, and Amy Dreher.

I would also like to thank the folks at the architectural firms Foster+Partners, Rogers Stirk Harbor+Partners, Bjarke Ingels Group, and the Port Authority of New York and New Jersey—in particular, Chris Ward, Glen Guzzi, Steve Plate, and Jim Keane. I'm also grateful for the support of Sal Lefrieri, Thomas Moran, Jai Krishnan, Donal O'Sullivan, Pete Rodrigues, Paolo Collavino, Con Reilly, Karen Auster, Bud Perrone, William Roth, Jim Miller, Andrew Woods, Sean Cox, Paul McGuire, Richard Kielar, and Jody Fisher, who helped in ways both big and bigger! And thanks go to the FDNY, NYPD, and PAPD.

Lastly, and without exception, I would like to thank every single individual who contributed to the rebuilding of the World Trade Center. I'm amazed at your endurance, your tenacity, your power of spirit, body, and imagination to create a milestone landmark that will last for generations and be admired for years. I thank you for your awesome achievement. I look forward to continuing the work until this project is fully done and dusted, the tools are put away, and these buildings for the world entire reach "once more to the sky."

ABOUT THE AUTHORS

SCOTT RAAB is a graduate of Cleveland State University and the University of Iowa's Writers' Workshop. The author of two books, *The Whore of Akron* and *You're Welcome, Cleveland*, he also spent nineteen years as a writer-at-large for *Esquire* magazine. He lives in Glen Ridge, New Jersey.

JOE WOOLHEAD was born and raised in Dublin, and has been living in New York City for over thirty years. When the attacks happened on September 11, 2001, he grabbed his camera and shot what he witnessed over the course of three days. His photographs from that time were published all over the world. His work has since been featured in the *New York Times*, *Esquire*, the book *A Century Downtown*, and the documentaries *Men at Lunch* and *The Irish New Yorkers*. In addition to collaborating with clients such as Disney and Related, he works with Silverstein Properties documenting the rebuilding at the World Trade Center site and the 9/11 Memorial & Museum. He currently resides in Queens with his wife, Ozy, and their son, Chet.

COLUM McCANN is the author of seven novels and three collections of stories. Born and raised in Dublin, Ireland, he has been the recipient of many international honors, including the National Book Award, the International Impac Dublin Literary Award, a Ordre des Arts et des Lettres from the French government, election to the Irish arts academy, several European awards, the 2010 Best Foreign Novel Award in China, and an Oscar nomination. In 2017 he was elected to the American Academy of Arts. His work has been published in more than forty languages. He is the cofounder of the nonprofit global story exchange organization, Narrative 4, and he teaches in the MFA program at Hunter College. He lives in New York with his wife, Allison, and their family.